gegenwart museum

Berlin!
The Berlinische Galerie
Art Collection
Visits Dublin 1991

Hugh Lane Municipal Gallery
of Modern Art
March 16th to June 16th, 1991

Sponsored by
Dublin 1991 — European City of Culture,
Dublin Corporation,
the Goethe-Institut Dublin,

and the
Senate Department for Cultural Affairs
of the City of Berlin.

With the kind support of
Lufthansa German Airlines

DUBLIN
1991
EUROPEAN CITY of CULTURE

Dublin 1991
European City
of Culture

BERLIN!
The Berlinische Galerie
Art Collection
Visits Dublin 1991

Berlinische Galerie
Museum of Modern Art,
Photography and Architecture
Martin-Gropius-Bau, Berlin

Exhibition

Conception:
Jörn Merkert
Eva Züchner
Janos Frecot
(Photography)

Realization:
Jörn Merkert
Eva Züchner

Organization and Coordination:
Barbara Dawson
Eithne Massey
Assisted by
Patricia Flavin
and Caitriona Smith

Supervising Conservators:
Katharina Orgaß
and Silke Zeich
Assisted by
Gudrun Wasser

Architects:
Ronan Boylan
J. J. McKeon

**Electricity and
Public Lighting:**
Alex O'Reilly

Technical Installation:
Michael Schulz
Assisted by
Beatrix Grohmann, Toni Tornow,
Berlin,
and
Fred Daly, James Doyle, Kevin
Dycher, Michael Fagan, Raymond
Fox, Dermot Furlong, Vivienne
Scully, Dublin

Catalogue

Published by
the Berlinische Galerie
in co-operation
with the
Museumspädagogischer
Dienst Berlin

Conception:
Eva Züchner

Edition:
Eva Züchner
Assisted by
Katja Reissner

English Edition:
Barbara Dawson

Graphic Design:
Georg von Wilcken
(MD Berlin)
Assisted by
Heike Littbarski
(MD Berlin)

Translations:
Richard Carpenter
Lucinda Rennison

Lithographs:
Meisenbach Riffarth & Co.,
Berlin

Production:
H. Heenemann GmbH & Co,
Berlin

ISBN 3-927873-09-8

© 1991 Berlinische Galerie, Berlin,
the authors and translators

Special Thanks to

Berlin:
Helen Adkins
Ingrid Andruck
Christiane Grathwohl
Doris Haneberg
Freya Mülhaupt
Ursula Prinz
John Schuetz
Armin Schulz
Christian Spork
Ingrid Streckbein
Carmela Thiele
Monika Voss

Crete:
Martin P. Tapir

Dublin:
Lewis Clohessy
Antoinette Dawson
Barbara Dawson
Barbara Ebert
Uta Haas
Eithne Massey
Ciarán McGonigal
Ingo Rott
Jim Wright

Frankfurt/Main:
Bernhard Jung

Front cover:
Iwan Puni
Synthetischer Musiker, 1921
Synthetic Musician
Oil on canvas
145 × 98 cm

Back cover:
Hannah Höch
Self Portrait, c. 1927
Silver gelatine paper
31,2 × 24,3 cm

Contents

Welcome

BERLIN!—The Berlinische Galerie Art Collection Visits Dublin 1991. This exhibition impressively documents the diversity and vitality of the German capital's art scene. It reflects the chequered history of a city which, suspended in the dynamic field between East and West, has always inspired artistic creativity.

We at Lufthansa German Airlines take particular pride in supporting this exhibition. Firstly, because we feel deeply attached to Berlin. It was there in 1926 that Lufthansa was founded, growing with the vibrant, cosmopolitan city into one of the world's leading international airlines. Secondly, because we have set our sights on Europe, whose cultural capital in 1991 is Dublin—in the centre of which we maintain a presence. Our roots are in Berlin, our perspectives in Europe.

We trust that this exhibition at the splendid Hugh Lane Municipal Gallery of Modern Art will afford visitors an interesting and entertaining encounter with Berlin and its art.

Heinz Ruhnau
Chairman
Lufthansa German Airlines

Foreword

Dublin Corporation is pleased to present BERLIN! at its Hugh Lane Municipal Gallery of Modern Art. This exhibition of works from the *Berlinische Galerie* celebrates the re-opening of our gallery, after extensive refurbishment. It is particularly appropriate that the art of this ancient city in the heart of Europe should be on show in Dublin—the European City of Culture for 1991.

BERLIN! is an exhibition of contrasts—between the different forms of art on display and the differing traditions of Eastern and Western European artists—radical 20th Century art in the setting of the restrained 18th Century elegance of Charlemont House. These contrasts result in a dynamic exhibition, appropriate for a city which acts as a cultural crossroads between Eastern and Western Europe.

This exhibition provides a foretaste of the varied and stimulating exhibition programme drawn up by this gallery for 1991, designed to appeal to a wide range of people—from experts in art to the general public. We look forward to welcoming many visitors to the gallery and we enthusiastically welcome BERLIN! to Dublin.

Sincere thanks are due to the *Berlinische Galerie*, the Senate Department for Cultural Affairs of the City of Berlin and indeed to all who contributed to the success of this exhibition. The show would never have been exhibited here without the hard work and dedication of many people, not least the Director of the *Berlinische Galerie*, Prof. Jörn Merkert, and the Exhibition Officers, Eva Züchner and Barbara Dawson. Thanks are also due to Dublin 1991, the Goethe-Institut, Mercedes-Benz, Ireland, and Lufthansa, who joined the Corporation in supporting the exhibition not only financially but also with advice and expertise.

Councillor Michael Donnelly
Lord Mayor of Dublin

Foreword

What do we know about Dublin? Perhaps a little through our reading of James Joyce – but not much more than that. What do we know about Europe? Quite a lot – but, one thing is certain, it can never be enough.

Making a city the European City of Culture each year has proved a very profitable arrangement. It helps us to learn something about Europe, about the things we have in common and the differences there are between our cultures. We welcome the choice of Dublin as the European City of Culture this year. Let us hope that the Dubliners will gain much from the variety of cultural activities offered, and that we – on the other hand – will have discovered more about Dublin and Irish culture as a consequence.

The Berliners are very much concerned to play an active role in the unification of Europe, in the process by which our continent – which has been separated for so long – is growing together. Our history, the geographical position of the city, and its artistic vitality place considerable demands on us to bring together the people of Europe, whether it be in the North or the South, in the East or the West. Culture is a means well suited to this task. I hope very much that the works of art from the collection of the *Berlinische Galerie* presented in this exhibition will have something to say to interested visitors in Dublin. If the exhibition succeeds in increasing our interest in each other, and strengthens our sense of unity, then it will also have been a success for the Europe of the future.

Eberhard Diepgen
The Governing Lord Mayor of Berlin

Introduction

Berlin greets Dublin! The European City of Culture 1991 has invited that of 1988 to be its guest. In response Berlin is bringing over a selection of the most attractive works in the collection of the *Berlinische Galerie*, its state museum of modern art, photography and architecture. Berlin is presenting its history with all its ups and downs mirrored in art. At the same time, the feeling for life expressed by its people—an exciting field of opposites and contradictions—becomes tangible. So its pulsating creativity becomes evident as its valiant spirit.

We encounter the vitality of art in the provocation of petit bourgeois ways of thinking, whether by Dada in the 1920s or by Happening and Fluxus in the 1960s and 1970s; likewise, we find the critical counterpart to reality, both in the New Objectivity of the Weimar Republic and in the Critical Realism of the 1968 generation. Lyrical excess of sensitivity to the world expressed in almost private visual poetry has its place in this city alongside the loud, expressive crying out of existential needs and desires. Berlin was and is—usually simultaneously—a place of the avant-garde and of persistent tradition; even more so than in other cities, the rebellious spirit of renewal has met with and meets with a stubborn defence of tried and tested positions.

With the art of the last seventy years, the viewer is not only confronted by the entire spectrum of modern art, he also experiences Berlin as a cosmopolitan pivot between the East and the West, and not only since the fall of the Wall. As well as Dada and New Objectivity, the eastern European avant-garde also had its home in Berlin, a tremendous variety of stylistic attitudes stimulated each other, and the situation has scarcely changed today.

Forty years division of the city and twenty-nine years of being walled-in have of course left their traces on Berlin; this exhibition tells that story, too. For example, the present day art scene in the eastern part of the city, which, until a few months ago, could scarcely be taken into account in the acquisition activities of the *Berlinische Galerie*, is only roughly outlined by a few examples in this exhibition,—chiefly loans from the artists. This signifies two things: on the one hand, the new tasks of the *Berlinische Galerie*, which was placed in a position of responsibility for the whole of Berlin overnight; and on the other hand, the museum's tremendous need to catch up within this field. Rapid decisions in cultural politics are necessary in order to allow us to act as a true museum; a place which preserves and yet which is living in the present.

It is unusual for a museum to travel. Many special efforts are necessary, even when as in this case there are important reasons for exposing valuable works to the conservatory risk involved in a temporary move. The unified Berlin is showing itself for the first time as a European metropolis before the tableau of the European City of Culture, Dublin, and

in doing so, it is expressing its thanks to all its friends around the world for the trust placed in its power of survival.

I would like to thank the Lord Mayor of Dublin, Councillor Michael Donnelly, for his city's generous hospitality, and also thank the Hugh Lane Municipal Gallery of Modern Art. I would like to thank Barbara Dawson and Eithne Massey, our Gallery colleagues who will take professional charge of our collection in Dublin and Ciarán McGonigal, Chairman of the Arts Advisory Committee. We are very proud and grateful that they did not hesitate in reopening, after one year's closure, their beautiful, fully renovated building to the public with this presentation of the *Berlinische Galerie's* collection.

The realization of the exhibition and catalogue was in the capable hands of Eva Züchner, who, with my close co-operating, developed the concept. With imagination and a wealth of knowledge, she has taken care of the realization of all aspects, both of the content and of organization. I should like to thank her most sincerely.

Thanks also to the co-publisher of this catalogue, the Museumspädagogischer Dienst Berlin, in particular to Georg von Wilcken, who was responsible for the graphic design.

Naturally, considerable thanks are due to the public and private sponsors, whose assistance ensured the prerequisites of this exhibition, — to Dublin Corporation, and here in particular Jim Wright, and to the Board of Dublin 1991 — European City of Culture and their chairman Lewis Clohessy, also to the Goethe-Institut in Dublin and its director Dr. Ingo Rott, to Mercedes-Benz, Ireland, and finally to the Berlin Senate Department for Cultural Affairs.

Our warmest thanks, however, must go to the main sponsor of this exhibition, Lufthansa German Airlines, who have helped us so often in the past and who also — in close co-operation with the *Berlinische Galerie* — supported this undertaking with great generosity. We have Lufthansa alone to thank for the fact that our literature and music event ›Berlin Sound Works‹ planned to coincide with the exhibition, will take place from 7th to 9th May in the Hugh Lane Gallery. It almost had to be abandoned because of lack of funds; Lufthansa came to our aid as a deliverer literally at the last minute.

I hope that this exhibition — and thus our collection — will meet with a great response among the Dubliners themselves and their guests from all over the world.

Jörn Merkert
Director
of the Berlinische Galerie

Berlin! or The Round Head
The Berlinische Galerie: Co–Operation between State and Private Initiative

Jörn Merkert

The history, between scepsis and utopia

Today, after fifteen years, the private society *Berlinische Galerie* is not alone in considering itself the Berlin state museum of modern art, photography and architecture. This healthy self-confidence is supported by a wide public which stretches beyond the limits of Berlin itself. The gallery's role is now recognized and promoted by those with political responsibility. This developed by no means as a matter of course, for things once appeared rather different, especially during the first decade after its foundation. And from the perspective of a museum, as an institution which generally thinks in terms of several generations, the *Berlinische Galerie*, after fifteen years, has scarcely outgrown its baby shoes.

In its wonderful permanent situation—a novelty even after four years—in the *Martin-Gropius-Bau*, which is surely the most attractive building which houses works of art in Berlin (West), the public's awareness of the gallery has grown immensely, leading us to almost forget its previously shadowy existence. It has assimilated its role quite naturally— if not entirely without difficulties—and almost as a matter of course, it now has an integral place in the many-faceted museum panorama of Berlin. This is evident in the number of its visitors, also in the considerable increase in public funds being made available to fulfil the gallery's task; it is indicated by the brilliant acquisitions which we have succeeded in making during recent years—chiefly with the assistance of the Foundation *Deutsche Klassenlotterie* (German Class Lottery); it can be seen in the significant donations we have received; and in the rapidly increasing number of members in the society which is still the legal entity of the museum; it is evident in the aims which the *Berlinische Galerie* has set itself, but also in those set by others; finally, it is clearly visible in the extraordinary identification of artists with ›their‹ state gallery.[1]

This all began some years before the actual foundation of the *Berlinische Galerie*. The idea was first voiced over a beer, and as early as 1969—during a critical survey of the Berlin art scene by Reiner Güntzer and Eberhard Roters.[2] It was discussed in more concrete terms in 1972, when Roters came back to Berlin from Nuremberg and tried to enlist support for it during endless negotiations in his position as presidential secretary of the Academy of Arts. His vision, which then appeared utopian, was to create an institution which would collect »numerous works of art created in Berlin, and important works characteristic of the intellectual and artistic profile of the city«, art which might otherwise »be lost to the city and easily transferred to museums and private collections elsewhere in Germany and the rest of the world.« For »neither the *Nationalgalerie* nor the *Berlin*

Museum were suitably fitted for this task, the *Nationalgalerie* because of its task to build up an international collection; the *Berlin Museum* because its predominant perspective was the history of the city, a perspective which demanded a highly defined collecting policy.«[3] Roters' vision became more real in 1973/74, when funds from the *Deutsche Klassenlotterie* to »save valuable art treasures from being lost to Berlin« made possible the first acquisitions for Berlin, among them such important pictures as *Der tolle Platz* (The Mad Square) and *Der Leierkastenmann* (The Hurdy-Gurdy Man) by Felix Nussbaum, as well as two paintings and five collages by Hannah Höch.

On the 21st November 1975, the time had finally come. The *Berlinische Galerie* was launched as a private society by fifteen patrons and interested citizens of the city.[4] At an exhibition in the Academy of the Arts, which lasted only a few days, it showed the first acquisitions, donations and loans in what was still a »logically rather sporadic arrangement.«[5] The statutes of the society say: »The *Berlinische Galerie* is a museum which collects art works and material concerning the artistic and cultural history of Berlin from the fields of visual art, architecture, artistic photography, applied art and design, carrying out research into these and making them available to the public.«[6] The founding director was Eberhard Roters.

The general reaction was restrained, and apart from those who had been enthusiastic about the idea from the start, the chief note was one of scepticism »according to the tenor ›firstly, nothing will come of it.‹ . . . And secondly: ›what does Berlin want with new museums? We have other worries.‹ . . . Concealed behind this openly declared hostility towards museum was the mentality of the sour-puss, a kind of faint-heartedness which is typical of Berlin society in many fields, the effect of which occasionally penetrates so far as to shape political opinion. There are many reasons for this faint-hearted spirit. It has to do with the political and social developments in Berlin after the war and the resulting traumata. It stems from an inflexibility of convictions in Berlin society which is scarcely rationalized by those involved; even today, this society has not been able to free itself from the post-war appeal. Some chalky dust from the last ruins still sticks to the membranes of society's soul . . . and as a result of all this, the Berliners have a shortage of cultural self-confidence. This lack of confidence is so deep-seated that it has taken on irrational traits, and it means a lack of faith in one's own cultural tradition, lack of faith in one's own cultural productivity, and all this despite the fact that evidence has long since proved the opposite.«[7]

The concept, between province and metropolis

It is very rare for a museum to be founded on literally nothing, and if at all, then—as in the case of the Art Collection North Rhine-Westfalia in 1961 in Düsseldorf, or the German Historical Museum in 1987 in Berlin—it has not only been far-reaching in its conception, but also in the political will behind it. This was by no means the case with the *Berlinische Galerie*. Its ›provincialism‹—in the sense of minor significance—seemed predetermined. For even the preconditions were basically different to those in Düsseldorf, for example, where the starting points were an international concept and the highest possible standards. In addition, suitable funds, gigantic even then, were made

available there. The *Berlinische Galerie* did not have even vaguely comparable sums. It was (and is), as a private society, particularly dependent on contributions and donations over and above its general allocation of money from the state of Berlin. Besides this, the collection was of course primarily locally orientated—but towards what a place!

In any case, for a long time many people living here did not seriously accept Berlin's cultural significance in the present day. They preferred to speak of it superficially and in a melancholy and reflective past tense as the setting for the ›golden twenties‹. The lost brilliance, intellectual flexibility and invention of Dada, New Objectivity and the eastern European Avantgarde were intended to console us over the concrete fragility of the present—so far as they were remembered at all, except in Scala, the Max Reinhardt Theatre and Josephine Baker with her banana skirts, or in memories veiled by the »chalky dust of the last ruins which stuck to the souls . . .«

There was precious little to see of the avant-garde in the collection of the *Nationalgalerie*, which had suffered focal damage in three ways—through the confiscation of *Entartete Kunst* (Degenerate Art), through the war and through the division of the city—or in the cultural history collection of the *Berlin Museum*, which was still young, having been founded as late as 1962. And an innocent local patriotism in the positive, European sense which might have stimulated exhibitions was late in coming.[8] (And fluctuating exhibitions are no alternative to a permanent museum collection, anyway.) The present always posed enough problems.

As if in a pressure cooker with a faulty valve, these problems stewed in their own juice in the isolated city after 1961. The result was not everyone's cup of tea, but initially, this fact was concealed beneath the front mentality of the island dweller. Later, it was hidden beneath megalomanic over-estimation of self and pseudometropolitanism; whether this was Karajanitis, festivalitis—the continual invention of new festivals well beyond the traditional autumn festival weeks—or the international artists' programme of the German Academic Exchange Service; or, during the most recent years, the Young Wild Movement and their oh so great international successes, the *Skulpturenboulevard* (Boulevard of Sculpture)—which was overshadowed by fuggy, Philistine argument—and the great celebrations of the 750th (!) anniversary, or as the *Cultural City of Europe* with a firework display of cultural events on a grand scale. The result of all this is that the cultural facts have not really been recognized; neither in the past, nor in the present.

Berlin has always loved to repress all thoughts of history, for the past is hauntingly close in everyday life. Despite this, perhaps because of it, Berlin (West)—to a large extent due to certain aspects of its political constitution, such as exemption from National Service—has attracted a colourful spectrum of people with an alternative view of life, a critical approach to social conditions and radically different needs to those of the bourgeois consumer and throw-away society. Besides: Berlin, destroyed by the Second World War, divided by the Cold War, and reconstructed as a brilliant showpiece for the West in the middle of the East, has—despite, even due to its exposed geopolitical position—actually remained a seething metropolis, for all its artificiality. It has often been compared with the New York of the thirties, it is incomparably different to Munich, Hamburg or Frankfurt on Main. Berlin (West) became the German centre of student

unrest in 1968 and, at the same time, it offered a dazzling foil to society's chic. Kreuz-berg, meanwhile, was left largely to decay for many years, a foreigners' ghetto and an artists' quarter, deteriorating into an eldorado for speculators and thus becoming the squatters' central field of action, it was regularly set alight on the 1st May, and has now finally become a model of cautious urban renewal. Berlin (West): quarrelsomely, narrow-mindedly provincial, a highly civilized metropolis, the setting for tension in world politics, a multicultural urban society, the experimental field for avant-garde models of society and a centre of decentralized cultural policy? Contradiction upon contradiction, contrast upon contrast, claim upon claim: nervously running on the spot, seething within itself.

From the beginning, financial need—especially caused by the »faint-heartedness« so haptically described by Roters—seemed to oblige the *Berlinische Galerie* to show inter-est only in work which others (in the city and elsewhere) did not want, that which they undervalued and which could therefore (still) be procured cheaply or even received as a gift. (Others, especially outside the city — »museums and private collections elsewhere in Germany and the rest of the world«—had also detected this and had not been idle.) But it was exactly the undervalued, the scorned, the unnoticed, the apparently unimportant which Roters valued highly; he recognized its historical and actual worth long before his colleagues, and wanted to offer it its true place. In doing this, he encroached on no-one's preserve, and did not need to compete, but he had to take on the Sisyphean task of conviction and persuasion in the face of ignorance and bigotry.

One means of doing this—rather than a permanent exhibition of the growing collec-tion—was to mount fluctuating thematic or monographic exhibitions. Roters presented the results of his acquisition activity to the public thirty seven (!) times in the seven and a half years from November 1978 to the move to the *Martin-Gropius-Bau* in May 1986. Above all, this was in the context of the so-called *Längsschnitte* (Sections) and *Quer-schnitte* (Cross Sections) held at Jebensstraße near the Zoo Station—in rooms previously belonging to the *Galerie des 20. Jahrhunderts* (Gallery of the 20th Century). Step by step, he gradually conquered the territory now acknowledged as belonging to the *Berlinische Galerie*: that is, to trace the main direction of Berlin art history from 1870 to the present day, including all its branches and the finest ramifications—something no other institu-tion did.[9] Thus Roters had created a place in which Berlin could experience its cultural identity. But the fact that, for years, many people considered such a place superfluous is an indication that they were not aware of any deficit. In one department of the collection in particular, this becomes strikingly clear. Roters made it a focus of his activity from the beginning and the *Berlinische Galerie* still devotes much attention to it today. This department concerns the artists who were persecuted during National Socialism; who were driven into hiding or murdered; those whose work suffered most particularly under the impact of terror and despotism. If it was not destroyed, their work is still scattered to the four winds and has thus often remained completely unknown. One of the most laudable tasks of the *Berlinische Galerie* is to give back dignity to these artists, who were stigmatized as ›entartet‹ (degenerate) under Hitler, restoring them to memory and thus keeping alive an awareness of the immeasurable loss suffered, a loss which has continued

to determine our actions and our thoughts until the present day. This task could (and can) only be fulfilled because the museum—with no financial means in theory and a starting budget of next-to nothing—has always met, especially with regard to its acquisition policy, with perfect sensitivity and the greatest understanding, from the Administration of the Senate for Cultural Affairs and the Foundation *Deutsche Klassenlotterie*.

But the disdain for one's own artistic achievements widespread in Berlin was not only reserved for the past, which was (and still is) often felt to be burdensome. As a result of the inferiority complex described by Roters, this disdain was also aimed at contemporary art. In Berlin, from a prejudiced standpoint, this seemed to lag behind developments in the Federal Republic and above all, to produce only second class work. For a long time, most people recognized little work as being original—apart from Critical Realism at the end of the sixties, which was not greatly valued in the Federal Republic. Psychologically speaking, the Berlin scene lay inaccessibly far from the mundane bustle of the Rhineland ›west-coast‹, and even as a destination for travel—»Berlin is worth a journey«—Berlin was often experienced as a walled-in cul-de-sac. (Although this was never entirely understood by artists such as Joseph Beuys, Wolf Vostell, Edward and Nancy Kienholz, George Rickey, Eduardo Paolozzi, Jan Kotik or Armando.) With some intelligent and far-sighted co-operation between the Administration and the *Berlinische Galerie*, however, it was possible to make a virtue out of this necessity, which was, despite appearances, closely related to the repression of the past.

The collection, between Klassenlotterie and the promotion of artists

Even for years after the founding of the *Berlinische Galerie*, ›promotion‹—it has to be written in inverted commas—of contemporary art was largely restricted to so-called ›necessary acquisitions‹, acquisitions which offered artists a minimal opportunity to counteract the disadvantage involved in living in Berlin (West). The art works which were bought almost indiscriminately according to social and/or artistic criteria in the context of this ›emergency programme‹ wandered into the notorious rather than famous Senate cellar. (The most significant were brought out again after many years by the *Berlinische Galerie* . . .) At best, these works served as (sometimes unappreciated) decoration in offices and rooms of the Senate.[10]

In the ›Programme to Promote Artists‹, which it has been possible to continually extend since its establishment at the instigation of Karl Sticht, the departmental head of fine art at the Senate Administration for Cultural Affairs, an instrument was created which, alongside differently organized social support for artists, specifically aims at promoting artistic quality. It is awarded according to the decisions of an acquisition commission, which makes regular visits to ateliers and gallery exhibitions in the course of a year. In order to prevent ›cellar-buys‹ from the word go, the works bought are only ones for which a place can be found in one of the institutions represented on the commission. In addition to the financial support of the acquisition, therefore, there is another equally significant benefit; the artists' work finds a place in a public collection. A side effect of this support for artists, therefore, is that museum collections benefit at the same time.[11] The *Berlinische Galerie*, and naturally contemporary artists, have profited from this

programme to a very great extent. They have often not only been helped in financial need, but they have experienced a real sense of promotion, support, encouragement and esteem. In this way, they have also found, in the *Berlinische Galerie*, a place in which their achievements could be assessed, appreciated, exhibited, made public and preserved, all of which is at least equally important. So the *Berlinische Galerie* became the institute which reflects the present day art scene in Berlin as no other does. It is a place where indications of the state of contemporary fine art in Berlin are presented for public discussion in exciting variety, radical contrast and incomparable abundance.

But what would be the sense of a ›museum of the present‹, which is a contradiction in itself, if the collection of contemporary art in it was not presented in contrast to those works which, with historical detachment, have already stood the test? How do judgements come about, if not in a comparison of the contemporary with historic quality? And how else can the security and reassurance of tradition develop; how else is it possible to recognize what is really new?

One of the impressive successes of the *Berlinische Galerie* since its founding has been to build up a collection which not only illustrates the network of historical relations and affinities involved in the development of art, but also presents tremendous, revolutionary inventions within the area of creative thought. This has only been possible due to the continual and generous support and promotion of our acquisition policy by the Foundation *Deutsche Klassenlotterie Berlin*. It is not only the most important patron of our museum, but of Berlin museums altogether. In effect, the *Berlinische Galerie* would not exist if it had not been for these often considerable donations, at least not the *Berlinische Galerie* as we know it. In this sense, an exhibition showing a cross section of the gallery's collection is not only a presentation of Berlin's art history, but must also be understood as an immense public thankyou to the Foundation *Deutsche Klassenlotterie Berlin*.

The interdisciplinary museum, between archive and educational work

In the supplement to its name, the *Berlinische Galerie* calls itself ›museum for modern art, photography and architecture‹. This is an indication of the interdisciplinary structure of its collections, as they were basically outlined in the passage from the statutes of the society quoted at the beginning. Alongside its art collection, which also has a rich cabinet of graphic art with several thousand examples of printed graphics and unique originals, the *Berlinische Galerie* also has a photographic collection, unusual both in size and quality in Berlin. It consists largely of examples of photography as an independent artistic medium.

The quality and the diversity of the photographic collection of the *Berlinische Galerie* became obvious two years ago, when an assessment was taken of the gallery's ten years collecting in this field with a large exhibition to mark the 150th birthday of photography.[12] This achievement followed the initiative of Janos Frecot, the head of our archive, library, and the photographic collection as a whole. He has accomplished pioneer work in the research of photography in Berlin and has created a permanent forum for this still largely neglected medium of artistic expression. In the meantime, the collection enjoys great international acclaim, which, as is usual here, has remained almost unnoticed in

Berlin. Even more than in the case of visual art, the selection of photography shown in this exhibition is only the tip of the iceberg.

The newest department has the oldest roots in the history of the *Berlinische Galerie* and its collection. The basis of the department of architecture is the archive of the United Workshops for Mosaic and Stained Glass, Puhl and Wagner, Gottfried Heinersdorff, which was presented to the museum at its foundation by the Senator for Art and Science then. The artists' designs for stained glass windows and mosaics kept in this archive mean that the *Berlinische Galerie* has some excellent examples—including the firms' documents applying to them—from the field of applied art and its industrial production between the turn of the century and the 1930s. After many years of painstaking preparation, a recent detailed exhibition gave some insight into the complexity of this part of the collection.[13]

Only in the last few years has the architecture department begun to concern itself particularly with the largely neglected field of building and urban planning in Berlin during the last twenty years. Here too, the archive's principle ensures that documentary material, such as all kinds of records concerning competition and construction planning, for example, are collected together with ›attractive‹ architectural drawings and models. This department is being assembled very rapidly in close co-operation with the Senate Administrations for Building and Housing, and for Town Planning and Conservation.

As the statutes of the society *Berlinische Galerie* say, the tasks of the gallery also include the collection and presentation of »material concerning the history of art and culture« and research into it. Thus we have directed particular attention, apart from the ›classical‹ acquisition policy, towards safeguarding explanatory additional material of various kinds. For if they are allowed to speak together with the work of art—which is complete in itself and autonomous—letters, manuscripts, documents and other records, which may appear of little significance at first glance, all offer an unobstructed view of the alchemist's den which is creative productivity. They can reflect equally vividly and vitally intellectual tensions, artistic connections, the authentic story of how ideas originated and of the social reality which provoked them all.

By acquiring the Hannah-Höch-Archive from the legacy of the artist in 1979, Eberhard Roters took a far-sighted gamble which proved right as this collection of paintings, collages and graphics by Hannah Höch, gave us the incomparable centre-piece of our collection. Not only are masterly examples of her art in all its various figurations housed in the gallery, but the web woven by her works and the valuable flotsam of her relationships and friendships contains a lively picture of her epoch, a picture which is concentrated in the person of Hannah Höch and those individuals involved in her life. This epoch not only includes one of the most exciting, stirring and active chapters in regional art and cultural history, but in German and European intellectual history as a whole.

In time for the 100th birthday of Hannah Höch in 1989, it was possible to produce the first volumes of her ›Life-Collage‹, in which the entire archive material is published.[14] In the exhibition held to mark the same event, art works and archive material were given equal priority in the display; an exemplary prototype of presentation which we should like to extend to the whole collection.[15] Apart from the long years of work which would

be necessary, we should also need at least twice as much exhibition space as we have available at present to achieve this. The realization of this completely different, entirely unusual type of museum is one of the many tasks we have set ourselves for the future. It would be an advantage and a stimulus for our visitors, and make the unmistakable profile of our collection's concept clear.

But most importantly, with this interdisciplinary concept of collecting, the *Berlinische Galerie* sees itself within a tradition of thought developed and practised during the Weimar Republic. Our brilliant model, the standard of which we have not reached as yet, is the endeavour of Alexander Dorner, the director of the Art Collections of the *Provinzialmuseum* in Hannover (1923—1936). With the *Abstraktes Kabinett* (Abstract Cabinet) of Lissitzky and the *Raum der Gegenwart* (Room of the Present) by Moholy-Nagy, this museum took an exemplary path in its policy of collecting and presentation. Its aim was to interfere, using the artistic media, in the social debates of its epoch, setting standards and enlightening the public. This ambitious pretension—but also faith in art as an intellectual force which could fulfil this almost utopian concept—was mercilessly persecuted and destroyed by the National Socialists. It is for this reason that German museums, even today, have to work for a particular knowledge and awareness. Art, more especially because it cannot be controlled by democratic methods, sets standards, and these in turn help us to pose necessary questions in the faceless society of the present, where other orientation is lacking.

The Round Head, between the East and the West

From the 9th November 1989, everything has been different. Since then, the *Berlinische Galerie* has also faced new perspectives and great tasks, without having to neglect its previous ones. Earlier on, forging along tortuous paths in at times dangerous territory and versatile thinking were necessary prerequisites—according to the motto of Francis Picabia: »The head is round so as to enable thoughts to change their course.« And so many a feat was necessary in order to achieve what today appears a matter of course. Eberhard Roters was a great master in this. Is is easy to underestimate that which appears a matter of course, that which we have grown accustomed to. And the prophet is often underrated in his own country. On the one hand, therefore, Berlin's cultural self-presentation here through chosen masterpieces from the collection of the *Berlinische Galerie* is an assessment, on international terrain, of fifteen years often laborious, always successful work.

On the other hand, this exhibition also sketches, for the first time, the new, extended outlines of the museum's work. For the *Berlinische Galerie* is not called the ›Westberlinische Galerie‹. With the fall of the Wall on 9th November 1989, even more so with the currency and social union between the two German states on 1st July 1990 and finally with the introduction of complete German unity on 3rd October 1990—the *Berlinische Galerie* has been catapulted into responsibility for the whole of Berlin with the almost unreal rapidity of political development, without being prepared for this in terms of personel, finance or space. It is also necessary that we carry this responsibility, because the *Berlinische Galerie*, in contrast to many other museums, does not have a sister

institution in the eastern part of the city, whose activities were even remotely comparable. In principle, therefore, there is a tremendous need to make up for this. For if in the future we—as a state gallery—wish to honour our desire to comprehensively document the developments in Berlin art during the epoch after 1949 in some interdisciplinary detail, then the whole—with isolated exceptions—field of art in the past capital of the GDR must be combed through, examined and subjected to new evaluation. In this, we shall be dependent on the advice and co-operation of colleagues from the previous GDR to a great extent. And for everyone, this process of growing together will mean changes. Certainly, our colleagues will have to broaden their critical perspectives; but we ›from the West‹ will definitely also discover that our past criteria and patterns of evaluation are no longer unquestionable and flawless. Nor will they be adequate to trace the forms of artistic expression which have emerged during the last forty years in East Berlin. For both sides it will be essential, as we know from daily experience, to at first tear down, piece for piece, the wall which exists within our minds.

With the help of loans from the artists, we have temporarily integrated into the collection some works which appeared significant in the field of contemporary art. With the *Berlinische Galerie's* present opportunities to acquire work—between the promotion of artists and the Class Lottery—the huge tasks I have briefly outlined are scarcely manageable. In the near future, there is the need for fundamental decisions on cultural policy, in order to enable the *Berlinische Galerie* to take action in its own particular field with the help of a budget specifically for acquisitions.

No-one can foresee what developments there will be in the Berlin art scene of the future. It will—as in any metropolis of the world—be less protective. The artists in the eastern sector are already directly aware of this; they face rising rents and the cessation of state grants and various forms of aid offered by the disbanded association of artists, help which included procuring ateliers and materials; and there is no question of a serious art market yet.

As far as cultural politics in the western part of Berlin are concerned, it can already be foreseen that our previous financial framework and means of promoting art will by no means be enough for the entire city. Indeed, they were all too meagre in the past. A simple quantitative increase in financial means and opportunities cannot do justice to the new quality brought by the unification of the city; besides, in the face of incomparable economic pressures and infrastructural necessities in all areas of society, an increase in the level of the budget seems rather unrealistic. However hard is may hit the individual artist, if he can no longer pay the rent for his atelier and is scarcely able to find a new and still suitable room, this is an aspect of ›normality‹; and in this way we are again discovering how the tens of years of being walled-in had created the warmth of the nest, a security we hardly noticed. Now the fresh air of the open city blows through this nest, but in the same way, so does the icy wind of ruthless economic interests.

But one thing can certainly be prophesied now: The art scene of the whole of Berlin will become more international in the years and decades to come, and it will be more oriented towards the East. With increasing freedom of visas and travel, a mass migration of hundreds of thousands of people from the eastern European states, such as we have

scarcely experienced in history, will come to the metropolis between East and West—a role which Berlin will fill, solely as a result of its geographical position. With these people, whose desire is to learn from the ideas and opportunities of the (still) western world, there will come ideas which are still foreign to us. In the 1920s, over 300,000 Russians lived in Berlin—with their own newspapers, magazines, publishing houses, cafes, shops, their own city districts; they were the humus for the eastern European avant-garde, which radiated from here to the rest of Europe. In the future, in a world which is no longer divided by the Cold War, in a Europe which has grown together, Berlin will again be just such a field of experiment. As the most eastern city of the West and the most western city of the East, it will be a place of meeting and of fascination for all the people of the West. It may be that Berlin—in a completely different sense to the one in which we use the concept in art history—will be the city of the avant-garde. Here, rather than anywhere else, people from all over the world will together participate in a community which embodies entirely contradictory ideas of the world—the result being many problems as yet unthought of. Also unforeseeable all the momentous effects on the art world.

1) At the suggestion of the *Berlinische Galerie*, its founding director Eberhard Roters was honoured by Berlin artists in a project of donations to the museum, one and a half years after retiring from his position. Around 200 artists, gallery owners, artdealers and estate executors took part with over 250 works. See the catalogue *Eberhard Roters zu Ehren — Schenkungen von Arbeiten auf Papier an die Berlinische Galerie zu seinem 60. Geburtstag* (In Honour of Eberhard Roters — Donations of Work on Paper to the Berlinische Galerie on His 60th Birthday), Berlin 1989

2) »The first person to have the idea of founding the ›Berlinische Galerie‹ was Reiner Güntzer, at that time departmental head of fine art at the Senate for Art and Science (today departmental head of museum work at the Senate for Cultural Affairs). To be exact: In the summer of 1969, before I went to Nuremberg as the director of exhibitions at the City Art Gallery there — after resigning from my post as general secretary at the German Society of Fine Art (Art Association Berlin) — I met him at ›Hanne am Hansaplatz‹ in order to say goodbye. . . . On the spur of the moment, during that conversation, I was able to list numerous

works of art which were no longer available, because they had come into someone's permanent possession during recent years and decades, and just as many which it might be expected would soon leave the country. If any action to salvage Berlin art was to have any chance at all, I stressed, then this was the last moment for it, and a start must be made immediately.« In: Eberhard Roters, *Kunst in Berlin von 1870 bis heute — Die Kunstsammlung der Berlinischen Galerie und ihre Entstehungsgeschichte* (Art in Berlin from 1870 to the Present Day — The Art Collection of the Berlinische Galerie and the Story of its Origins) in: *Sammlung Berlinische Galerie* (The Collection of the Berlinische Galerie), Berlin 1986, p. 18 f.

3) Roters, loc. cit. p. 19

4) »Among the founding members were Winnetou Kampmann, the president of the society from then until now, Karl Giese, Klaus Osterhoff, Uwe Hesch, Werner Küpper, Helmut Zeumer, Wolf Jobst Siedler, Werner Düttmann, Peter Pfannkuch and Margit Scharoun, and among the first members of the artistic committee were Professor Stephan Waetzoldt, Dr.

Irmgard Wirth and Eberhard Knoch. Senator Gerd Löffler, Reiner Güntzer and Christian Mothes took part in the meeting on behalf of the Senate. We have the active assistance of all these friends to thank for the fact that the ›Berlinische Galerie‹ managed to survive the early stages.« Roters, loc. cit. p. 17

5) Roters, loc. cit. p. 17

6) The Statutes of the Society *Berlinische Galerie,* § 2, para. 2

7) Eberhard Roters, *Kein Nachwort — ein Vorwort* (Not an Epilogue, But a Prologue) in: *Museumsjournal,* No. 3, January 1988, p. 6 f.

8) It should be remembered that the *Nationalgalerie* did not move into its premises by Mies van der Rohe until 1968. The *Berlin Museum,* still organized as a private society, moved into its own premises in Lindenstraße in 1969 and was taken over by the state of Berlin in 1971. — Certain exhibitions motivated a critical consideration of personal history and the development of a sense of identity. These included *Avantgarde Osteuropa* (Avant-Garde in Eastern Europe) *1910—1930,* German Society of Fine Art in the Academy of Arts 1967; *Aspekte der Gründerzeit* (Aspects of the Industrial Age), Academy of Arts 1974; *Tendenzen der Zwanziger Jahre* (Tendencies of the 1920s), an exhibition of the European Commission, 1977. (This exhibition was the idea of Stephan Waetzoldt, at that time general director of the State Museums of Prussian Cultural Heritage (S.M.P.K.); Roters was responsible for the department ›Dada in Europe — Works and Documents‹ in the Academy of Arts, and finally, *Berlin um 1900* (Berlin around 1900), an exhibition of the *Berlinische Galerie* in the Academy of Arts in 1984. All these projects were initiated and realized by Roters; in doing so, he created the exemplary type of interdisciplinary exhibition well known today, and almost taken for granted. The great Prussia exhibitions of the Berlin Festival and the Academy of Arts took place in 1981.

9) Roters, loc. cit. (Catalogue of the Collection), Footnote 2, p. 21

10) See my article *Aus dem Senatsdienststellentreppenhaus ins Museum — Die Bildhauerei in Berlin und ihre öffentliche Förderung* (From the Stairwell of Senate Offices into the Museums — Sculpture in Berlin and its Public Promotion) in: *Skulptur in Berlin 1968—1988 — Zehn Jahre Künstlerförderung des Senats — Ankäufe im Besitz der Berlinischen Galerie* (Sculpture in Berlin 1968—1988 — Ten Years Promotion of Artists by the Senate — Acquisitions in the Possession of the Berlinische Galerie), catalogue, series *gegenwart museum,* Georg Kolbe Museum, Berlin 1988, p. 8 ff.

11) See my article ›*Wolfgang!*‹ ›*Amadeus!*‹ ›*Mozart!*‹ — or *Die Künstlerförderung als Museumsförderung und umgekehrt* (Promotion of Artists as Promotion of Museums and Vice-versa) in: *Kunstszene Berlin (West) 86—89 — Erwerbungen des Senats von Berlin* (Acquisitions of the Berlin Senate), catalogue, series *gegenwart museum,* Berlinische Galerie, Berlin 1990, p. 8 ff.

12) See the catalogue of the collection and exhibition *Photographie als Photographie — Zehn Jahre Photographische Sammlung 1979—1989* (Photography as Photography — Ten Years of the Photographic Collection), Berlinische Galerie, Berlin 1989.

13) See *Wände aus farbigem Glas — Das Archiv der Vereinigten Werkstätten für Mosaik und Glasmalerei Puhl & Wagner, Gottfried Heinersdorff* (Walls of Coloured Glass — The Archive of the United Workshops for Mosaic and Stained Glass Puhl & Wagner, Gottfried Heinersdorff), catalogue, series *gegenwart museum,* Berlinische Galerie, Berlin 1989.

14) See *Hannah Höch — Eine Lebenscollage* (Hannah Höch — A Life-Collage) Archiv-Edition, Volume 1, 1st and 2nd Section, published by the Berlinische Galerie, edited by Cornelia Thater-Schulz, Berlin 1989.

15) See *Hannah Höch 1889—1978 — Ihr Werk, ihr Leben, ihre Freunde* (Her work, her Life, her Friends), catalogue, series *gegenwart museum,* Berlinische Galerie, Berlin 1989.

Pictures of Life in a Sea of Stone
Art in Berlin from 1900 to Today

Eberhard Roters

»Art that disregards the laws and limits set by Me«, the last emperor of the German Empire, Wilhelm II, smugly declared, »is no longer art.« The majestic dictate was directed against tendencies in Berlin's art circles that developed in 1898 entitled *Berliner Secession*. Artists like Max Liebermann, who discovered for himself the styles of Impressionism and Naturalism, represented this approach. Berlin, up to then an eldorado for imitative classicism, the painting of panoramas and massive paintings of battles to glorify the empire of the second emperor, joined therewith, albeit somewhat late, the international art development.

In 1892 an exhibition mounted by the Association of Artists had already caused a scandal with the works of the Norwegian painter Edvard Munch, one of the most important forerunners of Expressionism. Through pressure from the majority of the Association the exhibition was closed. The president of the Association, Anton von Werner, art advisor to His Majesty, placed himself at the head of the conservative opposition. In his notorious speech at the official opening of the Siegesallee (Victory Avenue, called »Puppenallee« or Avenue of Dolls by the Berliners) the emperor also argued for »true art«: The Muse should lift the soul in harmony and beauty instead of climbing down »into the gutter«.

Therewith a central core of modern art was negatively defined as everything that took leave of the imperial megalomania and concerned itself with the »forming of the idea of the intellectual city dweller«, as Kurt Hiller, a spokesman of Expressionism, programmatically advanced. The industrial age in Germany buried Prussian Berlin under a veritable construction fever; in a breathless tempo a multi-million city took shape with mansions, city palaces, and endless rows of tenement buildings sprouting from the sandy soil of the Mark Brandenburg. And it grew so quickly that the fantasy of the artists could only react to it with a nightmarish vision: with paintings of the city as a sea of stone, of the city's demons, of a rebellion of the buildings. In one of Armin T. Wegner's poems the buildings are described thus: »We murder the field!« Indeed, they march over the entire globe and bury nature in an endless flood of houses. Berlin, the fastest-growing city in Europe, had become the symbol of the modern metropolis—and thereby took over Paris' role as the pulsing capital of the 19th century.

In 1910 the new generation, for whom Berlin was to become the metropolis of modern art, created for themselves a forum with the *New Secession* and the founding of Herwarth Waldens magazine *Der Sturm* (The Storm). It was also Walden who formulated their programme, »that painting's task is not to imitate nature or to photograph people.« Rather it should clarify inner conditions, which was often perceived in the

picture itself as a distortion of visible reality. The modern Expressionism that begins here was a portrayal of the accelerated tempo and the strained nerves of big city life: yearning and fear, conflict, restlessness, premonition of catastrophe, accusation, and protest.

The immigration of the artist's circle *Die Brücke* (The Bridge), which gradually moved to the capital from Dresden between 1910 and 1911 was important for the Berlin art scene at this time. Only then did it gain the final accent to its colour and form pathos, which had been ignited from the experience of freedom in nature. Placed at the mercy of the world experiences of the Berlin melting pot, big city Expressionism was formed from a stylistic irritation.

In the magnetism of the street, painting discovered a new motif and changed its style. Ernst Ludwig Kirchner, the most nervous and most sensitive to the motor-like rhythm of the *Brücke* circle, displayed in his works the most intensive stylistic conversion of big city sensitivity. The neurasthenic consumption of this motor activity spread to his fingertips, and in his painting the hectic staccato of extended brush strokes intensifies to the large street paintings of 1913/14 with the depiction of the street-walkers, clad in imitation silk and ostrich feathers, sweeping through the streets, pulling proudly behind them their spontaneous admirers—an erotic street ballet.

Herwarth Walden's *Sturm* and *Die Aktion*, founded in 1911 by Franz Pfemfert, became the meeting places for young writers, essayists, artists and philosophers from the liberal left middle classes. Walden opened *Der Sturm* gallery in 1912 and created, with his exhibitions of expressionists, futurists and cubists, the most important forum for the assertion of international avant-garde in Europe. The emanations flowing from *Der Sturm* promoted this revolutionary style.

In the *Novembergruppe* (November Group), founded in 1918, we find again, above all, the artists from the *Sturm*. Artists from all directions in style, painters, sculptors, musicians and architects, progressives, revolutionaries, and those who considered them-selves such, came together in this association as a colourful diverse community of performers which remained in existence beyond the twenties. But a new situation was created by the war, the infernos of the battlefields and trenches, the massive dying in mustard gas, the revolution in Russia, the sailors' revolt in Kiel and the revolution in Berlin in November 1918, the murder of Karl Liebknecht and Rosa Luxemburg and the Weimar Republic, established in 1919, which was considered by many to be a poor compromise. Expressionism was passé. Yvan Goll, the writer, remembers »Expression-ism was a beautiful, good, great thing. Solidarity of the intellectuals. A march of the truthful. But the result was unfortunately, and at no fault of the expressionists, the German republic of 1920. Shop sign. Break. Please exit to the right. The astounded expressionist gapes.« Art reacted to these new experiences.

Two directions became noticeable with almost provocative aplomb—Dada and the New Objectivity. Dada used, for the first time, literary and pictorial methods as a unit, not only with the goal of exploding the means of perception of a world allegedly formed of solid values, but to decompose it. The motto: a central perspective means control, Dada means happy anarchy. The Berliner dadaists created a unique contribution to the art of our century, the critical Dada photo-montage. Its source is the heterogeneous

nature of daily events, the photoreproductions of which all are joined as decompositions. The hard core of Dada in Berlin was formed by Raoul Hausmann, George Grosz, Hannah Höch, John Heartfield, Richard Huelsenbeck and Rudolf Schlichter.

The Berlin of the twenties was reflected differently in the socially critical realism of paintings by Otto Dix, George Grosz, Franz Lenk, Gustav Wunderwald, Hans Baluschek and Käthe Kollwitz. A mirror that captures reality, with all its fascinating ugliness, using an excess of photographic clarity.

»Berlin is the capital of Europe«, Herwarth Walden wrote in 1923. »It's an equal distance, in one direction or another, from the Neckar, the Rhine, the Elbe and the Danube, from these rivers that are all awash in desolate poetry. Or botanically speaking, overgrown . . . Berlin is impersonal. The city has the privilege that great personalities have racked their brains over it, of existing completely in the interest of humanity. The architects have tried in vain to embellish the city, in spite of the fact that all of Bavaria, half of Greece and a pinch of Italy have been forced upon it. The Expressionism, also, of the upper and middle class art dealers has also been applied in vain. In a matter of weeks Berlin has digested the old and the new swindle and turned it gray . . . Is this not a great city in which the Russians live in the west, the Germans in the south and the Italians in the north? A city in which the Germans speak French, the Russians German, the Japanese broken German and the Italians English?« Not much has changed since then, cum grano salis. »In Berlin, it's safe to say, there's always something going on«, Walden added, »even if it's not necessarily going on safely.« The year 1933 put a definite end to safe goings-on in Berlin.

There is nothing to say about the art in Berlin during Hitler's reign. *Aufmarsch der Nullen* (Marching of the Nullities) was the name of Werner Heldt's melancholic, ironic drawing that appeared about 1933/34. What the nullities were propagating was neither art, nor anti-art, but an unspeakable non-art. Berlin art went underground. Carl Hofer's paintings testify to this. Dismissed from his position at the university in 1934, he was barred from the Prussian Academy of Arts in 1938 and forbidden to work or exhibit his paintings. Hofer, up to then a painter of cheerful Ticino landscapes and quiet, light shapes of young women, began to paint his gloomy visions of the times: *Die Gefangenen* (The Prisoners), *Schwarzmondnacht* (Black Moon Night), *Fliegeralarm* (Air Raid Warning), *Totentanz* (Dance of Death).

When World War II ended in May 1945, the Berlin artists also held their breath, but not for long. They then breathed a sigh of relief. The democratic powers in the cultural life of the city that had survived the ›thousand year empire‹ were more numerous than many had assumed. Exhibitions, promoted by the local authorities, took place amongst the ruins throughout the city's districts. The most significant occurrence in those first months was the exhibit *La Peinture Française Moderne* in 1946, put on by the cultural department of the French occupying forces in the Berliner Palace, which has in the meantime been demolished. The unaccustomed Berliners queued for hours. As early as August 1945, Gerd Rosen opened his gallery in the midst of the ruins of the Kurfürstendamm in a shop which had formerly sold military textiles, the first avant-garde gallery after the war. With the division of the city, West Berlin had inherited the New West, the

area around the Kurfürstendamm and the Gedächtniskirche (Memorial Church), the artistic centre which continued to flourish in post-war years. Intellectually, West Berlin is still the city of the New West. Rosen's first exhibition director, Heinz Trökes, was one of the primary representatives of the post-war style peculiar to Berlin in those early years, a sceptical Surrealism. His 1946 painting *Die Mondkanone* (The Moon Cannon) is now regarded as the visual consciousness of that time.

Among those young artists who grew up under the Nazis and weren't allowed to display their works from the outset, and who now found their first opportunity to do so in Gerd Rosen's circle were, especially, Hans Thiemann, Mac Zimmermann, Jeanne Mammen, Werner Heldt, Alexander Camaro and the sculptors Hans Uhlmann, Karl Hartung and Bernhard Heiliger. Heinz Trökes recalls, »There was an enormous intellectual hunger. Young and old stood in discussions and lectures, emaciated, side by side, and there were lively debates for and against modern art . . .«

The sharpening of contrasts between the allied protective powers and the formation of two German states under the omen of opposing ideologies also had an effect on the cultural life of the divided city. During the Realism debate in the GDR in the fifties, the provincial capitals there, Halle, Leipzig and Dresden, emerged as centres for its further development, but not so Berlin. The artists in the western part of the city rejected the normative aesthetics of Socialist Realism and took their orientation from the western countries. What was playing a role in the West Berlin of the fifties was the Abstract Expressionism of the *Ecole de Paris*, as well as Tachism, and the Informal and Action Painting of the Americans.

Thus the German artists developed their own style — the result of a tradition still alive from the Weimar era. Because, first of all, the argument for abstract painting had already begun in 1910 with the abstract works of Vassily Kandinsky, a Russian who was living in Munich, and the following generation was already well on its way to fully abstract art when, in 1933, the Nazis radically ended this development. Those who were then young, such as Theodor Werner in Berlin, only now found the opportunity to take up where they had been forced to leave off. Secondly, under the Nazis many artists developed a great aversion to the plain figurative allegory of national socialist painting. This often led to the rejection of all realistic art and to fully abstract painting — as a means of expressing the autonomous formation of a picture and as a testimony to the freedom of the individual responsible only to himself. Among the primary representatives of the Informal in Berlin were Hann Trier and Fred Thieler.

But in its essence, Berlin was and is a literary city, and that influenced the visual. The Berliners are closer to coarseness than to delicate *peinture*. There were already arguments about joint exhibition participation between the abstracts and the figuratives in the early fifties, which escalated in 1953 to a serious fight between the representational under the leadership of Carl Hofer and the abstract under the leadership of the art critic Will Grohmann, the vehement champion of international avant-garde. The form and colour eroticism of a cryptically sensual representation was already mixed into the creation of the works of artists still affected by the Informal, for example the sculptor Rolf Szymanski and the painter Walter Stöhrer. No matter how great their affection to

their teachers was, the students of the informal painters at the Art College were sick and tired of the stylistically exhausted tachistic trend. These students, which included Karl Horst Hödicke, Hans Jürgen Diehl, Ulrich Baehr, Bernd Koberling, Wolfgang Petrick, Markus Lüpertz, Peter Sorge and Lambert Maria Wintersberger, founded the first Berliner self-help gallery in 1964, and named it after the street on which it was located, *Großgörschen 35*. The explosion of talent acknowledged then by the critics has effected the Berlin art scene to this day. The *Großgörscheners* wanted something solid, spirited and cheeky, something the eye can rub up against—they wanted to recreate Berlin big city art. But not cool, like the American pop artists, they wanted it hot. Thus an ironically concrete, trivially metaphoric art was born, as is fitting for Berlin, is rooted between Realism and gesturing expression. One version, strongly inclined towards Realism and influenced by the student movement of 1968, reached its climax in the Critical Realism of the sixties and seventies. Two loners, Georg Baselitz and Eugen Schönebeck, who organized their *Erstes Pandämonium* (First Pandemonium) in their gloomy studio in 1961, latched onto other traditions. Their programme was an aggressive and provocative Expressionism presented with verve. The Baselitz exhibition in the Werner & Katz gallery on the Kurfürstendamm in 1963 became a scandalous success. Baselitz was tried in court of pornography of his painting *Die Große Nacht im Eimer* (The Great Night Shot to Hell). It resulted in an aquittal that went down in legal history. The ›dithyrambic‹ painting of Markus Lüpertz, Karl Horst Hödicke and Bernd Koberling also inclined towards the expressive. All three came from the *Großgörschen 35*. One sees in them, justifiably, the fathers of the New Wild Movement, those unruly painters of the disco and hard rock generation.

Today the recourse of the New Wild Movement to the expressionistic tradition is a thing of the past. Pluralism of style reigns, which isn't necessarily something negative. Berlin's artistic scene is still alive and experimenting. And Berliner art would be nothing without Berlin's tenement buildings, back courtyards and old factories. That's where the artists have their studios. And that's where they were and still are residing.

The Berlinische Galerie
Art Collection

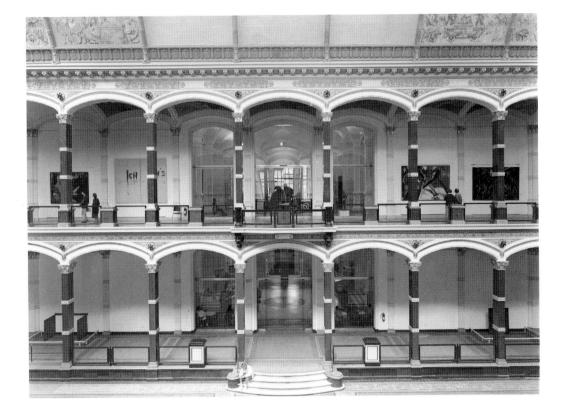

Dada in Berlin

Eberhard Roters

At the end of January, the beginning of February, 1916, the German writer and dramatist from Pirmasens, Hugo Ball, rented the *Meierei* (dairy) on Spiegelgasse 1 in Zurich to realize his plan for a literary cabaret. Ball, who was then thirty years old, had lived as an emigrant with his common-law wife, the lyricist Emmy Hennings, in neutral Switzerland since May of 1915. The premiere was held on February 5, 1916. The main characters of these soirees from then on were, aside from Hugo Ball and Emmy Hennings, the Alsatian Hans Arp, the Rumanians, Tristan Tzara and Marcel Janco, and the German, Richard Huelsenbeck. This was the birth of Dada.

The booklet published by Hugo Ball appeared in May 1916, and included the name of the new undertaking in its title, *Cabaret Voltaire*. The word Dada appeared for the first time in this publication and was submitted for the public's use. On June 23, 1916 Hugo Ball walked onto the stage of the *Cabaret Voltaire* in a stiff cardboard robe dressed as a cubistic shaman and commenced to festively intone an antiphonal singsong: »yolifanto bambla ô falli bambla grossiga m'pfa habla horem . . .«, and so on. That was the sign of the beginning. From that hour on the influence of Dada spread like a wildfire across Europe. Aside from Zurich, centres were ignited in Berlin and Paris. Dada declared coincidence the program, banality the aesthetic principle, apathy the ethical duty, anarchy the artistic impetus and intentional disorder the method. These devices proved to be remarkably fruitful; for the artists, poets and writers surely could not have predicted the results of what they had started when the destruction of the old order—that is, the traditional artistic order in which the traditional social order was reflected—brought about exciting, new inventions, and, therewith, the discovery of a new artistic practice; a statement of the sense was formed from the nonsense that is appropriate to the consciousness level of human civilization in our confusing century.

Dada was the expression of a disturbed, young generation. The performances, a forerunner of the Happening, interpreted by the shocked citizens as a cynical joke, were nothing other than the cry of desperation from those wounded to the very core of their soul by the ›bloody carnival‹ of the First World War and its material battles, which had gone mad with the consent of European society, the society of their mothers and fathers. Many of their statements which lifted this game with the absurd to a provocative stylistic principle of upsetting criticism, had their basis—and to this day this has not been adequately noted—in a religious attitude, which in view of the reality of the conditions all around, could only come to the surface in a broken form. This is true for Hugo Ball as well as, for example, Johannes Baader and Raoul Hausmann.

In January 1917 Richard Huelsenbeck came to Berlin to proclaim the message of Dada. After he got to know the Berlin art circle he was able to report back to Tristan Tzara in Zurich that Dada was already present. Indeed, pre-dadaistic tendencies had

formed within the critical intelligentsia of the imperial capital's liberal middle class already on the eve of the First World War, especially in the circle of artists and writers supporting the two cultural-politically avant-garde magazines *Der Sturm* (The Storm) and *Die Aktion* (The Action). Some of the Spiegelgasse Dadaists of Zurich had published articles in the *Sturm* or the *Aktion*, such as Hugo Ball, who had worked under Max Reinhardt in Berlin before the war, and Emmy Hennings and Tristan Tzara. The Berlin writer Paul Scheerbarth had already given a preview of dadaistic ideas in his fantasy stories around the turn of the century. The *Neopathetisches Cabaret*, put on in 1911 and 1912 by Salomo Friedlaender-Mynona and Carl Einstein, two of the most important *Sturm* publicists, Carl Einstein's grotesque novel *Bebuquin oder die Dilettanten des Wunders* (Bebuquin or the Dilettantes of Wonder), first published in 1912 in the *Aktion* (to this day a much underrated masterpiece of early Surrealism), as well as Friedlaender-Mynona's satirical and philosophical essays are all testimony to the importance of Berlin as a centre for a proto-dadaistic incubation period.

The painter Raoul Hausmann came to Berlin from Austria in 1901; in 1905 he met the sepulchre designer Johannes Baader who became his closest friend there. The turbulent friendship between Raoul Hausmann and Hannah Höch began in 1915.

In 1917 the brothers Wieland and Helmut Herzfelde founded the *Malik* Publishing House, which pays homage to Else Lasker-Schüler as it is called after one of her novels. Helmut Herzfelde took the pseudonym John Heartfield in 1916 in protest against the nationalistic anti-England propaganda. George Grosz, whose experiences on the front had inflicted him with a deep emotional trauma, became their closest colleague. Then came Walter Mehring with his sarcastic poems and essays. Thus, the core of Berlin Dadaism consisted of two competing groups of friends, who were bound, not least of all by Richard Huelsenbeck's communicative and reconciliatory organizational talents. On the one side were the individual anarchists, the ›Dadasopher‹ Raoul Hausmann, theoretician of contradiction and promoter of direct action, together with his friend, the ›Supreme Dada‹ Johannes Baader, whose voluntary-involuntary (it cannot be determined with certainty) genius of parody fed on a matchless permeation of religious megalomania, Prussian officialdom and a practical way of living. In the league, also, was Hannah Höch, who represented a Dadaism of erect bearing and human veracity with gentle but determined irony. On the other side the Herzfelde brothers together with George Grosz and Walter Mehring practiced the dadaistic revolution by means of radical left-wing satire. The magazines *Jedermann sein eigener Fussball* (Everyone His Own Football) and *Die Pleite* (The Bankruptcy) appeared successively in the *Malik* Publishing House with grim illustrations by Grosz which were primarily directed against the law-and-order mentality and the subservience of the first German republican government to the military. Scandals and bans followed successively.

High points of the Berlin Dada Movement were the Dada exhibit in the Graphics Cabinet I. B. Neumann in May 1919, and the *Erste Internationale Dada-Messe* (First International Dada Fair) which was opened in June 1920 by Dr. Otto Burchard. This became a huge and scandalous success with both the public and the press. The dadaistic tried and tested technique of challenging middle class taste was evident in this exhibition

in the sarcastic triviality of the exhibited objects, as well as in the intentional haphazard-ness of the production. Among the central pieces of the exhibition was Baader's *Plasto-Dio-Dada-Drama Deutschlands Größe und Untergang* (Plasto-Dio-Dada-Drama Ger-many's Greatness and Downfall), one of the first large assemblages of environmental art. The principle of montage from heterogeneous parts, the joining of the incompatible, was taken to react against the classical principle of composition with rigorousness. For just as the principle of composition embodies the picture of a perfect world, the principle of montage embodies the real contradiction of existence in which we have to find our way today, especially in a big city. This insight produced the original idea which Berlin Dadaism has contributed to the art of our century: photo-montage and photo-collage. Although independently, John Heartfield, the ingenious creator of the political agitation photo-montage, and George Grosz on the one hand, and Raoul Hausmann and Hannah Höch on the other, discovered for themselves the principle of photo-montage.

In his Hannah Höch biography from 1968, Heinz Ohff writes, »The unavoidable, if insignificant, question as to who initially created this art form remains unsolved among the artists themselves. In contrast to almost all other participants, Hannah Höch does not lay claim to it. She explains that she went to Gribow on the Baltic with Raoul Hausmann. In an old inn a framed picture was hanging on the wall such as professional photographers used to make before the invention of the modern fast film, in which they pasted individually photographed heads on a painted or prephotographed group, a momento of the school and recruit times in the early mass production sense. Hausmann said, ›But one could do something like that to photos generally‹, and back in Berlin it was done. ›The thought, at any rate, was his.‹ However, Hannah Höch was intimately involved in its further development and most likely also—here the roles cannot be disentangled—in its inspiration and first realization. After all, in the classroom under Orlik she was already pasting instead of painting.«

A colour lithograph created by Höch for reservists as a souvenir of their military service depicts an illustration of the uniforms with photographic portraits pasted on. It was mentioned in conversation between Höch and Heinz Ohff and was found in her estate after her death. It is now in the collection of the *Berlinische Galerie*.

Also from the estate is the only known photo-montage that Hannah Höch and Raoul Hausmann did together. It vividly illustrates Hannah Höch's stories on the creation. It is mounted on a double page from the magazine *Der Dada*, published by Hausmann, and contains on the right side Hannah Höch's part, put together with sections of machine parts, pictures of beetles, car tires and chassis parts (an entire automobile is half-hidden under other fragments) as well as words and word fragments; on the other side is Raoul Hausmann's part, with, among other things, a steam boiler, photos of naked ›savages‹ and a portrait photograph of Hannah Höch's profile. The two montages are connected to each other with a sort of piston rod. Due to the bold text in the lower left, the sheet has come to be known under the title *dada cordial*. The collage, which originated at the latest in 1920, is one of three incunabula of the dadaistic Berlin photo-montage (to be more exact, photo-montage in association with collage, since not all parts are photo cuttings), in the collection of the *Berlinische Galerie*.

The photo-montage *Dada-Rundschau* (Dada Panorama-Illustrated), by Hannah Höch in 1919, was given to the *Berlinische Galerie* in 1986 by the *Tagesspiegel* Press Foundation for the opening exhibition of its collection in the Martin Gropius Building. It originated at the same time as her large photo-montage *Schnitt mit dem Küchenmesser Dada durch die erste Weimarer Bierbauchepoche Deutschlands 1919* (Cut with the Dada Kitchen Knife through the First Weimar Beerbelly Epoch of Germany 1919) which belongs to the *Nationalgalerie* of Berlin. It attacks the men of the old and new government, the reactionaries and the ›revisionists‹, as well as the generals in uniform, the emperor, the crown prince, and Hindenburg, as well as the men at the top of the first government of the Weimar Republic, Ebert and Noske. She cut the two figures out of the notorious illustrated magazine photo which shows both men in bathing trunks (which then—hardly imaginable today—was considered extremely vulgar) and staged them mockingly in a self-satisfied pose. The social democratic government appeared too dull to the dadaists, too indecisive, too enslaved to the military, in short—counter-revolutionary. (In her later days, Hannah Höch once casually confessed to me that she still had a guilty conscious for having wronged Friedrich Ebert in those days.) The emancipatory pluck of the montage is recognizable in the upper left hand corner with the demand, in mounted newspaper letters, »German Women in the National Assembly«, as well as in the lower right in the motto, that reads together with the signature, »Limitless freedom for H. H.«

A collage of Hausmann's appeared about 1920 that resembles an epitaph, possibly an obituary for the year 1918, insofar as the two figures 1 and 8 suggest this interpretation. The collage is almost completely filled with an x-ray photograph of the profile of a human head, through which the skull bones shine (possibly a picture of Hausmann's own head or that of Johannes Baader, the sharp bend between the bridge and the tip of the nose recalls his features). The jaw bone joint is marked by a gear wheel. The beginning of Hausmann's idea of the ›mechanical head‹ is evident in the use of such a mechanical object, which was then realized in the Dada object *Der Geist unserer Zeit* (The Spirit of Our Time). To the lower right there is a playing card, the ace of clubs, inserted as a warning as it symbolizes death. Three large letters spread across the picture and combine to form the word »end«. On the lower edge of the skull, there where the start of the throat is cut off, a line of text is pulled along like a collar, »People are angels and live in heaven«. Johannes Baader uses these words in his flyer, published in 1919, *Die Acht Weltsätze* (The Eight World Sentences), in which he proclaims that the hereafter is the here and now, in other words, heaven on earth.

Also worth mentioning is a unique print design. These are 13 large format print sheets for a planned but never accomplished dadaistic hand atlas DADACO. The project was initiated in 1919 by the Kurt Wolff Publishing House in Munich. The »greatest standard works of the world«, initiated by both Huelsenbeck and Tzara, were to appear in January 1920. Heartfield was to take over the typographical design. Due to differences of opinion among the dadaists, the project was delayed. Kurt Wolff finally lost interest and sold the 13 proofs to Tristan Tzara. They were procured from Tzara's estate by the *Berlinische Galerie*.

Raoul Hausmann

Cover design for
›Volk, Kunst und Bildung‹
eine Flugschrift von Adolf Behne
1919
People, Art and Education/
a pamphlet by Adolf Behne
Water-colour on paper
22 × 15 cm

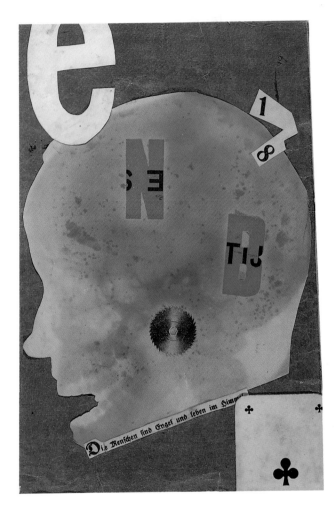

Ohne Titel (Die Menschen sind Engel
und leben im Himmel), c. 1920
*Untitled (Men are Angels and Live
in Heaven)*
Photo-montage and collage on paper
and cardboard
31×20,5 cm

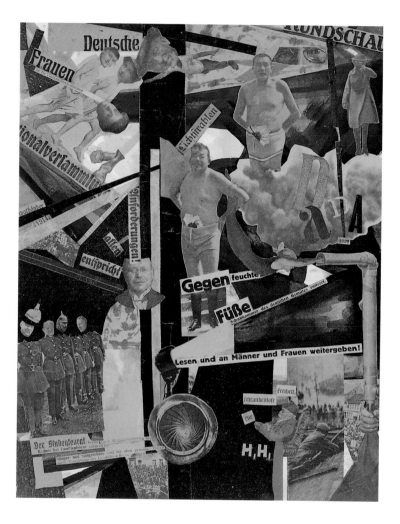

Dada-Rundschau, 1919
Dada-Panorama-Illustrated
Photo-montage and water-colour
on cardboard
45×35 cm

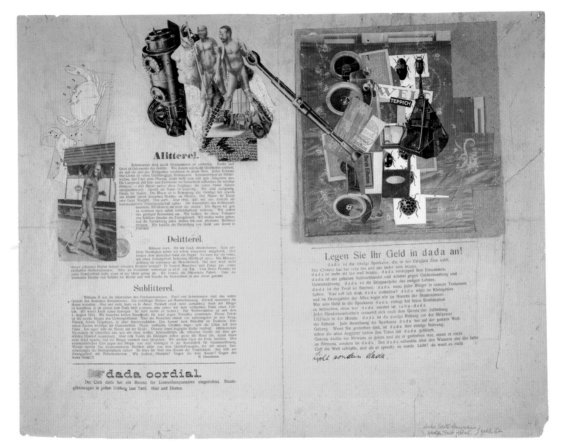

dada cordial, c. 1919
Collage and photo-montage on cardboard
45 × 58 cm

George Grosz

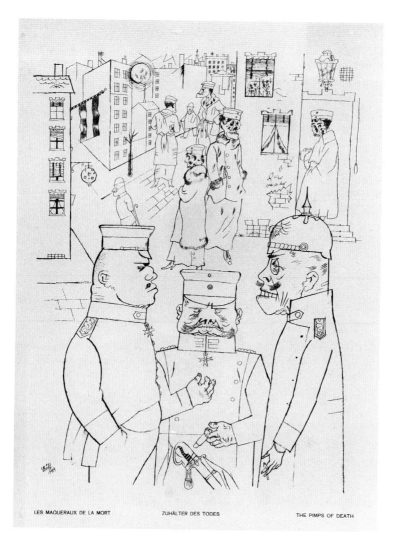

LES MAQUERAUX DE LA MORT ZUHÄLTER DES TODES THE PIMPS OF DEATH

Gott mit uns, 1920
God with Us
Lithography No. 6
from a portfolio with title page
and 9 lithographies
(Malik Publishers, Berlin)
each 48 × 39 cm

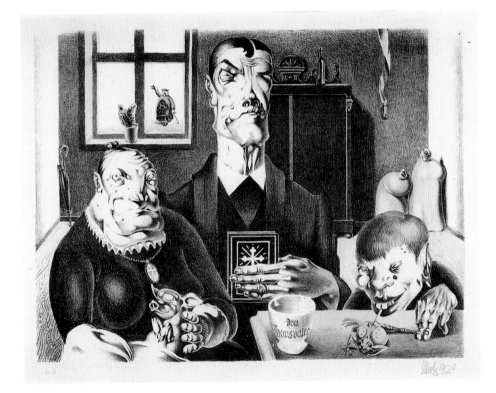

Wucherbauernfamilie, 1920
Family of Profiteering Farmers
Lithography
27 × 36 cm

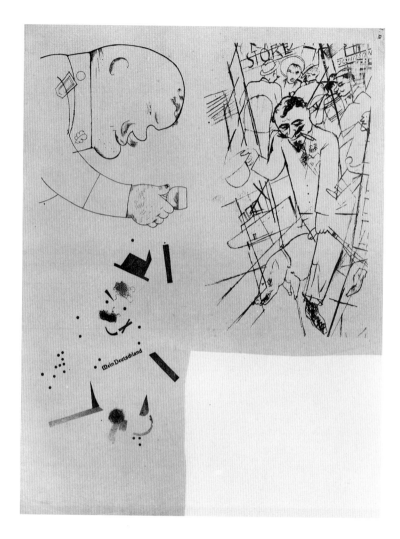

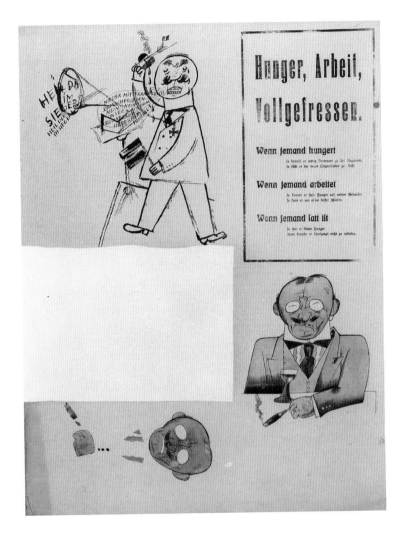

Dadaco
Dadaistischer Handatlas, 1919/20
Dadaist Hand Atlas
Book project of the Kurt Wolff
publishing house (did not appear)
2 of 13 proof pages

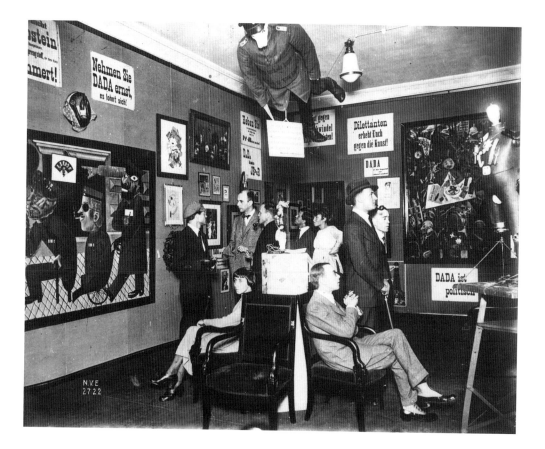

Left to right: Hannah Höch, Raoul Hausmann, Otto
Burchard, Johannes Baader, Wieland and Margarete
Herzfelde, Otto Schmalhausen, George Grosz and
John Heartfield. Far right: Grosz-Heartfield,
›Der wildgewordene Spießer Heartfield‹
The Petit Bourgeois Heartfield Grown Wild
On the ceiling: Heartfield-Schlichter,
›Preußischer Erzengel‹
Prussian Archangel

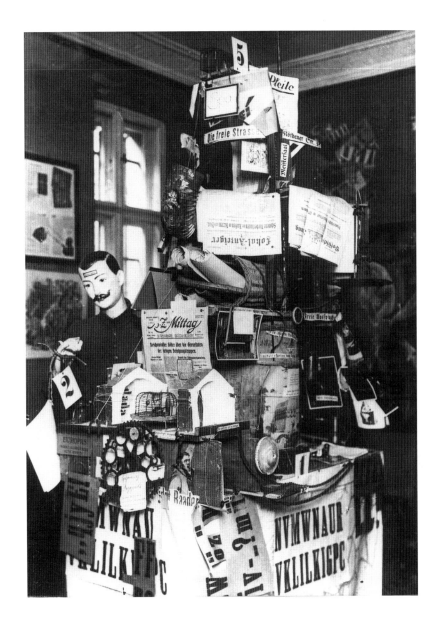

Das große Plasto-Dio-Dada-Drama
The Great Plasto-Dio-Dada-Drama
(location unknown)
Exhibited at the
First International Dada Fair, 1920

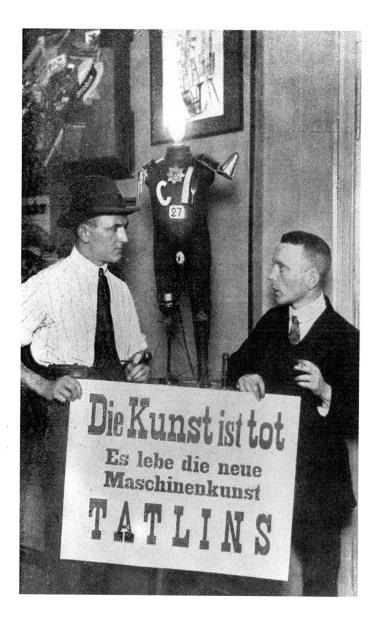

George Grosz and John Heartfield
Text on the poster:
Art is dead
Long live the new machine art of Tatlin

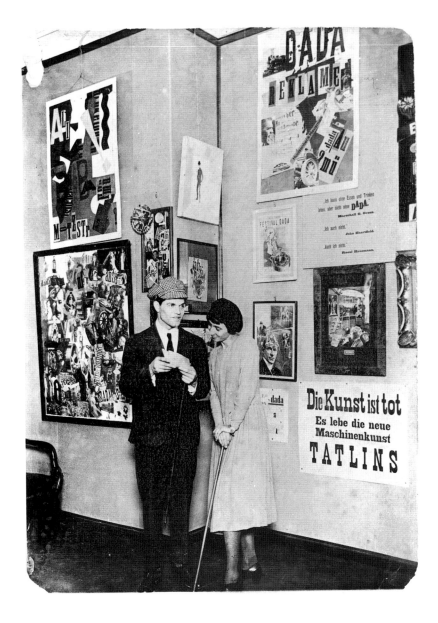

Raoul Hausmann and Hannah Höch

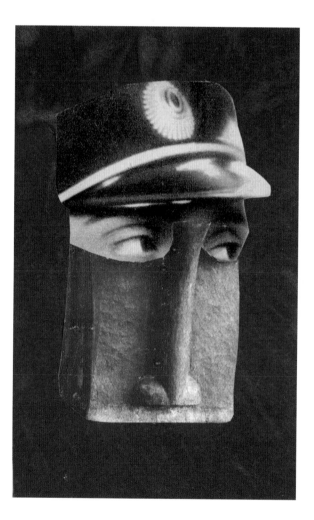

Mit Mütze
Aus einem ethnographischen
Museum IX, 1924
With Cap
From an Ethnographic Museum IX
Photo-montage and water-colour
on paper and cardboard
27,5 × 15,5 cm

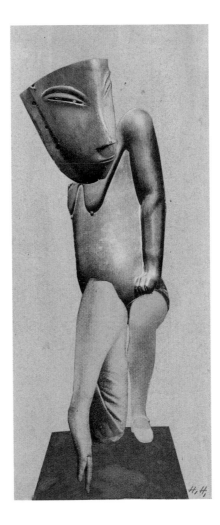

Denkmal I
Aus einem ethnographischen
Museum VIII, 1924
Memorial I
From an Ethnographic Museum VIII
Photo-montage and water-colour
on paper
19,8 × 8,9 cm

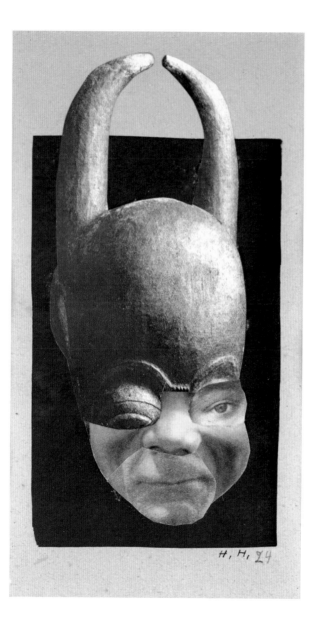

Ohne Titel
Aus einem ethnographischen
Museum X, 1924
Untitled
From an Ethnographic Museum X
Photo-montage on cardboard
19,5 × 12,5 cm

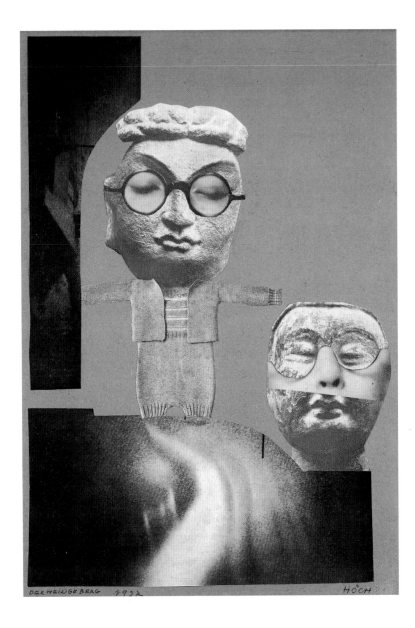

Der heilige Berg
Aus einem ethnographischen
Museum XII, 1927
The Holy Mountain
From an Ethnographic Museum XII
Photo-montage on cardboard
33,7×22,5 cm

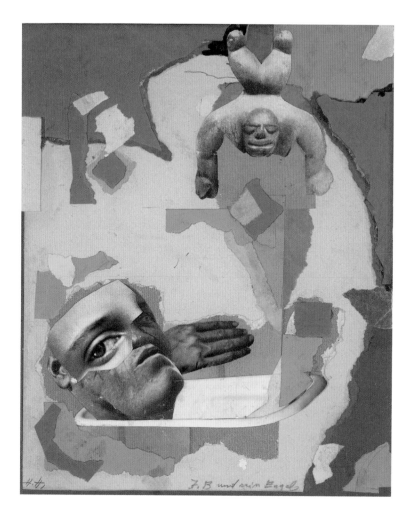

J. B. und sein Engel, 1925
J. B. and His Angel
Collage on cardboard
24 × 19,8 cm

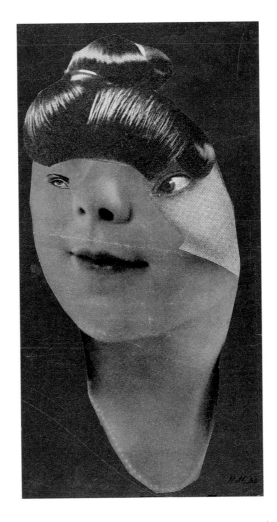

Deutsches Mädchen, 1930
German Girl
Photo-montage on cardboard
21,5 × 11,5 cm

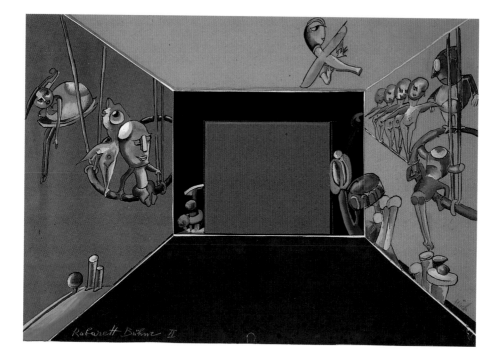

Stage design
Kabarettbühne II
Cabaret Stage II
for the anti-revue:
›Schlechter und Besser‹
(Worse and Better), 1924/25
by Hannah Höch, Kurt Schwitters,
Hans Heinz Stuckenschmidt
Pencil, ink, gouache and collage
on paper
34,2×48,5 cm

50

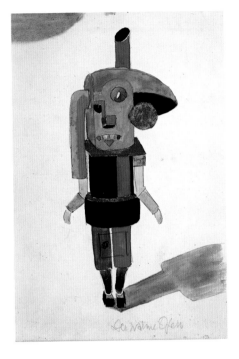 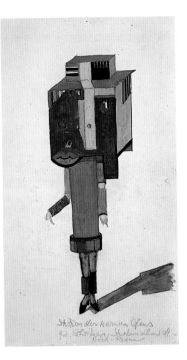

Figure sketches for the anti-revue:
›Schlechter und Besser‹
(Worse and Better), 1924/25
by Hannah Höch, Kurt Schwitters,
Hans Heinz Stuckenschmidt
Left: Der warme Ofen
The Warm Stove
Pencil, bronze, water-colour,
gouache on paper
22,3 × 15 cm
Right: Die Frau des warmen Ofens
The Wife of the Warm Stove
Pencil, bronze, water-colour,
gouache on paper
27,8 × 15,3 cm

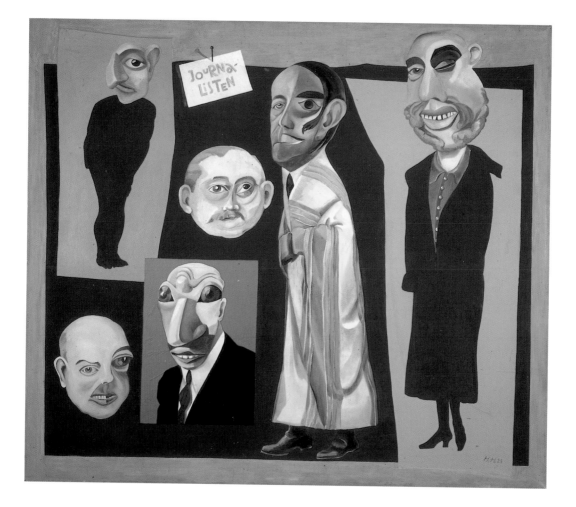

Journalisten, 1925
Journalists
Oil on canvas
86 × 101 cm

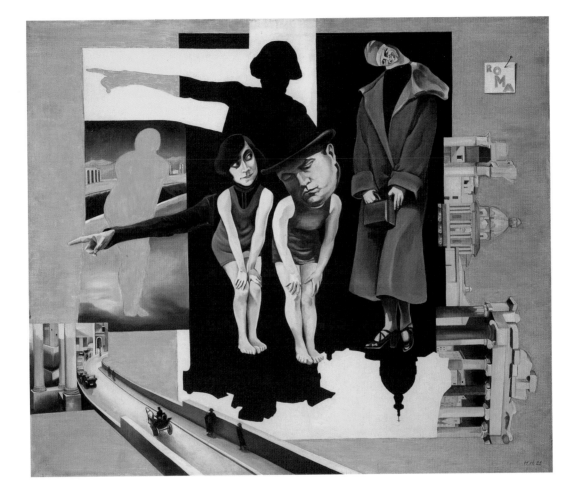

Roma, 1925
Rome
Oil on canvas
90 × 106 cm

Constructivism and the Constructed

Hubertus Gaßner

There are many faces of Constructivism, and it speaks with many tongues. Programmatic statements of the 1920s typify it as pure colours and elementary forms, although the right angle and the homogenous application of colour by no means constitute an exhaustive definition of constructivist works. This would be like letting the tiger, poised for a bold leap, land on our floor as a bedside rug. However, keeping to the facts, without glossing over them with theory and art history, many a constructivist work does indeed turn out to be a geometric patchwork carpet. It may have a decorative effect, but it only exudes a weak reflection of the energy with which Constructivism initially rebelled — as the epitome of revolutionary production, both in formal and social terms — against the art of the bourgeois, which included the expressionist convulsions and visions of redemption emerging from its individual soul.

The rearrangement of ›life‹ by art which was autonomous, was the aim inherent in all the designs of the constructivists and in the utopian patterns of thought which accompanied them. Life as a synthesis of the arts, the dream of late Impressionism, Symbolism and *Art Nouveau,* was now to become reality, but not in a realm beyond social reality and in opposition to it — as in Aestheticism — but within its limits, which could be broadened with the help of art.

The first attempts to resolve the contradiction of autonomous art and socially objective reality were made within a wide open sphere: in the picture planes of a Malevich or a Mondrian, cleansed from all mimetic illusion and conventions of design, or they were projected into empty space, space not yet occupied by tradition and specific social milieu as in the architectural projects of the *De Stijl* artists, the Russian constructivists and of Bauhaus. Malevich's Suprematism rejected both the sensitive nuances of the soul's feeling in highly-cultivated subjectivity and the subtle shades of colour in late impressionist painting, in which he saw the bourgeois soul shimmer — without true contours or form. Suprematism, rightly known as the father of Constructivism, aimed — at least in its incubation period between 1913 and 1915, but also in the 1920s — to advance towards the origin of reality, and for Malevich this meant towards elementary stimulation, not yet diminished by any form of individualisation. Analogising the inner and the outer world, the artist saw the macrocosm and the microcosm as »an infinite number of force fields, rotating around the pivots of their stimulation« (1922). Accordingly, the painter wanted his pictures to be understood as sections of the cosmos, as a universe in miniature, the empty, unlimited space of which — in this the white surface of the picture — was pervaded by coloured shapes which grouped themselves into such force fields. The artist tried out this electric construction in hundreds of drawings, either sketches for brightly-coloured paintings, or, as it were, as an experimentally drawn series to investigate the

creation of optical energy. In order »to make visible the stimulation« of the soul and the cosmos, forms move across the surface like a fleet in »free navigation« on the white sea of the picture, which in turn represents the infinite space of the inner world of the emotions and of the exterior, physical world.

Malevich describes the suprematist picture as »a construction ... based on the weight, the speed and the direction of movement« (1916). This ideal of dynamic construction is the legacy which Suprematism passed on to its successor, Constructivism, the most important exponents of which were El Lissitzky and Alexander Rodchenko. On 23rd September 1921, in a lecture before the Moscow constructivists at the Institute for Artistic Culture (INKhUK), Lissitzky once again emphasized the genealogy of the new art movement. It was indicative of art's new direction that the forms of movement described were demonstrated by the lecturer, using technical, architectonic examples. The rotation of technical objects around a central axis, or their linear progress in space took the place of centres of cosmic and emotional stimulation. The construction resulting from this movement breaks out of the two-dimensional picture framework, and becomes a three-dimensional object in true space.

Lissitzky gave his lecture in the INKhUK at a time when the members of this institute — which included almost all the artists of the Moscow avant-garde — had already turned away from so-called ›Veščism‹ (objectism) and had moved on to production art; that is, to the design of necessary articles. This development from the fictively useful object to the functional commodity, which Russian Constructivism went through in 1921, was above all a result of pressure from Rodchenko. His gouache on wood, painted in 1920, originated during the laboratory phase on Constructivism (1919—1921), when its fore-runners were establishing its basis using experimental creative methods. Rodchenko's picture belongs to the series of formal investigations in which he examined, with an almost scientific systematic approach, the behaviour of colour and form. The intention of the painter, in the arrangement of the overlapping circles and the economical use of black, white and red, is to suggest the movement of these coloured forms across the surface and into an imaginary depth. Contradicting impressions are evoked, causing a state of unresolved suspense in our vision. The large segment of a circle — the basis of the three round forms — thus appears, on the one hand, to be an independent form, although well cut off from the edge of the picture, which is positioned on the grey-black background. On the other hand, this form itself is merely the background which has been left, not completely covered by the black colour at the right hand edge of the picture, and which continues in the bottom right hand corner. In the same way, the uncut circular disc takes on a double aspect, since, as a result of its complete contour and its position, it appears to be part of the picture's closest plane, yet on the other hand, must be attributed to the white segment form because of its surface or its background, that is, to the furthest plane.

During the transition from Suprematism to Constructivism, a change of paradigms took place; from subjective, emotional stimulation to intersubjective social revolution, and from cosmic force fields to technically produced energy. In the course of this change it was inevitable that there would be dissent among the representatives of both move-

ments. Whilst the constructivists rebuked Malevich, claiming that his only concerns were the creation of a new stylistic system and his mystic, metaphysical excesses; he disassociated himself from Constructivism when it began to lead into production art.

Lissitzky, a close colleague of Malevich, but nontheless among the younger generation of constructivists, tried to mediate between the two positions. When he came to Berlin at the end of 1921, he had in his luggage the programme of the working group of constructivists at the INKhUK, written by Alexander Gan. In addition, he brought some photos of works by members of the group; as well as Gan, Rodchenko and Stepanova, these included the Stenberg brothers, Medunetzky and Joganson. Whilst the programme clearly called for »the actual conversion of laboratory works for the field of practical activity« in order to »mobilize the material elements of industrial culture«, the photographs still showed three-dimensional objects with no practical function. These were similar to those constructivist works which were shown at an exhibition of the group in Moscow during May 1921, which Lissitzky pictured in the journal *VESC — Gegenstand — Objet,* and published in Berlin, together with the writer Ilja Ehrenburg, from March 1922 onwards. Lissitzky was able to persuade well known artists of the Berlin avant-garde — such as Carl Einstein, Viking Eggeling, Hans Richter, Raoul Hausmann and Ludwig Hilberseimer — to contribute to this journal. The declaration of its programme, as might be expected from the title, was one of commitment to the creation of objects, but »it should not be thought that our understanding of objects expressly means necessary objects.« Distinguishing themselves from the utilitarian programme of the Moscow constructivists at the INKhUK, the publishers defend an extended concept of the object, for »every organized work — be it a house, a poem, a painting — is a useful ›object‹, not calculated to estrange a person from life, but capable of contributing to its organizations.«

As Hans Richter recalls, the circle of which he felt himself a member (along with the contributors to *Objet:* Doesburg, Caden, Graeff and Buchholz) was »introduced to the new art of the Russian Revolution on the broadest possible basis« by Lissitzky at the beginning of 1922, even if the Berlin artists did not concern themselves »particularly with the orthodox meaning of this concept, that had arisen with the Russian Revolution.« Rather than following the direction of the Russian constructivists' programme towards the creation of necessary objects, the German artists — in the process of painfully breaking with Expressionism and Dadaism — were fascinated by the constructivist paintings and sculptures »with their precision, lucidity, new three-dimensionality and floating geometry«. It was these epithets that Sophie Küppers, the past director of the *Kestner* Society in Hanover, chose to describe the impression which Lissitzky's pictures made on them at first sight, and she continues: »We were thrilled by the unassailable certainty which the Russian artist demonstrated in this compositions.«

This certainty in formal design, which created new architectonic worlds in empty, utopian space, was largely an expression of the Russian's conviction that he was among the creators of a future society, as yet in the process of construction. This new way of life was to be characterized above all by its rational and economic design in the interest of the collective. For Lissitzky to convince his followers in Berlin that the battle against subjecti-

vism and individualism in art and the philosophy of life was necessary, required a lot of persuasion. Sophie Küppers reports on his contacts in Berlin. »He took me to the atelier of Moholy-Nagy, where the latter's wife Lucia welcomed us as guests. Werner Graeff, Hans Richter, Raoul Hausmann and Hannah Höch were present. It was all about the new objectivity, concreteness, functionalism... Lissitzky, usually so reserved and modest, attacked the abstract ›soul‹ fiercely and savagely, whilst the intimidated expressionists, each in their own way, attempted to defend it.«

Amongst the defenders of the ›soul‹ was Erich Buchholz, who moved over from non-representational Expressionism to Constructivism during the years 1920—1922. He also reports on the atelier discussions in Berlin during 1922, which revolved around the Constructivism introduced from the East. »At this point, our opinions collied. My answer — that the starting point of our creativity should originate in an impulse, a release of potential, governed by a directing, measuring (thinking) eye and with a single aim: the final result, the work, being the realization of all this — met with Lissitzky's sarcastic response: ›Romanticism‹.«

It would be a mistake, however, to create an antithesis between the rationally calculating constructivist and the intuitively creative artist. Lissitzky also retained science and geometry within their limits in art: The »new method« of Constructivism »knows what one can and must know of art, and, where that which lies beyond understanding begins, that which leads us, with the inexorable certainty of the sleepwalker, to the necessary objective.« In his later writings, Buchholz repeatedly emphasized a differentiation between the supposedly merely rational, calculating method of creation, practised by the Russian and Hungarian constructivists, and his own impulse method, which arose from a sudden impulse of the brain, leading through the »physiologically determined process« of execution — which was »controlled only by the thinking eye« — to the finished work, which was then »solely and primarily the realisation.« However, this seems to have been dictated by the desire to set himself apart from the other constructivists in his originality, rather than do justice to the facts. The use of compass and ruler occasionally to be met with in the work of the Russian does not necessarily presuppose conscious and precise planning of the results of creation. The »certainty of the sleepwalker« is a more particular characteristic of the Russian artists than a calculated design process.

Amongst the representatives of Constructivism in Berlin was the painter Lajos d'Ebneth. Although not a constructivist of the first hour, he developed an original pictorial form in his work between 1923 and 1929 through a synthesis of the design principles of *De Stijl* and the Hungarian constructivists. In 1921, after studying architecture at the polytechnic in Budapest, the young d'Ebneth continued his training as a painter — already begun at the Budapest Academy of Art — at the Munich Academy under Franz von Stuck. In the second half of 1923, he moved to The Hague, where his compatriot, Vilmos Huszár, had settled in 1906. The pictures which emerged in this year show how d'Ebneth, under the influence of Huszár's unorthodox variation on the principles of neoplasticism, individually adapts the ›new design‹ (Mondrian). In the composition on a black blackground, from 1925, a rectangle (square) — as in many pictures by his compatriot — stands on one of its corners at the centre of the picture.

This retains the right angle — according to Mondrian the embodiment of the most universal and most powerful relationship of suspense, the crossing of the horizontal and the vertical — but by tipping, it is made more dynamic and labile. The relationship to Huszár's concept of painting is shown firstly by the overlapping of the surfaces of colour, suggestive of three-dimensionality, and their free floating in the empty space of the picture, unconstrained by the right-angled net of lines which anchors the colour forms to the picture's framework in the work of Mondrian, van Doesburg and other *De Stijl* painters, and secondly by the breaking up of the primary colours into intermediate tones and in particular the deep, radiant blue of the central square. The play of a few clear, large forms and multiple smaller forms and the weighing out of colour and form to present a relationship of balance around a visible central axis — expressly negated by Mondrian and van Doesburg as a sign of symmetry — are also pointers towards the relation between the two Hungarian *De Stijl* followers. The Hungarians' pictures have a more picturesque, decorative and animated effect than those of the Dutch, they are less rationally calculated and founded in the transcendental.

Catalogue of the First Russian Art
Exhibition, Berlin 1922
22,5 × 15 cm
Cover design by El Lissitzky

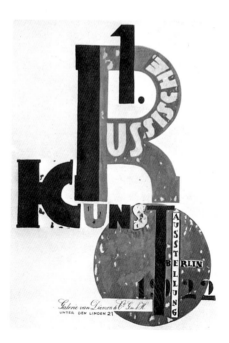

Naum Gabo
International Figure of Constructivism

Jörn Merkert

Naum Gabo belongs to the great in the art of the 20th Century. He has, like few other artists, revolutionised the concept of sculpture without passing through the stages of Cubism, Dada or Futurism, which have been the traditional development.

What we now recognize as Constructivism in sculpture has its roots in his work. It is therefore astonishing that Gabo has only now, after his death, found wider recognition especially after his retrospective in USA and Europe, 1985/86, in particular as far as the younger generation is concerned. One has to realize that the complexity and the almost naive influence of this art is still to be discovered and to be investigated in detail, especially the chapter of his life in Berlin 1922—1932, is only known in part. A lot of Gabo's work from this time was lost after his emigration to Paris and it was almost impossible to form a picture of his pioneering work for nearly half a century.

The artists and professional art world have always been aware of this: there is hardly a history of 20th Century sculpture or book about Gabo where the sculptures of these years are not reproduced, not as early masterpieces of Constructivism but as important stages of a new concept of sculpture. Only during his retrospective could one see the ›entire Gabo‹. At the beginning of the eighties, after Gabo's death in 1977, many carefully preserved but unassembled original pieces of sculptures were found stacked away in boxes and trunks in his studio in Connecticut. Slowly through the painstaking and archaeological-like work of his old and long time assistant, Professor Charles Wilson, Chicago, it was revealed that about a dozen sculptures had been found.

Next to some very early work from the second half of the first decade of the 20th Century, it was these very works from the Berlin era which have become legendary. Gabo had prepared his constructions and packed them for a long journey. His works were constructed in such a way that all conditions were taken into account. They were constructed like geometric puzzles. After his emigration from Germany, through all the problems of exile and then the joy he felt in his newer creations, he never attempted to put the earlier works together again, nor did he ever show them to anyone or even mention them. (A great part of these early works along with many drawings and archival material have been returned to the place of their creation, they have found their final home in the *Berlinische Galerie.*)

Another reason for the recent acclaim of Gabo's work is that he was a late discovery. His first big success was in the Berlin of the twenties—in the circle of the avant-garde and his special friends. After many years of continuous emigration, Moscow—Berlin—Paris —England and finally America, his work only found recognition again during the fifties. Unjust as history is, his work was not really of the ›Zeitgeist‹. Apart from the short

historical moment during the twenties until the beginning of the thirties, Constructivism, as a trend in art, never played a leading part either in painting or sculpture.

It has been established, however, that amongst many artistic expressions over many years Constructivism is still a principal trend. Gabo's astonishingly multifaceted work is a very good example. As a leading constructivist he has never been absolutely identified with this direction but has followed it as a basic idea which not only related to his work but also to his attitude to the world.

Gabo formulated his new ideas in his famous *Realist Manifesto,* also signed by his brother Nathan (later Antoine) Pevsner, which put a stop to Cubism and Futurism. On 5 August 1920, Gabo's 30th birthday, it could be read in all the streets of Moscow. The text puts great confidence into the possibilities of a technical dimension during war and revolution. The artist however believes in the force of art which changes the world and includes fundamental ›elements of real life‹ as his own means for furthering the ideas of art. Even if very ›abstract‹ art is always realistic in respect of art, fundamental distinctions have to be made:

1. Space and time are two fundamental elements of real life. Therefore art has to identify with these to correspond with life.
2. Volume is not the only expression of space.
3. The static rhythms are not the only expression of time. Kinetic and dynamic elements are the only ones which express real time.

The direction art took in Moscow in 1921 and the return to ›realistic art‹ was not just disappointing for Gabo, this new tendency was also an absolute contradiction to his position which he had so well formulated in his *Realist Manifesto.* For this very reason Gabo accepted gladly the opportunity of helping, together with other artists, with the organizing of the First Russian Art Exhibition at the Galerie van Diemen, Berlin, when he was officially asked by Lunacharsky, the Soviet Commissar for Culture. He was responsible for the constructivist part of the exhibition, in which he himself was represented by eight sculptures, amongst them various constructivist heads, a torso, kinetic construction and several reliefs. The reaction to his work was very positive. The dadaist film maker Hans Richter said: »Gabo was, for me, the great sensation.«

Gabo experimented with the ideals he formulated in his *Realist Manifesto,* i.e. of visionary ideas and possibilities in contemporary art in general, but especially in the field of sculptural room constructions of the twenties. He arrived at extraordinary solutions. In Gabo's view, sculpture no longer had the mandate to depict reality rather it was to be an independent object of reality in which the elements of real life-like movement, time and space are part of the art. For this reason special modern technical materials are of central importance in his work. These were, from a traditional point of view, absolutely unimaginable—glass, steel and all sorts of synthetic materials.

The sculptures became absolutely free, nonobjective, transparent room-constructions which were made up of many parts. The personal handwriting of the artist as it existed in clay and stone for the traditional sculptor is now absolutely extinct. The clear form and modern material and the regularity of strict geometry are the exact calculation of an inspired imagination, where the artistic materials with which the completely new aesthe-

tic had been voiced. With these works, which often have titles like ›Tower‹, ›Monument‹, ›Fountain‹, Gabo's conceptual vision is apparent and one day these room constructions, when it is technically possible, will be built on monumental scale. However, Gabo, in 1932, had to leave Berlin for Paris with the oncoming Nazi Germany — storm troopers had searched his studio — it was not the first or last time that this citizen of the world went on his travels, forced by the ideological and politicised society. Looking for his freedom and independence for his art he hoped to find an asylum and a home in exile. In Paris, the mecca of the arts of those years, and a meeting place of emigrants, Gabo found it impossible to stay, even though there were many international avant-garde artists there and his brother Antoine Pevsner already lived in Paris for many years. However, as the international constructivists created a new centre in Paris with *cercle et carré* or *abstraction-création* Gabo the loner found it difficult to find his way. In Berlin it was Gabo above all others as a central figure in constructivist sculpture. Gabo had made this town into a central focus of abstract-constructivist style. In Paris, however, the climate was more of warring factions which battled between various stylistic trends. Battles between Post Cubism, later Surrealism, between organic abstraction and traditional figuration. He saw no possibility of making his own way in Paris. Gabo, who arrived late to international stylistic importance in constructivist sculpture, finally became in Paris a loner, who left the warmth of a group and one would almost say, stubbornly made his own way into solitude.

In 1936 he moved to England where he had already participated in various exhibitions of constructivist art and had made many friends. In 1946 he finally went to USA where he believed he could make a new beginning with his utopic futurist art. He hoped that in the new world he would find a greater understanding for his art and as there was no preceding tradition, develop his pioneer ideas.

Naum Gabo made history with his *Realist Manifesto* in 1920 but even more through his work which followed the rules he had laid down in his manifesto which sounded like Utopia to his fellow men. For over sixty years he formulated new solutions for his artistic ideas with wonderful variety. In the development of his work he arrived from static geometric transparent rather architectonic planer constructions to the steriometric room ideas, from nylon threads to sprung wires. With these he achieved world acclaim in the fifties.

With his radical ideas, Naum Gabo takes a special place in the history of sculpture of this century. He has not achieved this through evolutionary renovation but through the whole development of his life's work, patiently and painstakingly constructed. The importance of his intellectual ideas and work assume a singular position within the modern art world. Gabo made it clear in the manifold activity of his work that Constructivism was not only a stylistic direction which had a limited life, but a profound ideological state of mind.

Iwan Puni
A Russian in Berlin

Eberhard Blum

Foreword

I first came across the name Puni in connection with the *Suprematist Manifesto* by Kazimir Malevich. In 1915, Puni was amongst those who signed and advocated it. Who was this Russian, about whom I knew nothing until 1975, when an impressive exhibition of his work took place at the *Haus am Waldsee*, Berlin—and what did he do? I have tried to find my own answer to these questions.

I

Iwan Albertovich Puni was born in 1894. His father was a cellist in St. Petersburg. From 1910 to 1912, Puni attended a school of art in Paris. As early as 1913 and 1914, he participated in the exhibitions of the *Salon des Indépendants*, where pictures by Braque and Picasso were also on view.

II

It is 1913, and *Le Sacre du Printemps* by Igor Stravinsky has its premiere in Paris. The most frequently cited musical scandal of the century occurs (comparably ardent arguments only arose in the 1950s and 1960s, at performances of the works of John Cage). The Russian Stravinsky quickly becomes world famous. Claude Debussy, the first musician with whom Stravinsky played his new partita on the piano, completes his *Préludes* in the same year, performs them, and is working on his important late chamber music. It is out of the question that Puni knows nothing of these events. Puni returns to Russia until 1919, working in various revolutionary artists' groups. In 1919, he flees to Finland, coming to Berlin in 1920. Ferruccio Busoni is living in Berlin and has just been appointed director of a masters' class at the Academy of Arts. His *Entwurf einer neuen Ästhetik der Tonkunst* (Outline of New Aesthetics in Music) draws many young composers, anxious to study under him, to Berlin. The young composer and pianist, Stefan Wolpe, leaves the Berlin College of Music disappointed after one semester, preferring to study at Bauhaus in Weimar. Edgar Varèse has already left Berlin, is living in New York, working on *Amérique* and preparing *Hyperprism* and *Octandre*. Arnold Schönberg, who is later to become Busoni's successor at the Academy, has begun to formulate the theory of his twelve-tone music and has already caused a sensation in Berlin with his *Pierrot lunaire*. In Berlin, Hermann Scherchen directs exemplary performances of new and classical music. In 1918, Braque paints his picture *The Musician* in France, a high point of the period later to be described as Synthetic Cubism. Raoul Hausmann writes and publicly recites his Dadaist sound poems in Berlin.

III

In 1920, over three hundred thousand Russians are living in Berlin. Authors, musicians, painters, philosophers and politicians live mainly in the area of Berlin still known today as the ›old West‹, and play an intensive role in the intellectual, material, and political life of the city. Puni lives and works in Kleiststraße, between Nollendorfplatz and Eisenacher Straße. It is the point where the underground trains regularly roar up from the earth or disappear into it, a visual and audible drama still to be experienced there during the 1960s, a street otherwise almost completely destroyed by the war and by ›reconstruction‹ programmes. Which music does Puni know and like when he begins, after several successful exhibitions in Berlin, to paint his *Synthetic Musician* in 1921? Does he go to concerts? Does he know any musicians personally? It is not impossible that he has met the young American musician Georges Antheil in the gallery *Der Sturm* (The Storm) in Potsdamer Straße, or that he has got to know Kurt Weill in the *Novembergruppe*, where he has close contacts and has exhibited. The Berlin successes of his compatriot, Stravinsky, will surely not have escaped him, either. Ernst Bloch has reported them so impressively. What is happening here? A young painter obviously has musical as well as visual intentions. Puni is making an attempt to lend musical processes a visual form. He combines a realistically painted person, representative elements, abstract pictorial features, and coloured geometric shapes to produce an exciting ›composition‹. A perfect cubist ›one man band‹ is visible. The musician has the bow of an imaginary stringed instrument in his hand,—do not forget: Puni's father was a cellist—he has lifted it and appears to pause in his playing, listening for the sounds which he has coaxed from his ›instrument‹. What sounds might these be? Perhaps Stravinsky's concertinos for stringed quartet, mingled with recollections of *Sacre*? Or are they even the dreams of Varèse, who, a few years later in New York, will endow our musical century with his *Ionisation*, solely for sound instruments?

IV

The painter has already concerned himself with the theme of music for a long time, he longs to grasp it through a visual portrayal. Perhaps it is that wish which the American composer Morton Feldman calls the »abstract experience«, that area of direct experience through sound where metaphors become unnecessary. Clearly Puni's desire is to take a step on the path towards this experience.

V

Puni's picture was first shown at the *Große Berliner Kunstausstellung* (Great Berlin Art Exhibition) in 1922. In 1923, the painter left Berlin, moved to Paris, and Iwan Puni became Jean Pougny.

Epilogue

Viewing Puni's picture re-awakens my long-standing desire for a place in which visual art, music, theatre and all the experimental forms of art can be presented with equal competence, a place in which projects can be developed which take into account the reality of the arts and the conditions in which they are created and have their impact.

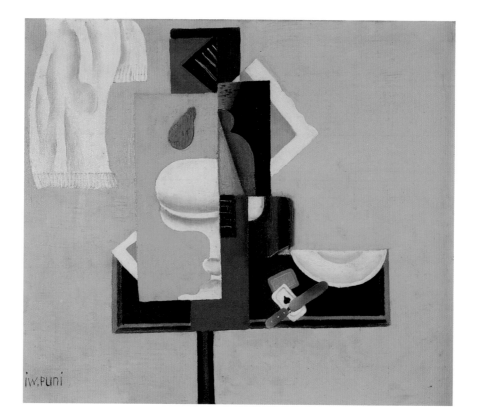

Komposition
Konstruktivistisches Stilleben, 1920
Composition, Constructivist Still Life
Oil, ceramic collage on canvas
54×63 cm

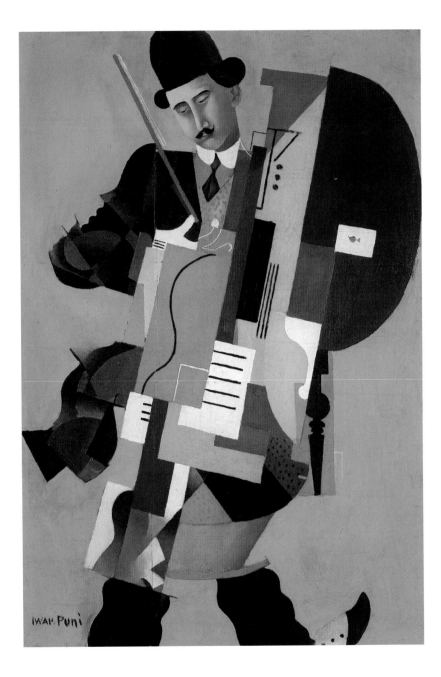

Synthetischer Musiker, 1921
Synthetic Musician
Oil on canvas
145×98 cm

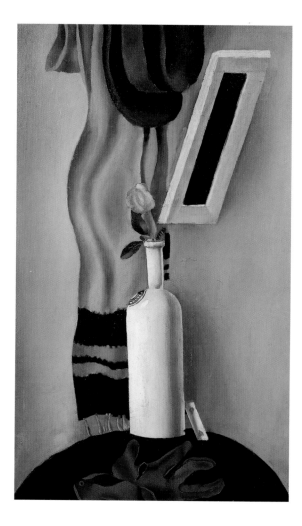

Stilleben mit weißer Flasche, 1922
Still Life with White Bottle
Oil on canvas
68 × 42 cm

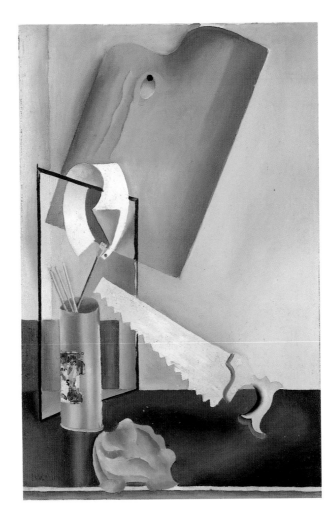

Stilleben mit Säge und Palette, 1923
Still Life with Saw and Palette
Oil on canvas
77,5 × 51 cm

Study for ›Head in a Corner Niche‹
c. 1916/17
Ink on paper
14 × 12,5 cm

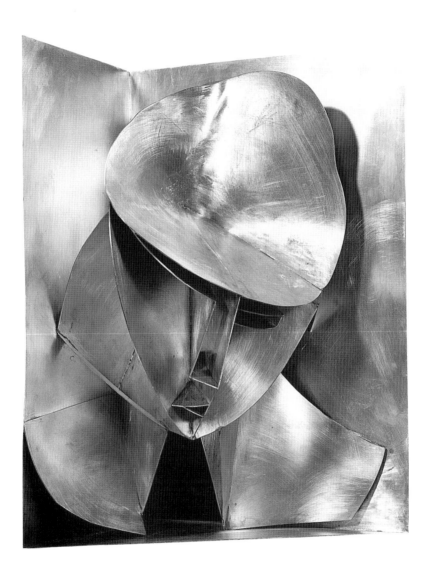

Constructed Head No. 3
(Head in a Corner Niche), 1917/1964
Silica-bronze
62,2×70×35 cm

Study for ›Torso‹, 1916
Pencil on paper
42,2×33 cm

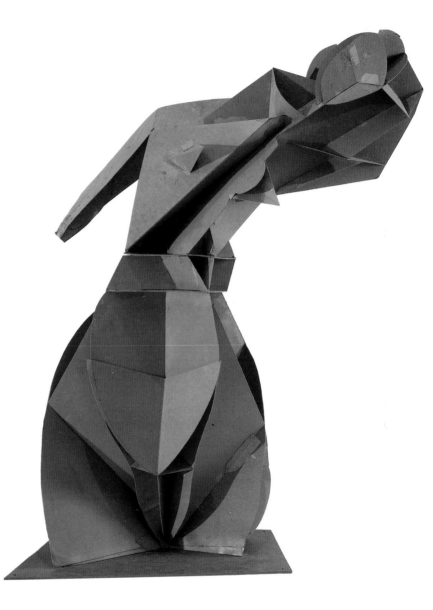

Maquette for the
›Constructed Torso‹, Winter 1917/18
Reassembled in 1985
Cardboard
117×93×50 cm

71

The Realist Manifesto, Moscow 1920
Leaflet
64×76,2 cm

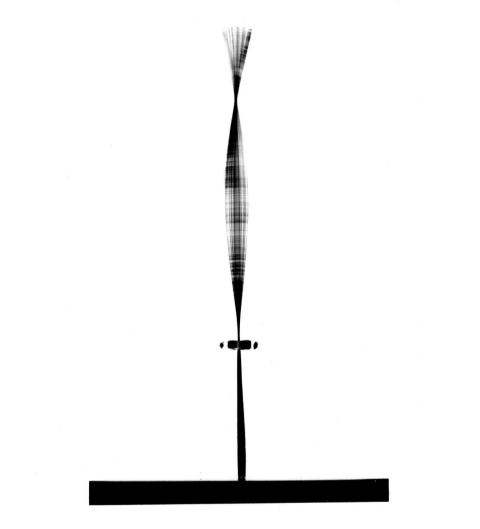

Kinetic Construction (Standing Wave)
Winter 1919/20
Reconstructed in 1990
Metal rod with electric motor, plinth
Height 61,5 cm

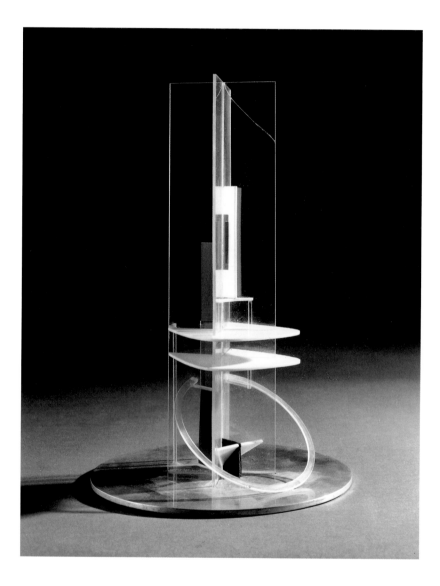

Column, 1922/23/c. 1947
Perspex on aluminium base
Height 28,2 cm

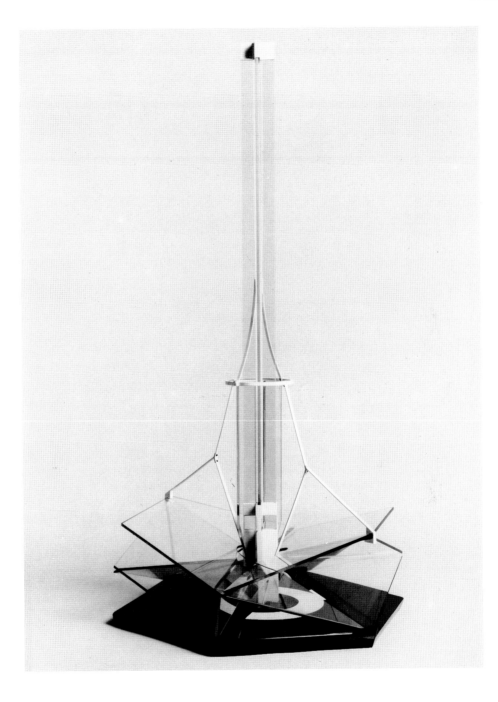

Construction in Space: Vertical
1923—1925
Reassembled in 1986
Glass, painted brass and plastic on
black painted wooden base
Height 110 cm

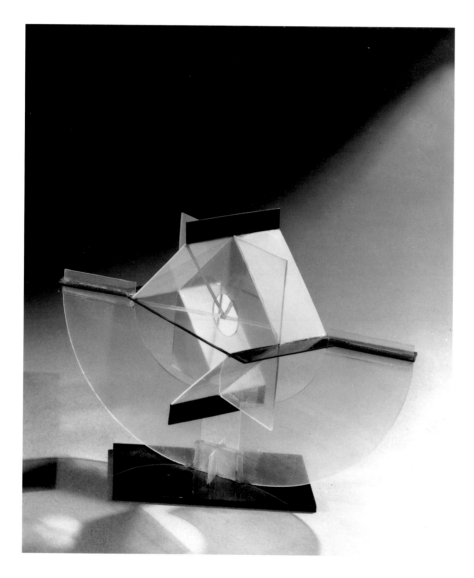

Model for a ›Construction in Space
with Balance on two Points‹
c. 1924/25
Reassembled in 1978/79
Celluloid on plastic base
13,5 × 18,2 cm

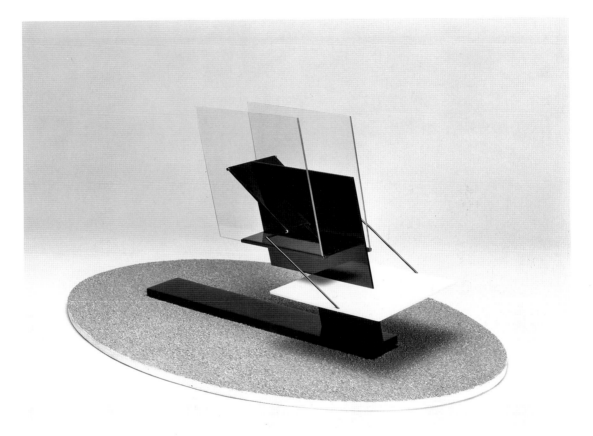

Monument for an Airport
1924–1926
Reassembled in 1985
Glass (replaced), enamelled brass
(newly painted)
and wood on wooden base
49×73,3×30 cm

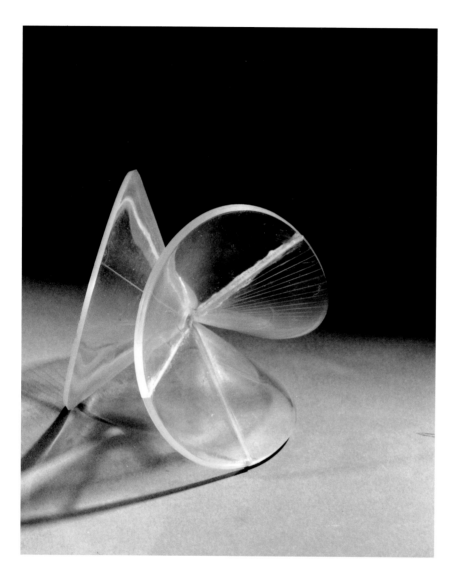

Model for a ›Spheric Theme‹
1936/37
Perspex
Diameter 10,2 cm

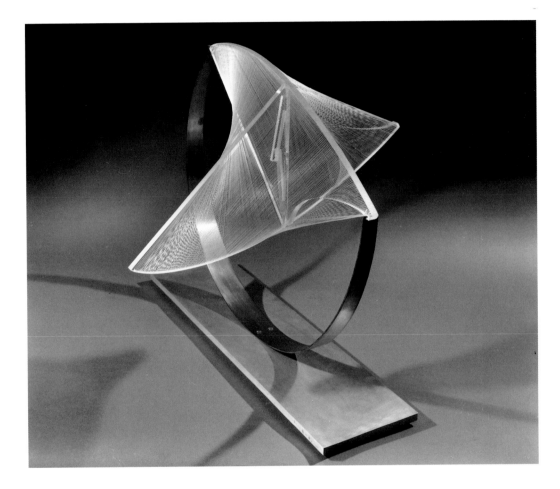

Construction in Space: Suspended
c. 1957–1965
Perspex, nylon monofilament,
gilded phosphor-bronze cradle on
aluminium base
51,3×61,6×52,7 cm

Naum Gabo

Study for a Nude, c. 1915/16
Ink on paper
12,6 × 14,2 cm

80

Study for a Kneeling Figure, c. 1915
Pencil and charcoal on paper
51×36 cm (irregular)

Study for a Tower, c. 1917
Pencil on paper
40,3 × 28,5 cm

Study for a Relief, c. 1917–1919
Pencil on paper
48×35 cm

Edmund Kesting

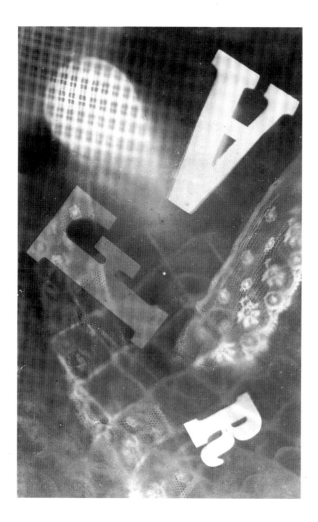

Photogram, 1923
Silver gelatine paper
23,5×15 cm

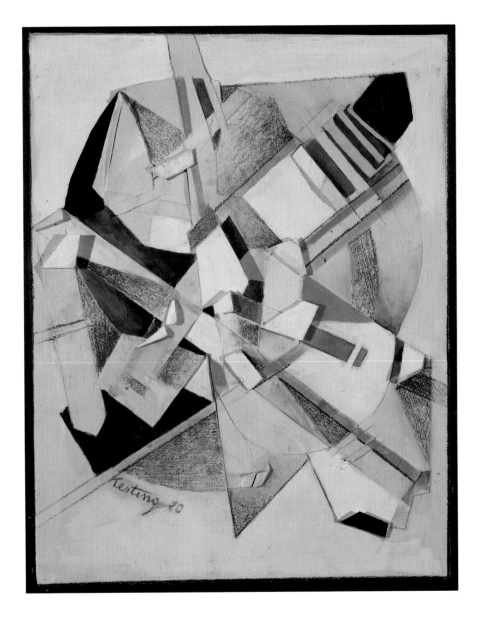

Collage, 1920
Combined techniques on cardboard
30×24 cm

Suprematist Drawing, c. 1925–1927
Pencil on paper
15,5 × 10,5 cm

Suprematist Drawing, c. 1925–1927
Pencil on paper
18 × 11 cm

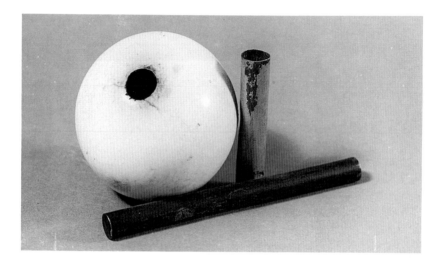

Pen Rack, 1923
Billiard ball, brass casing, metal rod
5,2×9,2×5,2 cm

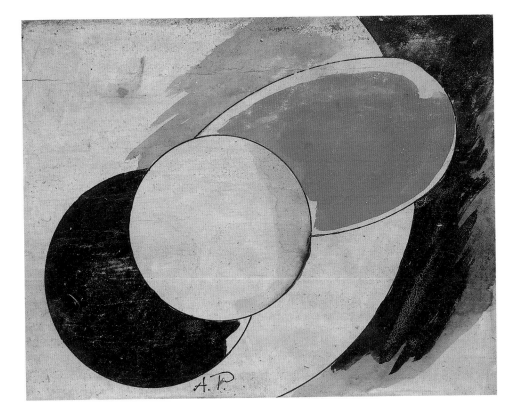

Untitled, c. 1923
Gouache on wood
14 × 17,7 cm

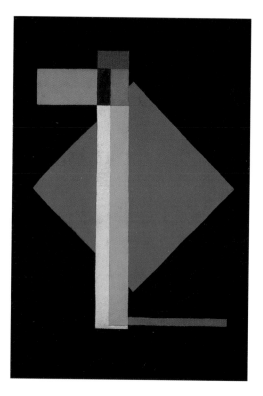 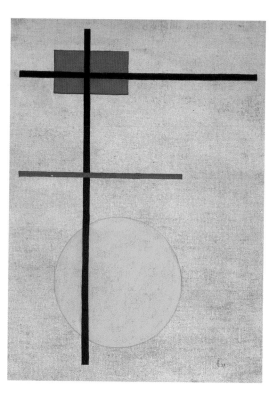

Composition (Blue Square
on Black Background), 1925
Oil on canvas
60×42 cm

Composition, 1927
Oil on canvas
56,5×41,5 cm

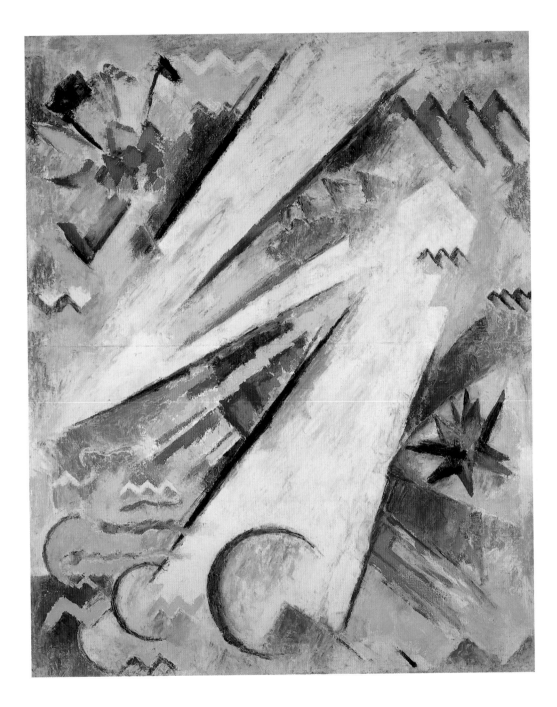

Großer Blitz (Fuge), 1920
Great Flash (Fugue)
Oil on canvas
165 × 134 cm

New Objectivity
The German Realism of the Twenties

Wieland Schmied

The art of New Objectivity is especially bound to the epoch in which it originated. It developed in, and disappeared with, the Weimar Republic. Its beginnings were acknowledged in 1919, and the year 1933 was its end. The painting that was enthroned afterwards was neither new nor objective: it paid homage to false ideals and was committed to unrealistic illusions. Only a very superficial examination would see a continuation of New Objectivity in the new ›art‹ of the Nazi period.

The new Realism, which originated with the young Republic of 1918/19, was characterized by uncertainty, scepticism and sobriety: it was qualified by a recollection of the simple facts of reality, and it sought a confrontation with time.

After the ecstasy of Expressionism, one sought the sobriety of the glance after the cosmic dreams, the banal themes, after the exuberance of feeling, freedom from all sentimentality. Where Expressionism reached for the stars, now one wanted to regain the ground under one's feet. Then, when the apocalypse arrived, one was weary of apocalyptic pathos. Actual horrors suffered and contemporary battles are portrayed differently from the vision of coming catastrophes. One only remained close to Expressionism in the fascination of the rhythms of the modern metropolises and the frequent fixation with big city motifs.

Other than that, however, no more euphoria and no being beside one's self, no devotion to cosmic distances and the unconscious depths within one's own self, no trips to India and in the South Seas, no trips down to the ›mothers‹. Instead, the disregard of one's self and the convulsions of one's little ego was felt to be the task. New Objectivity was about focusing on the here and now, the view out of the window and on everyday happenings and the asphalt in front of the house, the view onto the street and into the gutter, into the factory and shipyard, into the operation room and the brothel, sometimes it even fell on an allotment garden or a gatekeeper's hut or a small happiness in some remote corner, or remained hanging on a clothesline perspective in the backyard.

G. F. Hartlaub was the originator of the concept ›New Objectivity‹ as a collective description for the realistic tendencies in the painting of the twenties. He used it for the first time in a May 1923 bulletin in which he, as the newly appointed director of the *Mannheimer Kunsthalle*, issued an invitation to an exhibition. In this bulletin, which he sent to sympathetic colleagues, critics, art historians and galleries and which was also published in the *Kunstblatt* (Art News), he wrote:

»I would like to organize a medium-sized exhibition of paintings and graphic works in the autumn which could be given the title ›The New Objectivity‹. My purpose is to unite representative works of those artists who in the last ten years have been neither impres-

sionistically dissolved nor expressionistically abstract, neither purely sensual outwardly nor purely constructive inwardly. I want to show those artists who remained true to or returned to the positively tangible reality with a confessionalistic streak . . .«

The exhibition could only be realized two years later, from June 14 to September 18, 1925, although not, as originally planned, as a European manifestation, instead it was limited to Germany and was entitled: *Neue Sachlichkeit. Deutsche Malerei seit dem Expressionismus* (New Objectivity. German Painting since Expressionism). Beckmann, Dix, Grosz, Kanoldt, Mense, Nebel, Scholz, Schrimpf and, the Swiss, Stoecklin were among the most largely represented.

The New Objectivity is deeply rooted in the art of the 19th century. It is impossible to pursue all its models and predecessors here and to analyze individually how much it owes to what influence.

No artist's work has played such a decisive role for so many painters of the New Objectivity as Giorgio de Chirico's *Pittura Metafisica* of 1910—1917. It is these, strictly speaking, ›antimetaphysical‹ images which herald the decay of the old ›metaphysical‹ order. Without this order, which had held all the manifestations together and had given them meaning, all objects appear isolated and enigmatic. We encounter them on de Chirico's spatial stage among irritating perspectives, as though in a museum. Man sees himself confronted by a world of artefacts that have become strange to him and with which he can no longer cope. Modern man's fear, isolation and loss of orientation become pictures in de Chirico's visions of the empty squares, surrounded by renaissance architectures like backdrops.

When coherence is lost the particulars, the objects, become even more important. We might compare the objects to the fragments of a broken and scattered mosaic, which cannot be joined together again as a realistic whole. When these objects are asked the old questions—which de Chirico does in his paintings—then they seem puzzling, strange, ›metaphysical‹. If we do without asking questions and accept them without questions, then we reach New Objectivity.

The artist of New Objectivity feels that he has been put in a world whose inner-relation he does not understand and whose development he does not control. He is at its mercy and so he clings to the objects. For him, they mean a firm hold, a last unambiguous security in a world becoming ever more incomprehensible. For New Objectivity everything freezes to a thing, to an object. We can also speak of a flight into the objects. The world of New Objectivity is a chilled and rigid world.

It is less a new style than a new way of seeing; this springs not only from changed optics, but also from a changed attitude towards the phenomena of life, and it demands a turn towards other themes that are, in radical proportion, taken from the environment of modern civilization and from everyday life.

The optics are comparable to a photo lens, indeed exceeding it in precision: they portray everything equally focused, even the background. The glance drops indifferently, as though accidentally on the objects, which it registers exactly.

Partiality appears only where there is political commitment against social injustice and solidarity with the oppressed predominates, where the feeling cannot be restrained,

where one's point of view cannot be concealed, as it does with individual representatives of the ›left wing‹, such as, Otto Nagel, and later, Hans Grundig. But, partiality is the opposite of objectivity, and those pictures often mentioned today, belong in the strictest sense more to the realistic rather than the objective art of the twenties. Even Otto Dix, who was definitely, passionately involved with his objects, a cool will to observe triumphs. Inner commitment and sobriety of view are by no means mutually exclusive, as is proved by many paintings of the New Objectivity. In the conservative wing, however, with Kanoldt and Schrimpf, the limit between restrained feeling and sentimental expression is from time to time exceeded.

The New Objectivity brought about not only a new turn towards the world of objects, it also meant a new confrontation with things. It was an attempt, in a world-historical hour of uncertainty, after the destruction of a war, in the middle of political, economical, social crises, to get hold of things anew, to regain control over them, and more: through faithful and non contemptuous observation, to spiritually penetrate them, to grasp them in their own selves, in their true secret, in their quiet aura—to, in this way, empirically and inductively, create a new orientation in a chaotic and incomprehensible world, and to comprehend the world in its most inner cohesion.

As a political metropolis, Berlin was also a melting pot for the different artistic currents. The artists of New Objectivity, concentrated around the *Malik* Publishing House, around Grosz and Heartfield, around the *Rote Gruppe* (Red Group), founded in 1924, had to coexist with other diverse tendencies: the late Impressionism of Max Liebermann, the calmed Expressionism of Schmid-Rottluff, Carl Hofer's tranquil Realism, Hannah Höch's refined Dadaism, Christian Schad's neutral and sober as well as detached glance which gets under the skin, the still turbulent handwriting in the painting of Ernst Fritsch, Gustav Wunderwald's modern big city romance, the living humanism of Käthe Kollwitz, as well as the proletariat milieu of Hans Baluschek, Otto Nagel and Heinrich Zille.

Rudolf Schlichter came from Karlsruhe, where he studied under Wilhelm Trübner and Hans Thoma. At the beginning of the twenties, we find him in Berlin in the *Novembergruppe* circle, involved in Dada activities, and soon a co-founder of the *Rote Gruppe* of 1924—he was on their board along with Grosz and Heartfield. Schlichter is, next to Dix, Grosz, and Hubbuch, one of the most important artists of the time. He knew man exactly, like all good portraitists, he saw through him, but he did not scorn him. His feverish psychologism was combined with his succinct sobriety, his most rigorous definitions of man pulsed with creatural participation and with sympathy. He was an alert, precise observer. His commitment to the victims of war, society's insignificant, the underground and the night-side of the big city is undeniable. Earlier, his yearning for the Wild West and American Indian games meant for him a chance to escape from provincial confinement and oppressive small town claustrophobia, and later his insatiable erotic curiosity allowed him to become a delicately accentuating portrayer of morality in his time.

Of all of the painting themes that Otto Dix treated, none shocked like his portrayal of the war and the war cripple, with which he was obsessed. He began in 1919 with the

representation of returning war cripples, who he saw in Dresden. He summoned them onto his canvas, onto his sketch pads, onto his etching plates. For him, every medium, every stylistic incongruity was justified in capturing them. Collage, assembly, painting, photo, code, sketching, script. This is not about mastering the world, this has to do with the unmasterable, that which never allows itself to be transformed into art without a residue. Otto Dix painted man as nature, as a creature of drives, the prostitutes on the street as lurking, creeping wild cats, who were stalking their prey in the jungle of the city. His portrayals also show men with their primal instincts. Otto Dix had the courage to grasp ugliness, but—unlike George Grosz—he did not hate. He condemned the war, not men. He showed that baseness was common, but he did not scorn man in his wretchedness and shabbiness; he loved him in his misery and baseness, the listening blind man, the cynical-looking pimp, the starved-to-the-bones old man, or the beauties of the night, who are not beautiful at all. He accepted them in a sober and unsentimental way that kept faith with the visible—because the object itself already included all that there was to say if one only looked closely enough.

Otto Dix
Eldorado, 1927
Water-colour on paper
56×34 cm

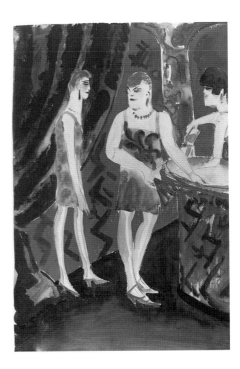

George Grosz is a deeply contradictory figure in his greatness and his failure, in his successes and in his tragedy, a biting mocker who secretly loved, a man who longed for the normal life of the citizen that he scorned and castigated and who for this reason disdained and castigated himself and at the same time, smilingly, admitted that he yearned for these things. When Dada came to Berlin, he was one of the first to embrace this movement and to give it its own face; hard, aggressive, political. He returned from the war, the first time in 1915, discharged because of illness, then, after being called up again, 1917, just barely escaped the death penalty for desertion. He knows the world, he has comprehended the hollowness of its phrases, and when he draws them now, he remembers the lies of the pompous middle-class ideals of pleasure and the hypocrisy of their nature. He learns to hate. He becomes a communist and advocates the idea of an artistic commune, all the louder the more he quietly doubts the ideology. He introduces new stylistic elements to his drawings: naivity and, similar to the awkwardness of childrens' drawings, the direct and angular doodlings on house walls, in wash rooms, in urinals, the absurd associations of the drawings of the insane, which Prinzhorn had then appropriately published in his *Kunst der Geisteskranken* (Art of the Mentally Ill). His victims were the winners of the war who drank their champagne, the capitalists who exploited the proletariat, the bar strategists that heralded national dignity, the out-of-work generals who dreamed of new war games, of their purchasable playmates and women; those were his contemporaries in the twenties, politicians and industrialists, hookers and pimps. He saw them as ›human‹, he drew them at the parties they celebrated, while they were pursuing their pleasures, in domestic circles, nude, undressed, in underclothes, their misshapen bodies pouring over their belts, out of their pants, and out of their stockings, he saw under their clothes and behind their disguises.

When New Objectivity came to an end in the year 1933 with the persecution of art initiated by those in power in the Third Reich, it had already passed its apex. Now and then, the art of New Objectivity is accused of having allowed itself to degenerate into the official Nazi art, or it had, in many respects, given away the foundations for this officially ordained ›blood and soil‹ glorified daubing promoted by the *Haus der Deutschen Kunst* (House of German Art) and others.

These accusations are, when examined without prejudices and passion, unjust. Indeed, at the beginning of Nazi rule only the smallest portion of the realistic artists of the twenties had left Germany, such as Breuer, Lea Grundig, George Grosz, Davringhausen, Heartfield, Meidner, Neuschul, Räderscheidt, and finally, Max Beckmann. Only very few New Objectivity artists were worldly, and for that reason did not feel inclined to grasp the idea of a destiny in exile, where a foreign language is spoken. The only path open to most of them was that of internal emigration. This is the path that most of them took.—The only representation for most artists of New Objectivity between 1933 and 1945 was the ›Entartete Kunst‹ (Degenerate Art) exhibition in Munich in 1937.

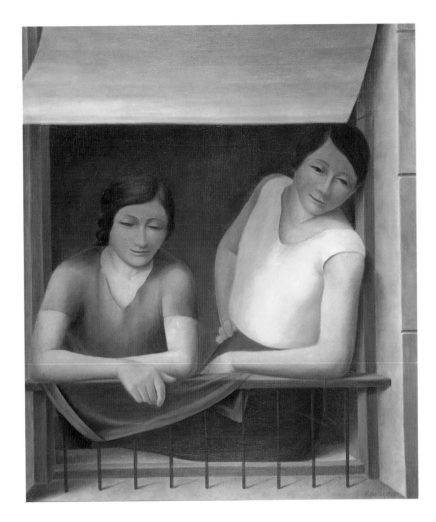

Zwei Mädchen am Fenster, 1928
Two Girls at the Window
Oil on canvas
85 × 72 cm

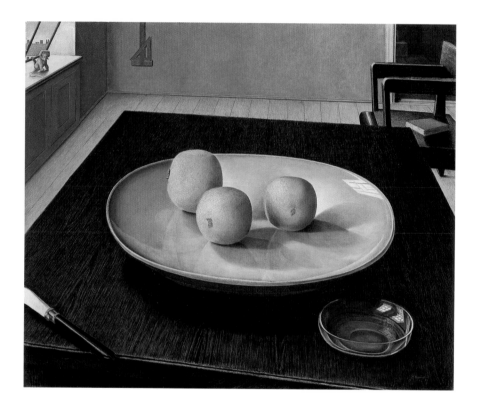

Orangenstilleben, c. 1924
Still Life with Oranges
Oil on wood
54×65,5 cm

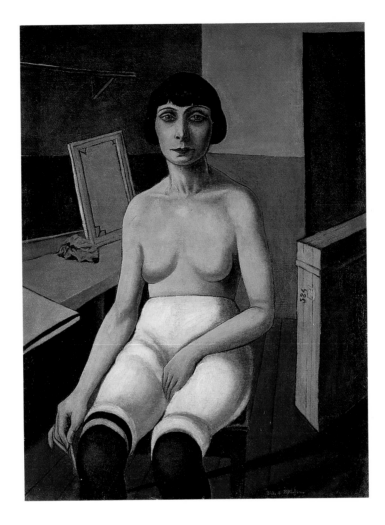

Sitzende Jenny, undated (c. 1922/23)
Jenny Sitting
Oil on canvas
86,5×65 cm

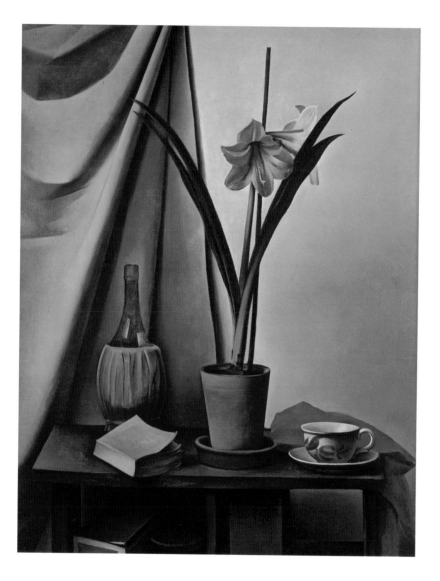

Stilleben III mit Amaryllis, 1926
Still Life III with Amaryllis
Oil on canvas
106×80 cm

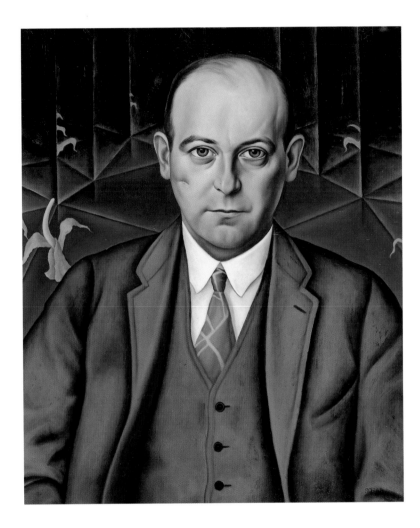

Ludwig Bäumer, 1927
Oil on Wood
61×50 cm

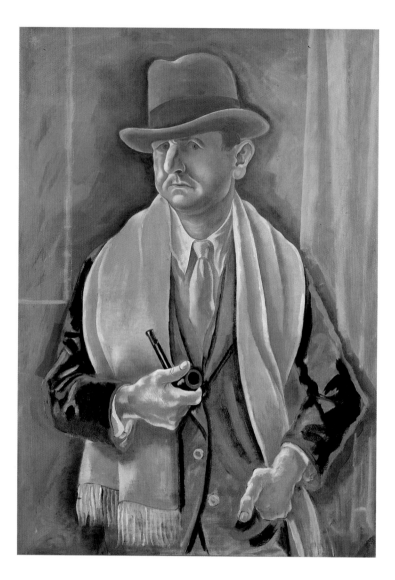

Selbstporträt, 1928
Self Portrait
Oil on canvas
109,5 × 80 cm

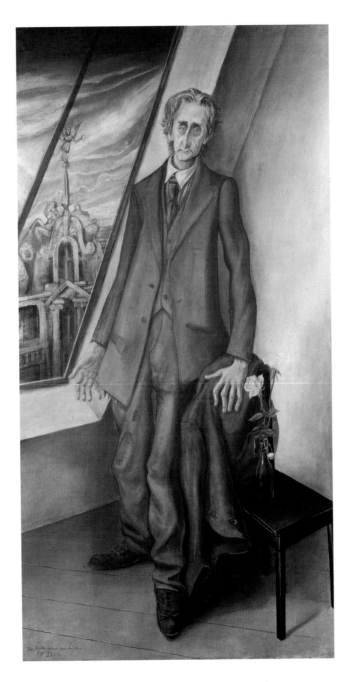

Bildnis des Dichters
Iwar von Lücken, 1926
Portrait of the Poet Iwar von Lücken
Oil and tempera on canvas
226 × 120,5 cm

Jeanne Mammen

Portrait, end of the 1920s
Pencil on paper
50 × 38 cm

104

Männerporträt, c. 1925
Portrait of a Man
Charcoal on paper
58,9×45,9 cm

Joachim Karsch

Fragende, 1929
Questioner
Bronze
109×48×50 cm

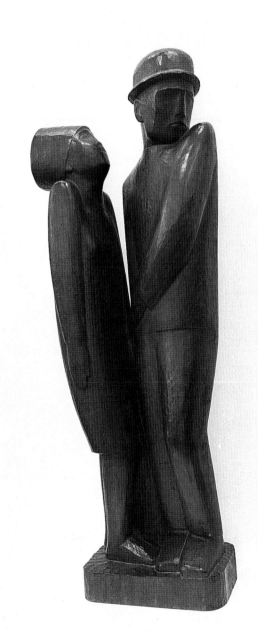

Abschied, 1928
Parting
Mahogany wood
105 × 38 × 19 cm

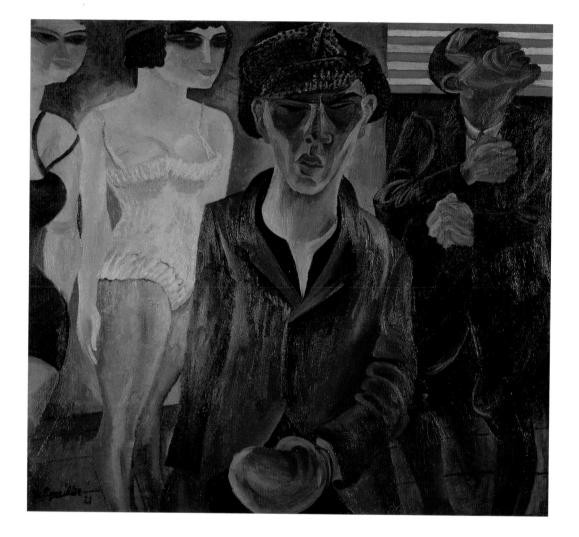

Der Schaubudenboxer, 1921
The Show Booth Boxer
Oil on canvas
95,5 × 105,5 cm

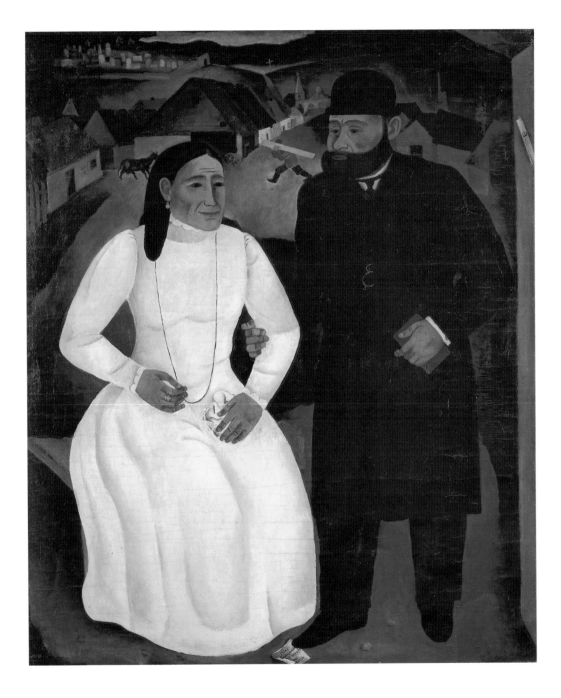

Meine Eltern I, 1925
My Parents I
Oil on canvas
150×125 cm

Felix Nussbaum

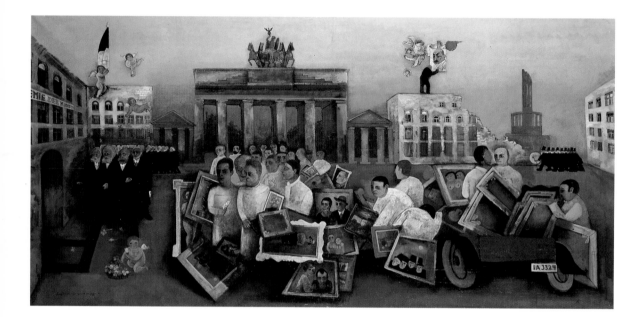

Der tolle Platz, 1931
The Mad Square
Oil on canvas
97,5 × 195,5 cm

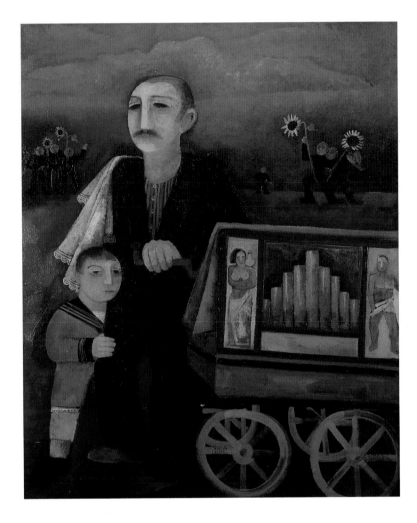

Der Leierkastenmann, 1931
The Hurdy-Gurdy Man
Oil on canvas
88×73,5 cm

111

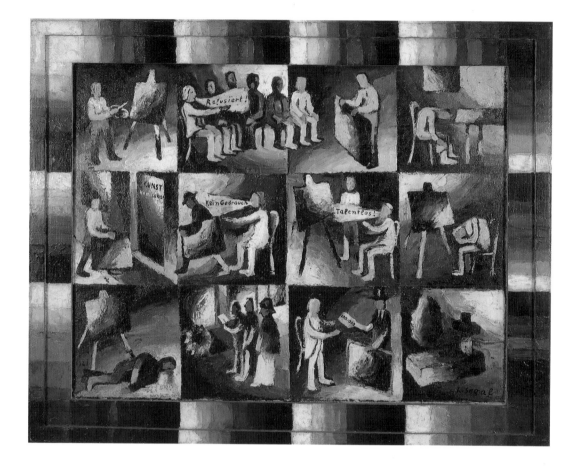

Künstlers Erdenwallen
(Der Maler), 1921
Artist's Pilgrimage on Earth
(The Painter)
Oil on canvas
62×82,5 cm
(with painted frame
77,5×98×3,5 cm)

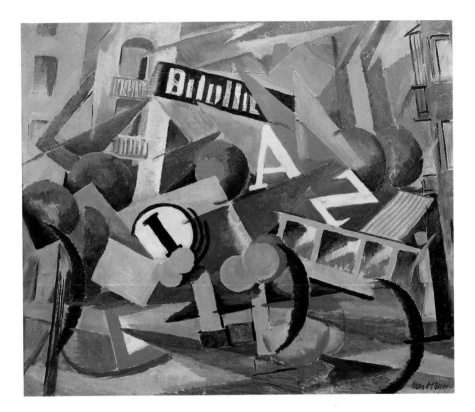

Straßenlärm, 1920
Street Noise
Oil on canvas
62×75,5 cm

113

Nikolaus Braun

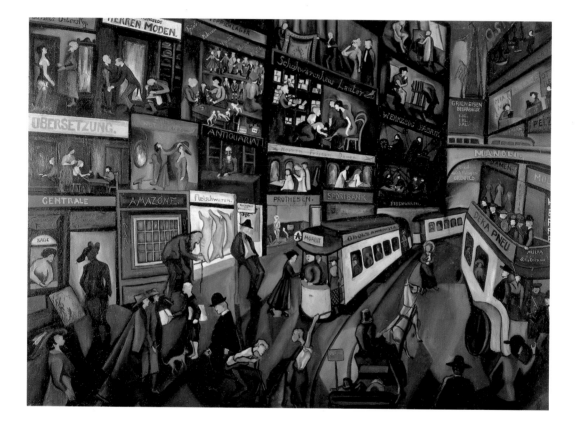

Berliner Straßenszene, 1921
Berlin Street Scene
Oil on hardboard
74 × 102 cm

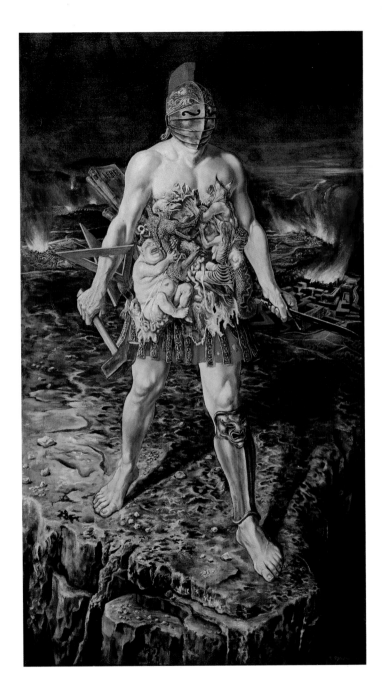

Blinde Macht, 1937
Blind Force
Oil on canvas
180 × 100 cm

New Beginnings
The Berlin Art Scene after 1945

Ursula Prinz

In August 1945, the Gerd Rosen gallery opened its premises at Kurfürstendamm 215 with an exhibition by Heinz Trökes and Jürgen Eggert. The war had just ended, the city lay in ruins, the people were starving; but the exuberance with which its cultural life began to stir was all the greater for that. There was a lot to catch up on. In the earliest post-war period, cultural awareness was stimulated above all by a movement in painting similar in style to the work of Heinz Trökes, influenced by the French surrealists—this was new ground for the Berliners and they welcomed it eagerly.

No other exhibition experienced a rush like the one of modern French art, which was shown at the destroyed palace by the Allies in 1946. Soon a bitter argument over abstract and realist art developed. This culminated, in 1955, in the famous debate published in the journal *Der Monat* (The Month), a debate between the post-war director of the Berlin Academy of Art, Carl Hofer, and the art critic and promoter of abstract artists, Will Grohmann. In the eastern sector of the city, art remained bound up with Realism, whilst the artists in the western zones strove harder for contact with the international art scene.

Among the abstract artists of the war and early post-war years was Theodor Werner. His picture *Pierrot lunaire*, named after Arnold Schönberg's composition, is the atmospheric image of a delicate and vulnerable introverted soul; forms float in it like planets, and harmoniously interlacing lines create an almost musical web making it an expression of introspection.

The development of Hans Uhlmann's plastic oeuvre, with its tendency towards abstraction, also took place in isolation and concealment. Uhlmann managed the first art exhibitions after the war at the art council in Berlin-Steglitz and arranged the programme of exhibitions, lectures and discussions in the Gerd Rosen Gallery from 1946 to 1948. During National Socialism, Uhlmann had spent two years, from 1933 to 1935, in the prison in Berlin-Tegel for conspiring to commit treason—he had distributed leaflets—and in the years that followed he was compelled to earn his living as an engineer.

His *Weiblicher Kopf* (Female Head), composed of zinc plates, originated in 1940. The somewhat abstract, cubist forms and the way in which volume has been produced by a raster of flat surfaces are reminiscent of Naum Gabo's early constructivist sculptures, and betray a concept of plastic design, oriented towards environment and light, close to that of Gabo. Uhlmann is not concerned with representation or with modelling, but with plastic orientation in space and time. His artistic development in the period which followed therefore led him even further away from the purely representative. His sculptures finally consisted largely of powerful lines grasping at space, moulded in steel which

was occasionally coloured black or red. Uhlmann was one of the most important artists in Berlin to make a decisive contribution to the development of modern sculpture.

In Berlin there was and is also a highly traditional, classical school of sculpture, working in materials such as stone, marble, wood or bronze. One of its representatives was Georg Schrieber, who created plastic works of great significance, above all his voluptuous nudes.

Werner Heldt was perhaps *the* painter of post-war Berlin. In his cityscapes, empty of people, the houses watch us with their black windows as if staring from dead eyes, a permanent memento mori, even though there is not always a skull obstructing his favourite perspective from the window. Werner Heldt's painting developed from all but realistic works to almost abstract pictorial structures. In his *Fächerbild* (Fan Picture), the houses appear to be made of playing cards. The perspective is still that from a window, but the window frame has disintegrated. A sweeping line serves as a basis to set the scene. The houses are floating, reeling, staggering as if drunk. The whole has the effect of a raft at sea or a flying carpet. It conveys the mood of the times; a dance on unsteady or sunken ground, of a society embarking on a new era with conflicting feelings.

Together with Katja Meirowski, Hans Laabs, Alexander Camaro and Johannes Hübner, Werner Heldt was the co-founder of the literary, existentialist artists' cabaret *Badewanne* (Bathtub) in Nürnberger Straße. *Der Raucher* (The Smoker) by Hans Laabs with his dignified and powerful expressiveness, testifies to the atmosphere of this period.

At this time, Alexander Camaro, who had struggled through the war years as a dancer, painted slightly abstract, but still chiefly figurative, large scale pictures with a representational tendency. For lack of any other materials, these were sometimes painted on simple tent canvas. Camaro resumed his style of the post-war years in his newest works, which ended a phase in the fifties and sixties when his pictures were abstract and often included semi-symbolic accents. A world of fantasy is once again animated by all manner of figures, by women, animals, memories of landscapes. These pictures are dreamt, the pictures of dreams, the secret of which lies concealed in their simplicity, pictures arising from a conscious and captive surrender to life, enchanted by the beauty of the world's soul.

In the fifties some of the leading abstract and informal artists besides Camaro came to Berlin as college teachers, among them Fred Thieler and Hann Trier. Their influence determined the development of Berlin art in the sixties.

Hann Trier's influence in Berlin continued into the seventies. Two large ceiling paintings in the Palace of Charlottenburg are his original work.

Fred Thieler has accompanied entire generations of artists up to the present day as a teacher and a friend. His vital, gesticulative painting is usually created on the floor rather than at an easel, by pouring colour directly onto the picture and involving his whole body in the process of painting. Its affect on the viewer is immediate and gripping. Just as the artist gave himself to the presence of the picture during the process of painting, so the viewer may lose and find himself in the fathomless depths and ramifications of opalescence as if in the intricate fissures of his inner self.

The collages of Herbert Kaufmann—also a college lecturer for many years, are

stricter in tone. They also arose in an informal spirit, but they appear more constructed and their attraction lies in the materials used.

The graphic, sometimes agonizing pictures of the younger Walter Stöhrer are vastly different to the almost classical cheerfulness of many of Thieler's paintings. Stöhrer draws his stimulus from that which he has read and from handwriting. His artistic ancestry lies with *Art Brut* and the psychic automatism of the surrealists. The inner strife of the artist, deeply involved in conflict with his own psyche, has been directly transmitted to his pictures.

The sculptures of the much older Rolf Szymanski seem to have an affinity with these pictures, although Szymanski has always concerned himself with the human image. Above all, his sculptures, created out of sheer volume, are dedicated to the female body. Szymanski kneads the mass of his material to give it a indented, rounded and thoroughly sculpted surface, so that it appears to have been driven out from the heart of the figure. His figures therefore convey the impression of living creatures, which is what makes Szymanski's work so unmistakable.

The artist couple, Matschinsky-Denninghoff, has been working for some time using a system of welding together metal rods or pipes, giving their sculptures a surface structure which determines all. The works are abstract, but they nevertheless point to organic concepts such as growth and movement, in some ways, they themselves are organic. They are not a portrayal of nature, but reveal its inner structures. They make use of natural methods and thus suggest a wealth of associations to the viewer. They are able to arouse atmosphere and impressions which range from the most subtle to the most vehement and archetypal.

All these artists belong to the first generation of ›new beginnings‹, are masters of their art now known as ›classic‹, whilst those examined in the following are somewhat younger, and some of them are still the subject of controversial public discussion.

Marwan, who comes from Syria and has lived in Berlin for thirty years, has chosen his own face as the subject of his art for decades. Quite apart from the examination of his own psyche which is involved in this, the face gives him an opportunity for pure painting with a rich differentiation of colour, as it has now extended to the very edges of the picture, almost bursting its limits. The surface of the picture which appears to have been ploughed, is all but plastic in form. A highly abundant palette of colour is excitingly mingled with its object, so that the drama of colour almost renders the exterior of the subject forgotten, thus revealing its inner dynamics.

Bernd Koberling has a remarkably colourful palette. He prefers landscape themes. The brilliant red of a flower in the dark green of a wood is not only an aspect of nature's beauty in his work, it is also something threatening, dangerous. On closer observation, we see a television set hidden in the wood. Nature is not observed independently, but in connection with our civilisation and the dangers it causes. A generous application of thin paint to raw, scarcely primed jute is reminiscent of the practices of the *Brücke* artists. In the meantime, of course, dimensions have grown to the comparatively huge and content has been relativized. Koberling works in cycles. Among his more recent series of pictures is the *Loch im Fluß* (Hole in the River), a group of almost black pictures, which are

nonetheless full of nuances and only offer a slight suggestion of representation, of the landscape.

The same generous brush work and application of paint can be found in the work of K. H. Hödicke. Using a powerful contrast between light and shade and a heavy application of colour in large patches, he compels the character of his subject onto the canvas, for example the *Kriegsministerium* (War Ministry) or the *Martin-Gropius-Bau,* which was flanked by the Wall until very recently. With the simplest of means, he succeeds in translating the social and political content of his work into a visual language. Hödicke's painting is a stimulus and starting point for numerous young artists in Berlin, above all for the Young Wild Movement.

The expressive method of Wolf Vostell is much more aggressive. His cementing-in of objects points to the hardening and inflexibility of our lives and our realities. In his dé-coll/age object, *Deutscher Ausblick* (German Perspective), part of the cycle *Schwarzes Zimmer* (Black Room) from 1958/59, Vostell refers to the realities of the divided Germany after the Second World War. Barbed wire wraps itself over the picture, the television and the wooden planking. The newspaper photos are a reference to militarism, to the Soviet army and the East German ›People's Army‹, for example, and the little musical boxes are evidence that even small children busy themselves with the idea of war. The group is completed by a crucifix and the title page of the *Spiegel* magazine showing a photo of the Pope. Catholicism is here brought into association with militarism in a way which makes both appear fatally entwined. Injury, destruction, division and decay, this is the pessimistic message of the ›German Perspective‹.

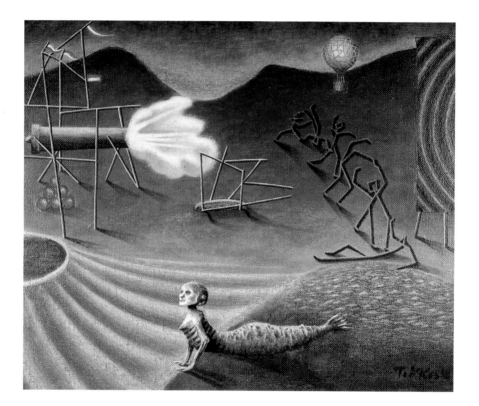

Die Mondkanone, 1946
The Moon Cannon
Oil on canvas
40×48 cm

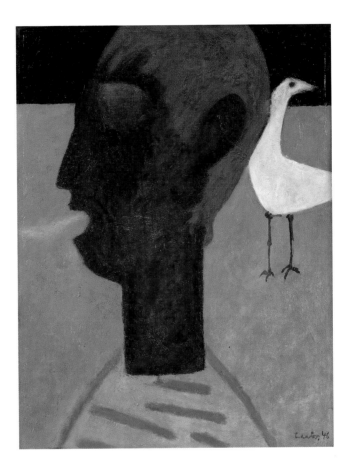

Der Raucher, 1946
The Smoker
Oil on canvas
46,5 × 36 cm

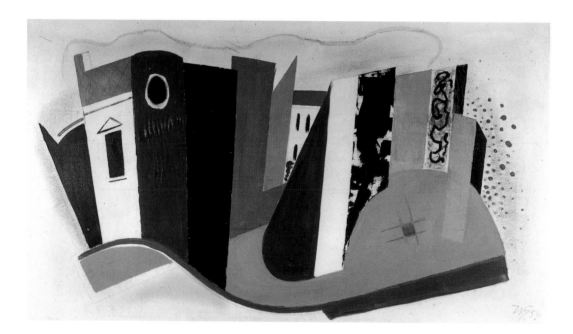

Häuserstilleben (Fächerbild), 1954
Still Life with Houses (Fan Picture)
Oil on canvas
60 × 105 cm

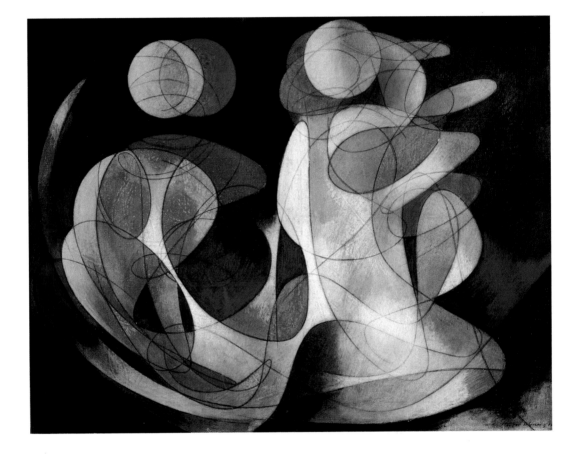

Pierrot lunaire, 1944
Oil, pencil on canvas
114,5 × 145,5 cm

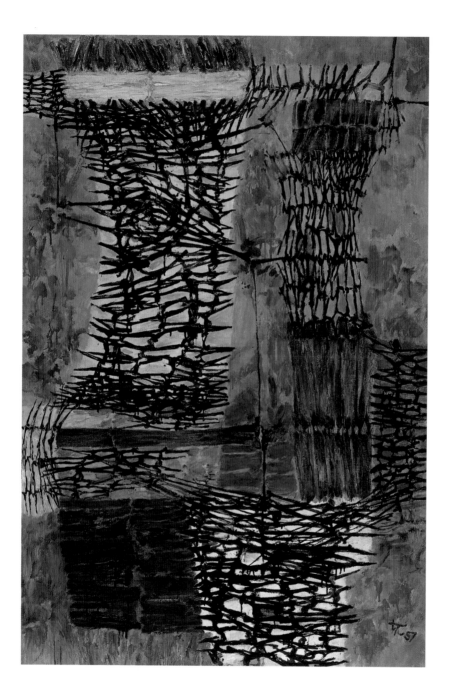

Vibration VIII, 1957
Oil on canvas
146,5×97,5 cm

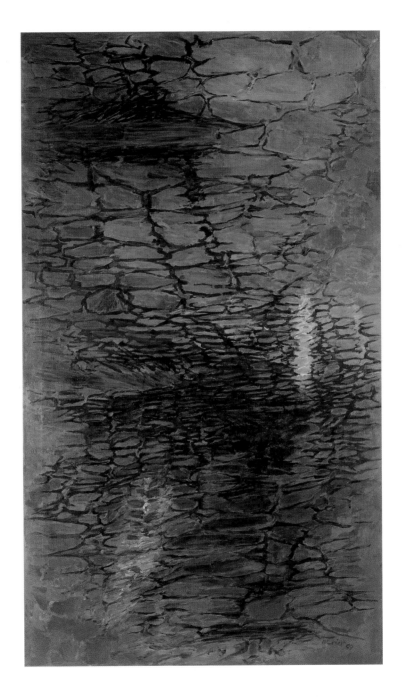

Ambidextro, 1959
Oil on canvas
194,5 × 114,5 cm

Fred Thieler

O.R. 59 (Rotierend), 1959
O.R. 59 (Rotating)
Oil on hessian
130×130 cm

126

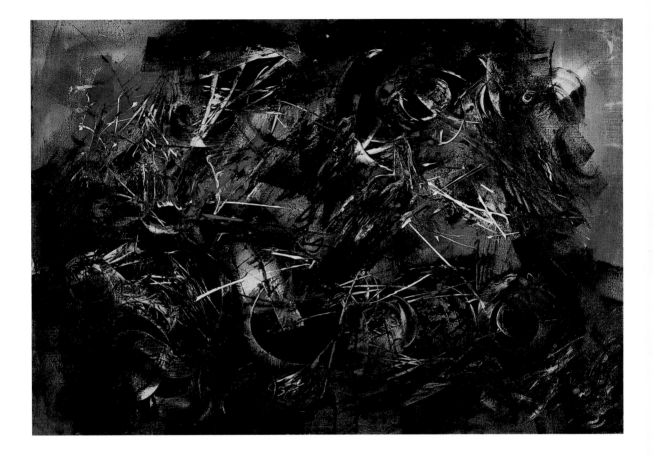

Dunkles Rot-Schwarz, 1959
Dark Red-Black
Combined techniques on hessian
130 × 191 cm

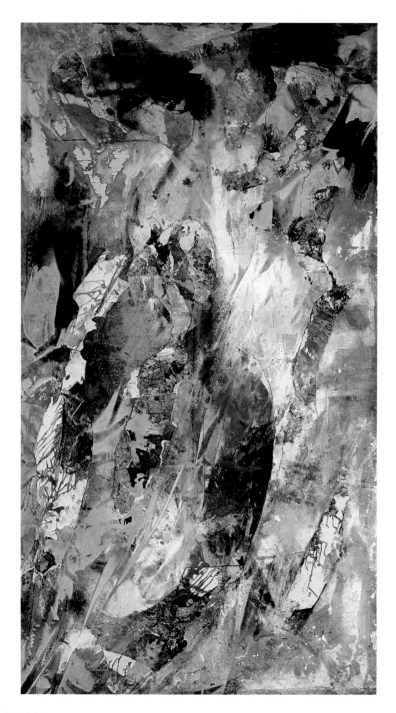

Hommage à Tiepolo, 1965
Combined techniques,
collage on canvas
263 × 145,5 cm

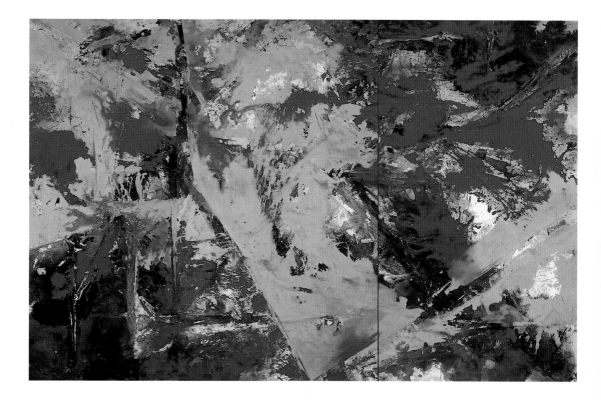

Mit lichter Mitte, 1990
With a Light Centre
Combined techniques on canvas
3 parts, 290×450 cm

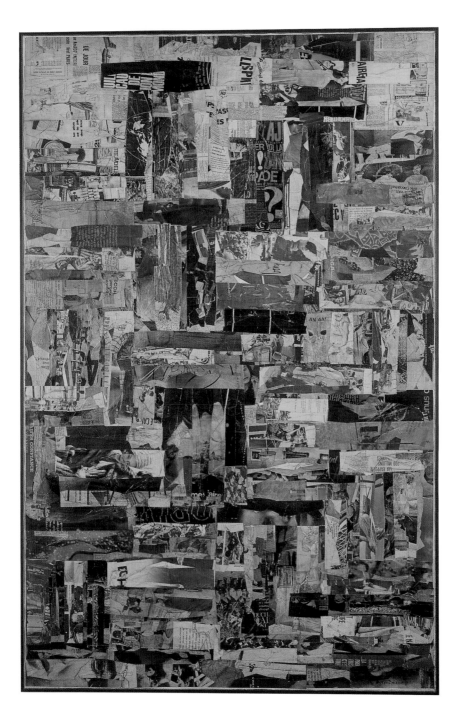

Porte bleue, 1961
Blue Door
Collage on canvas
200 × 130 cm

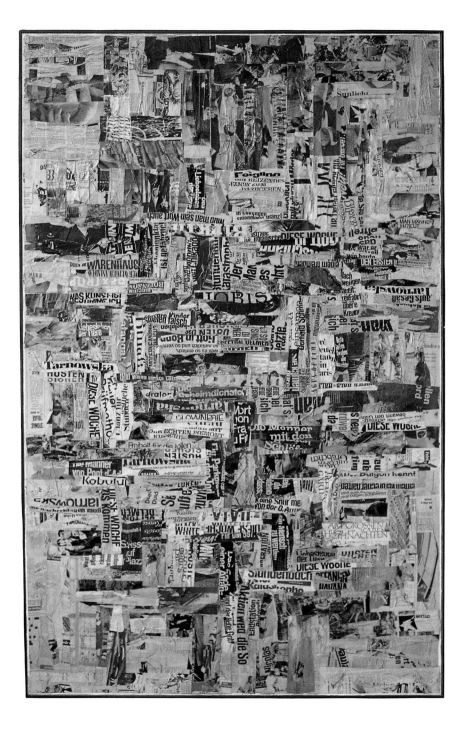

Metropolis, 1962
Collage on canvas
200 × 130 cm

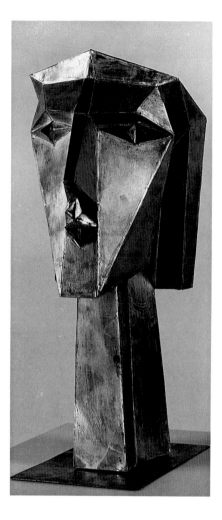

Weiblicher Kopf, 1940
Female Head
Sheet zinc
42 × 15 × 23 cm

Fünfecksäule, 1971
Five-Cornered Column
Chrome-nickel steel, three-coloured
110 × 36 × 33 cm

Vorstadtkino, after 1945
Suburban Cinema
Oil on hardboard
62 × 87 cm

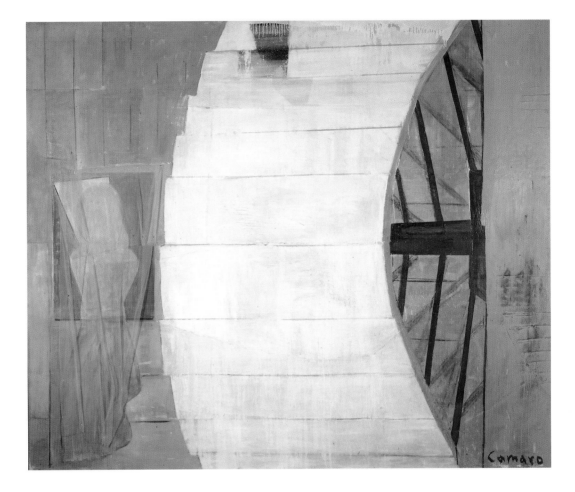

Gobi — Großes Mühlrad, 1981/82
Gobi — Great Mill-Wheel
Combined techniques, tulle collage
on canvas
241×287 cm

Alexander Camaro

Caza Muerta, 1980
(Der Käfig, Der weiße Fuchs, Die Falle,
Objekt Strandgut II)
Dead Hunt
(The Cage, The White Fox, The Trap,
Object Driftwood II)
Combined techniques on canvas
Triptych, each 250×200 cm
Wooden object, 36,5×70×100 cm

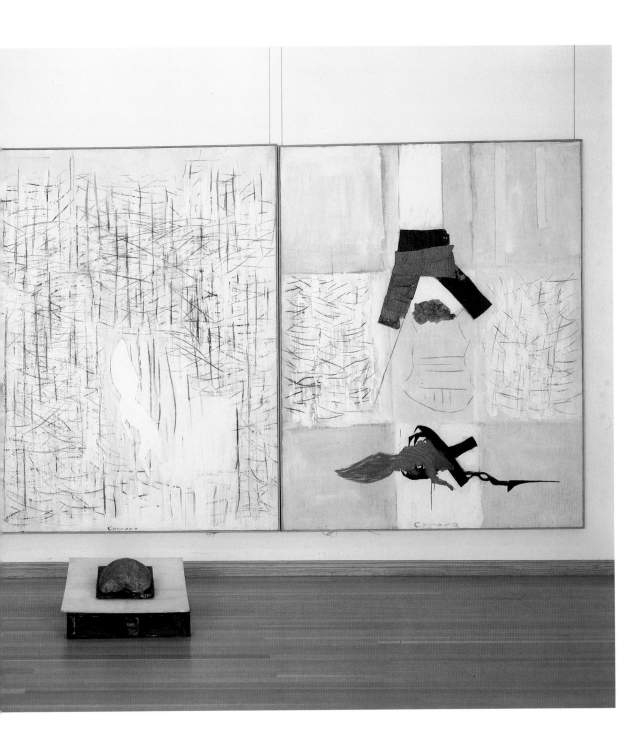

Comeback of the External World
Berlin Realists of the Sixties and Seventies

Eckhard Gillen

The gates of the documenta II in Kassel had only just closed in the late summer of 1959 when, like an omen, the oversized version of the *Metamatic* drawing machine by Jean Tinguely showed up in front of the *Musée d'Art Moderne de la Ville de Paris* for the first Paris Fall Biennale Art Festival, a machine that automatically and constantly ›painted‹ infinitely variable tachistic pictures. »The action painting of the last 10 years, Tachism, was demonstrated ad adsurdum. If a machine can produce Tachism . . . was it then still necessary and sensible for the artist to create Tachism? The road was open . . . but where did it lead? How would it continue?« This question, the theme covered in the June 1960 issue of *magnum 30*, was the concern of students of tachistic painting in Berlin, Düsseldorf, and Munich.

Answers had already been formulated in Paris, London and New York; the road signs read ›New Realism‹, ›Pop Art‹, ›Neodadaism‹. The ordinance, loosely formulated in *magnum 30,* was the »Comeback of the External World«. The motto of the fifties: »For a different art« (Michel Tapié) was replaced and now, at the beginning of the sixties, read: »For a different life«.

The bottom line that Dada had set with its negation of the concept of art was taken by Pierre Restany, the chief theoretician of the *Nouveaux Réalistes* (New Realists), on the occasion of an exhibition in the Paris Gallery Iris Clert in May 1961, as a starting point to »get the feet back on the ground« at, as the title of the exhibition and an accompanying manifesto put it, *Fourty Degrees above Dada*. The artist was called upon to integrate »himself back into the real« beyond the abstract, polemic anti-art-gesture of the Readymades of Marcel Duchamp so that he »identifies it with his own transcendence, for there is still emotion, feeling, and finally, poetry«.

With that the programme for the sixties was formulated: Life infects art and art transcends life through its poetization. At the end of the decade the slogans of the Paris May of 1968 were »Power to the Imagination!« and »Poetry must be made by all! Change the world!« This was the title of an exhibition of the *Moderna Museet,* Stockholm, organized by Pontus Hultén, which radically questioned the forms of traditional means of art when it was taken over by the *Münchner Kunstverein* (Munich Art Association) in 1970.

The destructive, aggressive impulse of the Informal was, as it were, ›lifted‹ by the *Nouveaux Réalistes* and from then on no longer materialized in the atelier, but in the public arenas of the city, for example through tear down actions and décollages (Hains, Rotella, Villeglé, Vostell). Vostell, »A destroyed poster looks very similar to a tachistic painting. I asked myself: Why is reality sometimes more interesting than its invention?

I thought: If a destroyed poster is already a tachistic painting, why should I copy it . . .?« (Interview in: *magnum 47*, April 1963). The first priority among the American and English Pop artists and the *Nouveaux Réalistes* in France was the phenomonology of every day life. With the help of montage, collage, décollage, and material accumulation, and without ideologically critical intentions, they investigated the ambivalence of the big city industrial civilization between the warehouse universe and its flip side, the junk yards (Warhol designated his artistic principal »Recycling«).

A critical-analytical variation in the ›mainstream‹ of New Realism devoted to the external world originated, significantly, in the early sixties in Berlin; the frontline city of the Cold War, the link between east and west, and the most endangered point in the world. Although the impulse came from outside, from Paris, London, New York, the bacillus ›New Realism and Pop Art‹ could only be virulent for a few years in the specific climate of Berlin—not in Düsseldorf, Cologne or Munich—and in the form of a socio-critical diagnosis.

The young Rhinelander René Block took over an important role as mediator of the *Nouveau Réalisme* and Pop Art movement, which was accepted more quickly and was accordingly more productive in the Rhine province, and in the Berlin art scene. He opened his small gallery in 1964 with an exhibition that presented West Germans and Berliners with *Neodada, Pop, Décollage, Kapitalistischer Realismus* for the first time in Berlin. The title of the exhibition characterized the programme. From Düsseldorf came Konrad Lueg, Gerhard Richter, Sigmar Polke and Manfred Kuttner; the Berliners were represented by K. H. Hödicke and K. P. Brehmer. From Cologne came Wolf Vostell. Aside from the exhibitions, the main emphasis of the gallery work was placed on Happenings, Fluxus events and Performance. Joseph Beuys had his first Berlin appearance on December 1, 1964, with *Der Chef/The Chief.*

The legendary retrospective *New Realists and Pop Art*, on loan from the *Gemeende Museum Den Haag*, was shown between November 1964 and January 1965 in the Berlin Academy of Arts, its only German location. Still, none of the young German Neodadaists and Realists were included. René Block protested against this inconsideration with a gas mask. The group of *Nouveaux Réalistes* around Restany was represented almost completely. But the biggest excitement and most lasting impression on the Berlin art scene was made by the American and English Pop artists. This impressive panorama of the international avant-garde, one of the last times that this claim could be made, confirmed and encouraged an entire generation of artists who, born between '38 and '39, had enrolled in studies at the Berlin Art College. With all the differences in their later artistic development, they had one common impulse, to get away from »the tachistic frothiness« (Georg Baselitz). But the alienation of Tachism was not as rigorous and abrupt as it later might have appeared to us.

Karl Horst Hödicke, who joined the Art Association *Vision*, founded in 1961 by Bernd Koberling and others, today still proudly designates himself as a »trained tachist« who wanted to paint figurative pictures. He was fascinated by Pop Art's big city iconography, but reacted against its design-like coldness finding reassurance in Beckmann, Kirchner, and the old German paintings. In 1964, he began with the series *Passagen* (Passa-

ges). He used slides and colour photos that he had taken himself as a starting point for his examinations which were conducted by the medium of colour, of light phenomena and mirror effects. His work with photography was similar to that of most Berlin realists, but his unadulterated aesthetics of the surface separated him from their deeply meaningful and critical analysis. The diffuse light between sundown and late evening, »the mood shortly before the light is completely gone« determines the grim, eerie radiation of his city landscapes from 1977/78. They are all inspired by the city panorama that is visible from a former printing plant on Dessauer Straße where Hödicke had set up his atelier. The building stands alone like a boulder in the dead center of the former imperial capital, directly on the Wall, which in the meantime has been torn down, between the wasteland of the former Potsdamer and Anhalter train stations. The painting *Martin-Gropius-Bau, ehem. Kunstgewerbemuseum* (Martin Gropius Building, former Arts and Crafts Museum) shows, for instance, the view from the atelier towards the northeast, towards the corner of Stresemannstraße and Niederkirchner Straße. To the right in the picture is the Martin Gropius Building, the present day seat of the *Berlinische Galerie*. Right next to it, abruptly, as if jostling the building, is the former Prussian House of Parliament on the other side of the Berlin Wall, which melts into the base of the building as a black diagonal. The stage of history has been left, all that remains are the props. The only sign of life from the deserted eeriness seems to shine from the East Berlin television tower, which rises above the scenery in the background.

In 1964 most of the colleagues in his year of study were master students or had just finished their studies as prospective teachers for art education or as free-lance agents. Most wanted, at all costs, to avoid becoming a teacher. But there were still no galleries interested in young, unknown artists, and no financially strong patrons. Together with Markus Lüpertz, who came to Berlin in 1963 from the Düsseldorf Art Academy, Hödicke found an exhibition space at Großgörschenstraße 35 which would set the standard as a ›self-help‹ gallery. The rent, 120 DM, would be divided by 12 people. At the opening on June 16, 1964, with an exhibition by Hödicke, the number was up to 15, all of whom signed a membership contract a week later: Ulrich Baehr, Hans-Jürgen Diehl, Wolfgang Petrick, Peter Sorge, Lambert Maria Wintersberger, and others. The concept was a success, the press was enthused about the »audacious enterprise in an audacious location«.

In the founding year of *Großgörschen 35*, a demonstration against the visit of the Congolese minister president Moise Tshombé, was to become the initial fuse which ignited the Berlin student movement. With that, the prototype of a new form of demonstration was born, that of the ›rule breakers‹. The time of petitions and appeals, of Easter marches and resolutions was drawing to an end. The revolt could begin. It was the revolt of a »fatherless society« (Alexander Mitscherlich, 1963). Not only were the fathers missing in the family, but—more important still—the father figures of a new culture were absent. The generation of the twenty-year-olds then knew almost nothing at all about the Weimar Republic and the Third Reich. The past, which had been successfully blocked out for a long time, finally caught up with the Germans with the kidnapping of Adolf Eichmann on May 23, 1960, by the Israeli secret service. On April 11, 1960, the trial

against the man primarily responsible for the Holocaust, the so-called »Final Solution« began in Jerusalem and ended with a death sentence which was carried out in 1962 by hanging. On December 20, 1963, the largest proceedings ever held in German legal history against mass murder began in the plenary hall of the Frankfurt City Council. This was the so-called »Auschwitz Trial« against 21 former concentration camp guards. After 20 months and 182 days of proceedings, throughout which 359 witnesses from 19 nations had provided testimony, the sentences were read on August 19, 1965.

The title of Wolf Vostell's painting *Wir waren so eine Art Museumsstück* (We Were a Kind of Museum Piece), which originated in Cologne in 1964, is a quote from the testimony of the witness Piotr Mishin on the 105th day of proceedings about the treatment of Soviet prisoners of war in Auschwitz, especially by the defendant Stefan Baretzki. In his painting, Vostell uses a cutting from page 8 of the *Frankfurter Allgemeine Zeitung*, number 253 from July 30, 1964, with the report of an observer of the trial, Bernd Naumann, under the title »We were a kind of a museum piece«. Vostell mounts this newspaper cutting in a sequence of contemporary photographs, which he paints over with spray paint. Only fragments of the article can be read, in areas that were spared by the paint, or where the paint is transparent. With a little effort, sentence fragments like »had to do ›physical training‹ outdoors at twenty degrees in the cold« or »I can't really remember« can be deciphered. The sentence that inspired the headline of the article and the title of the painting cannot be read, »We were so few (Soviet prisoners of war—ed.), we were a kind of museum piece in this large, international camp.« Vostell is apparently not concerned about the legibility of his report of the proceedings, his painting is not meant to be a contribution to the understanding of the Auschwitz Trial. And the press agency pictures, mounted next to and on top of one another, reproduced a million times, are also just as inadequate in representing the events for which they stand, icon-like. Photographs on the left and the right hand side of the painting show workers throwing stones at a Soviet tank on Leipziger Platz in the early afternoon hours of June 17, 1953, and the flight of a member of the ›People's Police‹ during the construction of the Wall on August 13, 1961, recalls the time when Berlin was a frontline city and neuralgic point of the Cold War; they show American and West German domestic policy, race riots and a solidarity demonstration for the *Spiegel* news magazine after the chief editors and the publisher Rudolf Augstein were arrested in October 1962 because of a report on the NATO manoeuvre *Fallex 62*. Between these surfaces, from left to right, the face of the suspected Kennedy assassin, Lee Harvey Oswald, distorted by pain, four times. The famous photograph shows the moment in which the barkeeper Jack Ruby shot Oswald at point-blank range with a pistol. The selection and order of the pictures and of the newspaper cutting is interchangeable. Vostell does not see himself as a modern historical painter who wants to explain post-war history in a critical-analytical manner from a personal or political standpoint. He collects and mounts ›phenomenological‹ documents of human aggressions: war, terror, accidents. But he isn't satisfied with a distanced presentation of the mere factual, as is Warhol with his contemporary silk screen prints (for instance, *Jackie*, 1964; *Race Riot*, 1965). By ›blurring‹ and painting over, he hides and alienates the material: »Blur it in order to see clearly! The imagination of the observer

can supplement what is missing with suppositions of what was there before, thus a continuous tension is created« (Vostell). He is not concerned, as many believe, with the mere shock, with the provocation of the publication. The speculations about quotations of horror are purposefully disappointed.

Arwed Gorella participated in a historical exhibition in the early seventies about the *Pariser Kommune 1871* (Paris Commune 1871) and the *Kunst der bürgerlichen Revolution* (Art of the Middle Class Revolution). The failure of the Russian October Revolution typically occupied him in his works. *Die Galerie der Philosophen* (The Gallery of Philosophers), 1974, belongs to a series of melancholic, reflective paintings about the relationship between theory and practice. The Marxist formula on Hegel and German idealism, turning what is upside down upright, is paraphrased here: Jack Schlesinger's well known Hegel portrait is standing on its head. Gorella declares this position as correct by painting the name plate on the lower strip of the frame. If this picture is leaning up against the wall with the others—taking up almost half of the painting—the portrait of Marx hangs in the second section of the gallery rooms, no larger than the heads of the militiamen, but completely within sight. Three dwarfish clowns, with white make-up and in white tuxedos with top hats, are assigned to the upside-down Hegel. Art, which according to Hegel's dictum has ceased to be the medium of recognition, it has become a plaything of sophisticated interpreters. A raven, which appears to embody the restlessly searching spirit of the artist, leaves behind the narrow, perspectively stacked chambers of the ideological system of theories in a distant future and flies away.

The *Schule der Neuen Prächtigkeit* (School of New Magnificence) (Manfred Bluth, Johannes Grützke, Matthias Koeppel and Karlheinz Ziegler) originated early in 1973 and saw itself as a life raft »on the sea of all-encompassing wretchedness«. These floods »of . . . exemplary design, practical pantyhose, didactical art exhibitions . . . and checkered painting« were opposed by »the confidence to discover magnificence anew.« »Don't let yourselves be tyrannized by the right angle . . .« In contrast to the veristic social diagnosis of Critical Realism, Johannes Grützke was interested in the pathetic-expressive gestures of the twenties. »Magnificence can only be born out of intensified sensation.« Grützke's exact observations and virtuously illuminated pictures of painted human theatre are completely within this sense. Grützke paints his contemporaries according to his own mirror image: »When I look at myself in the mirror I look at the entire world . . . It's always me, and I don't consider the entire world any better or worse than myself.«

Since E. T. A. Hoffmann, the dark side of our existence in Berlin has been an ever present countercurrent under the surface of the factually sober, conceptually analytical Realism in art, for instance in that of George Grosz or Wolfgang Petrick. Especially Petrick's extensive work since 1963, in its ambivalence between the criticism of civilization and the search for a comprehensive, sensually affective realization of human existence analogous to the mystic experience of ›savage thought‹, shows that the familiar labels of the sixties, such as ›Critical Realism‹, have long become unsuitable. Crests, helmets and magic hoods show up in his works as a main motif again and again, with which the protagonists of his paintings, in a condition of helplessness and at the mercy of threatening technical devices and acts of nature, attempt to protect themselves. The

Haubenleute (Crested People), 1965, are reminiscent of stickmen that cover the walls of silent places and arouse our fantasy imagining them as cryptic symbols of secret lusts and passions. They are strange hybrids, as if from a distant star, with trunks and crest-like growths, armed to the teeth with pistols, daggers, and so on, that somehow appear harmless. The influence of *Art Brut* is obvious. The aggressiveness of lines and colours doesn't have a definite target, but absentmindedly roves around like a nomad, enjoying the grotesque intensity. Since the mid-seventies, mutations of human bodies with the heads of birds, apes and cats and with proliferous animal hair are increasingly replacing the metamorphoses between man and the monstrous technical devices. As in the early eighties, eventually, wolves' heads, as natural ›magic hoods‹, displace the artificial protective helmets and diverse masks with which Petrick's figures move through the unrestrained floods and fiery passions of a strange, eerie, trackless world. Technology, as an instrument for the control of nature, has become a shackle. The animal instincts and energies made taboo, push to the surface and attack the socially determined super-ego in nightmares.

Wolfgang Petrick
Tarnkappe, 1983
Magic Hood
Gouache on photostat
41,5 × 29,5 cm

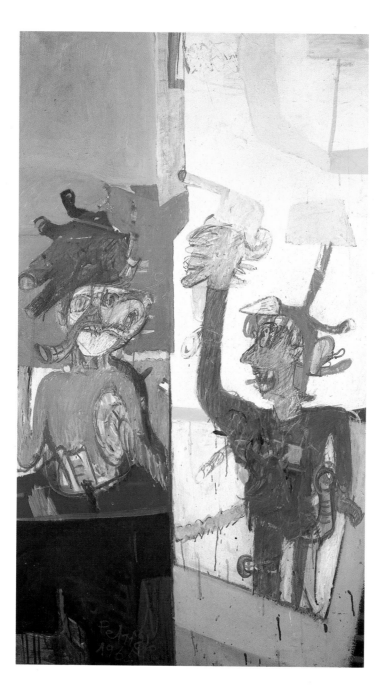

Haubenleute, 1965
Crested People
Combined techniques
on raw cotton
161×93 cm

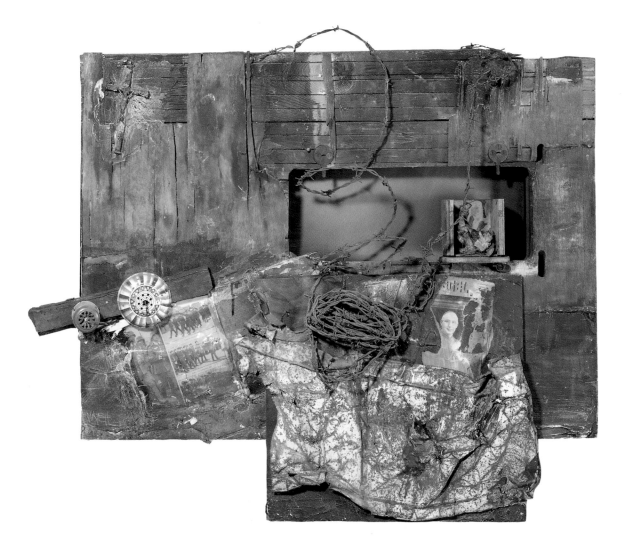

Deutscher Ausblick
German Perspective
From the cycle ›Schwarzes Zimmer‹
(Black Room), 1958/59
Dé-coll/age object
Wood, barbed-wire, tin, newspaper,
bones, television set
197,5 × 129,5 × 81,5 cm

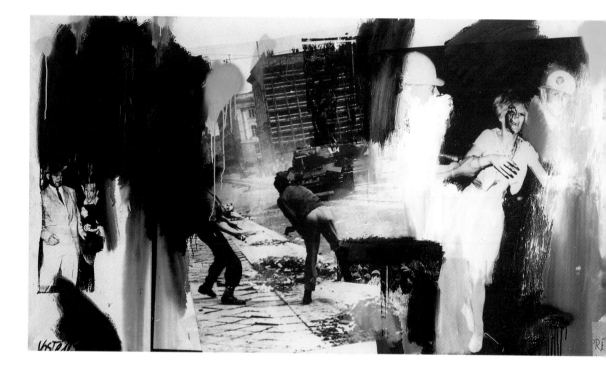

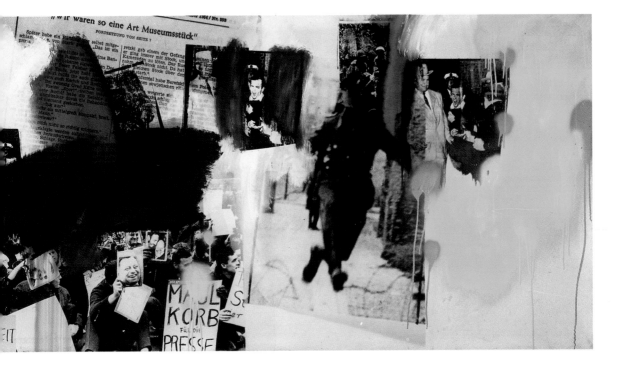

Wir waren so eine Art
Museumsstück, 1964
We Were a Kind of Museum Piece
Screen print, spray paint on screen photo
120 × 450 cm

K. H. Hödicke

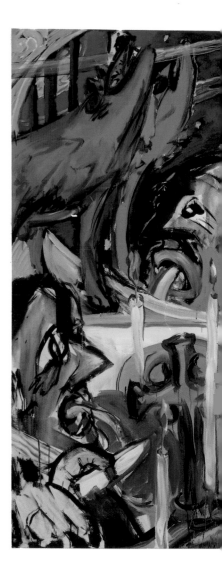

Großer Schlachter, 1963
Great Slaughterer
Synthetic resin on canvas
Triptych, 180×80/175×130/
180×80 cm

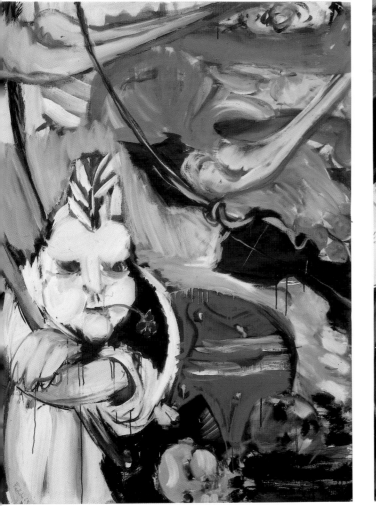

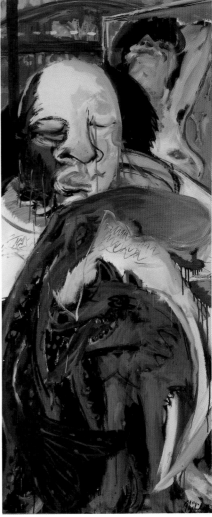

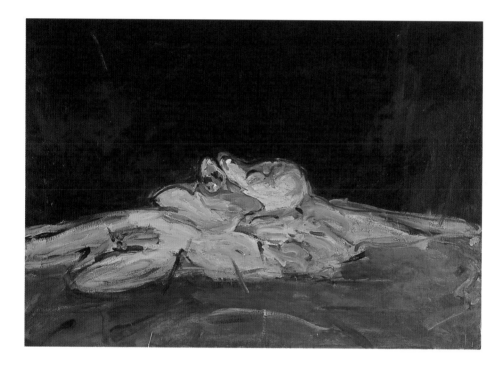

Figuration, 1963/64
Oil on canvas
89 × 130 cm

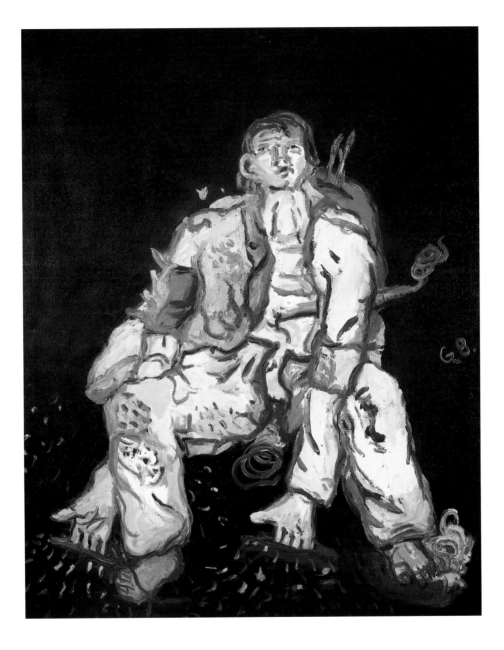

Ein moderner Maler, 1966
A Modern Painter
Oil on canvas
162 × 130 cm
On loan from Aberbach Fine Art,
New York

Ohne Titel, 1963
Untitled
Ink and water-colour on paper
61×43 cm

Selbst mit roter Angeljacke, 1963
Self Portrait in Red Angler's Jacket
Synthetic resin on raw cotton
70 × 155 cm

153

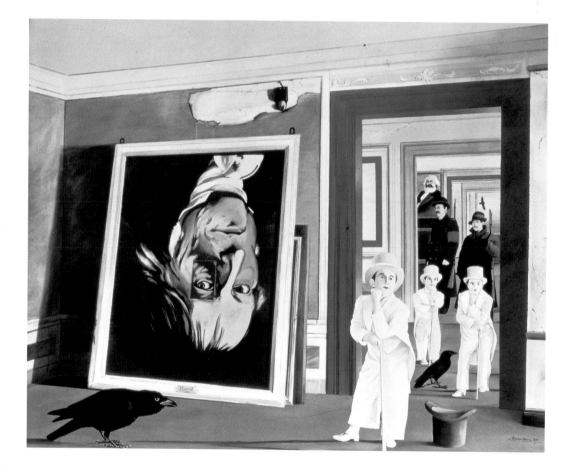

Die Galerie der Philosophen, 1974
The Gallery of the Philosophers
Oil and acrylic on canvas
160 × 203 cm

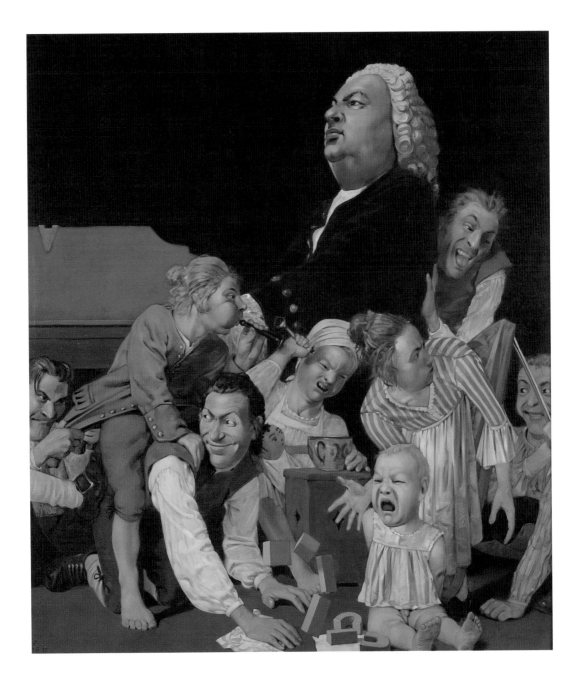

Bach, von seinen Kindern gestört
1975
Bach, Disturbed by his Children
Oil on canvas
205 × 180 cm

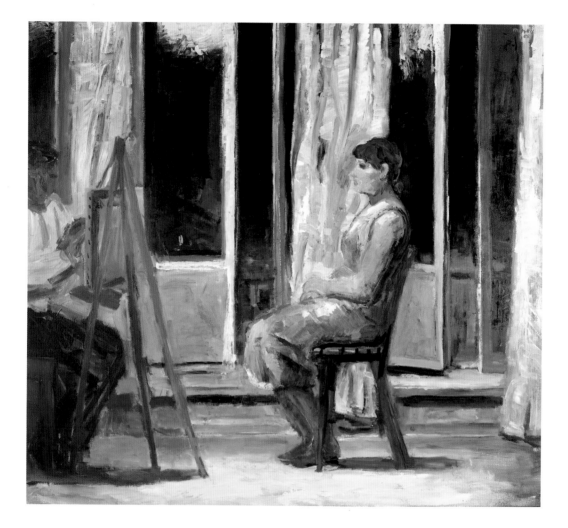

Modell mit Maler, 1988
Model with Painter
Oil on canvas
180 × 200 cm

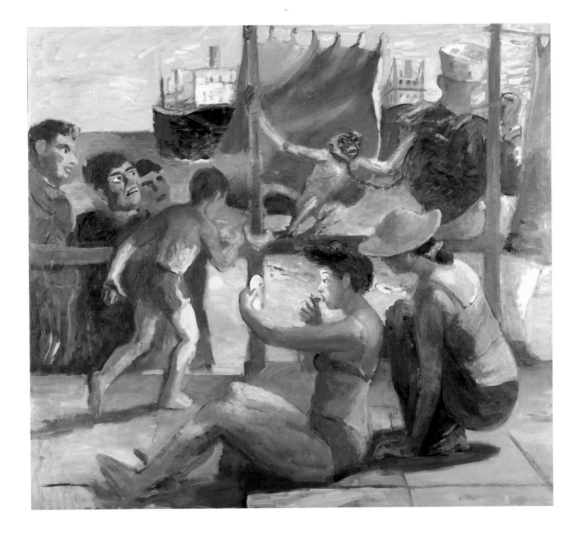

Meerkatze, 1986
Guenon
Oil on canvas
179,5×200 cm

Hans-Jürgen Diehl

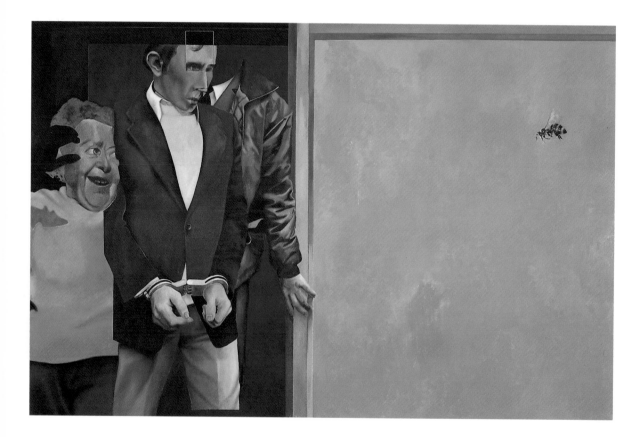

Freiheit, 1976
Freedom
Oil on canvas
151×230,5 cm

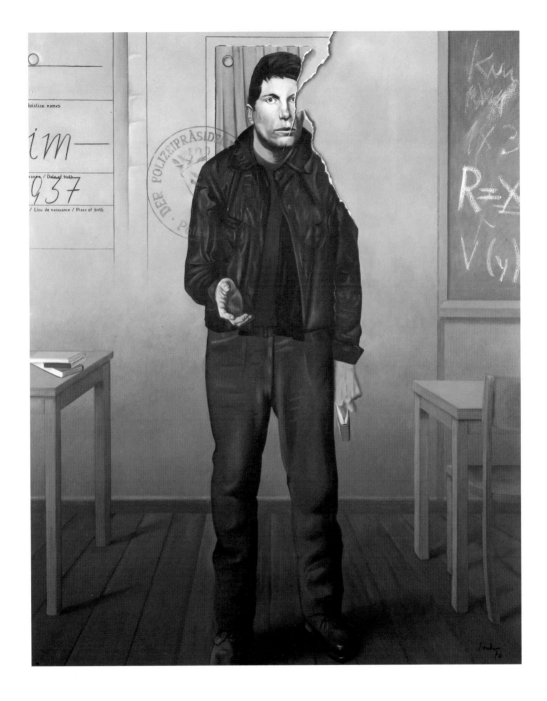

Die lädierte Identität des vom Berufsverbot
betroffenen Kunsterziehers H. J. Schreiber, 1976
The Ruined Identity of the Art Teacher
H. J. Schreiber, hit by Berufsverbot
Oil on canvas, 150 × 120 cm

Versuche über die Großstadt, 1977
Experimental Sketches of the City
Coloured crayon on cardboard
4 parts, 179×90/98×90/98×90/
179×90 cm

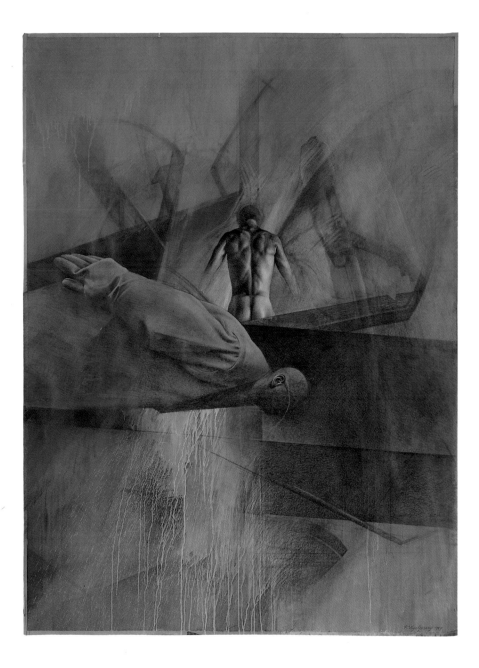

Quer zum Licht, 1987
Against the Light
Acrylic and graphite on cardboard
200 × 150 cm

»It's me«
The Seventies and Eighties

Heinz Ohff

The two-part canvas is two meters sixty centimeters high and three meters wide. The outer proportions alone bear witness to a strong self-confidence, the content even more so. It consists of a message, such as one might find (increasingly since the seventies) on house walls, freshly cleaned façades and empty billboards, catchword: graffiti. It reads (despite the running of the paint), »It's me«; nothing more.

Yet ... at second glance one discovers a certain artistic delicacy, that one could almost describe as an anti-delicacy. The artist, Ter Hell, who painted the picture, is inspired by his teacher, Thieler, and thus by the fifties. This is not direct graffiti such as is generally found in the big cities, but an artistic theme, a gesture that is captured and frozen here. Like Walter Stöhrer, the other great Berlin ›gesturer‹ beside Thieler, Ter Hell uses words as the point of departure in painting. But where Stöhrer paints over the words, keeping them invisible or only half visible, developing brush and colour flourishes from them that soon gain their own significance and dominate the painting, with Ter Hell they remain in the centre of the artistic process, a goal in itself, the motive and content of the painting.

That it has its own aesthetic is another story, which, although not completely covered by Tachism (Thieler) or gestures (Stöhrer), overlaps both. It is used more instinctively by Ter Hell in order to bring the message to the man, the observer. It dissolves, so to speak, but it is not necessarily the final goal. Yes, one suspects a little that Ter Hell parodies this style at the same time. He has rediscovered something historical and uses it for his current concern.

Exactly that seems to be the endeavor of the eighties. Young painters (as well as sculptors and object artists) adopted something done in the past in order, if not to make something new out of it, to at least produce something unmistakably individualistic. Consciously second-handed individuality is in. After the sixties and seventies, when the artist liked to step back behind his work, in that he allows the paramount to dominate — usually allowing itself somehow to be named ›society‹ — he has found himself, his own personality, and his desire for art. Admittedly that occurred because the way was paved by previous developments. Ter Hell's self-confident breast beating with the smashed out »It's me«, ME, the artist, sounds like an echo. A renaissance of genius occurs over and over again in the course of art history. The artists of the eighties use this like a quarry. One may join in wherever one wants. In the end everything has already existed once. The addiction to originality of the past is passé. The word ›innovation‹ has resounded as the core and primal word through modern movements since the beginning of this century. It has, however, been accepted that not everything which claimed to be innovative actually

was (the first to become sceptical was none other than the most innovative of all, Marcel Duchamp, when he, at the end of his life, integrated a naturalistic waterfall into an Environment). Surprisingly, a certain modesty runs parallel to the self-assurance of the artist. One wants individuality again, but it no longer has to be all so very new. Or one must no longer pretend that that which one produces originated without any forerunner and only from itself, which is very seldom the case.

This realization, which is not only limited to Berlin, but which had its beginnings here, was slowly nurtured and did not develop rapidly (art seldom or never does). By the end of the sixties and in the seventies, in the peak time of Critical Realism, there were the Fluxus artists who, along with Wolf Vostell—with irony and a multi-medial attitude—created very individual works, such as for example Ludwig Gosewitz and Tomas Schmit, post-dadaistic loners, whose work had an effect on this monumental city style like a response to Pop Art which, strangely enough, hardly made any impact in Berlin.

The actual contribution of the seventies art was the Environment. There had been spatial layouts before, and would be again, but it was only then that artists moved away from the centre of an otherwise widely theorizing art of the mind, of highest intellectualism. Edward Kienholz (mentioning his name is unavoidable when one speaks of Environment worldwide) has also critically taken up German themes. Raffael Rheinsberg then further abstracted and individualized this art form by documenting and surmounting the culturally historical with found items.

Above all, it was the fathers of the Young Wild Movement of the eighties who, as early as the end of the sixties, had prepared the ground for a return to the individualistic, and a resignation of art history at the same time. One day they renounced innovation. K. H. Hödicke, who came from the Fluxus circle, applied himself to a renewal of the realistic expressionistic tendencies after he had already painted big city mirror paintings in the form of display windows in which ads shone in neon light. And Dieter Hacker, who emerged in the seventies with a series of theoretical anti-art or apart-from-art exhibitions, found a starting point for ›new-old‹ panel painting, although he persistently resisted earlier panel painting methods (for a while he painted with the brush between his teeth). It was to no avail: despite this he became a protagonist of the Pre-Young Wild Ones, similar to Bernd Koberling, who once stretched milky synthetic foil in front of his Nordic landscapes to distort them. Lüpertz and Baselitz must also be named and then the ancestral portrait gallery of the eighties in Berlin is as good as complete. What followed was, and is, an explosion of talent such as one may only have experienced before in the sixties.

Before we risk the danger of infinitely listing names, we must cite two loners who mark a turning point of sorts, in any case a boundary: Dieter Appelt with his Happening-like, but photographically precisely preserved events referring to the archaic, and Armando, the Dutchman, who initiated the return of panel painting within a conscious limitation of concept art, so to speak.

At the end of the seventies and early eighties, a young generation appeared, who, following the example of older performances, broke out of the framework of the then customary modern. In the *Selbsthilfegalerie am Moritzplatz* (Self-Help Gallery), this

›Impetuous‹ painting developed, which, since then, has become the badge for Berlin-specific art. The artists' names are well known. Salomé (Wolfgang Cylarz), Rainer Fetting, Helmut Middendorf, Bernd Zimmer, together with Anne Jud and G. L. Gabriel, the only two women represented. All paint figuratively and representationally; almost all are students of K. H. Hödicke, in all, they are the trademark of and identify with the big city such as Berlin. They had and have international success.

But the ›Impetuosity‹ of the Young Wild Movement forms only the one side of the development. A great number of the young panel painters had to travel a longer path, which, similar to that of the young Italians, led back to the mythical, albeit an uniquely different mythology, which derives its symbols and borrowings from antiquity, from de Chirico and the *Pittura Metafisica*, from Chia, Clemente, Lüpertz, but also from painters such as Petrick and Diehl who are also driven by (or away from) Critical Realism into myth. Peter Chevalier, Thomas Lange, Ina Barfuß and Thomas Wachweger are four protagonists in this direction which forms a link to the ›Impetuous‹ as well as to Stöhrer.

How totally without permanent contours this grouping remains, extraordinarily varied—eerily Hofmannesque from Max Neumann, to include Biblical themes from Albert Pümpel, something like macabre eroticism from Heike Ruschmeyer, and pure poetic narrative art from Galli. Even with performance a direct path leads back (or forward) to Barbara Heinisch. Albert Merz, Helga Möhrke, Cornelia Schleime, Ludger Stöckmann, Ralf Kerbach—the pluralism which has ruled the scene for so long became even more pluralistic in the eighties, particularly when one considers that almost all side roads and byways continue on. To illustrate this, here are two examples, Eva Maria Schön was able to add her own and new accents to Constructivism, and Lilli Engel to Monochromism.

Sculpture in particular has developed richly. It has already received new impulses through the inclusion of unusual materials, such as cement and coal used by Rainer Mang; the Berlin Wall (worked with a pneumatic drill) and other available three-dimensional objects by Olaf Metzel, the serial found object adaptation by Raffael Rheinsberg, the reinforced iron from which Frank Dornseif produces his contour forms. Herbert Wiegand's method of knocking out surprisingly sensitive sculptures from wood is most likely, directly parallel to ›Impetuous‹ painting. Wood and steel collide in the work of Peter Tiefensee, iron and stone in the work of Hartmut Stielow.

Stielow is a member of the sculptors' group *Odious*, where the special tendencies of the eighties are most easily demonstrated. The young artists who already found themselves together at the Berlin Art College, where they studied under Philip King, David Evison or Bernhard Heiliger, work together as well as individually; their material originates from the scrapyard in which they, like their painter colleagues, hark back to that which existed previously, the very classic modern iron sculpture from González to Anthony Caro. Herewith, Gisela von Bruchhausen, Klaus Duschat, Klaus H. Hartmann, Gustav Reinhart, Hartmut Stielow, and David Lee Thompson each found individual paths: a »being together«, »beside one another«.

A »being-together«, »beside-one-another«, »apart-from-each-other« has developed the art of the eighties in Berlin. Inertia played an equal role along with forward drive, which has now certainly slowed down. A certain modesty is unmistakable. The panel painting

and the figure has returned, but so has the complete abstract canon from the splashes and blends of Tachism back to Cubism's wealth of facets. A time of following has begun that consciously uses what has come to light in the art world to pursue the course of the modern. A surfeit of pauseless ›innovation‹, has led to a point at which one rests awhile, hopefully without rusting.

Ursula Sax
Fahne/Windskulptur, 1990
Flag/Wind Sculpture
Spinnaker Material
488×297 cm

K. H. Hödicke

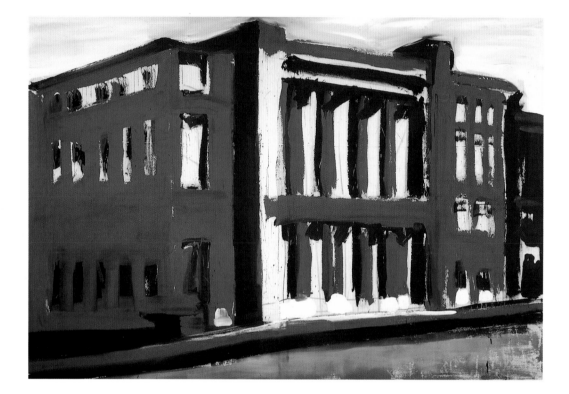

Kriegsministerium, 1977
War Ministry
Synthetic resin on canvas
184,5 × 270 cm

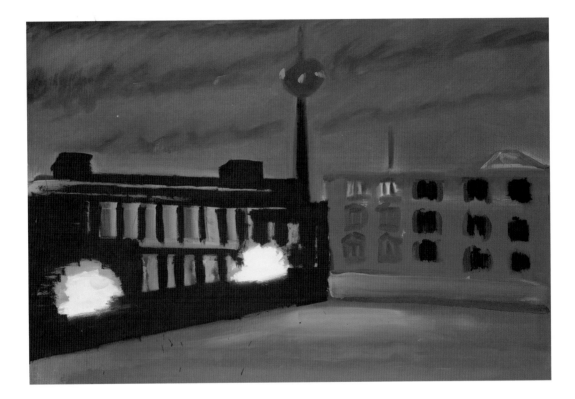

Martin-Gropius-Bau
(ehem. Kunstgewerbemuseum), 1977
*Martin Gropius Building
(Former Arts and Crafts Museum)*
Synthetic resin on raw cotton
187 × 270 cm

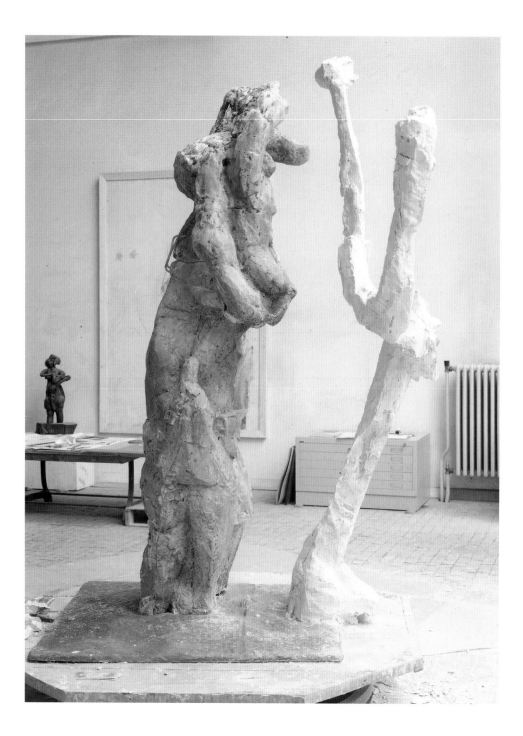

Gebreite, 1985–1988
Plaster and iron plinth
250 × 146 × 166 cm

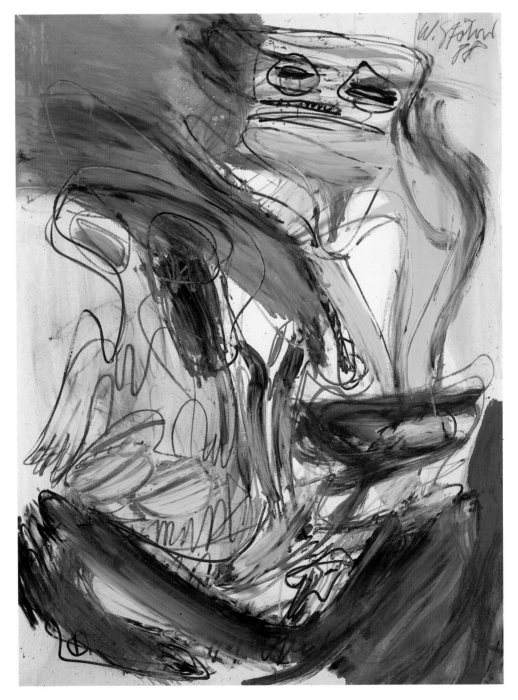

Nadja VII,
Hommage à André Breton, 1988
Combined techniques on canvas
200 × 150 cm

Marwan

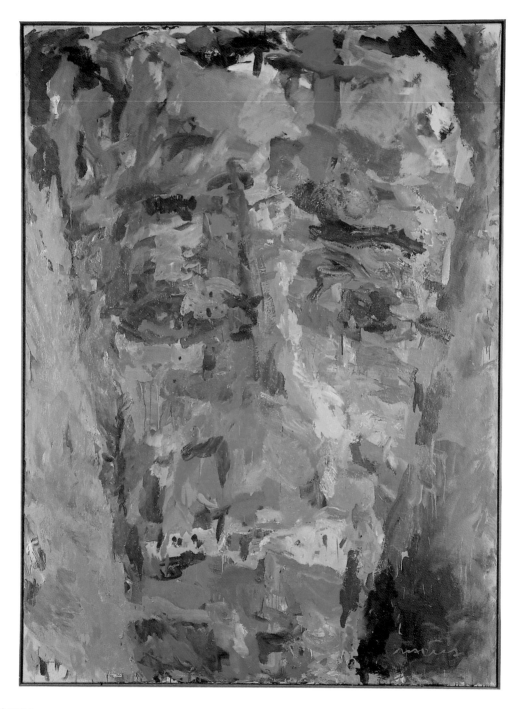

Kopf, 1986
Head
Oil on canvas
260×195 cm

170

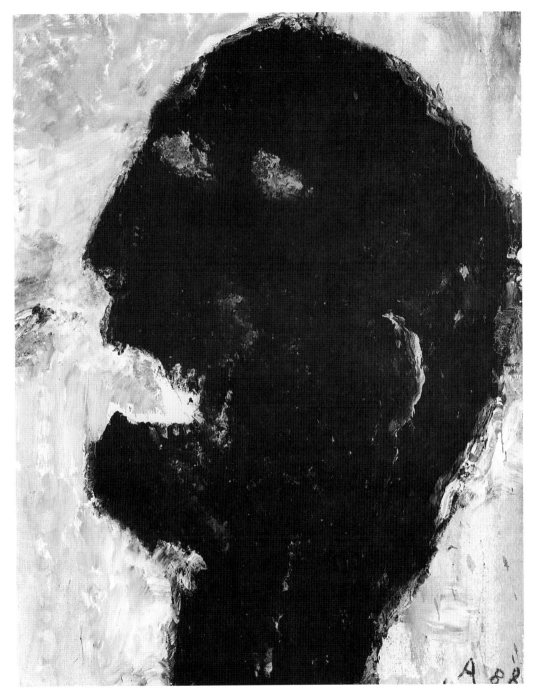

Kopf, 31. 12. 88, 1988
Head
Oil on canvas
251×198,5 cm

Gefechtsfeldbesichtigung
1980—1982
Viewing the Battlefield
Oil on canvas
2 parts, each 226×175 cm

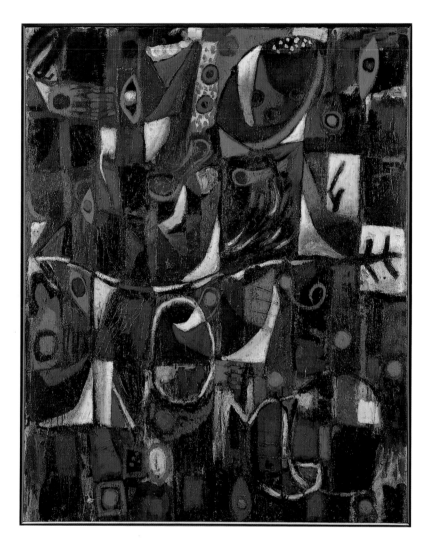

Kongo-Mann mit Speer, 1981
Congo Man with Spear
Oil on canvas
162 × 130 cm

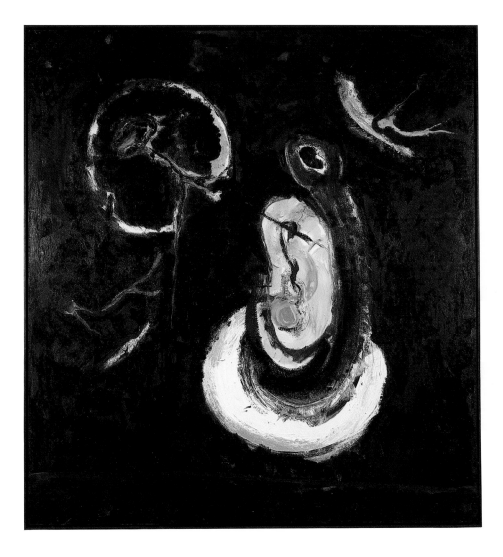

Loch im Fluß, 1988
Hole in the River
Oil on canvas
225 × 210 cm

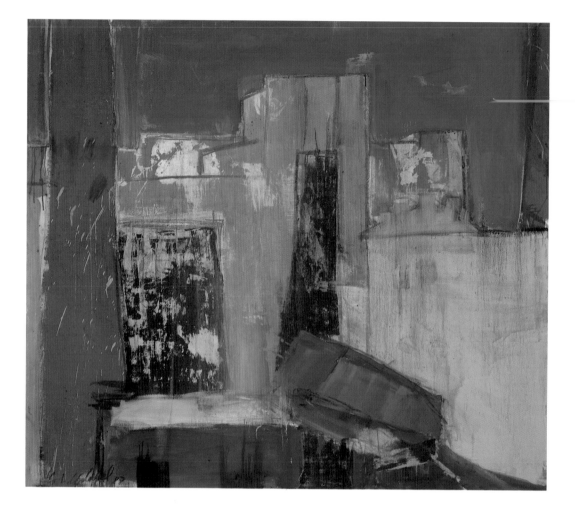

Fabrikhaus, 1987
Factory Building
Oil on canvas
189,5×219,5 cm

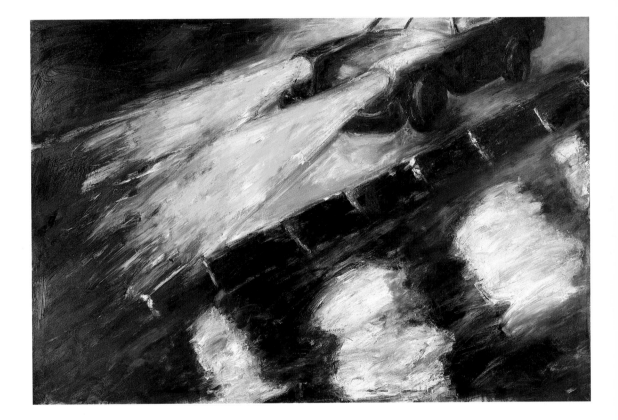

Landwehrkanal, 1986
Oil on canvas
192×286 cm

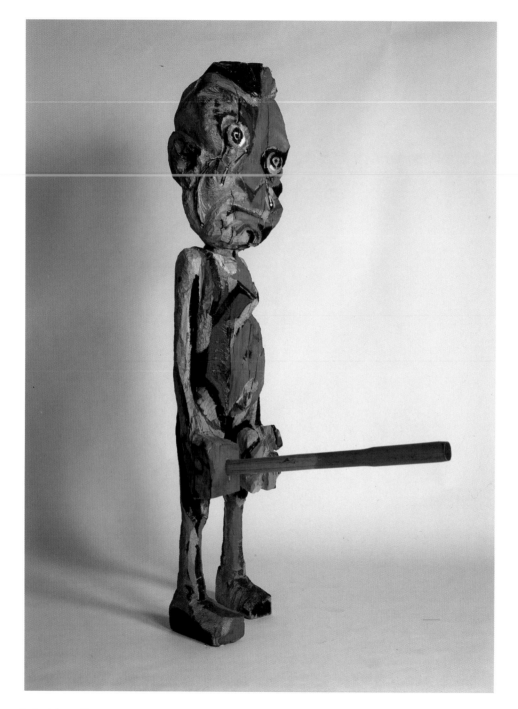

Du mußt doch bewaffnet sein!, 1984
But You Must Be Armed!
Painted wood
185×40×120 cm

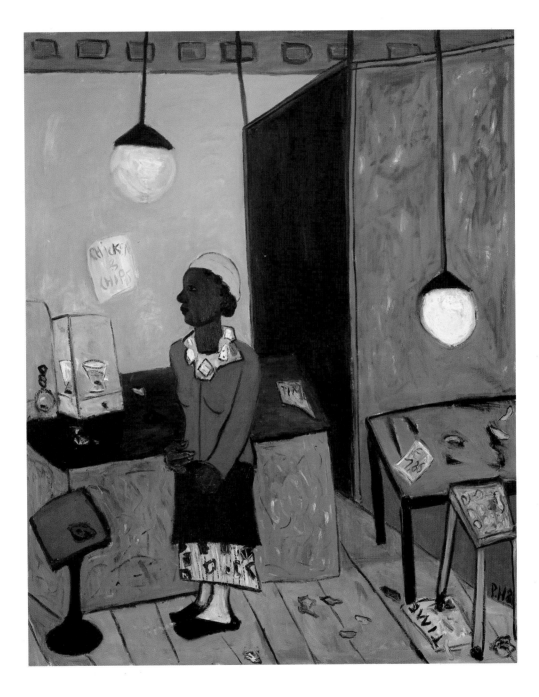

Chicken and Chips, 1986
Oil on canvas
200 × 160 cm

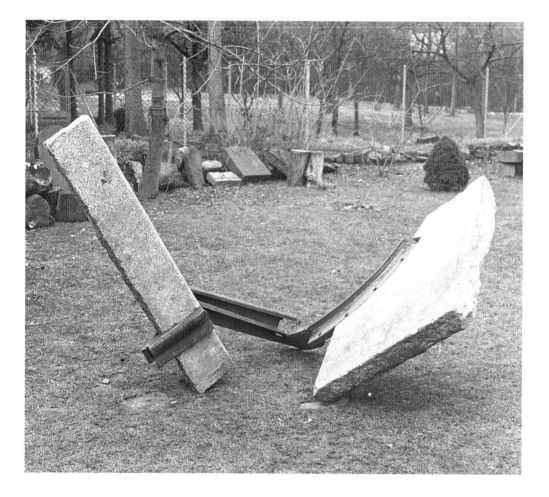

Waage, 1984/85
Scales
Stone and steel
145 × 240 × 150 cm

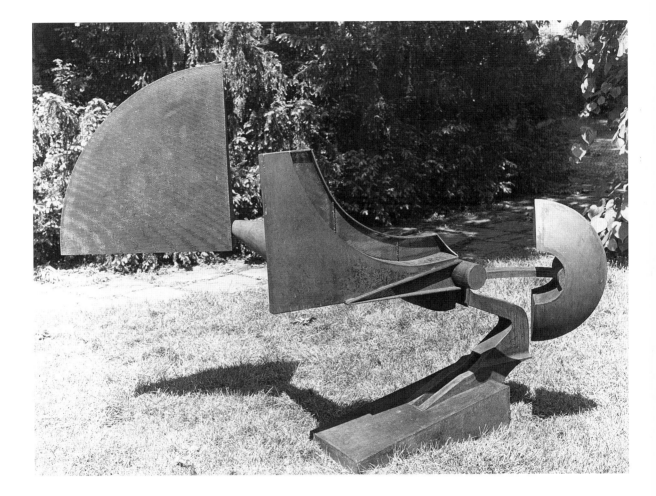

Eisentirade, 1982
Iron Tirade
Steel
165 × 140 × 230 cm

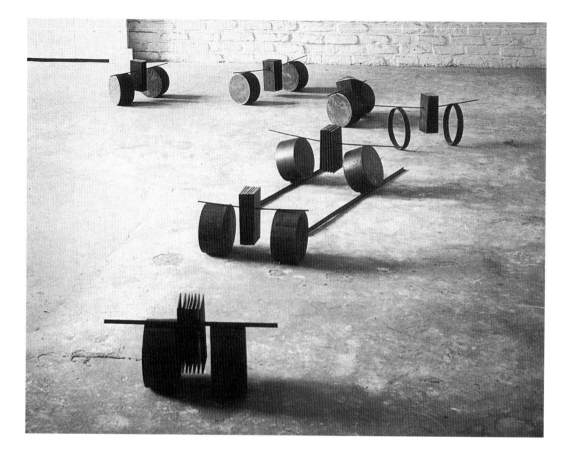

Fahren, 1989
Driving
Steel and concrete
30 × 210 × 400 cm

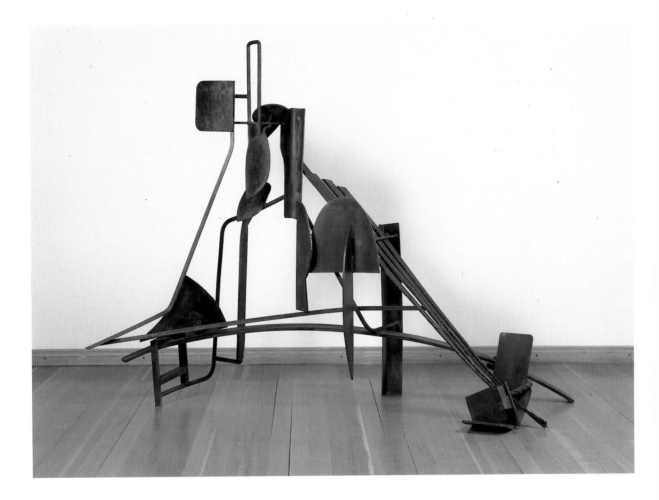

Corrida, 1988
Bull-Fight
Steel, coloured setting
183×246×113 cm

Helmut Middendorf

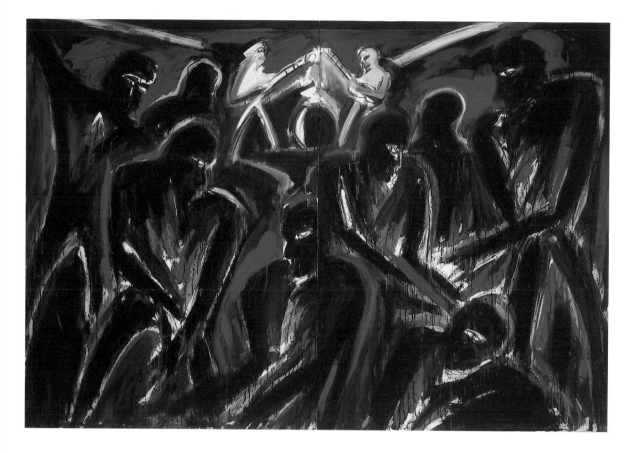

Großstadteingeborene, 1979
Natives of the City
Combined techniques on canvas
189,5 × 280,5 cm

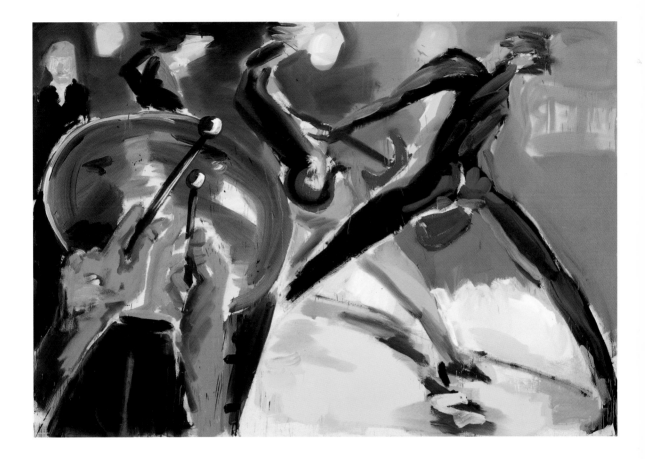

Drummer und Gitarrist, 1979
Drummer and Guitarist
Distemper on canvas
200×290 cm

185

Jens Umlauf

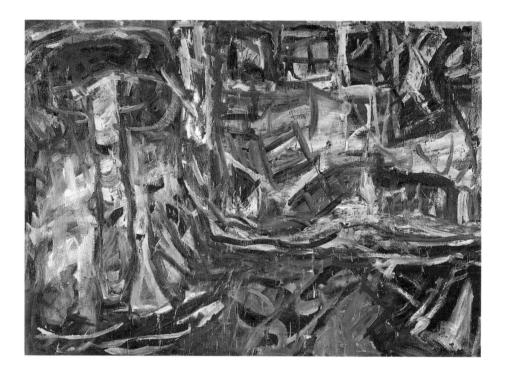

Ohne Titel, 1986
Untitled
Oil on canvas
176,5 × 246 cm

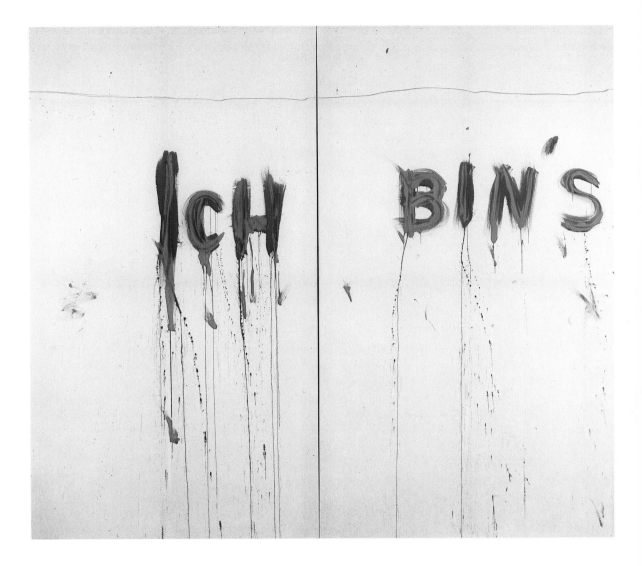

Ich bin's, 1980
It's Me
Combined techniques on canvas
2 parts, each 260 × 154 cm

The Other Side
Art from East Berlin

Gunhild Brandler

»Freedom is always the freedom of those who think differently.« In 1988, citizens of the GDR protested in East Berlin against censorship and regimentation, and this quotation from Rosa Luxemburg was their motto. After the great political changes it has become clear, not for the first time in history, that freedom has more to do with art than with politics or morality, although it is still dependent on these two categories. Art remains separate and different.

The function and the meaning of art under socialism as it was practised in the GDR was not artistic or aesthetic, it was social and moralistic, even by those born after 1950. After all, at the end of the 1980s, these artists—the fourth generation—had already been working in the GDR for almost ten years. The everyday experience of socialism led to the necessary withdrawal of art into a socially critical role and strict moralistic structure.

Although the wilful expressiveness of the eighties is seen as an aesthetic revolt against the conformity of Realism in the GDR, this was a human reaction rather than questioning in a conceptual sense. Human, yet not universal; it strove neither for ironic distance nor did it express a kind of love-hate relationship. Its aim was to redress the balance in the face of the omnipresence and widespread agony of socialism.

The first demonstrations in the GDR still had a quasi expressive style. But before this style really had chance to reverberate, the independent course of history took over. Its protagonists—first and foremost the artists—rebelled against political events once more. For their ideas had been banally converted into an ideology with the speed to be expected from a society now truly based on effciency and achievement. As early as 1990, galleries set up in business selling ›pictures from the 9th November‹. Artists such as Jürgen Böttcher-Strawalde, Frank Seidel or Gerd Sonntag had always managed to distance themselves from this sort of activity. Despite their avoidance of the semi-official exhibitions, they managed to break into the ranks of the established artists through their connections with peace, conservation and human rights groups. It was this refusal to conform that had a subversive effect rather than their art works themselves. Their rejection of the academic realistic canon had always been seen as provocative. It has not proved possible for Socialist Realism to take over the expressive in art, neither in the past nor in the present.

Strawalde remained in seclusion as a painter, and his work—often on paper—was correspondingly small in format. His first abstract picture dates from 1959. The official sectors in art ignored him as a film-maker, in accordance with their idea that the various genres should be kept strictly separate. For the first time, it has now become possible to appreciate the work of such an artist according to criteria beyond personal achievement.

We can scarcely comprehend what opposition there was to the blazing colour of Walter Libuda's work for such a long time. There were many reasons for this; collective opinion could not grasp it, the constellation of representative forms offered no symbolic interpretation, and Libuda's personal relationship to his subject had eradicated all but the very essence of natural colour and of the object itself.

Frank Seidel also broke out of the tradition of realistic sculpture, his three dimensional objects appear to touch the space around them, simultaneously rendering it indiscernible. The crumbling material unites both destroyer and destroyed, with not moral pretension.

With the paintings of Werner Liebmann it was impossible to reinterpret the subject of man within the masses so as to conform with the official idea of security for the individual—and only those affected could establish their concrete relevance. The prevailing pathetic image of mankind was scarcely compatible with the harshly coloured frontal perspectives of heads and figures by Gerd Sonntag—the larger form reduced, confused, dismembered, a clownlike alienation of the noble image of the German soul-searcher.

Of course German tradition does have some influence, for the problems of human existence have always presented a vital stimulus; we need think only of the mythology of Max Beckmann, the apocalyptic visions of Carl Hofer or Otto Dix. Here we find the roots of the work of Trak Wendisch, and that of all those artists connected with the Leipzig Art College and Bernhard Heisig, artists such as Libuda and, indirectly, Liebmann. Whilst Libuda, the loner, lives out his obsessions in colour in a state beyond good and evil, Trak Wendisch is constantly stimulated by the complex and complicated world situation. There is of course no existent evil which was not also immanent in the bureaucratic authoritarian model of socialism. With the ritual of a message, art seems to be filled with purpose once more. Expressiveness, which originated chiefly in the East and developed into the prevalent style of the eighties, is now masochistically refuelling itself—from a moral viewpoint. The old utopia, according to which the individual can achieve complete fulfilment, is back in vogue.

More than anything else, a belief in the authentic, the individualistic, characterizes and unites the most recent art from eastern Germany. This belief is one of the obvious differences between West and East German Expressionism today; each is revolving within its own sphere, unable to comprehend the spirals of the other.

The concept of individuality had been greatly perverted within socialist society. So much so that as late as the mid 1980s, the sculptor Fritz Cremer, at an exhibition in East Berlin, could stir up feelings with a simple quotation from the *Communist Manifesto:* »Into the place of the old bourgeois society. . . there will step an association in which the free development of every individual is a precondition for the free development of all.«

The artists could also be described as schizophrenic rather than at one with themselves. Their pictures and their identities originated in a correspondingly conflicting sense of not accepting the status quo, on the one hand, and on the other hand, the harsh reality of existing conditions. Thus the expressions of individuality, although disparate in the totalitarian system, grew similar. In the ghetto, there were limits to art's originality. The grey concrete Wall remained as a link in the minds of these artists, as unapproachable as

death and not comparable with the bright, cheerfully sprayed graffiti on its outside. Only a very close look reveals, despite all the East German artists have in common, that there are artistic and temperamental differences impossible to bridge. There had been some splintering in their ranks, even before the recent political changes, a fissure which was as great as that between East and West, although it had been covered up. In his biographical notes, Gerd Sonntag admits: »The underground groups appear to me to be as much against individuality as the officialdom of the Party. They are too keen, too petty, born of hate, as irate as a blinded bull.« The artistic debate is more complex than this.

This exhibition attempts to set the work of seven artists from East Berlin alongside the more abstract expressive tendencies of the West. The awareness of an existence once divided is scarcely evident in the pictures. Our present memories of the Wall have already become no more than words, and in the same way, the actual differences in art are becoming no more than marginal discontinuity—which will inevitably be forgotten in the continuing linear historiography.

The art from East Berlin appears to effortlessly take its place in the somewhat diffuse, expressive style of the Germans as a whole, a style which has always stood out conspicuously from the classical or the baroque of other countries. The choice has been made within specific categories, giving continuity and reverting to the Expressionism of the twenties in Berlin. There are indeed equivalents here to the reaction to the disintegration of humane values after the First World War, to the individualisation of what was collective and contemporary; though the colours and forms are more severe, more muted, even gloomy in comparison. In this sense, at first, the art from the East German states appears to be a complement to that of the West rather than offering anything new. This is the status quo at the end of a period of anachronistic local history. The wave of Expressionism is at low tide, there is still insufficient reflection and the field of art is barren—only those who have already made their mark in the past are able to assert themselves.

The presence of the past, a characteristic sought by those art historians who compartmentalize, will no longer pose a question in the work of those artists born around 1950. The work of these artists was never regional; it can only be classed as Berlin art at all in terms of its place of origin, for in fact East Berlin art has always been dominated by a more sensitive and conservative style of painting. The true, fatal circumstances of desired unity, a state not (yet) reached, cannot unify art either.

At the end of the millennium, nothing can be characterized in spatial or linear terms. Instead, we have a chaos of styles and tendencies, which only brute force could shape into any form of a monument to the historical situation.

The borders are open in a European, international way of thinking, beyond petit-bourgeois German attitudes. Past exclusion is too much a thorn in the eye of East German artists for them to risk losing the other eye with which they have always squinted beyond their own surroundings. The Soviet song-writer, Wladimir Wyssotzky, has more in common with Tom Waits than the artistically comparable movements of Impetuous Art and Expressionism which prevailed in both parts of Germany during the 1980s. All these artists found their true, complex identities in intellectual, unprejudiced commun-

ication through film, television, literature and music. The ruinous socialist cities appeared to compare more with urban America than with the order of West German society. The severity of the painting of Killisch and Wendisch is connected to the aggressive language of such Molochs. On the other hand, Killisch and Libuda have a sense of mental adventure in common, as well as the increasing format of their work.

Within such a wide context of thought, political and ideological premises, as well as extreme subjectivism, disintegrate—true free thinking then emerges. Interplay between the visual and the philosophical is the key in a real cultural range, a tense interplay which the need to fulfil a social duty does not compel to seek a false balance.

The Wall, July 1990
Graffitti: Leave the wall alone
Photo: Gudrun Petersen

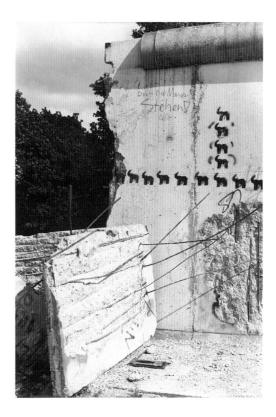

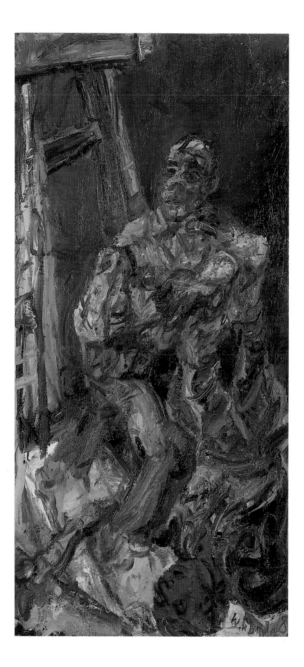

Der Kopfstand, 1985
The Headstand
Oil on canvas
210 × 100 cm

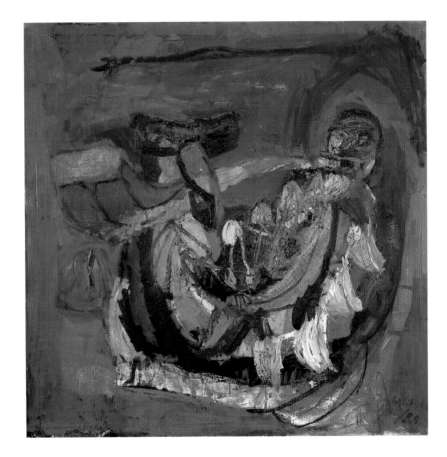

Das Rondell, 1988
Oil on canvas
130,5 × 130,5 cm

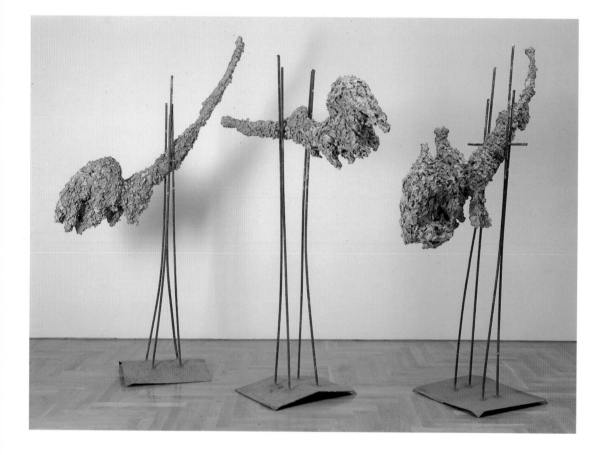

Three Sculptures, 1990
No. 190, No. 191, No. 192
Plaster, iron parings and iron
185×144×55/183×143×55/
175×150×52 cm

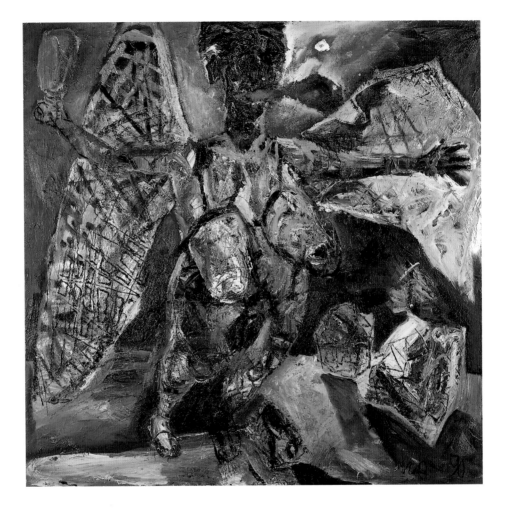

Die große Freiheit, 1990
The Great Freedom
Oil on hardboard
170,5 × 174 cm

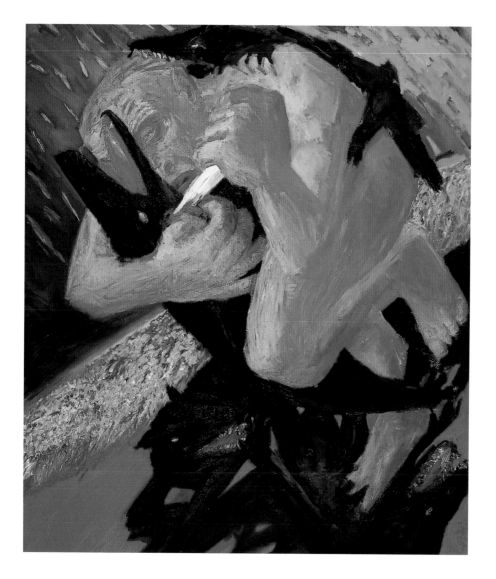

El Coloso, 1986/87
The Colossus
Oil on canvas
240 × 204 cm

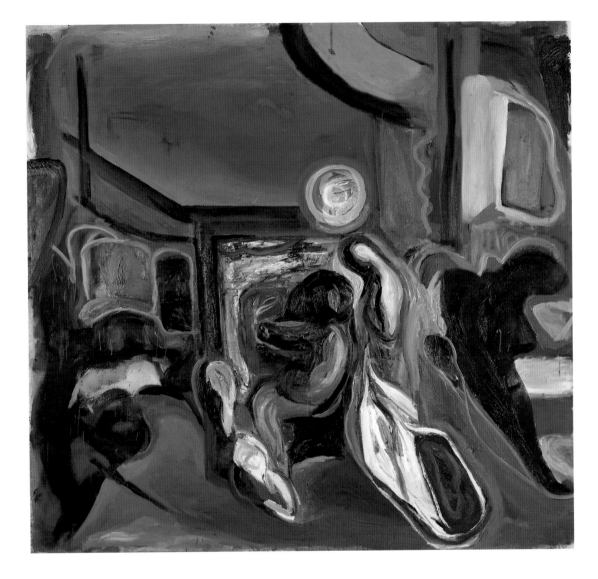

Das Atelier des Malers, 1990
The Atelier of the Painter
Oil on canvas
248 × 268 cm

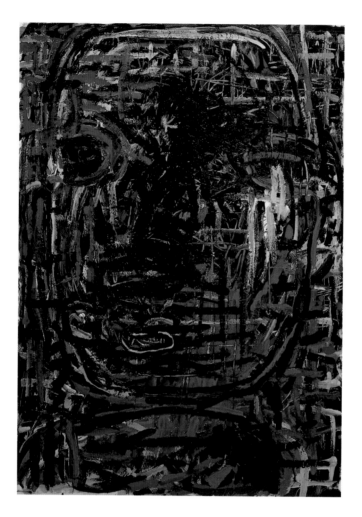

Oedipus-Köpfchen, 1990
Oedipus I
Little Oedipus Head
Oil on paper on canvas
100×73 cm

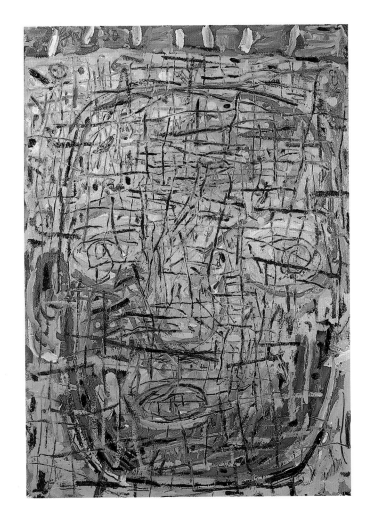

Marzahner Kopf, 1990
Oedipus II
Head from Marzahn
Oil on paper on canvas
100×73 cm

199

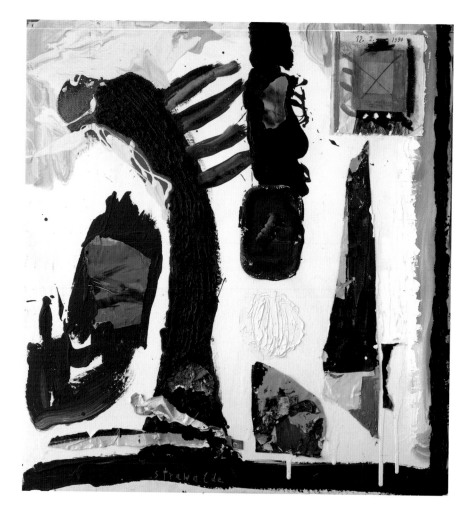

Geröllbild I, 12. 1. 1990
Rubble Picture
Oil, acrylic, collage on cardboard
120×114 cm

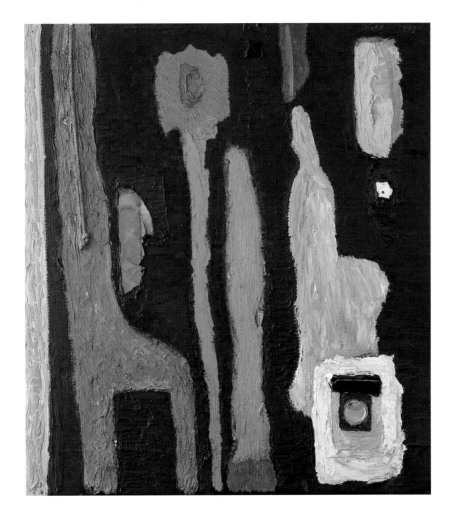

Aprilbild, 1990
April Picture
Oil, acrylic on cardboard,
assemblage
119 × 107 cm

New Constructivist and Conceptual Art

Ursula Prinz

It is astounding that there are so many high quality representatives of constructivist art in Berlin, a city which has always been more associated with Realism and Expressionism than with any other artistic trend, even if their presence appears to be more denied than appreciated by the public. Constructivist art seldom reaches a wide spectrum of the public, but in Berlin the difficulties are multiplied. As a result, there is hardly a single constructivist here who does not cultivate his connections with West Germany, Italy or America.

Constructivist art goes back to the twenties. In the Berlin of those days, it had an audible voice within the circle of international artistic trends. Naum Gabo, the author of *The Realist Manifesto,* which was really a constructivist manifesto, was also one of the first artists to experiment with kinetic objects. Kinetics was to become a magic word in our century and since then many artists have spent much time investigating this field. Hardly anyone, however, has been able to create, with such poetry, such facility and such precision, seemingly floating forms which enchant the viewer with their elegant, dance-like movements like George Rickey. He is without doubt the ›old master‹ of kinetic art in the present.

George Rickey is surely one of the most popular living artists working in a constructivist style. He is an old friend of Naum Gabo, and he came to Berlin from America many years ago as a guest of the Berlin Artists' Programme run by the German Academic Exchange Service. Rickey has not only been a regular visitor to the city since, but is now firmly established with his own domicile here. The discs of his kinetic sculpture have now been turning for decades in front of the *Nationalgalerie*, and in the meantime, he has become so much a Berliner that the *Berlinische Galerie* also calls one of his sculptures its own.

Wolfgang Ludwig, Göta Tellesch, Christian Roeckenschuß and Arnulf Letto are among the middle generation of Constructivists who have been working in Berlin since about the middle fifties. Most of them came from the circle of the college lecturers, Hans Uhlmann and Alexander Camaro. They formed a group with Henryk Berlewi, who was invited to Berlin at the beginning of the sixties by the Berlin Artists' Programme of the German Academic Exchange Service. The group *Zero* from Düsseldorf (Heinz Mack, Otto Piene, Günther Uecker) and their international circle found a forum in Günter Meisner's gallery *Diogenes*.

Johannes Geccelli, who came from the Rhineland, began to teach at the College of Fine Arts in 1965. His work indicates that constructivist art does not always arise from non-representational motifs, by any means. The figure, which was the creative starting point, is still visible or somehow tangible in many of his works. It was only in the course

of years that it disappeared more and more beneath the gridwork of paint. It is as if the figure has been devoured by light. Geccelli works with a module, in a series of layers of paint strokes, all the same except for some variation in colour. Colour is the element which fills these pictures with vitality, almost overshadowing their construction. Geccelli's pictures convey mood, thus breaking the rules of classical Constructivism. The artist's great achievement is the retention of feeling without drifting into sentiment. Technique and ›content‹ are woven together in a masterly fashion to create a harmonious whole.

Raimund Girke has moved even further from the constructivist concept; his near white egg-tempera pictures, the origins of which lie in gestures, are characterized by an atmospheric density and vitality despite their reduction in form.

Kuno Gonschior employs powerful colours. The raster of small dabs of paint in earlier years has now been transformed into large scale pictures with patches of brilliant colour, so intense in expression that they all but leap at the viewer.

Among the younger generation, the pupils of Geccelli, Girke and Gonschior, there are a great number of artists working in the constructivist spirit. One such artist is Frank Badur, whose compositions, often arranged in vertical stripes, are constructed out of several layers of paint, each becoming more refined and delicate in colour. The effect is reached less by the colour itself than by the method of application.

Angelik Riemer shows that she is not merely commited to a cool form of Constructivism by her tempera pictures, which are created with many layers of paint, of which a deep Paris Blue is always dominant. Yet the strictness of her painting method is purely constructivist. Many layers of paint applied in short, straight brush strokes provide the background to a picture which finally appears almost monochrome blue. Simplicity is obtained through this opulence. The lengthy painting process gives the colour its depth, and, although it may be invisible in the finished work, it is its true basis.

Gerdi Sternberg places distinct areas of brilliant colour alongside each other, whilst the black of Bernhard Garbert, applied to plastic forms set before a wall, has qualities which decorate a room with its haptic substantiality.

The collages of Claudia Busching are of architectural austerity, yet they are not purely pictorial constructions, but empirical, abstract pictorial creations.

Constructivist art can differ greatly in content, can be created in very differing ways, and there is no necessity for right angles in order to classify a work as constructivist. It is the artist's method and approach, which has always something to do with construction. His resulting work, however, is often filled with emotion which in turn is aroused in the viewer. Pure technique, machine art, for example that of Tatlin in Russia at the beginning of this century, has yielded its place in visual art to design.

The Environment, an art-form which originated, like constructivist art, at start of this century, is playing an increasingly important role in present day art. Jakob Mattner combines the experiences of Russian Constructivism, of Lissitzky, for example, with the light experiments of Laszlo Moholy-Nagy, creating from light, mirrors and glass meditative spaces as poetic as they are intelligent, whilst their insubstantiality seems to open up a new artistic dimension.

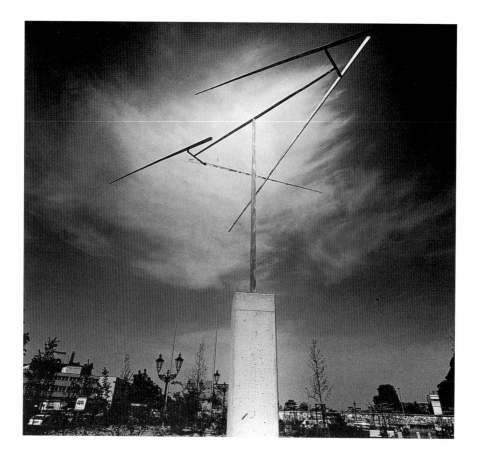

Lilli Engel also conveys insubstantial spaces through her pictures. These can appear like weathered old walls, and sometimes they were in fact created by directly exposing the foundation of paint to the wind and weather.

The Environments of Raffael Rheinsberg, the essence of which is an object and its history, produce their effect in this context. Rheinsberg discovers objects on historical sites which not only offer evidence of their previous use, but also of their era and its bearing on the present. These objects, placed into a new context in art, are even more disquietening in their effect.

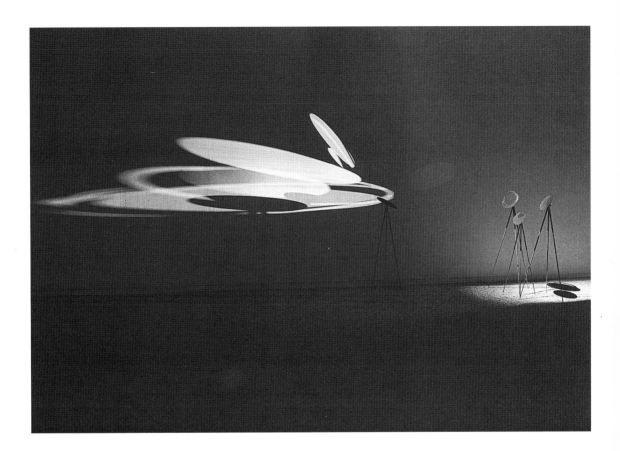

George Rickey
Four Lines in a T (Berlin), 1985
Stainless steel
400 (max. 772) cm × 550 (max. 1118) cm

Jakob Mattner
Percussion II, 3rd version:
Wirbel *(Whirl)*, 1986—1988
Glass, mirrors, tripods, light
3 × 11 m

205

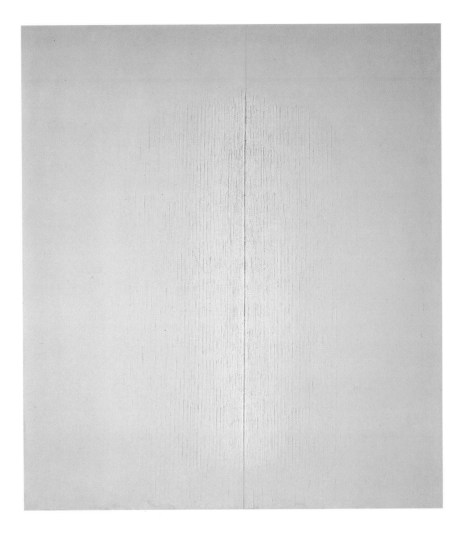

Schwarzspalt-Weißspalt, 1987
Black Crack – White Crack
Acrylic on canvas
Diptych, each 200 × 180 cm

Frank Badur

Weiß neben Weiß, 1985
White and White
Oil on canvas
150×250 cm

Ohne Titel, 1983
Untitled
Egg tempera on canvas
201 × 220 cm

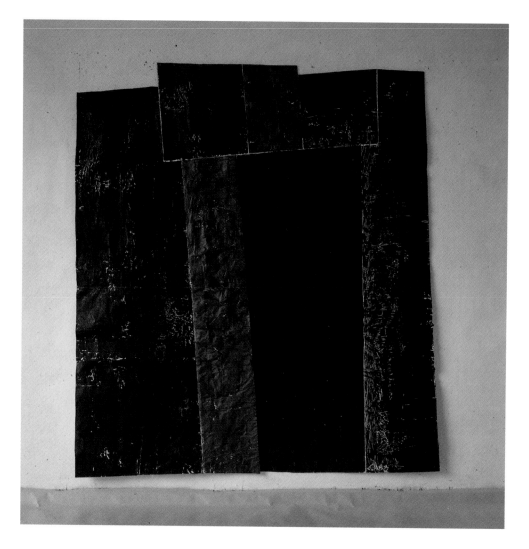

Ohne Titel, 1988
Untitled
Acrylic, dispersion paint, collage on
paper
190×174 cm

Erinnerung III, 1989
Memory III
Oil and wax on canvas
250×200 cm

Angelik Riemer

Drei Große, 1983
Three Large Ones
Egg tempera on canvas
Triptych, 280×600 cm

In contemplation of the topic II,
From the series ›Zerstörte Bilder‹
(Destroyed Pictures), 1989
Combined techniques on canvas
280 × 280 cm

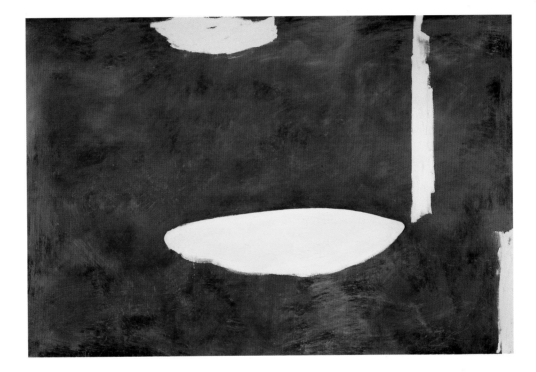

Ohne Titel, 1988
Untitled
Oil on canvas
190×280,5 cm

215

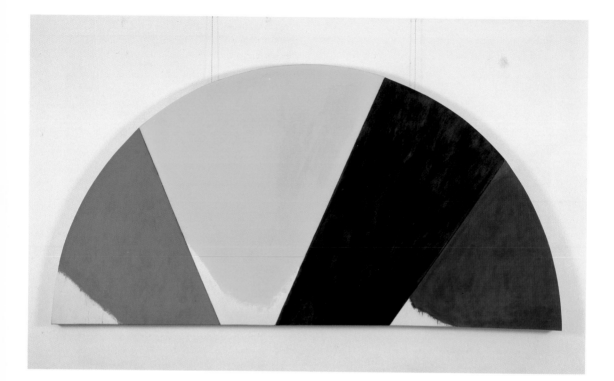

Halbrundbild I, 1986–1988
Semi-Circular Picture I
Combined techniques on canvas
183,5 × 368 cm

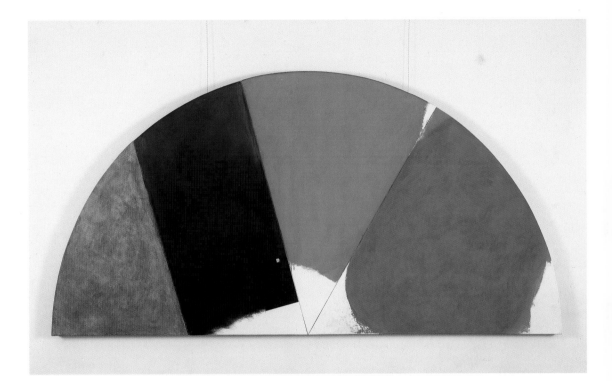

Halbrundbild II, 1987–1989
Semi-Circular-Picture II
Combined techniques on canvas
183,5 × 368 cm

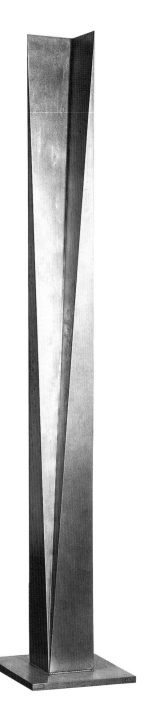

Stele XII, 1978
High grade steel
255×21×21 cm

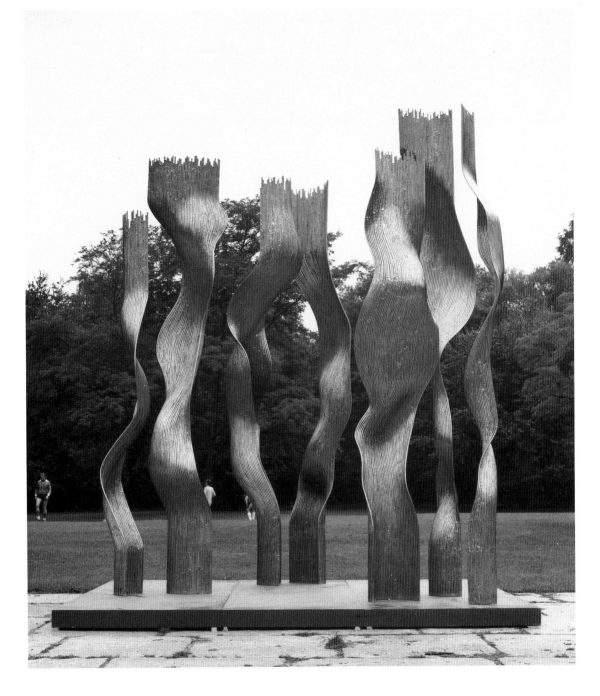

Die Versammlung, 1984
The Assembly
Brass and tin
Height 3 m

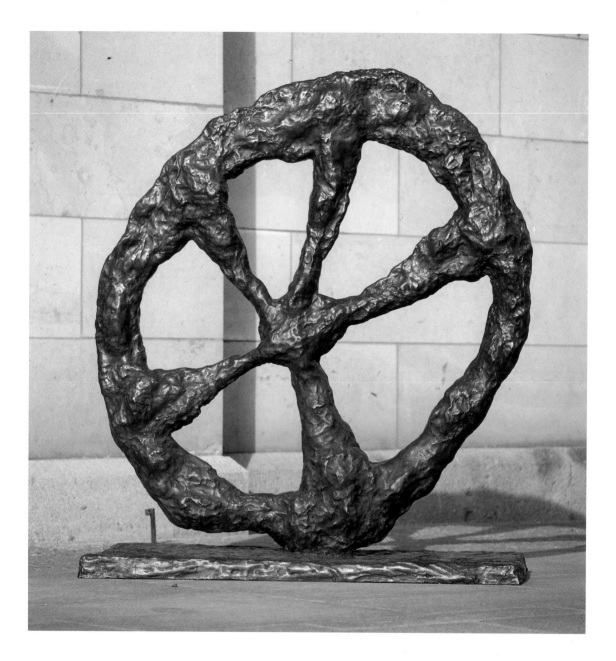

Das Rad 1/3, 1989
The Wheel 1/3
Bronze
170 × 160 × 20 cm
Plinth, 8 × 160 × 60 cm

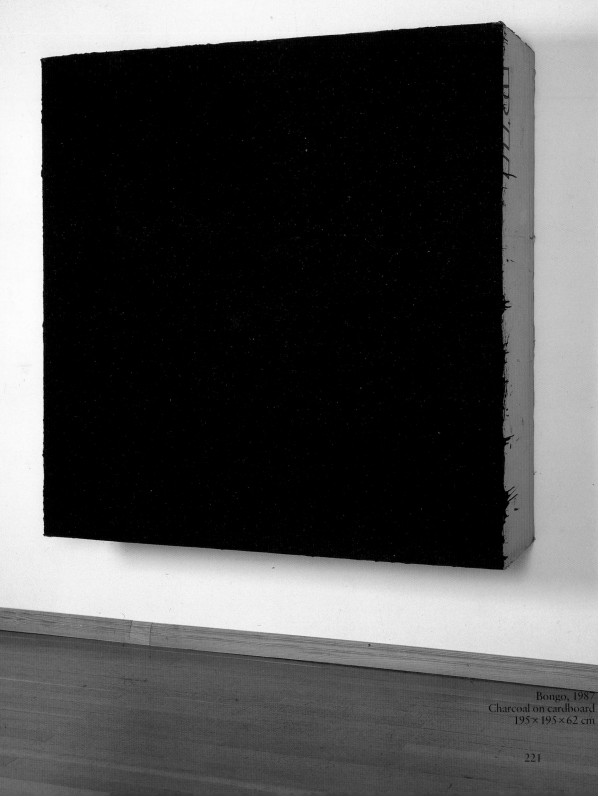

Bongo, 1987
Charcoal on cardboard
195×195×62 cm

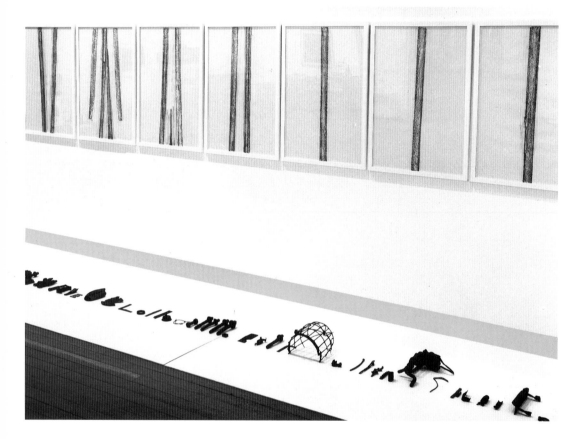

Zwischen den Schienen,
Berlin Nordbahnhof, 1984
Between the Rails,
Berlin North Station
11 drawings and 69 found objects

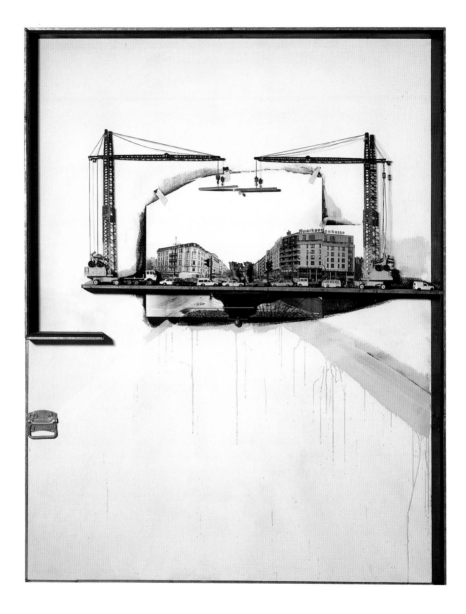

The Drawing for
the Dumb Dumm Duel, 1986
Photo, toy cars, metal bears,
wooden console, metal rails, paint
185 × 143 × 12 cm

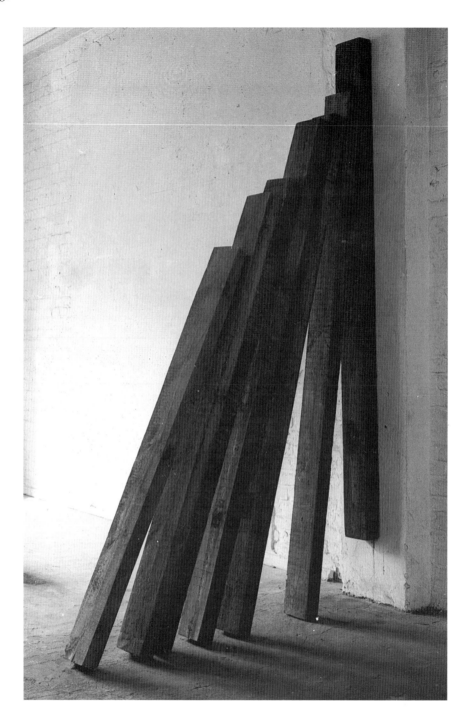

Ohne Titel, 1988
Untitled
Building beam, 7 parts
Height 220 cm

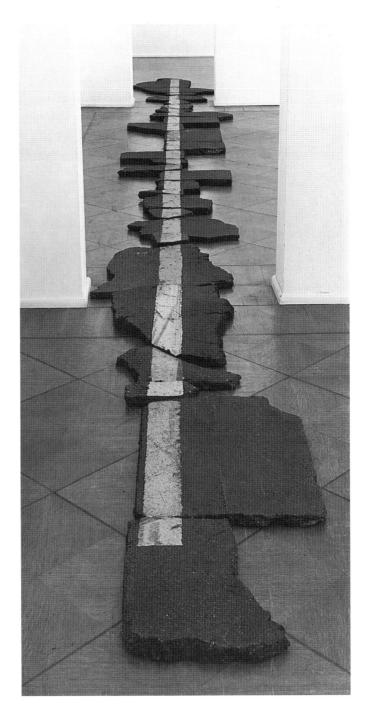

Autobahn A 4, 1989
Motorway A 4
Pieces of asphalt with existing
white line
11,60 × 1,20 m

Drei Steine, 1982–1987
Three Stones
3 stones, 1 audio-cassette with
recording
3 loudspeakers with cables
1 autoreverse walkman, 1 adapter

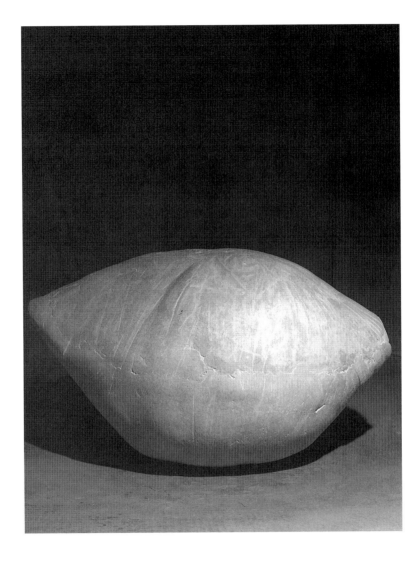

Ohne Titel, 1985
Untitled
Concrete, dyed pink
83×145×89 cm

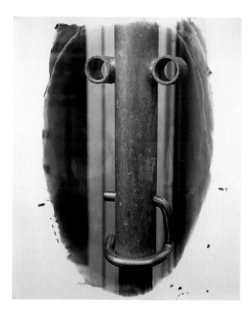

Opfer und Täter, 1988
Victim and Perpetrator
Silver gelatine paper on canvas
Unique print
2 parts, 150 × 127 / 195 × 127 cm

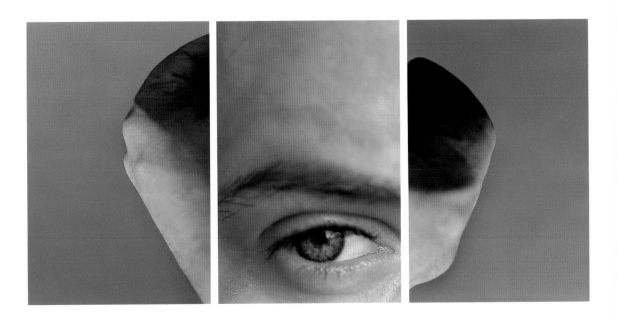

Untitled, Triptych No. 12, 1988
3 parts, unique print, C-prints
Entire size 150,5 × 301,5 cm

Raimund Kummer

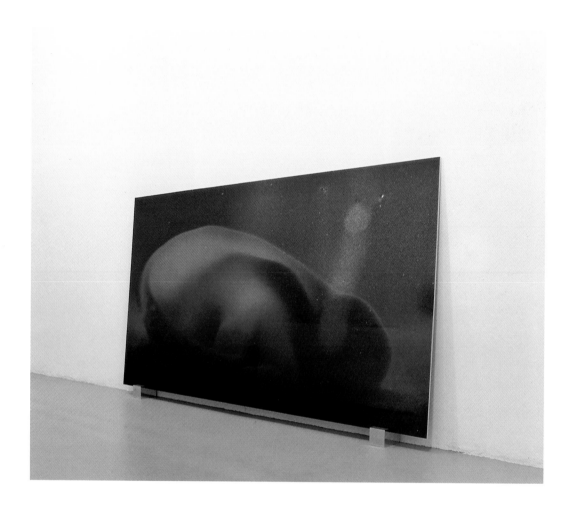

Untitled, 1985—1987
Cibachrome and aluminium
Unique print
125 × 223 × 16 cm

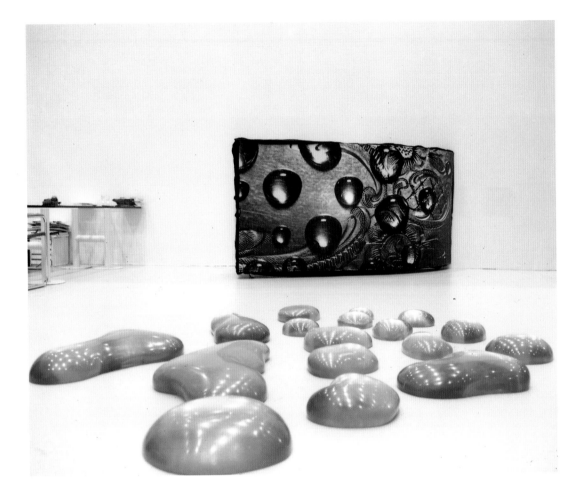

Byl 4, 1988
Colour transparency, perspex, light
box and drop-shaped floor objects
Unique print
125×262×60 cm

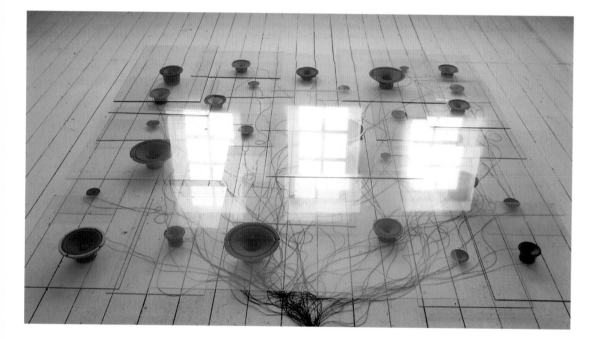

Das Quadrat, 1987
The Square
35 square panes of glass
in varying sizes,
35 loudspeakers of varying design,
4 walkmen, 4 amplifiers,
4 sound cassettes,
200 m unipolar black litz and
other cabling
250 × 250 cm

24 Piece Percussion Installation, 1987
for the composition ›24 Combinations after the I Ging‹
by Wolfram Erber
24 stands, sound boards and switchboxes
100 m cable and 1 perspex box with electric
control system

Tu Peux Situ View, 1986–1990
Wire found objects on synthetic boards
0,5 × 25 m

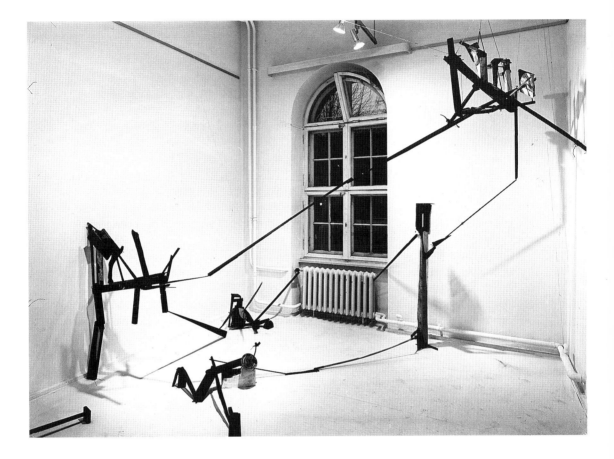

Der elfte Gesang, 1987
The Eleventh Hymn
Wood, string, dispersion colour,
coal-tar paint
400×450×550 cm

The Photographic Collection

Janos Frecot

›Photography‹ is many things simultaneously: it is a craft, a technique employing optical and chemical means, a visual medium, and a method used by artists to document their ideas, concepts, installations and projects. To put it another way: by means of the camera and a chemical process, images of actuality, or, equally well, pictures of a non existent reality, can be produced. The camera itself is not even essential in their creation: photo-montages, photograms, ›light graphics‹ have all emerged beyond the realms of classical photography. In the case of some of these, it is debatable whether they still belong to the field of ›photography‹, or whether they are works of art. The boundaries have become fluid, at least since the experimental photography of the twenties, since Laszlo Moholy-Nagy, El Lissitzky or Man Ray.

The following does not aim to present a condensed history of photography in Berlin: it mentions the names and the areas of the photographic world which are represented in the collection of the *Berlinische Galerie*, a collection which we have only been assembling since 1979.

The oldest material in the collection is a number of portrait daguerreotypes from Berlin ateliers during the 1840s. With the introduction of the glass-plate negative in the middle of the 1850s, from which contact prints could be made onto paper, numerous portrait ateliers grew up in Berlin. Hundreds of examples of their work are available, highlighting one very important aspect of such a collection: it presents us with illustrative material concerning areas of cultural and social history beyond that of photography itself.

Our oldest architectural photographs show the great synagogue in Oranienburger Straße, taken in 1866, shortly after the completion of the building. The architectural shots by Max Panckow originated a little later, and show the new buildings of the *Gründerjahre* (industrial age) and numerous villas in the new suburbs. The atelier of F. Albert Schwartz, who became one of the great urban and architectural photographers of the Prussian, later national capital, was already operating at this time. His work is represented in our collection by a group of landscape and plant studies from the early 1880s—like pages out of a photographic sketchbook—by a series about the iron works, a villa and a park with greenhouse belonging to Borsig in Moabit, and finally by a number of architectural shots of considerable interest to the city historian. The city views of Hermann Rückwardt help us to picture the fine, prosperous new streets, squares and buildings—shots of great photographic perfection, which the photographer offered for sale in presentation folders. Heinrich Zille, whose photographic work between 1900 and 1910 is represented in the collection by 235 vintage prints and 430 glass-plate negatives, enables us to see the old and the poor, the darker face of Berlin, which was ripe for

demolition; the simple people, men coming from work, women shopping, children playing with nothing, and the fairgrounds, brokendown lodgings, rubbish heaps and dusty hills on the perimeter of the city. The urban and landscape photographer, Max Missmann, is represented by views of Berlin and the surrounding area, of the Grunewald and the health resorts lying at the edge of the city. In Nicola Perscheid, the up and coming modern metropolis in the years before the First World War had a portrait and genre photographer who satisfied the fashionable world's need for representative pictures in an *Art Nouveau* style—he worked the summers in Baden-Baden, the winters in Berlin. Portrait and genre photography was always a documentation of fashion and lifestyle: that is evident in an excellent, although small collection of works by Nicola Perscheid, Jacob Hilsdorf, Rudolf Dührkoop and Minya Diez-Dührkoop which are concerned with the craftswoman, Anna Muthesius—they show, in her appearance and her clothing, the modern bourgeois style which is also expressed in the ambience of her country house situated beside the Rehwiese and designed by her husband, the famous architect Hermann Muthesius. The great period of experimental photography is represented by photographs, photograms and photo-montages by El Lissitzky, Laszlo Moholy-Nagy and Heinz Hajek-Halke.

The time of the Weimar Republic from the end of the First World War until the beginning of the National Socialist dictatorship was apostrophized for a long time as the ›golden twenties‹: a period of hectic and remarkably prolific cultural production in the areas of painting, literature, music, theatre, dance and music hall: a world of glamour marketed by the new medium of art and entertainment, the film, whilst the economy meanwhile dragged itself from crisis to crisis—accompanied by political conferences aiming to free Germany from the ostracism of the victorious nations as proclaimed in the Treaty of Versailles. This was Erich Salomon's sphere of activity. He was one of the greatest photo-journalists of the time, and his illustrated reports on the sessions of the Reichstag, on the conferences between Berlin and Paris, London, Geneva or The Hague were accepted enthusiastically by the illustrated journals and studied avidly by the public. His photography stands out in its vitality, its semblance of proximity and intimacy, contrasting with the rigidity of the usual flash and group photography. Always using new tricks with, however, immense social aplomb, his sensational pictures drawn from the political scene which was generally shy to publicity were a constant success.

Among the prerequisites for successful press photography was competition amongst the newspaper publishers, talented photographic editors open to innovation, and a number of press agencies. Berlin offered a profusion of these: two media giants, Ullstein and Scherl, had their base here, and in addition to the illustrated newspapers, there were illustrated magazines such as UHU, *Scherls Magazin* and *Querschnitt*; there were illustrated weekly supplements to the great dailies, such as *Weltspiegel* and *Zeitspiegel,* and there were fashionable journals such as *Elegante Welt, Die neue Linie* and *Der Silberspiegel*. But it was not only the photo-journalists such as Salomon, Felix H. Man, Martin Munkacsi, Erich Comeriner or UMBO (Otto Umbehr) who became popular in this way; the magazines were also a treasure trove of portrait and fashion photography from the twenties. A city like Berlin had very many portrait ateliers, and, unlike the craftmanship of

the court photographer's atelier or the atelier specializing in a portrayal of the customer's social standing, such as that of Perscheid, these ateliers aimed to express the individuality of the sitter, capturing more than a mere likeness. Lotte Jacobi made portraits of the greats in art and science. Steffi Brandl, who came from Vienna and was a pupil of Trude Fleischmann, received many actresses, singers and dancers in her atelier, as her guest book reveals. Ateliers such as those of Cami and Sasha Stone, Béla Balasz or Ewald Hoinkis worked in several areas of photography. But our collection not only boasts work from Berlin ateliers, it also includes portraits of artists who left their mark on Berlin's cultural life between the wars without living here permanently, for example portraits of painters, authors and architects by August Sander, Lucia Moholy and Hugo Erfurth. A group of twenty photographs by Erwin Blumenfeld from his years in Paris (1936—1941) are indicative of his innovative photography, much influenced by Man Ray, in the areas of fashion and portraiture.

In a group of early works by Fritz Brill, a pupil of Johannes Itten and Herbert Bayer, aspects of advertising photography become manifest. Heinz Hajek-Halke also produced advertising pages for magazines and journals; the techniques with which he experimented here, montage, double and multi-exposure, were used later on in the free pictorial arrangements of his ›light graphics‹. We glean information about the early experimental photography of Hajek-Halke from a small, but historically significant archive which belonged to the photographer Martha Astfalck-Vietz, whose role in the creation of Hajek-Halke's earliest experimental images had not been realised until recently. She herself also made extraordinarily interesting portrait studies, and took shots of nudes and dancers in which the ›roaring twenties‹ appear truly visible.

One particular group of works concerning the history of photography and of everyday life is a collection of pictures by Berlin photographers from the archive of the magazine *Volk und Welt*, which appeared between 1934 and 1944. The collection gives insight into the way ideological propaganda was conveyed to the educated middle class, at whom the cultural magazine, with its serious approach, was aimed. Initially, most of these photographs seem unpolitical and neutral in theme. Yet on further examination, the material illustrates the possibility of manipulating photography through a combination of appropriate captions: the photographs show how aesthetic value can be used for propaganda purposes.

Fritz Eschen began to work in photo-journalism around 1930, whilst also devoting time to portraiture. We also possess a great number of works by Eschen from the post war period: portraits of artists, scholars, politicians, as well as views of the ruined Berlin, the new beginnings among the rubble and the arguments about Germany's political future which reached their first climax in the blockade.

This period is evoked equally well in the commentaries by Henry Ries, who had emigrated to the USA: in his *Rosinenbomber* (Raisin Bomber) picture, he created an almost symbolic image of the emotional and political ties between Berliners and the Western Allies, in particular the Americans—political ties which became firmer during the rebuilding and the economic miracle of the 1950s, only to undergo a more critical examination in the time of the Vietnam War and the student protests.

Michael Schmidt
Waffenruhe, 1984—1987
Cease-Fire
Silver gelatine paper
1 of 45 parts, 60×50 cm

The fashion photographs from Berlin, an important fashion centre between 1955 and 1965, taken by the Hamburger F. C. Gundlach, clearly present the atmosphere of new self-confidence at a time when little was thought of participation in the political processes and a ›leave me out‹ attitude prevailed. There is no end to the reality which photography transposes, as close observation indicates—and not only visible reality, for good photographs also carry hidden messages: they ask questions without immediately answering them, and the questions continue to haunt us into our dreams. This was the kind of picture which Herbert Tobias, whose archive of negatives we have, aimed to take. As a portrait and fashion photographer and as the creator of highly atmospheric, poetic situations in the life of the youth and the gay scene in Berlin, Paris and New York, he produced contemporary images of considerable force. The photographs of Rolf von Bergmann, which have preserved the art scene in Berlin and New York, could also be described in this way.

A new generation of photographers has appeared in the last twenty years, a generation which sees itself neither as amateurs, nor as masters trained in the craft of photography, a group which works neither as photo-journalists nor as illustrative photographers. The ›author-photographer‹ is emerging as one who choses his themes and isolates them as a composition whilst developing his own pictorial language. In Berlin, the *Werkstatt für Photographie* (Photographic Workshop) was set up, initiated by Michael Schmidt, and continued to work under his direction for many years. This was a centre for emerging photography, oriented towards international, in particular American photography, and where exhibitions of work by leading contemporary photographers were arranged. In its own work, the workshop aimed for technical professionalism and a high level of contemplation and consciousness. Schmidt is represented in our collection by single pictures from the early period, along with complete series from his Kreuzberg and Wedding projects (1978 and 1980) and from the exhibition *Waffenruhe* (Cease-Fire) (1987); pupils of the workshop include Wilmar Koenig, Thomas Leuner, Ursula Kelm, Christa Mayer, Friedhelm Denkeler, Dieter Binder. Gabriele and Helmut Nothelfer occupy a special position with their scenic images. Among those photographers who concern themselves with an exact description of the city's physiognomy and the continual alterations to it are Karl-Ludwig Lange, Ute and Bernd Eickemeyer, Hans W. Mende and André Kirchner.

A line can be drawn from the experimental photography of the twenties and thirties, which developed out of such contrasting movements as Dada, Bauhaus and Surrealism, through the graphic, technical inventions of advertising photography (which sometimes, as with Bayer, Brill or Blumenthal, had more to do with art than with commerce) to the abstract configurations of the ›light graphics‹ produced by Hajek-Halke and Kurt Wendlandt. The latter also used his immensely varied and imaginative techniques in book illustration. Two pupils of Hajek-Halke, who taught photography at the College of Fine Arts, play a significant role in the further development of photographic methods and techniques on the contemporary art scene and are themselves teachers at the Art College today: Floris M. Neusüss, who makes photograms and develops photographic concepts, and Dieter Appelt, who has progressed away from the photography of reality, portraits of

artists and the reproduction of apparently imaginary realities to his own developing of material and the use of long exposures, returning to the origins of photography. Whilst his works in the seventies were still descriptions of scenarios and processes, albeit descriptions of great quality and with plastic significance, his newest works concern the true core of photography: the sensitization of material through exposure time and the transfer of impulses from life onto the light-sensitive film; time becomes visible as vibration, as breath, as condensation.

Karl String, whose legacy of material we also have, made similar processes visible, for example by photographing a candle burning down and extending the shortening shadow it throws with the use of white light: materially, the burnt-down candle leaves a trace of its burning, in immaterial terms it is still existent in the ›memory‹ of the picture.

Raffael Rheinsberg occupies an extreme position through his work with ›findings‹. In his ›verbal, or literal photography‹, these objects are captions from snapshots, written on pieces of paper and fastened to a notice-board, whilst a non-stop tape produces the inane sound of a polaroid, continuous and senseless. Where photography is neither a document nor an image, it is a mere pastime.

The young contemporary photo-art scene can be roughly divided into those works which emerge in photography but extend beyond its limits, passing into the realm of visual art, and into those works by artists, usually painters and installation artists, who use photography as a means towards the realization of their visual concepts. The works of Elfi Fröhlich, Wilmar Koenig, Gosbert Adler, Ulrich Görlich, Andrea Sunder-Plassmann, Caroline Dlugos, John Schuetz and Thomas Florschuetz belong to the first of these groups, those of Dunja Evers, Enzo Enzel, Hermann Pitz and Raimund Kummer can be counted among the second. In general, it may be said that the boundaries between art and photography have become permeable during the last ten years. A new photography, a form of image art, has long since come into being, and must be seen as a branch of contemporary painting rather than of classical photography.

Brüder, 1928 or 1929
Brothers
Silver gelatine paper
12 × 16,7 cm

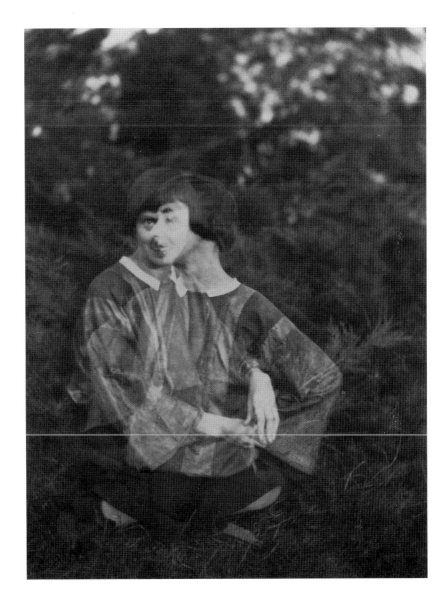

Self Portrait, c. 1927
New enlargement, 1985
Silver gelatine paper
31,2 × 24,3 cm

The Sailor, 1926/27
Silver gelatine paper
24 × 18 cm

Oskar Schlemmer in Ascona
1926/27
Silver gelatine paper
23,5 × 17,5 cm

245

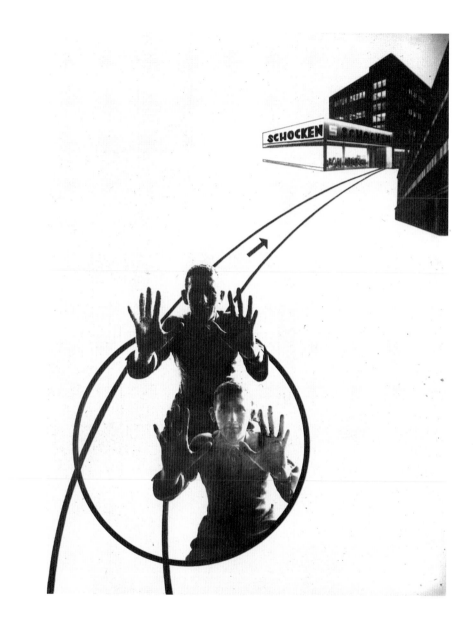

Poster Design for
the Department Store Schocken
Probably 1927
Vintage print
Silver gelatine paper
22 × 16,3 cm

Poster Design for Pelikan, 1924
Vintage print
Silver gelatine paper
49,7 × 34,8 cm

Photogram, 1935
Silver gelatine paper
18,2×23,9 cm

31/F7, 1931
Photogram
Silver gelatine paper
24×18 cm

Portrait of Heinrich George, undated
Oleograph
41,8×34,8 cm

Portrait of Valeska Gert, c. 1931
Silver gelatine paper
21,6 × 16 cm

Der Lausbub, c. 1930
The Rascal
Silver gelatine paper
24,3 × 18 cm

Kurt Gerron During the 6-Day-Race
at the Berlin ›Sportpalast‹, 1930
Silver gelatine paper
33,5 × 23,7 cm

Untitled, c. 1935—1938
Silver gelatine paper
30×24,2 cm

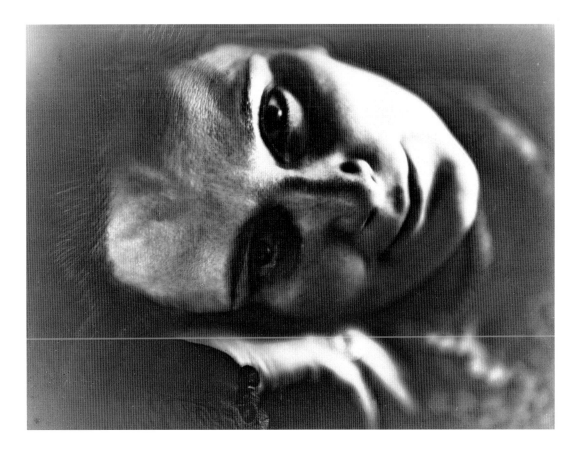

Portrait of Lily Hildebrandt, 1926
Silver gelatine paper
17,8 × 23,9 cm

Erich Salomon

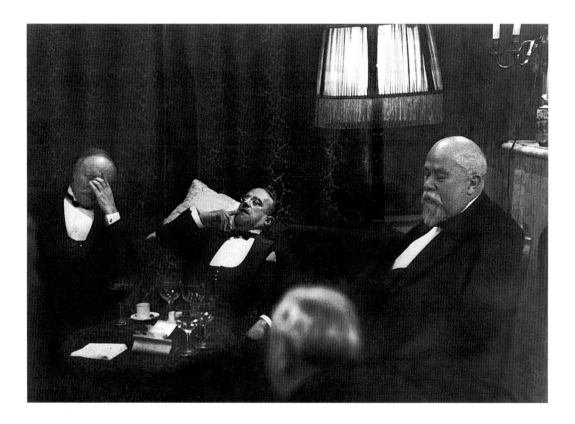

A Night Sitting of the German and
French Ministers at the Conference on
War Debts in The Hague, 1930
Silver gelatine paper
29,5 × 41,4 cm

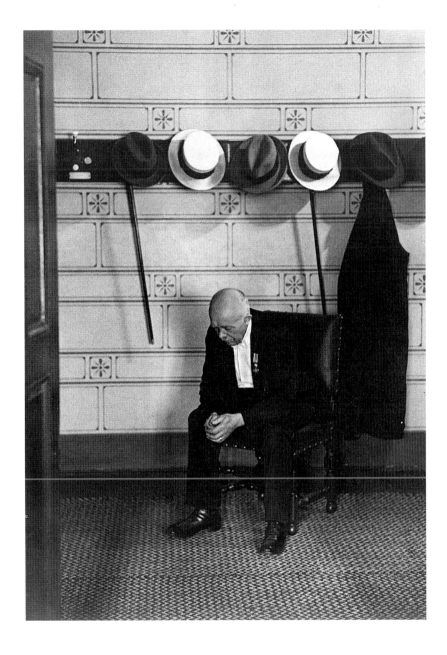

A Servant Waits Patiently under the
Hats of the Ministers for the End of
the Night Sitting. The Hague, 1930
Silver gelatine paper
43×29,8 cm

Friedrich Seidenstücker

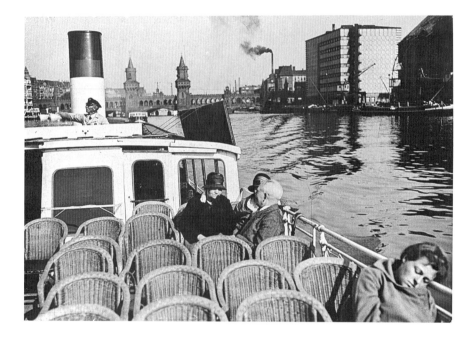

Montags. Oberbaumbrücke, 1930
Mondays.
Silver gelatine paper
12,5 × 18 cm

Rast im Wald, c. 1930
Rest in the Wood
Silver gelatine paper
18 × 12,8 cm

Children Near the Station
Friedrichstraße, 1954
Silver gelatine paper
25,5×37,8 cm

Jerusalem Church Destroyed, 1954
New enlargement, 1981
Silver gelatine paper
34,5 × 34,5 cm

Versuch, etwas ohne Erfahrungswert zu sehen oder ein
bestehendes Prinzip in Frage zu stellen, 1977
*Attempt to See Something without Empirical Value or to
Question an Established Principle*
4 parts sequence, Silver gelatine paper, each 28 × 18,5 cm

Inszenierung der Authentizität, 1987
Production of the Authenticity
4 parts of a 20 parts installation
C-prints, each 40×60 cm

Selected Biographies of the Artists
Compiled by Armin Schulz

Armando Painter, author
1929 Amsterdam — lives in Berlin

From 1950 onwards, Armando attended the university in Amsterdam, hearing lectures on the history of art, history and philosophy for several semesters. His first series of paintings, *Peintures criminelles,* came into being in 1954, and the same year saw his debut as an author in the avant-gardist literary magazine, *Podium.* From 1957 to 1969 he worked as a journalist in The Hague. In 1958, along with Kees van Bohemen, Jan Henderikse, Henk Peters and Jan Schoonhoven, he was co-founder of the *Nederlandse informele groep,* and in 1960, he was involved in its development into the group *Nul,* of which he remained a member until 1964; this group had close connections with the German circle of artists, *Zero.* His first volume of poetry, *Verzamelde Gedichten (1951—1963),* was published in 1964. In 1965, he stopped painting and dedicated himself completely to literature and journalism. It was not until 1967 that he began to draw again, in 1972 to paint. In 1967, he published, together with Hans Sleutelaar, the book *De SS'ers. Nederlandse vrijwilligers in de Tweede Wereldoorlog.* In 1979/80, he received a grant from the German Academic Exchange Service in the context of the Programme for Artists in Berlin; since than he has lived in Berlin, where large format paintings in series with titles such as *Feindbeobachtung* (Observing the Enemy), *Fahne* (Banner), *Gefechtsfeld* (Battlefield), *Melancholie* (Melancholy) have emerged. Since 1988, he has also created sculptures in bronze. He was represented in the exhibition *Ambiente Berlin* at the Biennale in Venice in 1990.

Frank Badur Painter, sculptor
1944 Oranienburg, near Berlin — lives in Berlin and Finland

From 1963 to 1969, Badur studied under Hermann Bachmann at the College of Fine Arts in Berlin. In 1971, he worked in London for several months. Since 1973, he has also maintained an atelier in Finland. In 1974, he was co-

founder of the group of artists, *System,* which was renamed *Systema* in 1975. Between 1977 and 1980, he exhibited within this circle together with Johannes Geccelli and George Rickey, among others. His first sculptures in steel were created in 1978, the first series of wooden ›floor objects‹ in 1983. His first working residence in the USA was in 1982, as a fellow of George Rickey's Hand-Hollow-Foundation, East Chatham (New York) and with a grant from the German Academic Exchange Service. He was awarded the Art Prize TetraPak, Hochheim, the Citizens' Prize for Visual Art from the town of Mülheim, and a working grant from the Bonn Art Fund in 1984. In 1985, he was made professor at the Berlin College of Fine Arts. In 1989, he erected an environmental work, *Hommage à Otto Freundlich,* in the synagogue at Oerlinghausen. He was represented in the exhibition *Ambiente Berlin* at the Biennale in Venice in 1990.

Georg Baselitz Painter, graphic artist, sculptor
1938 Deutschbaselitz (Oberlausitz) — lives in Derneburg (Lower Saxony) and Imperia (Italy)

Georg Kern, who began to use the name Georg Baselitz in 1958, initially applied to the College of Fine Arts in Dresden, but was turned down. In 1956, he made the acquaintance of Ralf Winkler (A. R. Penck) in Dresden. In 1956, he passed the entrance examination of the School of Forestry in Taranth, but did not commence his training as a forester. In the same year, he made a successful application to the Academy of Fine and Applied Arts in Berlin-Weißensee, studying painting under Walter Womocka and Herbert Behrens-Hangeler. After two semesters, in 1957, he was sent down from the academy due to ›socio-political immaturity‹, the condition for his reapplication being a year's work experience at the colliery combine *Schwarze Pumpe* (Black Pump). In the same year, Baselitz moved to Berlin (West) and studied under Hann Trier at the College of Fine Arts from 1957 to 1962, becoming his master

pupil in 1961. In 1958, he became a friend of Eugen Schönebeck. In 1961, together with Schönebeck, he had his first one man exhibition in a condemned house in Berlin-Wilmersdorf. On this occasion, they wrote the *Pandämonisches Manifest I. Die Dichter heben noch immer die Hände (1. Version). Im Rinnstein lagen die Dichter (2. Version)* (Pandemonic Manifesto I. The poets are still raising their hands, 1st version. The poets were lying in the gutter, 2nd version), which they published in poster form. In 1962, Baselitz and Schönebeck published the *Pandämonisches Manifest II. Vorruf zum Pandämonium* (Pandemonic Manifesto II. The first call to pandemonium), also in poster form. In 1963, during Baselitz' one man exhibition in the gallery of Michael Werner and Benjamin Katz in Berlin, his pictures *Der nackte Mann* (The Naked Man) (1962), and *Die große Nacht im Eimer* (The Great Night Shot to Hell) (1962/63) were confiscated by the public prosecutors. A trial on the charge of ›distributing indecent pictures‹ followed and continued until 1965, ending with the calling off of the proceedings and the release of the pictures, but without acquittal. In 1964, his programmatic exhibition, *1. Orthodoxer Salon* (1st Orthodox Salon) took place in the gallery of Michael Werner in Berlin — showing only one picture with the purely arbitrary title *Oberon*. In 1965, he spent six months in Florence with a grant to the Villa Romana. In 1966, on the occasion of his exhibition in the gallery Springer in Berlin, he published the manifesto and poster *Warum das Bild ›Die großen Freunde‹ (1965) ein gutes Bild ist* (Why the Picture ›The Great Friends‹ is a Good Picture). In 1966, he moved to Osthofen near Worms. In the same year, he painted his first fracture picture. In 1968, he received a grant from the cultural circle of the Federal Association of German Industry, Cologne. In 1969, he painted *Der Wald auf dem Kopf* (The Forest on its Head), the first picture with a reversed motif. In 1972, he participated in the documenta 5 in Kassel and in 1975, in the Biennale of Sao Paulo, together with (Blinky) Palermo (Peter Heisterkamp) and Sigmar Polke. In 1976, he illustrated *Die Gesänge des Maldoror* (The Songs of Maldoror) by Isidore Ducasse, Comte de Lautréamont, with twenty reproduced drawings, published by Rogner & Bernhard, Munich. Between 1976 and 1981, he spent periods of time living and working in Florence. In 1977, he began to work on diptychs. In 1977, as a protest against the participation of artists from the GDR, such as Bernhard Heisig, Wolfgang Mattheuer and Werner Tübke, Baselitz and

Markus Lüpertz abstained from exhibiting at the documenta 6 in Kassel. In 1977, he was nominated to the College of Fine Arts in Karlsruhe, becoming a professor there in 1978. In 1979/80, he created the ensemble of eighteen egg tempera pictures *Straßenbild* (Street scene), which led him to concern himself with sculpture in wood. In 1980, he completed his first wooden sculpture, begun in 1979, *Modell für eine Skulptur* (Model for a Sculpture), which he showed the same year at the Biennale in Venice, exhibiting together with Anselm Kiefer. Since then, he has also worked as a sculptor. Since 1981, he has maintained an atelier in Castiglione Fiorentino (Italy). In 1982, he was represented at the documenta 7 in Kassel. From 1983 onwards, he taught as a professor at the College of Fine Arts in Berlin. In 1985, Baselitz wrote the manifesto *Das Rüstzeug des Malers* (The Painter's Equipment), which was given as a lecture in London and Amsterdam in 1987, and published as a poster. In 1986, he received the Kaiserring Prize from the city of Goslar and the Art Prize from the North German State Bank, Hannover. In 1988, he gave up his teaching position at the Art College in Berlin in a protest against the controversial appointment of Volker Stelzmann to the College, an artist who had emigrated from the GDR to West Berlin in 1986. In 1988, he moved into an atelier in Imperia (Italy). In 1988, he illustrated Samuel Beckett's *Bing* with 24 etchings and a woodcut, published by the gallery of Michael Werner, Cologne. In 1989, Baselitz was made a Knight of the Order of Art and Literature by the French Minister of Culture, Jack Lang.

Susanne Bayer Sculptress
1960 Berlin — lives in Berlin

In 1977, Susanne Bayer began to study ceramics under Walter Popp at the Polytechnic in Kassel. In 1978, she moved to the College of Fine Arts in Braunschweig, where she studied sculpture under Heinz-Günter Prager and Emil Cimiotti until 1984, becoming the latter's master pupil in 1983. In 1985, she moved to Berlin and into an atelier which she shared with Erika Klagge. In 1987, they had a joint exhibition *Tapetenwechsel* (A Change of Surroundings) at the wallpaper storehouse in Grunewaldstraße, Berlin. Since 1987, she has created spatially oriented plastic works in several parts, using steel and concrete, and since 1988, she has produced sculptural drawings. In 1988, she received a working grant from the Senate for Cultural Affairs, Berlin. In the same year, she travelled to Spain for two months.

Nikolaus Braun Painter
1900 Berlin — 1950 Budapest

Braun became the pupil of Arthur Segal in 1920, and through his intervention, a member of the *Novembergruppe,* in whose exhibitions he frequently participated between 1923 and 1930. Together with Lajos Kassák, he exhibited at Herwarth Walden's gallery *Der Sturm (The Storm)* in 1924. Between 1924 and 1926, he published his photos and photoreliefs in Walden's journal of the same name. In 1925, his article *Das konkrete Licht* (Concrete Light) appeared in a joint publication with Segal, *Lichtprobleme in der Bildenden Kunst* (Problems of Light in Visual Art). In 1927 and 1928, he exhibited together with Segal's school of painting in Berlin and Braunschweig. Braun's work from the time in Berlin is thought to be lost. In 1937/38 he emigrated to Budapest, where he committed suicide in 1950.

Gisela von Bruchhausen Sculptress
1940 Berlin — lives in Berlin

After training as an assistant in medical technics, it was not until 1978 that Gisela von Bruchhausen began her studies in sculpture under Philip King, David Evison and Robert Kudielka at the Art College in Berlin, completing them in 1984. In 1982, together with Klaus Duschat, Klaus H. Hartmann, Gustav Reinhardt, Hartmut Stielow and David Lee Thompson, she founded the group of sculptors, *Odious,* who still have a joint atelier at Humboldthafen in Berlin. In 1985 she received a grant for the Cité Internationale des Arts, Paris, in 1986 a working-grant from the Senate for Cultural Affairs in Berlin. In 1987, she assisted Anthony Caro with the workshop *Stahl '87* (Steel '87) during the Sculpture Workshops in Berlin. Since 1989, she has had a lectureship at the Art College in Berlin. She has been invited to the Emma Lake Workshop in Saskatchewan (Canada) in 1990.

Erich Buchholz Painter, sculptor, architect
1891 Bromberg — 1972 Berlin

After teacher training in Bromberg, Buchholz worked as a primary school teacher there from 1911 to 1915. In 1915, just as he was about to take up his studies under Lovis Corinth in Berlin, he was called up into war service. In 1916, after a period in a military field hospital, he was called up once more and met the director and actor, Karl Vogt, with whom he worked together during 1917 as a dramaturge and stage designer at the theatre in Bamberg. In 1918, after the end of the First World War, he made his first abstract drawing in Berlin. Between 1918 and 1920, he did woodcuts, re-using some of the printing blocks in 1920/21 to develop his coloured wood reliefs. In 1920, under Vogt, he designed the stage set, in large scale, movable areas of colour, for August Strindberg's *Schwanenweiß* (Swan-White) at the Albert Theatre in Dresden. His first glass painting emerged in 1921, and the first coloured glass sculptures in 1921/22. His first one man exhibition took place in 1921 in Herwarth Walden's gallery *Der Sturm* (The Storm) in Berlin; but he parted with Walden as early as 1922. He began to concern himself with architecture — with furniture construction, interior design, exhibition construction (1923) and ship building (1925). He designed his atelier room in Herkulesufer 15, Berlin, according to constructivist ›absolutely abstract‹ principles. This atelier became a meeting place and point of discussion for Adolf Behne, Arthur Segal, Richard Huelsenbeck, Raoul Hausmann, Kurt Schwitters and Viking Eggeling, Ludwig Mies van der Rohe, Jacobus Johannes Pieter Oud, Ludwig Hilberseimer, Hans Poelzig, Max and Bruno Taut, Theo van Doesburg, Laszlo Moholy-Nagy, Laszlo Peri and Ernst Kállai. He maintained contact with the *Novembergruppe,* but did not take part in their exhibitions. In the course of the ›First Russian Art Exhibition‹ in the van Diemen gallery in Berlin, he came across the Suprematism of Kazimir Malevich and met El Lissitzky personally. From 1923 to 1931, he exhibited several times with the group ›The Abstracts‹ at the ›Great Berlin Art Exhibition‹ in Berlin. In 1923, he designed the model for a kiosk consisting of a glass cube with metal rods and fluorescent tubes, and in 1924 the model for the Of-house, an egg-shaped house. In 1927, he published *Das rote Heft* which included a text about his egg construction. In 1933, he was forbidden to exhibit and to paint by the National Socialists. His first exhibition after the Second World War took place together with Edmund Kesting and Herbert Behrens-Hangeler during 1946 in Birkenwerder near Berlin. In 1947, William Wauer organized a one man exhibition of Buchholz' work in Kunsthaus Tempelhof, Berlin. In 1953, he published his text concerning Neoplasticism, Suprematism and absolute abstraction *Die große Zäsur.* In 1957, he had a one man exhibition in the Gerd Rosen gallery, Berlin. In 1959, he became a member of the Federation of German Artists, Berlin. In 1967, he published his *Untersuchungen über das Lichtkabinett.*

Claudia Busching Painter
1954 Munich — lives in Berlin

Busching studied painting under Hann Trier at the Berlin Art College from 1976 to 1981, becoming the latter's master pupil in 1980. In 1982, she had her first one woman exhibition in the artists' gallery factory Klausenerplatz 19, Berlin. In 1983, she won the first and second prizes in the competition *Kunst am Bau* (Art in the Context of Architecture) for the Federal Garden Show to take place in Berlin in 1985; she realized her design, the painting of a façade, within the grounds of the Federal Garden Show in 1984. A further one woman exhibition took place in the *Kutscherhaus*, Berlin, in 1986; in 1987, she participated in the exhibition *Zehn: Zehn. Eine Gegenüberstellung aktueller Kunst aus Berliner und Kölner Ateliers* (Ten: Ten. A Comparison of Present Day Art from Ateliers in Berlin and Cologne), in Berlin and Cologne. She received a working grant from the Senate for Cultural Affairs, Berlin, in 1986, in 1987/88 from the Bonn Art Funds and in 1988, a grant from the Federal Home Office to stay at Casa Baldi in Olevano Romano (Italy). She was represented in the exhibition *Ambiente Berlin* at the Biennale in Venice in 1990.

Alexander Camaro Painter
1901 Breslau — lives in Berlin and in Kampen on Sylt

From 1920 to 1925, Camaro studied painting under Otto Müller at the State Academy of Fine and Applied Art in Breslau, whilst also studying music at the Breslau Conservatory. In 1926/27 he ran his own school of painting in Breslau. In 1928, he was trained as a dancer by Mary Wigman, as whose partner he performed in a production of the dance drama *Das Totenmal* (The Mark of Death) by Albert Talhoff in Munich, in 1930. From 1930 onwards, he worked as a dancer and artiste in theatres, cabaret, varietés, opera houses and on tour at home and abroad. From 1933 to 1945, the National Socialists imposed an exhibiting ban on Camaro as a pupil of Otto Müller, who was ostracized as a ›degenerate‹ artist. Camaro lived illegally in Germany from 1944 until the end of the war. Almost all his work was lost due to bomb damage and poor storage during the war. He worked as a free-lance artist again from 1946 onwards in Berlin. In 1947, he had his first one man exhibition in the Gerd Rosen gallery in Berlin. In 1951, he received the Berlin City Art Prize and became professor at the College of

Fine Arts in Berlin, where he taught until 1975. He has been a member of the Academy of Arts since 1956. He was a guest of honour at the Villa Massimo in Rome in 1974. In 1980, he was awarded the Lovis-Corinth-Prize, in 1982 the The Silesian Cultural Award from the state of Lower Saxony and in 1988, the Major Distinguished Service Cross of the FRG.

Hans-Jürgen Diehl Painter
1940 Hanau — lives in Berlin and New York

Diehl began his training in 1956 at the Academy of Drawing in Hanau, from 1959 onwards he studied under Hermann Kaspar at the Academy of Fine Arts in Munich, from 1961 under Legeult at the Ecole Nationale Supérieure des Beaux-Arts in Paris and finally, from 1963 onwards, at the College of Fine Arts in Berlin, where he completed his studies as master pupil of Hann Trier. In 1964, together with 14 other Berlin artists, he was co-founder of the team of exhibitors known as *Großgörschen 35*, to which he belonged until the secession of the Critical Realists in 1967. He was one of the original members of the New Society for Fine Art in Berlin in 1969. In 1972, he helped to found the group of artists known as *Aspekt*, with whom he continued to exhibit until 1978. From 1973 to 1976, he taught as a visiting professor of painting at the College of Fine Arts in Braunschweig, and has been professor of painting at the Berlin Art College since 1977.

Otto Dix Painter
1891 Gera (Thuringia) — 1969 Singen

Between 1905 and 1909, Dix completed an apprenticeship as a decorative painter in Gera. With the aid of a grant, he was able to study under Richard Merbert, Richard Guhr and Paul Naumann at the School of Applied Art in Dresden from 1909 to 1914. In 1914, he volunteered for war service and was sent to the field artillery as a machine-gunner. From 1919 to 1922, he attended the Academy of Art in Dresden as a master pupil of Max Feldbauer and Otto Gußmann. Here he was a founding member, together with Conrad Felixmüller and others, of the *Dresdner Sezession Gruppe 19*; this circle had close contacts with the *Novembergruppe* in Berlin. In 1920, he took part in the *Erste Internationale Dada-Messe* (First International Dada Fair) in Berlin. He studied at the Düsseldorf Academy under Heinrich Nauen

and Wilhelm Herberholz from 1922 to 1925. There he became a member of the circle surrounding the art dealer Johanna Ey and of the group of artists called *Das Junge Rheinland* (Young Rhineland), to which Otto Pankok, Gert Wollheim, Jankel Adler and others also belonged. In 1924, he became a member of the *Berlin Secession*. He participated in the exhibition *Neue Sachlichkeit* (New Objectivity) in Mannheim in 1925. From 1925 to 1927, he lived as a free-lance artist in Berlin and then in Dresden, where he taught as a professor of the Academy of Art, until 1933. In 1931, he was nominated as a member of the Prussian Academy of Arts in Berlin. He lost his offices under the National Socialists in 1933, in 1934 he was forbidden to exhibit. He withdrew to the provinces — in 1933 to Randegg near Singen, in 1936 to Hemmenhofen by Lake Constance. In 1937, Dix was represented at the exhibition of ›degenerate art‹ by eight paintings, many watercolours, drawings and graphic work; 260 of his works were removed from public collections and most of them were destroyed. As late as 1945, he was signed up for war service in the ›Volkssturm‹ (the homeguard put into active service); he was a prisoner of war until 1946, when he returned to Hemmenhofen.

Klaus Duschat Sculptor
1955 Ventersdorp near Johannesburg (South Africa) — lives in Berlin

From 1975 to 1979, Duschat studied sculpture under Helmut Rogge and Dietrich Klakow at the Art College in Hanover, from 1980 to 1984, he studied under Bernhard Heiliger at the Berlin Art College, becoming his master pupil in 1984. Since 1976, he has also produced drawings. In 1979, he received the grant of the state of Lower Saxony for up-and-coming artists. In 1982, together with Gisela von Bruchhausen, Klaus H. Hartmann, Gustav Reinhardt, Hartmut Stielow and David Lee Thompson, he founded the group of sculptors called *Odious* in Berlin, which has exhibited together since 1983. His first one man exhibition took place in the Society in Wolfenbüttel with Rigo Engler. He spent 1983/84 in Bleckede Castle on the Elbe with a grant for artists awarded by the state of Lower Saxony. Since 1983, he has created works for public places in Berlin, Hildesheim, Hofheim/Taunus, Ulm and Braunschweig, and, between 1983 and 1985, joint works by the group *Odious,* in Berlin, in Ostalbkreis/Aalen (Baden-Württemberg), in Neuenkirchen/Soltau and on the occasion of

the Federal Garden Show in Berlin. He was awarded a working grant by the Senator for Cultural Affairs in Berlin in 1986. In the same year, Duschat received the prize for sculpture from the *Secession Darmstadt*, and has been a member there since then. In 1987, together with Thompson, he participated as a lecturer in the All India Multi Media Sculptor's Camp Cum Workshop in New Delhi (India).

Lajos d'Ebneth Painter
1902 Szilagysombyo (Hungary) — 1982 Lima (Peru)

D'Ebneth studied at the Academy of Art in Budapest and architecture at the Technical University in the same city. In 1921, he emigrated to Munich and became the master pupil of Franz von Stuck. In the same year, he had his first one man exhibition there at the *Glaspalast*. In 1923, he moved to The Hague, where he was in close contact with the *De Stijl* group, in particular Vilmos Huszár, who became a close friend. It was here that he also participated in the Dada activities of Kurt Schwitters and Theo van Doesburg. In 1923, he took part in the jury-free art show in Berlin and put forward a draft proposal for city planning concerning Alexanderplatz in Berlin. Invited by Walter Gropius, he taught on a free-lance basis at Bauhaus in Dessau; from there he cultivated contacts with the circle of artists around Herwarth Walden's gallery *Der Sturm* in Berlin. In the same year, he exhibited there together with Kurt Schwitters and Arnold Topp. Briefly, he took up residence in Berlin. In 1927, he became a member of the ›International Association of Expressionists, Futurists, Cubists and Constructivists‹. The Abstracts‹ in Berlin. In 1927, he published the essay *Dynamische Komposition* and advertising designs in the magazine *i 10. Internationale Revue,* which existed between 1927 and 1929 and to which Schwitters, Huszár, Moholy-Nagy and Walter Benjamin also contributed. In 1928, he returned to the Netherlands and in 1949 he emigrated to Peru.

Karl-Heinz-Eckert Painter, sculptor, sound-installation, assemblage and performance artist, photographer
1950 Halle (Westphalia) — lives in Berlin

In 1970, Eckert began his studies in painting at the Berlin Art College, completing them as the master pupil of Raimund Girke in 1976. In the same year, his first one man exhibition took

place at the gallery *Nothelfer* in Berlin. In 1981, he created *An das große Glas. Hommage à M. D.* (To the Great Glass), an installation with paving stones pasted with photos of window fronts from the Kurfürstendamm broken in spring 1981. He has experimented with sound installations since 1982 and with performances since 1983. In 1982 and 1983, he took part in the exhibition projects of the artists' organization *Büro Berlin*, which was founded by Raimund Kummer, Hermann Pitz and Fritz Rahmann in 1980. Between 1983 and 1986, he published four art books with drawings and partly with texts: *Hirnschlag/Stegreif* (Stroke/Extempore), Wittenbrink Publishers, Regensburg 1983, *Teckningskursen*, Rainer Publishers, Berlin 1985, *Die Duftstrecke* (The Fragrant Stretch), Wittenbrink Publishers, Regensburg 1986, and *Dessin trouvé*, Künstlerhaus Bethanien, Berlin 1986. In 1984, he participated in the exhibition *im toten winkel* (in the blind spot) in Hamburg. In 1986, he exhibited in *Künstlerhaus Bethanien*, Berlin, *Tu Peux Situ View*. In 1988, he received the P.S. 1 grant to New York from the Senate for Cultural Affairs in Berlin.

Ulrich Eller Painter, musician, sound installation, object and performance artist
1953 Leverkusen — lives in Berlin

Eller studied painting at the Berlin Art College from 1977 to 1983, and in 1983 as the master pupil of Herbert Kaufmann. He has worked with photography and video since 1977. His scriptorial activity in the open countryside, such as lettering on the ground and on cliffs, began in 1978. In 1979, he began to analyse material sounds and brought the concept of space into his work. From 1981 onwards, he experimented with motor music and expressive drawings. He had his first one man exhibition in the gallery *Gianozzo*, Berlin, in 1981. In 1983, he completed his first state examination in the theory of art, in 1985, the second. He took on a teaching post in plastic design at the Technical University, Berlin, in 1983/94. He was awarded a grant by the Karl Hofer Society, Berlin, in 1983/84. In 1985/86, he received an atelier grant for the *Künstlerhaus Bethanien*, Berlin, and in 1986, the Karl Hofer Prize awarded by the Berlin Art College. He was artistic assistant at the Institute for Representation and Design in the department of architecture at the Technical University, Berlin, from 1985 to 1990. He participated in the documenta 8 in Kassel in 1987, with *Fensterstück* (Window Piece), a music and sound composition for a window. In 1988, he took part in the exhibition *Klangräume* (Sound Spaces) in Saarbrücken, and in 1989/90, in the exhibition *Ressource Kunst. Die Elemente neu gesehen.* (Resource Art. A New Way of Looking at the Elements), in Berlin, Saarbrücken, Munich and Budapest.

Lilli Engel Painter
1939 Solingen — lives in Berlin

In 1959, Lilli Engel began her studies in painting at the College of Fine Arts in Berlin — four semesters under Hans Jaenisch and Peter Janssen and a further semester under Hans Kuhn. In 1962, she transferred to the Académie des Beaux-Arts in Alexandria (Egypt) for three semesters, where her first works in landscape and spatial contexts emerged. In 1963, she returned to the College of Fine Arts in Berlin, and became the master pupil of Hans Kuhn in 1966. In 1967, she participated in the exhibition of the Association of German Artists in Nuremberg. She travelled to Mexico and Italy several times, where she lived and worked chiefly in Padua. In 1973/74, she took over the artistic direction at the Hebbel Theatre in Berlin. Since 1974, she has created *found paintings*, which show the aesthetic in the destruction and the instability in relationship to the places where they are found, without making any alteration. Since 1981, surfaces and techniques for the treating of surfaces have become a leitmotiv in her painting and room installations. In 1982, her first one woman exhibition took place at the Art Society in Mainz. In 1982, she was co-founder, with Ricarda Fischer, Matthias Wagner, Axel Schäfer and Raffael Rheinsberg, of the *Quergalerie* in Wedding, Berlin. Exhibitions, performances and installations by the founders and other artists took place here until 1985. In 1985, in the context of an exhibition by the *Gruppe Schauplatz* (Group Arena) — which existed between 1983 and 1985 — of work by Rheinsberg, Peter Werner and Susanne Wehland among others, Engel initiated the presentation of a peep show in the strong-room of a branch of the Berliner Bank on Moritzplatz in Kreuzberg, Berlin. In September 1989, she worked together with Raffael Rheinsberg on an installation to recall the 50th anniversary of the beginning of the Second World War, *Zerstörte Bilder* (Destroyed Pictures). The installation was in the Langemarck Hall in Charlottenburg, Berlin, the National Socialist's hall of honour for the dead of the First World War. In 1990, she was represented in the exhibiton *Ambiente Berlin* at the Biennale in Venice.

Conrad Felixmüller Painter, graphic artist
1897 Dresden — 1977 Berlin (West)

Felixmüller began his training in 1911 at the Dresden Elementary School of Applied Art, continuing it in 1912 at a private school of painting run by Ferdinand Dorsch and at the Dresden Academy of Art under Carl Bantzer, and concluded his studies as a master pupil in 1915. From that time onwards, he had many personal contacts to Berlin through his acquaintance with the circle surrounding Herwarth Walden's journal and gallery *Der Sturm (The Storm)*, where he often exhibited, and that surrounding Franz Pfemfert's journal *Die Aktion*, to which he contributed from 1916 to 1926. In 1917, he founded the *Expressionistische Arbeitsgemeinschaft Dresden* (Expressionist Working Group) with Walter Rheiner and Felix Stiemer, together they published the journal *Menschen* (People) in 1917/18. As a conscientious objector to war service, he worked for some time as a nursing auxiliary in a field hospital. In 1918 he became a member of the propaganda committee of the *Sozialistische Gruppe der Geistesarbeiter Dresden* (Socialist Group of Intellectual Workers), in 1919 a member of the *Novembergruppe* in Berlin and of the KPD (German Communist Party). In the same year he founded the *Dresdner Sezession Gruppe 1919,* of which Otto Dix was also a member. In 1925, he became the president of the association of artists in Saxony, and secretary of the national association of artists. In 1933, his art was scorned by the National Socialists in the exhibition ›Reflections of the Decay in Art‹ in Dresden, in which 40 of his works were shown. In 1934, he moved to Berlin. He was expelled from the Association of Berlin Artists in 1937. Seven of his works were shown in the exhibition ›Degenerate Art‹ in Munich. In the following year, 151 of his works were removed from public collections and numerous early works were lost. This was also because Felixmüller himself, in particular after 1933, destroyed a certain proportion of his early work. In 1941, the effects of the war led to the loss of his atelier and flat in Berlin, and he moved to Damsdorf near Dahme in Fleming. As late as 1944, he was called up as a gunner in the National Guard and taken as a prisoner of war. Between 1945 and 1961, he lived in Tautenhain near Leipzig. From 1949 to 1962, he taught scientific drawing as a professor of the faculty of pedagogics at the University of Halle/Saale. In 1961, he moved to Köpenick, Berlin, in 1967 to Zehlendorf, Berlin.

Rainer Fetting Painter, film-maker, sculptor
1949 Wilhelmshaven — lives in Berlin and New York

After an apprenticeship as a joiner and the qualification of journeyman, whilst working on a voluntary basis as a stage designer at the state theatre of Lower Saxony North in Wilhelmshaven (1969 to 1972), Fetting studied from 1972 to 1978 at the Berlin College of Fine Arts — finally as a master pupil — under Hans Jaenisch. In 1977, he founded, together with Helmut Middendorf, Bernd Zimmer and others, an artists' self-help gallery at Moritzplatz in Kreuzberg, Berlin. His first one man exhibitions took place here in 1977 and 1978. In 1978/79, he received a grant from the German Academic Exchange Service for a working residence in New York. Together with Middendorf and Zimmer, he created murals in the concert hall SO 36 in Kreuzberg, Berlin, in 1979. After a joint exhibition in 1980 together with Zimmer, Middendorf and Salomé in the *Haus am Waldsee,* Berlin, they became known as ›Heftige Maler‹ (Impetuous Painters) or the ›Neue Wilde‹ (New Wild Movement). Fetting has also worked as a filmmaker since 1975, and as a sculptor since 1986. In 1989, he received the art prize awarded by the Union of Metal Workers.

Peter Foerster Painter
1887 Aachen — 1948 Frankfurt (Main)

Foerster studied at the School of Applied Art in Aachen and at the teaching centre of the Arts and Crafts Museum in Berlin under Woldemar Friedrich and Georg Koch. He became a friend of Mies von der Rohe. As a member of the *Novembergruppe,* he took part in their exhibitions from 1920 to 1925. In 1935, he received the Dürer Prize from the city of Nuremberg. He was awarded a grant to the Villa Massimo in Rome in 1936/37. In 1939, he became the director of the gallery Anhalt in Dessau. He taught at the Reimann School in Berlin.

Hannes Forster Sculptor, works in a given context
1955 Tuttlingen (Baden-Württemberg) — lives in Berlin and Tuttlingen

Forster studied art education at the Berlin Art College from 1979 to 1986, from 1984 onwards, he was the master pupil of Herbert Kaufmann. It was during his studies, in 1982,

that the first works in a specific context (in situ) emerged. His first one man exhibition took place in 1983, in the *Künstlerhaus* in Hamburg. In 1983, he took part in the founding and realization of the exhibition project, *Halle Trapez* in Wedding, Berlin. From 1984 onwards, together with Boris Doempke, later with Martin Bartel and Markus Kohn, he has conceived and organized the exhibition project *Der Standort — Raum für Installationen* (The Setting — A Place for Installations) in Schöneberg, Berlin, which has taken place in changing venues in and outside of Berlin since 1987. He completed his first state exam in art education in 1987. In 1985, he received a grant from the German-French Centre for Youth Work in Bonn, and from 1985—1987, he had a grant for the promotion of up-and-coming artists from the Berlin Art College. In 1988, he was awarded the grant for visual art from the area of Mark Brandenburg, Lüdenscheid, and in 1989, a working grant from the Art Foundation, Baden-Württemberg, Stuttgart. In the same year, Forster won the art prize *junger westen* (young west) for sculpture from the town of Recklinghausen. He was represented in the exhibition *Ambiente Berlin* at the Biennale in Venice in 1990.

Naum Gabo Sculptor
1890 Briansk (Russia) — 1977 Middlebury, Connecticut (USA)

Gabo firstly studied medicine (1910) and sciences (1911) at the University of Munich, then, in 1912, structural engineering at the Technical University in the same city. In 1912/13, he attended lectures given by the art historian, Heinrich Wölfflin. In 1914, he left Germany due to the outbreak of war and lived in Christiania near Oslo. His first constructions were created in 1915/16; from that time onwards, he changed his own surname, Pevsner, to Gabo, in order to distinguish himself from his brother, Nathan (Antoine) Pevsner. After the outbreak of the Russian Revolution in 1917, he returned to Moscow, and between 1918 and 1920, he worked unofficially on various projects with David Sterenberg, the director of the ISO, the department of interpretative arts at the Commissariat for Education. The first *Kinetic Construction* came into being in 1920, as did the *Realist Manifesto,* which was also signed by his brother. In 1922, the Commissar for Education, Anatolij Lunacharsky, granted him permission to co-organize the setting up of a section on abstract art in the *First Russian Art Exhibition* in the van Diemen gallery in Berlin.

He lived in Berlin from 1922/23 until 1932. In 1928, he gave lectures at the Bauhaus and developed a project, which was never carried out, to floodlight the square in front of the Brandenburg Gate — this was part of a city-wide festival of light planned by the architect Hugo Häring. In 1931, he took part in an international competition to design the *Palace of the Soviets* in Moscow, which was planned, but never built. After his atelier had been searched by the National Socialists in 1932, he emigrated to Paris, where he became a member of the group of artists, *abstraction — création.* In 1936, he moved to England, in 1946 to the USA.

G. L. Gabriel Painter
1958 Munich — lives in Berlin

From 1976 onwards, Gabriel studied under K. H. Hödicke at the Berlin Art College, concluding her training as master pupil in 1981. Since her first one woman exhibition at the gallery at Moritzplatz in Berlin, the painter, daughter of Fred Thieler, has called herself G. L. Gabriel. In 1981, she received the first prize in the competition *Kunst am Bau* (Art in the Context of Architecture) in Berlin, in 1982 she was awarded a grant for resident study in Santo Domingo and in 1984 a working grant from the Bonn Art Fund. During 1986 and 1987, she travelled in South America and Japan.

Bernhard Garbert Painter
1957 Vardingholt (Westphalia) — lives in Berlin

From 1978 to 1985, Garbert studied painting at the Berlin Art College, a master pupil of Johannes Geccelli from 1983 onwards. During 1980, he lived in the South of France for six months. Between 1981 and 1983, he created caligraphic, chess-board and puzzle pictures, as well as pictures using nails, and the *Mennige* series. In 1984, he painted zig-zag pictures and made the first experimental series of small objects in wood, mortar and rubber, etc. He completed his first state examination in 1985. In the same year, he created *The Wax-book, Sandpapers* and large pictures on card. His first one man exhibition was in the gallery of Anselm Dreher Berlin, in 1986. In the same year, he participated in the exhibition for the Dorothea-von-Stetten-Prize for art in Bonn. In 1986, he created *Glass ashes* and *Typewriter drawings,* during 1988, he worked on paper with anti-rust and oil and created *folded sheet pictures.* He received a working grant from the Senate for Cultural Af-

fairs, Berlin, in 1988, and in 1989, the Senate's P.S. 1 grant to New York, where he stayed until 1990. During his year in New York, he developed three dimensional picture-objects in cardboard, ashes or coal dust, *Rubber glasses, A hundred milk cartons* and, for the P.S.-1 Museum for Contemporary Art, the installation for four equalsized wall boxes, *Time Out.* In 1990, Garbert was awarded the prize to promote young artists from the Federation of German Artists, donated by the Association of German Savings and Giro Banks, Bonn.

Johannes Geccelli Painter
1925 Königsberg (East Prussia) — lives in Berlin

After military service and a period as a prisoner of war, Geccelli studied under Heinrich Kamps, Paul Bindel and Bruno Goller at the Academy of Art in Düsseldorf from 1947 to 1951. He then taught art in Mülheim (on the Ruhr) for over ten years. He was a visiting lecturer at the College of Fine Arts in Hamburg in 1964. In 1958, he received the sponsorship prize from the state of North Rhine Westfalia, in 1960 the Villa Romana Prize, Florence and, in 1963, the Ruhr Prize. In 1965 he was appointed professor of painting at the College of Fine Arts in Berlin. Geccelli was a fellow of the Hand-Hallow-Foundation, East Chatham, New York, and a visiting lecturer at Hunter College in New York in 1980. In 1983, he was invited to the Centre International d'Expérimentation Artistique in Boissano (Italy) as the artist in residence. He retired from his teaching post at the Berlin Art College in 1988. Geccelli was represented in the exhibition *Ambiente Berlin* at the Biennale in Venice in 1990.

Raimund Girke Painter
1930 Heinzendorf — lives in Berlin and Cologne

At first, Girke studied at the School of Arts and Crafts in Hanover in 1951/52, then under Otto Pankok and Georg Meistermann at the Academy of Art in Düsseldorf from 1952 to 1956. In 1959, he received the town of Wolfsburg's prize for painting, in 1962, the Youth Art Prize of Stuttgart. From 1966 to 1971, Girke was a lecturer at the School of Arts and Crafts in Hanover, and has been a professor at the College of Fine Arts in Berlin since 1971. He was represented in the exhibition *Ambiente Berlin* at the Biennale in Venice in 1990.

Kuno Gonschior Painter
1935 Wanne-Eickel — lives in Berlin and Bochum

From 1957 to 1961, Gonschior studied painting under K(arl) O(tto) Götz at the Art Academy in Düsseldorf, and from 1961 to 1963 at the University of Cologne. After 1959, he began to paint pictures consisting of series of dots overlapping infinitely. His first one man exhibition took place in the gallery *Niepel,* Düsseldorf, in 1961. From 1963, he concerned himself with artistic research into the perception of colour. In 1963, he participated in the exhibition of the group of artists *Zero,* which existed between 1958 and 1966 of which Heinz Mack, Otto Piene and Günther Uecker were the chief members. From 1967 onwards, he experimented with square and round convex shapes and with balls. After 1968, he began to create installations showing drops of colour and the vibration of colour in space. In 1969, he became a member of the German Federation of Artists, Berlin. He has been developing his murals and floor paintings since 1970. He was represented at the documenta 6 in Kassel in 1977. He taught painting at the seminar of art and its didactics at the teacher training college in Münster from 1972 to 1981, and has taught at the Berlin Art College since 1982.

Arwed Gorella Painter, graphic artist
1937 Schweidnitz (Silesia) — lives in Berlin and Braunschweig

Gorella began his training at the College of Fine Arts in Berlin in 1955, completing it in 1960 as a master pupil of Alexander Camaro. He has been a free-lance painter and graphic artist since 1961. Since 1967/68 he has also worked in the theatre and designed stage sets, initially for the *Schaubühne am Halleschen Ufer* in Berlin, and since 1981, for productions by Ellen Hammer at the *Kammerspiele* in Bonn-Bad Godesberg and for plays by Heiner Müller and other authors at the workshop of the *Theater Bonn.* In 1968, he was awarded a prize by the Heinrich-Zille-Foundation for critical graphic art. He was among the founding members of the *Neue Gesellschaft für Bildende Kunst,* Berlin (New Society for Fine Art) in 1969. In 1971, he worked together with Thomas Neumann on the production of a television film about ›Artists and Communards — The Paris Commune of 1871 in Visual Art and Contemporary Photography‹. Together with Hans-Jürgen Diehl, Wolfgang Petrick and oth-

ers, he founded the group of artists *Aspekt* in 1972, with whom he exhibited until 1978. He was awarded a guest lectureship at the College of Education in Berlin in 1974. In 1975, he became a member of the Federation of German Artists. He was appointed professor at the State College of Fine Arts in Braunschweig in 1977.

George Grosz Painter, graphic artist
1893 Berlin — 1959 Berlin (West)

Grosz began his studies in 1909 at the Academy of Arts in Dresden under Richard Müller, Robert Sterl, Raphael Wehle and Osma Schindler. Between 1912 and 1917, he attended the School of Applied Art in Berlin and studied under Emil Orlik. He volunteered for war service in 1914, in order to anticipate certain conscription by his own choice of regiment. He became unfit for service for health reasons in 1915, and was temporarily discharged. At Ludwig Meidner's in Berlin, 1915, he made the acquaintance of Wieland Herzfelde and John Heartfield. He was called up to war service in the artillery again in 1917. As the result of an assault on an officer, he appeared before a military tribunal. The threat of the death sentence could only be averted through the intervention of his sponsor, Harry Graf Kessler. He was temporarily committed to an institution for the ›war insane‹. His first two portfolios of graphic work appeared in Herzfelde's *Malik* Publishing House in 1917. He was one of the co-founders of Dada Berlin in 1918. In the same year, he joined the *Novembergruppe* and the KPD (German Communist Party). In 1919, he founded the journals *Die Pleite* (Bankruptcy) together with Herzfelde, *Jedermann sein eigener Fußball* (Everyone his own football) with Franz Jung and *Der blutige Ernst* (Bloody Earnest) with John Hoexter and Carl Einstein. In that year he and Heartfield also produced programmes and satirical puppets for Max Reinhardt's cabaret, *Schall und Rauch* (Sound and Fury). In 1920, he participated in the ›First International Dada Fair‹ in Berlin. In 1921, 1924 and 1928, Grosz was put on trial for charges of ›offence against the army‹, ›offending public decency‹ and ›blasphemy‹. From 1923 onwards, Grosz paid no more membership fees to the KPD. In 1924, he was president of the *Rote Gruppe* (Red Group) in Berlin. He worked for the journal *Der Knüppel* (The Cudgel) from 1924 to 1927. In 1925, he took part in the exhibition *Neue Sachlichkeit* (New Objectivity) in Mannheim. He was one of the founders of the *ASSO — Assoziation revolutionärer bil-*

dender Künstler (Association of Revolutionary Artists) in 1928. In 1929, he participated in the anniversary exhibition of the *Novembergruppe*. In 1932, he spent time in New York as a visiting lecturer at the *Art Students League,* and in 1933 he emigrated there. He taught drawing at this institute until 1955, and from 1933 to 1937, he ran his own school of drawing together with Maurice Sterne. His work was represented in the National Socialists' exhibition of ›degenerate art‹ in Munich in 1937; in 1939, they seized 285 of his works from public collections and destroyed the majority. He was expatriated by the National Socialists in 1938. George Grosz became a member of the Academy of Arts in Berlin in 1958. Shortly before his death in 1959, he returned to Berlin.

Johannes Grützke Painter, author,
musician
1937 Berlin — lives in Berlin

From 1957 to 1964, Grützke studied at the College of Fine Arts in Berlin, concluding his training as a master pupil of Peter Janssen. In 1965, he was a co-founder of the Berlin music group, *Erlebnisgeiger* (Happening-Violinists). In 1973, together with the painters Manfred Bluth, Matthias Koeppel and Karlheinz Ziegler, he founded the *Schule der Neuen Prächtigkeit* (School of New Magnificence); the group disintegrated in 1978, but the artists continued to follow their programme. He was a guest lecturer at the College of Fine Arts in Hamburg during 1976/77. He has written revues and theatre plays since 1979 and designed stage sets for plays, revues and operas at theatres in Berlin, Stuttgart and Hamburg since 1980, chiefly for productions by Peter Zadek. From 1985 to 1989, he was a free-lance contributor and artistic advisor to Zadek in Hamburg. He has been working on a 32 metre long frieze for the Paulskirche in Frankfurt (Main) since 1989.

Dieter Hacker Painter, publisher,
stage designer
1942 Augsburg — lives in Berlin

From 1960 to 1965, Hacker studied under Ernst Geitlinger at the Academy of Fine Arts in Munich. In 1970, he moved to Berlin, where he opened the *7. Produzentengalerie* (producers'/performance gallery) in 1971, which remained in existence until 1984. From 1972 onwards, he published the gallery's newspapers. In the gallery, he concerned himself with a criti-

cal portrayal of themes in cultural politics and an analysis of the artistic media. His own painting has developed out of this work since 1975. In 1974, he taught as a guest professor at the Art College in Hamburg. He published, together with Andreas Seltzer, *Volksfoto. Zeitung für Fotografie* (The People's Photo. Magazine of Photography) between 1976 and 1980. Between 1977 and 1980, he produced several television films with Seltzer and others, two of them concerning the photography of the everyday. Between 1986 and 1990, he designed stage sets and costumes for the *Schaubühne am Lehniner Platz* in Berlin, the *Schauspielhaus* in Düsseldorf and Bochum — some of which were for plays by Botho Strauss. Hacker was represented in the exhibition *Ambiente Berlin* at the Biennale in Venice in 1990.

Raoul Hausmann Painter, sculptor, author, photographer
1886 Vienna — 1971 Limoges (France)

Hausmann's father was an academic painter and gave his son painting lessons as early as 1900. In 1900, the family moved to Berlin. Hausmann was a friend of Johannes Baader from 1905 onwards. From 1912, he contributed to Herwarth Walden's *Der Sturm* and from 1917, to Franz Pfemfert's *Die Aktion*. Among his friends were Erich Heckel, Karl Schmidt-Rottluff, Salomo Friedländer (Mynona), Ludwig Meidner, at whose ›Wednesday evenings‹ he was often present, and Franz Jung, with whom he collaborated on the journal *Die freie Straße* (The Clear Road) during 1915 and 1917. He was a close friend of Hannah Höch from 1915 to 1922. In 1918, he played a decisive role in the establishing of the Berlin *Club Dada*, to which Richard Huelsenbeck, Johannes Baader, George Grosz and John Heartfield also belonged. In the same year, he and Hannah Höch invented the artistic technique of photo-montage; the first posters and phonetic poems emerged. In 1919, he organized the first Berlin Dada exhibition in the graphic cabinet of I. B. Neumann. In 1919, he published, together with Baader, the first two issues of the journal *Dada*, the third, together with Grosz and Heartfield, in 1920. He undertook a Dada-Tour to Dresden, Leipzig, Prague and other cities with Baader and Huelsenbeck in 1920. He, Grosz and Heartfield were among the organizers of the ›First International Dada Fair‹ in Berlin in 1920. Together with Kurt Schwitters and Hannah Höch, he went on an ›Antidada-Merz-Tour‹ to Prague in 1921. He made the

acquaintance of Otto Freundlich and Hans Arp. In 1923, he participated in Kurt Schwitters' *Merz*-construction in Hanover. In 1921, he published in Theo van Doesburg's journal *De Stijl*, and in 1922, in the latter's journal *Mécano*. In Berlin in 1922, he had contact with artists surrounding the journal *MA*, published by Lajos Kassák, among them Moholy-Nagy and El Lissitzky. In 1923/24, his work appeared in the journal *G*, published by Hans Richter. In 1926, he began the work on his novel, *Hyle*. In 1927, he invented the *Optophon*, a device for transforming coloured forms into music and vice versa. His first systematic photographs emerged in 1930. In 1930/31, he contributed to the journal *a bis z. organ der gruppe progressiver künstler* (a to z. mouthpiece of the group of progressive artists), published by Heinrich Hoerle in Cologne. In 1933, he fled the National Socialists as a ›degenerate artist‹ and went to Ibiza (Spain), where he lived until the outbreak of the Spanish Civil War in 1936. In 1938/39 he was in Paris. After the invasion of German troops, he fled to the South of France, where he supported himself as a language teacher. From 1944 onwards he lived in Limoges.

John Heartfield Painter, photo-montager, typographer
1891 Berlin (Schmargendorf) — 1968 Berlin (East)

Helmut Herzfeld began an apprenticeship as a bookseller in Wiesbaden in 1905. In 1907/08, he took lessons there from the painter and academic draftsman, Hermann Bouffier. He attended the School of Applied Art in Munich from 1908 to 1911, and after working in advertising graphics in Mannheim in 1912, he attended the School of Applied Art in Charlottenburg, Berlin during 1913/14. In 1914, he was called up to the Guards, but was exempt from military service because of a supposed mental illness in 1915, serving instead as a temporary postman. In protest over the war propaganda smear campaign against the English, he called himself John Heartfield. His friendship with George Grosz began in 1915. In 1916/17, together with Franz Jung, he published the journal *Neue Jugend* (New Youth), for which he did the typographical design. He and his brother, Wieland Herzfelde, founded the *Malik* Publishing House in 1917. He became acquainted with Richard Huelsenbeck. In 1918, he joined the newly established KPD (German Communist Party), and provided the typographic design for its publications until 1933. From 1919, he

participated as ›Monteurdada‹ in the activities and the publications of the Berlin Dadaists. In 1920, he was co-initiator and co-organizer of the ›First International Dada Fair‹ in Berlin. The hanging ceiling sculpture, *Preußischer Erzengel* (Prussian Archangel), which he had assembled together with Rudolf Schlichter and which was exhibited at the fair, led to a trial in 1921 on the charge of ›defamation of the armed forces‹. From 1921 to 1923, he was responsible for the artistic advice concerning the scenery and settings of Max Reinhardt's stage in Berlin, from 1921 to 1938 he was the book designer of the *Malik* Publishers. He worked together with Grosz on the journal *Der Knüppel* (The Cudgel) from 1923 to 1927. In 1924, he was co-founder of the *Rote Gruppe* (Red Group). The same year saw the creation of his first ›Photo-Montages‹ concerning Contemporary History‹, which then appeared regularly, from 1930 to 1938, in the *AIZ. Arbeiter-Illustrierte-Zeitung* (Workers' Illustrated Newspaper) and after 1936 in the *Volks-Illustrierte* (People's Illustrated). In 1928, he became a member of the *ASSO*. In 1929, he took part in the International *Werkbund* exhibition *Film und Foto*. He emigrated to Prague in 1933, to London in 1938. In 1950, he moved to Leipzig, and in 1956 to East Berlin. In 1957, he received the National Prize of the GDR.

Ter Hell Painter
1954 Norden — lives in Berlin

Ter Hell began his studies at the Berlin Art College in 1976, completing them in 1981 as the master pupil of Fred Thieler. In 1979, together with Frank Dornseif and others, he founded the group of artists and self-help gallery *1/61,* the name of which derived from the postal code of the Berlin district of Kreuzberg in which it was situated. Between the opening exhibition in 1979 and the final exhibition in 1980, all the members of the group had a one man show in the gallery's rooms, the converted floor of a condemned factory building. In 1982, he lived in New York on a P.S. 1 grant awarded by the Senate for Cultural Affairs in Berlin. In 1982, he received the *Glockengasse* art prize from the city of Cologne, and in 1983 the Philip-Morris-Prize, Munich, awarded in the context of a competition and exhibition *dimension IV. Neue Malerei in Deutschland* (New Painting in Germany) held in Berlin, Munich and Düsseldorf. Ter Hell was represented in the exhibition *Ambiente Berlin* at the Biennale in Venice in 1990.

Peter Herrmann Painter
1937 Großschönau near Zittau — lives in Berlin

Herrmann began his training as a painter at the adult education centre in Dresden under the painter and film-maker Jürgen Böttcher. From 1955 onwards, he, Peter Graf, Peter Makolies and Ralf Winkler (A. R. Penck) were among Böttcher's circle of friends in Dresden. Before the erection of the Wall in 1961, Herrmann took part in an exhibition at the Academy of Arts in Berlin (West). A joint exhibition held at the Pushkin-House in Dresden in 1965 was closed down early by the artists after the organizers had attempted to remove controversial works. It was not until 1971 that his first one man exhibition took place at the *Lücke Frequentor* in Dresden. At the beginning of 1984, he emigrated to Hamburg, in 1986, he moved to West Berlin.

Hannah Höch Painter, photo-montager
1889 Gotha — 1978 Berlin (West)

Höch began her training in 1912 as a student of Harold Bengen at the School of Applied Art in Charlottenburg, Berlin, but was compelled to interrupt it by the outbreak of the First World War in 1914. She resumed it in 1915 at the teaching centre of the Arts and Crafts Museum in Berlin, in the specialist class for graphics taught by Emil Orlik. In the same year, she took on a part-time job as a pattern draftswoman for the needlework editor of Ullstein Publishers, where she remained an employee until 1926. From 1915 to 1922, she was a close friend of Raoul Hausmann, through whom she came into contact with the Berlin Dadaists. In 1918, they invented the technique of photo-montage. In 1919, she participated in the first Dada exhibition in Berlin in I. B. Neumann's cabinet of graphic art, and took part in the ›First International Dada Fair‹ in Berlin in 1920. She went on an ›Antidada-Merz-Tour‹ to Prague with Hausmann and Kurt Schwitters in 1921. She created two ›grottos‹ for Schwitters' *Merz*-construction in Hanover in 1922 and 1925. Hans Arp worked in her atelier during 1923. In 1924, she got to know Piet Mondrian through Theo van Doesburg in Paris. During 1924/25, she, Schwitters and Hans Heinz Stuckenschmidt worked together on stage sets and costumes for the unfinished ›Anti-Revue‹, *Schlechter und Besser* (Worse and Better). After 1926, she lived in The Hague with the Dutch authoress, Til Brugmann, and had close connections with the

De Stijl movement. They moved to Berlin together in 1929. Höch took part in the *Werkbund* exhibition in Stuttgart, *Film und Foto,* in 1929. A one woman exhibition planned at the Bauhaus in Dessau in 1932 was prevented from opening by the National Socialists in the state government. She and Til Brugmann separated in 1935. In 1939, she found refuge in a disused warden's house at a small airport in Heiligensee, Berlin. Here she was able to protect her considerable collection of works and documents by artist friends from the National Socialists, salvaging them throughout the war years. In 1961, she was a guest of honour at the Villa Massimo in Rome, and in 1965 she became a member of the Academy of Arts in Berlin.

K(arl) H(orst) Hödicke Painter,
filmmaker, object artist
1938 Nuremberg — lives in Berlin

After practical work in building construction, Hödicke began his study of architecture in 1959 at the Technical University in Berlin, but changed courses during his first semester, moving to the College of Fine Arts, where he studied painting under Fred Thieler. In 1961, he and Bernd Koberling joined the group of artists calling themselves *Vision,* Berlin and Munich, which had already existed for a year. He left the group a year before it dissolved, to become, in 1964, co-founder of the group of twelve artists named after the address of their gallery, *Großgörschen 35* in Berlin. The group's opening exhibition was also his first one man exhibition. In the same year, he received the Youth Art Prize of Mannheim. He left the gallery *Großgörschen 35* in 1965 together with Markus Lüpertz, Bernd Koberling and Lambert Maria Wintersberger. He spent time in New York during 1966/67 and began to produce experimental films. He was awarded a grant to the Villa Massimo in Rome in 1968. He has taught as a professor at the College of Fine Arts in Berlin since 1974. He has been a member of the Academy of Arts, Berlin since 1980. He was represented in the exhibition *Ambiente Berlin* at the Biennale in Venice in 1990.

Rolf Julius Drawer, musician, photographer, soundinstallation artist, concept artist
1939 Wilhelmshaven — lives in Berlin

From 1961 to 1966, Julius studied graphics at the School of Art in Bremen, then until 1969 at the College of Fine Arts in Berlin, becoming the master pupil of Friedrich Stabenau in 1968. His first one man exhibition took place during 1967 in the gallery Siegmundshof in Berlin. Between 1972 and 1975, he worked as an art teacher in Brake (Lower Weser) and during 1976/77 in Bremen. He began to work with the photographic medium in 1974. From 1975 onwards, he concerned himself with the combination of new music and visual art. During 1976, his photographic ›body‹ actions took place. In 1978, he returned to Berlin. From 1979 to 1982, he created endless series of minimalist photos, from 1979 onwards he produced compositions on sound tapes and musical installations. From 1980 onwards, he developed room concepts, objects with music and music actions; since then he has also made conceptual drawings. During 1980, he participated in the exhibition *Für Augen und Ohren* (For the Eyes and the Ears) at the Academy of Arts in Berlin. In 1980, he began to run his own tape and cassette producing company ›Julius Edition‹. In 1980/81, he arranged a ›Berlin Concert Series‹, with a private monthly musical activity in and for Berlin. Since 1982, he has produced tape compositions using electrical acoustic elements. In the same year, his first single appeared in the Gianozzo Edition, Berlin. From 1983 onwards, he created performances and independent drawings. During 1983, he spent time in New York with the P. S. 1 grant from the Senate for Cultural Affairs, Berlin, producing his *Concert for a Long Time* there. In 1984, he received a grant from the Bonn Art Funds. During 1984/85, he moved into an atelier in *Künstlerhaus Bethanien,* Berlin, where he created his *Musik für dieses Gebäude und den Platz davor* (Music for this Building and the Square in Front of it) and produced his L. P. *Lullaby for the Fishes.* He was awarded a working grant by the Senate for Cultural Affairs in 1986. He was represented at the documenta 8 in Kassel with a music installation. During 1989/90, he took part in the exhibition *Ressource Kunst. Die Elemente neu gesehen* [Resource Art. A New Way of Looking at the Elements) in Berlin, Saarbrücken, Munich and Budapest, and during 1990 in the exhibition *Blau: Farbe der Ferne* (Blue: The Colour of the Distance) in Heidelberg.

Alexander Kanoldt Painter
1881 Karlsruhe — 1939 Berlin

Kanoldt began his studies in 1899 at the School of Applied Art in Karlsruhe. He continued

them at the Karlsruhe Academy of Fine Arts, from 1901 to 1903 in the drawing class given by Ernst Schurth, from 1904 to 1906 in the painting class offered by Friedrich Fehr, becoming the latter's master pupil from 1906 to 1909. He moved to Munich in 1909 and was co-founder, with Adolf Erbslöh, Alexej von Javlensky, Vassily Kandinsky, Gabriele Münter and Marianne Werefkin, of the *Neue Künstlervereinigung München* (New Association of Munich Artists), which continued until 1912 and was the basis for the establishment of *Der Blaue Reiter* (The Blue Rider) in 1911. Kanoldt founded the *Münchner Neue Sezession* (New Secession Munich) together with Javlensky, Paul Klee and other artists in 1913, taking part in their exhibitions regularly until 1920 and 1924. He was in war service as an officer between 1914 and 1918. After 1918, he maintained his contacts with Munich, with Carlo Mense and Georg Schrimpf. He lived in Italy for long periods during 1924 and 1925. In 1925, Oskar Moll appointed him professor at the Academy of Fine and Applied Art in Breslau. In the same year, he took part in the exhibition organized in Mannheim by Gustav Friedrich Hartlaub, *Neue Sachlichkeit* (New Objectivity). Together with Carl Hofer, Rudolf Schlichter and Georg Scholz, he founded the *Badische Secession* in Freiburg in 1927. Tensions between Oskar Moll and Kanoldt led to the latter's resignation from his teaching post in Breslau in 1931. He opened a private school of painting in Garmisch. He became a member of the NSDAP in 1932 but was scorned as a ›degenerate‹ artist at the exhibition ›Government Art from 1918 to 1933‹ held in Karlsruhe in 1933. On the instigation of the National Socialists, he acted as director of the College of Fine Arts in Schöneberg, Berlin, from 1933 to 1936. The *Badische Secession* was forced to dissolve in 1936. He resigned voluntarily from his post as director and took on a master's atelier at the Prussian Academy of Art. In 1937 17 of his works were confiscated from public collections in the context of the National Socialist action concerning ›degenerate art‹. After his death in 1939, a memorial exhibition took place at the gallery of Günther Franke in Munich.

Joachim Karsch Sculptor, graphic artist
1897 Breslau — 1945 Großgandern near Frankfurt (Oder)

Karsch studied at the School of Applied Art in Breslau from 1911 to 1914. He continued his studies in Berlin during 1915/16, firstly at the School of Applied Art, then at the Art Academy under Peter Breuer. He was obliged to work in Silesia as an alternative to war service in 1918, returning to Berlin in 1919. He received the State Prize of the Prussian Academy of Arts in 1919 for his figurative group, *Hiob und seine Freunde* (Job and His Friends). He spent some time during 1922/23 earning his living as a factory worker for AEG, Schering and other firms. He moved to Hannsdorf near Glatz in Silesia in 1924. He then destroyed the major part of his work up until that date. He returned to Berlin in 1928. His first one man exhibition was at the Neumann-Nierendorf gallery in 1931. In 1932, he profited from a grant to the Villa Massimo. He met Gerhard Marcks in 1935. In 1938, some of his works in public collections were confiscated and disposed of as ›degenerate‹ by the National Socialists. Between 1938 and 1942, he made a living by designing prospectuses for publishing firms and by teaching life drawing at the School of Textiles and Fashion in Berlin. He moved to Gandern at the beginning of 1943. At the end of 1943, his atelier in Berlin was destroyed in an air raid, along with all his work which had remained there. His work stored in Gandern was also destroyed in the course of the Russian occupation. He and his wife chose to commit suicide rather than comply with the Russian deportation order from Gandern in 1945.

Herbert Kaufmann Painter
1924 Aachen — lives in Düsseldorf

From 1946 to 1950, Kaufmann studied painting under Werner Heuser and Heinrich Kamps at the Academy of Art in Düsseldorf. His first one man exhibitions took place between 1954 and 1956 in the gallery *Arnaud* in Paris. During 1954 and 1955, he exhibited at the *Salon des Réalités Nouvelles* in Paris. He has been a member of the Association of German Artists, Berlin, since 1956 and was their vice-president between 1982 and 1985. He led the *Gruppe 53* (Group 53) in Düsseldorf from 1957 to its disbanding in 1959. In 1955, the group had emerged from the *Künstlergruppe Niederrhein 1953* (Artists' Group, Lower Rhine 1953), and its members included Gerhard Hoehme, Albert Fürst, Winfried Gaul, Peter Brüning, Egon Kalinowski, Otto Piene, Heinz Mack and others. In 1958, Kaufmann created relief-like pictures, stone inlays, in 1959, his first collages, and in 1960, his first newspaper collages, which were layered. In 1959, he exhibited his collages at the Long Beach Museum of Art, Long Beach (Cali-

fornia/USA). He received the prize to promote artists from the state of North Rhine-Westfalia, Düsseldorf, in 1961. Between 1964 and 1970, with interruptions, his advertising pillars were produced. At first these were still in a collage technique, later he simply painted them. During 1964, he spent a month in New York. He taught painting at the College of Fine Arts in Berlin from 1967 to 1990. He has used negative film material in his collages since 1969. Since 1971, he has produced collages in acrylics. He has exhibited regularly with the *Neue Gruppe* (New Group), Munich, since 1976, since 1979 as a member. In 1977, he returned to pure collage techniques. In 1984, he developed his cardboard pictures. Since 1990, he has lived only in Düsseldorf.

Edmund Kesting Painter, photographer
1892 Dresden — 1970 Birkenwerder near Berlin

From 1911 until the beginning of his war service in 1916, Kesting studied at the Academy of Applied Art in Dresden. After the end of the First World War, he began to study 1918/19 at the Dresden Academy of Art under Richard Müller and Otto Gußmann, becoming the latter's master pupil until 1922. In 1919, he founded his own school of art in Dresden called *Der Weg — Neue Schule für Kunst* (The Way — New School of Art). In the same year, he developed his *Bildbauwerke*, pictorial reliefs created through the tension of the canvas, partly above and partly below the canvas stretcher — in some of these, found objects are mounted. In 1921, during a lecture in the gallery Arnold in Dresden, he met Herwarth Walden for the first time. Kesting's first one man exhibition then took place in Walden's gallery *Der Sturm* (The Storm). In 1924, he was represented at the First General Exhibition of German Art in Moscow. From 1926 onwards, he exhibited several times in the section *Die Abstrakten* (The Abstracts) at the Great Berlin Art Exhibition. In 1926, he founded his second art school, *Der Weg* in Berlin. Its first director was Lothar Schreyer, then Hans Haffenrichter in 1927 and in 1931, Hans Jaenisch. In 1930, he was represented at the exhibition *Das Lichtbild* (The Photo) in the section ›Film and Photo‹. During 1930/31, he moved from Dresden to Berlin. In 1933, he was forced to close his two art schools by the National Socialists; in addition, between 1933 and 1945, they forbade Kesting to exhibit and to paint. In this period — after his first photographic experiments had been with trans-

fer techniques around 1917 and with portrait and still life shots around 1929 — Kesting concerned himself increasingly with photographic art, photograms, photo-montage and the sandwich technique; he developed his own invention of ›chemical‹ painting. In 1937, twelve of his works were confiscated in the context of the Nazis' action against ›degenerate art‹. In 1945, he was organizer and co-founder, with Hermann Glöckner and others, of the group *der ruf — befreite kunst* (the call — liberated art). In 1946, he was among the organizers of the General Exhibition of German Art in Dresden. In 1946, he was appointed professor at the Art College in Berlin-Weißensee, and in 1956, he was nominated for a post at the German Academy of Film and Television in Potsdam-Babelsberg. His book, *Ein Maler sieht durchs Objektiv* (A Painter Looks through the Objective), was published in 1958. In 1961, he took part, for the first time after the Second World War, in an exhibition: *Europäische Avantgarde* (European Avant-Garde) *1919—1932* at the Palace of Charlottenburg in Berlin.

Edward Kienholz Concept, object and environment artist
1927 Fairfield (Washington) — lives in Berlin and Hope (Idaho)

Kienholz has never completed an academic education in art. Among his jobs after visiting several colleges, all for a brief period of time, were work in a hospital, as the manager of a dance-music group, a bar-owner, a window-dresser, a representative for vacuum cleaners, as assistant nurse in a clinic for the mentally ill, a restaurant owner and a representative for foreign cars. He moved to Los Angeles in 1953, and it was here that his first wooden reliefs appeared in 1954. He established the avant-gardist Now Gallery in 1956, but closed it again in 1957. In the same year, he and Walter Hopps opened the Ferus Gallery together. His first environment, *Roxy's*, named after a famous brothel in Las Vegas, was created in 1961. His first retrospective exhibition, in 1966 in the Los Angeles County Museum, was almost closed down early because of controversy which arose over his work. In 1972, he met Nancy Reddin, since then they have worked together. Since 1973, when he received a grant to work in Berlin from the German Academic Exchange Service, they have lived in Berlin for one half of each year. In 1975, he received a Guggenheim-Grant. In 1977, they opened The Faith and Charity in Hope Gallery in Hope (Idaho).

Their draft design *The Berlin Fountain* won them the first prize in a competition run by the Technical University Berlin in 1983, but its realization was forbidden by the council for town-planning of Charlottenburg and the Senator for Domestic Affairs in power at that time. In 1987, they took part in the project *Skulpturenboulevard* (Boulevard of Sculpture) in the course of Berlin's 750th anniversary celebrations. Their project, the *The Dumb Dumm Duel*, consisted of two building cranes in Germany's national colours and was intended for Adenauerplatz; the then governing Lord Mayor of Berlin felt that out of consideration for the GDR its realization should be prevented, and it did not come about. Kienholz was awarded the Arnold-Bode-Prize by the city of Kassel in 1989.

Nancy Reddin Kienholz Concept, object and environment artist
1943 Los Angeles — lives in Berlin and Hope (Idaho)

Nancy Reddin Kienholz, like Edward Kienholz, has not had academic training in art. After studying briefly at university and breaking off her studies, she worked in several jobs. These included legal reporter, medical assistant, salesperson, rodeo-rider, dog-trainer and photographer. She has worked together with Edward Kienholz on art projects since 1972, in 1979, they began to sign their work jointly. Both were represented in the exhibition *Ambiente Berlin* at the Biennale in Venice in 1990.

Klaus Killisch Painter
1959 Wurzen — lives in Berlin-Prenzlauer Berg.

Killisch has lived in Berlin (East) since 1971. After A-levels there he at first completed an apprenticeship as an electrician between 1976 and 1979, then studied painting under Heinrich Tessmer and Dieter Goltzsche at the College of Art in Weißensee, Berlin, from 1981 to 1986. He became a candidate for membership of the Association of Artists of the GDR in 1986. He has been a free lance artist since then. He has also taken part in collective exhibition projects with the artists Susanne Rast, Beata Palucka-Alvarez and Sabine Herrmann in Berlin (East), Stockholm and Dresden. In 1988, he was represented in the exhibition *Der eigene Blick. Berliner Kritiker zeigen Kunst ihrer Wahl* (Personal Viewpoint. Berlin Critics Show Art of their Choice) in Berlin (East). His first one man

exhibition took place in the avant-garde gallery *Eigen + Art*, Leipzig. In 1990, he was represented at the three day festival of art *L'autre Allemagne hors les Murs* in the Grande Halle de la Villette, Paris, and at the exhibition *Ambiente Berlin* at the Biennale in Venice.

Erika Klagge Sculptress
1953 Hamburg — lives in Berlin

Klagge studied sculpture under Jochen Hiltmann at the College of Fine Arts in Hamburg from 1975 to 1982, and under Monika Murash at the Berlin Art College during 1982/83. She moved into an atelier together with Susanne Bayer in 1984. In 1988, she and Marianne Pohl exhibited a joint work in the exhibition *Kunststück Farbe*, Berlin. She received a working grant from the Senate for Cultural Affairs, Berlin, in 1990. During 1990/91, she has been teaching sculpture (metal) in the department of art education at the Berlin Art College.

Bernd Koberling Painter
1938 Berlin — lives in Berlin

Between 1955 and 1958, Koberling completed his training as a cook, and worked in this job until 1968, the start of his financial independence as an artist. Whilst working as a cook, he also studied (from 1958 to 1960) at the College of Fine Arts in Berlin under Max Kaus. From 1959 onwards, he travelled frequently to Scandinavia, journeys which made a lasting impression. In 1961, together with K. H. Hödicke, he was a member of the group of artists known as *Vision* (Munich and Berlin), which existed from 1960 to 1964. Other members included Manfred Laber, J. A. Marxmüller and J. K. S. Hohburg. He lived briefly in Great Britain during 1961/62. In 1965, he had his first one man exhibition as a guest of the Berlin artists' co-operative gallery, *Großgörschen 35*. He received a grant to the Villa Massimo in Rome in 1969/70. He was awarded the prize of the Association of German Critics, Berlin, in 1970. He lived in Cologne from 1970 to 1974, and, after 1972, also in Berlin, where the development of his political consciousness through the students' movement in 1968 led to a period in which he was closely connected with the ›Maoist League against Imperialism‹. From 1976, he was a guest professor at the Academies of Art in Hamburg, Düsseldorf and Berlin, before being appointed a professor at the College of Fine Art in Hamburg in 1981. He was nominated

professor at the Berlin Academy of Art in 1988. He was represented in the exhibition *Ambiente Berlin* at the Biennale in Venice in 1990.

Issai Kulvianski Painter, sculptor
1892 Janova (Lithuania) — 1970 London

From 1908 onwards, Kulvianski studied at the School of Art in Wilna and worked independently at the Jewish trade school, ORT. He became a friend of Chaim Soutine. In 1912, he studied at the College of Fine Arts in Berlin under Hugo Kaufmann. He worked together with Max Liebermann and Hermann Struck. During 1913, he lived in the communal ateliers *La Ruche* in Paris, where he met Marc Chagall. He was called up as a soldier in the Russian Army in 1914 and in 1915 he was taken prisoner. As a prisoner of war, among other activities, he designed stage sets for the camp theatre. After his release in 1918, he returned to Berlin and worked with Leo von Koenig and briefly with Lovis Corinth. From 1920 onwards he had connections with the Berlin *Novembergruppe,* becoming a member in 1924, and taking part in their exhibitions until 1929. During 1927/28, he taught in Berlin schools. From 1927 to 1929, he worked as an illustrator for the *Radio-Zeitung* published by Hermann Reckendorf. He fled to Palestine from the Nazis in 1933, leaving his entire works behind, which, with only a few exceptions, were thus lost. In Tel Aviv in 1934/35, he taught, with Georg Leschnitzer, at his own private school of painting, and from 1937 to 1940 at a seminar for art teachers in Tel Aviv. He left Israel in 1950 and lived in France until 1968. In 1969, he returned to Berlin and died on a journey in London in 1970.

Walter Libuda Painter
1950 Zechau-Leesen — lives in Berlin

Between 1965 and 1968, Libuda completed an apprenticeship as a painter and varnisher in Altenburg; he then worked as a theatre painter at the State Theatre in Altenburg until 1971. He served in the ›Nationale Volksarmee‹ (People's Army) from 1971 to 1973. From 1973 to 1978, he studied under Dietrich Burger, Hans Mayer-Foreyt, Ulrich Hachulla, Bernhard Heisig, Gerhard Kurt Müller and Arno Rink at the College of Graphic Art and Book Design in Leipzig. During 1978/79, he was Heisig's master pupil there and during 1979/80, an assistant in basic courses. His first one man exhibition took place in the Graphic Club of the Intelligentsia in Zwickau in 1979. He worked as a free lance

painter in Leipzig between 1980 and 1982. He has been a member of the Association of Artists of the GDR since 1981. In the same year, he received the critics' prize in the annual exhibition, *100 ausgewählte Grafiken der DDR* (100 Selected Graphics of the GDR). During 1981, he made a short journey to Venice, in 1982 to the USSR. From 1982 to 1985, he was an assistant in basic and specialist courses at the College of Graphic Art and Book Design in Leipzig. In 1983, he was awarded the prize to promote up-and-coming artists given by the state art dealers of the GDR at the exhibition ›100 Selected Graphics of the GDR‹ and also the second prize in the competition, *Junge Künstler der DDR und der UdSSR* (Young Artists of the GDR and the USSR). In 1985, he moved from Leipzig to Berlin, since then he has worked in both these places alternately. During 1987, he travelled to the FRG, in 1988 to Finland. In 1988, he began to practise sculpture. During 1988, he participated in the exhibition *Zeitvergleich '88. 13 Maler aus der DDR* (Comparison of the Times '88. 13 Painters from the GDR), Berlin (West). In 1989, he travelled to the USA. In 1990, he and Hubertus Giebe represented the GDR at the Biennale in Venice, where he was also presented in the exhibition *Ambiente Berlin.*

Werner Liebmann Painter
1951 Königsthal (Thuringia) — lives in Berlin and Dresden

From 1969 to 1973, Liebmann completed studies in chemistry at the Martin Luther University in Halle/Saale, after which he worked until 1976 as a project engineer. After introductory practical experience in painting under Willi Neubert in Thale during 1976/77, Liebmann studied painting and graphics autodidactically at the Academy of Industrial Design, Burg Giebichenstein in Halle/Saale from 1977 to the completion of his diploma in 1982; here he entered into critical discussion with Hannes Wagner and Gudrun Brüne. His studies were accompanied by several threats of expulsion from the academy. In 1982, he became a candidate for membership of the Association of Artists of the GDR, in 1985, a full member. His first one man exhibiton took place in the Club House of the Trade Unions in Halle in 1983. From 1983 to 1986, he was the master pupil of Bernhard Heisig at the Academy of Graphic Art and Book Design in Leipzig; this grant enabled Liebmann to work independently despite the fact that the customary state support and aid

for young artists after study was denied him because of ›offences‹ against the prescribed course of study. He has taught introductory courses at the College of Fine Arts in Dresden since 1986. He moved to Berlin in 1987. In 1988, he participated in the exhibition *Zeitvergleich — 13 Maler aus der DDR* (A comparison of the times — 13 painters from the GDR) in Berlin (West) and in *Junge Kunst der DDR* (Young Art from the GDR), which was shown in Wilhelmshaven, Bremen and Emden. In 1990, he was represented at the exhibition *Ambiente Berlin* at the Biennale in Venice.

El Lissitzky Architect, typographer, painter
1890 Polschinok (Russia) — 1941 Moscow

Lazar Markovich Lissitzky studied architecture at the Technical University of Darmstadt from 1909 to 1914. When the war broke out he returned to Russia and gained his diploma as an architectural engineer in Moscow in 1918. In 1917, he became a member of the Department of Fine Art at the Commissariat for Public Education (IZO). In 1917, he designed street decorations for Moscow and the first Soviet flag. Marc Chagall appointed him professor of graphics, printing and architecture at the Free State Art Workshops in Vitebsk in 1919. Here he also worked with the group of artists called *Unovis,* newly founded by Kazimir Malevich. His first *Prounen* were created. In 1920, he became a member of the newly established Institute for Artistic Culture (INKhUK), and in 1921, the director of the faculty of architecture at the Higher State Workshops for Art and Technology (VKhUTEMAS) in Moscow. During 1921/22, he spent time in Berlin, and participated in the *Erste Russische Kunstausstellung* (First Russian Art Exhibition) organized by David Sterenberg, Nathan Altmann and Naum Gabo in the van Diemen gallery in 1922. In the same year, together with Ilja Ehrenburg, he published the journal *VESC-Objet-Gegenstand.* He became a member of the *Novembergruppe* and took part in their exhibitions between 1922 and 1929. In 1923, he took on the typographical design of Vladimir Majakovski's book *For the Voice.* Together with Kurt Schwitters, he published the *Nasci* magazine of the journal *Merz,* and with Hans Arp, in 1925, *Die Kunstismen.* During 1924/25, he designed the Moscow skyscraper project *The Cloud-Bow.* After two years residence in Brione, near Locarno, he was extradited from Switzerland in 1925 and returned to Moscow, where he taught interior design and furnishings in the faculty of wood and metal work at VKhUTEMAS. He continued to work as a typographer and designer of exhibition space — in 1926 he designed the *Raum der Gegenstandslosen* (The Room of the Non-Representationals) in Dresden, in 1927, the *Raum der Abstrakten* (Room of the Abstracts) in Hannover, in 1928 the Soviet pavillion in Cologne and in 1929, the space for the Soviet group at the exhibition *Film und Foto* in Stuttgart.

Markus Lüpertz Painter, author
1941 Reichenberg/Liberec (Bohemia/Czechoslovakia) — lives in Düsseldorf and Berlin.

Lüpertz studied at the School of Art and Craft in Krefeld under Laurens Goossens, and at the Academy of Art in Düsseldorf between 1956 and 1961 — with interruptions which included a year's work underground in the mining industry. He has been a free-lance artist since 1961. He moved to Berlin in 1962 and two years later, together with K. H. Hödicke, Wolfgang Petrick and Peter Sorge, he founded the artists' self-help gallery *Großgörschen 35,* leaving the project along with Hödicke and others in 1965. He formulated his own aesthetics of art in the *Dithyrambisches Manifest,* 1966. He was able to spend 1970 in Florence on a grant to the Villa-Romana. In 1971, he received the prize of the Association of German Critics, Berlin. From 1974 onwards he was a guest lecturer, and after 1976 a professor at the College of Fine Arts in Karlsruhe. His first volume of poetry *9×9* appeared in 1975. In 1977, he organized the first biennale exhibition in Berlin. In 1977, he and Georg Baselitz refused to take part in the documenta 6 in Kassel, as a protest against the participation of artists from the GDR, such as Bernhard Heisig, Wolfgang Mattheuer and Werner Tübke. He lectured as a professor at the Summer Academy in Salzburg during 1983. He spent a period of study in New York in 1984. He has been a professor at the Academy of Art in Düsseldorf since 1986, and since 1987 he has been its Vice-Chancellor. He was represented in the exhibition *Ambiente Berlin* at the Biennale in Venice in 1990.

Kazimir Severinovich Malevich Painter, architect
1878 Kiev — 1935 Leningrad

During 1895, Malevich studied at the art school in Kiev. From 1896 to 1904, he lived and work-

ed in Kursk as a technical draftsman for the railways. His first impressionist pictures were painted between 1903 and 1905. During 1904/05, he studied at the School of Painting, Sculpture and Architecture in Moscow. In 1905, he participated in the struggles at the barricades during the First Russian Revolution. From 1905 to 1910, he studied in the private atelier of Fedor Rerberg in Moscow. During 1907, he participated for the first time in an exhibition of the Moscow Association of Artists, together with Vladimir Burliuk, Natalya Goncharova, Vassily Kandinsky and Mikhail Larionov among others. During 1910/11, he painted primitivist pictures, between 1911 and 1914, he developed — building from the principles of Cubo-Futurism — ›alogical‹ pictures. In 1910/11, 1914, 1916 and 1917, he exhibited with the group of artists *Jack of Diamonds* in Moscow. In 1912, he was represented at the second exhibition of *Der Blaue Reiter* (The Blue Rider) in Munich. In 1912, he became a friend of Mikhail Matiushin. In 1913, he became a member of the *Union of Youth* in Petersburg together with David and Vladimir Burliuk and Vladimir Tatlin, but left with Tatlin in 1914. In 1913, the futuristic opera *Victory over the Sun* was conceived and performed in the Luna Park Theatre in Petersburg, for which Malevich designed the costumes and the stage sets. In 1914, Malevich met Filippo Tommaso Marinetti during the latter's visit to Russia. In the same year, he took part in the exhibition in the Salon des Indépendants in Paris. In 1915, he painted his first suprematist pictures, and his leaflet *From Cubism to Suprematism in Art, to New Realism in Painting, to Absolute Creation* appeared. In 1915, he participated in the first futurist exhibition, *Tramway V,* organized by Iwan Puni and Xenia Boguslavskaya in Petrograd and in 1915/16, in the final *0,10* in Petrograd, at which his picture *Black Square on a White Background* was shown. During 1916, Malevich and Puni gave lectures on ›Cubism, Futurism, Suprematism‹ at the Tenichevskij School and The Subov Institute for Art History in Petrograd. In 1916, he also took part in the exhibition *The Store,* organized by Tatlin in Moscow. During the same year, he was called up to the Russian Army. In 1917, he was accepted as a member of the *Federation of Leftist Artists* and was elected as president of the department of fine art in the Moscow soviet of military deputies. In 1918, he published some articles on the politics of art in the Moscow magazine *Anarkhija.* In 1918, he was appointed professor at the Free State Workshops (SVOMAS) in Petrograd. In the same year, he

designed the scenery for Vladimir Majakovsky's play *Mystery Bouffe,* directed by Wsewolod Meierhold in Petrograd. In 1919, he returned to Moscow and took over a painting studio and a textile studio at the SVOMAS. In the same year, he moved to Vitebsk at the invitation of Marc Chagall, becoming the latter's successor as director of the art school there. There he published his theoretical essay *Concerning New Systems in Art.* In 1919/20, his first one man exhibition took place in Moscow. In Vitebsk during 1920, he initiated the founding of the group UNOVIS (Affirmers of the New Art), to which El Lissitzky, Ilja Chashnik, Nicolai Suetin and Nina Kogan belonged. In 1920, Malevich produced their *Suprematist Ballet.* In 1920, he also gave lectures ›on the new art‹ in Smolensk and published his leaflet *Suprematism. 34 Drawings.* He returned to Petrograd in 1922. He was represented at the ›First Russian Art Exhibition‹ in the van Diemen gallery in Berlin during 1922. In 1923, he published his manifesto *The Suprematist Mirror.* Together with members of UNOVIS, he developed models of suprematist architecture, which he called *planity* (1923) and *arkhitektony* (1925). He became the director of the Museum for Artistic Culture (MKhk) in Petrograd, beginning to reorganize it in 1923, so that five departments emerged; for formal and technical systems in painterly culture under Malevich's own directorship, for organic culture under Matiushin, for material culture under Tatlin, for experiments under Pavel Mansurov, and for general methodology under Pavel Filonov, later under Nikolai Punin. In 1924, he gave his lecture ›On the additional element in art‹ there. In 1924, the Museum for Artistic Culture was changed into the Institute for Artistic Culture (INKhUK), and Malevich became its director; in 1925, it was recognized by the state (GINKhUK). At the beginning of 1926, he was released from his duties as director of the GINKhUK, which was then disbanded at the end of that year. In 1927, he travelled to Warsaw and on to Berlin, where he spent two months during the special exhibition *Kazimir Malevich* at the ›Great Berlin Art Exhibition‹. At Bauhaus in Dessau, he met Walter Gropius and Laszlo Moholy-Nagy, who arranged for Malevich's *Introduction to Suprematism and the Additional Element in Art* to be published in the series of Bauhaus books. After his return from Germany in 1927, he worked two years at the State Institute for the History of Art in Leningrad. In 1927, together with Chashnik and Suetin, he designed satellite towns for the area surrounding Moscow. In 1929, he returned to represen-

tative painting. In 1930, he was the victim of repression. In 1932/33, he was the director of the Experimental Laboratory at the Russian State Museum in Leningrad.

Marwan (Kassab-Bachi) Painter
1934 Damascus (Syria) — lives in Berlin

Initially, Marwan studied Arabic Studies from 1955 to 1957 at the University of Damascus and then painting at the College of Fine Arts in Berlin from 1957 to 1963, completing his training as a master pupil of Hann Trier. He has been a free-lance artist in Berlin since 1963. Whilst still in Damascus, he was awarded the first prize for sculpture given by the autumn salon there, and in Berlin in 1966, he received the prize awarded by the Carl-Hofer-Society. He spent time in Paris in 1973 with a grant from the Cité Internationale des Arts. He taught at the Berlin Art College as a guest professor from 1977 onwards, and was nominated professor in 1980. He was represented in the exhibition *Ambiente Berlin* at the Biennale in Venice in 1990.

Martin Matschinsky Sculptor
1921 Grötzingen (Baden) — lives in Berlin

Between 1938 and 1840, Martin Matschinsky completed an apprenticeship as a photographer in Karlsruhe. He was called up to military service in 1940, and was held a prisoner of war until 1947. Between 1948 and 1950, he trained as an actor at the Otto-Falckenberg-School in Munich. He worked as an actor in various theatres from 1950 to 1954, finally at the State Theatre in Darmstadt, where he met Brigitte Denninghoff. They moved to Munich together in 1954, and since 1955 they have worked together on art projects, still using her technique of soldering brass bars together, or the welding of chromium nickel steel pipes. Both were represented in the exhibition *Ambiente Berlin* at the Biennale in Venice in 1990.

Brigitte Matschinsky-Denninghoff
Sculptress
1923 Berlin — lives in Berlin

Brigitte Matschinsky-Denninghoff studied one semester course at the College of Fine Arts in Berlin in 1943 and one semester at the Academy of Fine Arts in Munich under Toni Stadler

during 1946. In 1948, she became Henry Moore's assistant in England and in 1949/50, with a grant from the Solomon-Guggenheim-Foundation, New York, she was Antoine Pevsner's assistant in Paris. In 1949, she was the only sculptress along with six painters — among them Willi Baumeister, Rolf Cavael, Rupprecht Geiger and Fritz Winter — to co-found the group *ZEN 49* in Munich, taking part regularly in their exhibitions from 1950 to 1956/57. She worked as a stage designer at the State Theatre in Darmstadt during 1953/54, where she met Martin Matschinsky, with whom she has worked together since 1955. At Winter's suggestion, she ran the department of sculpture at the Academy of Art and Craft in Kassel as a guest lecturer during 1957/58. She and Matschinsky took part in the documenta II in Kassel in 1959. They were awarded the Prix Bourdelle, Paris in 1959. In 1961, they moved to Paris from Munich, where they had lived since 1954. They took part in the Biennale in Venice in 1962, and in the documenta III in Kassel in 1964. They have lived in Berlin since 1970. In the context of the project *Skulpturenboulevard* (Boulevard of Sculpture) during Berlin's 750th anniversary celebrations, their sculpture *Berlin* was erected on Tauentzienstraße.

Harald Metzkes Painter
1929 Bautzen — lives in Berlin

Metzkes was called up to war service as late as March 1945 and was an American prisoner of war for a short time. He began to paint in 1946 and took his first lessons with the water-colour painter, Alfred Herzog. He trained as a stone mason under the sculptor Max Rothe in Bautzen from 1947 to 1949. From 1949 onwards, he studied painting at the College of Fine Arts in Dresden, under Rudolf Bergander and Wilhelm Lachnit. After completing this training, he lived as a free-lance artist in Bautzen from 1953 onwards. He took up his studies again from 1955 to 1958 as the master pupil of Otto Nagel at the German Academy of Arts in Berlin. It was during this period, in 1957, that he undertook a journey to China together with Werner Stötzer and John Heartfield. After 1958, he worked as a free-lance artist again. In 1976, he was awarded the Käthe-Kollwitz-Prize by the Academy of Arts in the GDR and in 1977, the National Prize of the GDR. He has taken part in the Biennale in Venice three times, in 1984, 1986 and 1988. He became a member of the Academy of Arts in the GDR in 1986.

Helmut Middendorf Painter, experimental film-maker, musician
1953 Dinklage — lives in Berlin and Athens

Between 1970 and 1974, Middendorf worked together with Gregor Espelage as a guitarist und multi-media artist. From 1973 to 1979, he studied under K. H. Hödicke at the College of Fine Arts in Berlin, becoming his master pupil. His first film experiments were during this period. Still in the course of his studies in 1977, he and Rainer Fetting were co-founders of the gallery at Moritzplatz, which existed until 1981. He was guest lecturer in experimental film at the Berlin Art College from 1979 to 1981. Together with Fetting and Bernd Zimmer, he created murals for the concert hall SO 36 in Kreuzberg, Berlin. Together with Fetting and others, he took part in the exhibition *Heftige Malerei* (Impetuous Painting) at the *Haus am Waldsee* in Berlin in 1980. During the same year, he received a one year grant from the German Academic Exchange Service for a period of study in New York.

Otto Möller Painter
1883 Schmiedefeld (Thuringia) — 1964 Berlin (West)

From 1904 to 1907, Möller studied under Philipp Franck at the Art School in Berlin. During 1907/08, he took lessons from Lovis Corinth. In 1911 and 1912, he participated in the exhibitions of the *Berliner Secession*. In 1909, he himself began teaching in Berlin schools. He completed war service between 1915 and 1918. He was a member of the *Novembergruppe* from 1919 to 1932 and frequently took part in their exhibitions. After 1920, he worked for several years at the Berlin Central Institute together with Bernhard Hasler, drafting a reform of art teaching methods in Berlin. From 1920 to 1940, he was appointed to teach methodics and paedagogics at the Academy of Art Education in Schöneberg, Berlin. He was forbidden to work and to exhibit between 1933 and 1945. From 1946 to 1955, he was a professor of art education at the College of Fine Arts in Berlin.

Hermann Nonnenmacher Sculptor
1892 Coburg — 1988 London

Nonnenmacher completed an apprenticeship as a sculptor in wood, and then studied at the School of Applied Art and the Academy of Art in Dresden. He lived as a free-lance artist in Berlin from 1919 to 1938. In 1931, he won the first prize in a competition to design a large sculpture for the outer façade of a state swimming baths; but this work was destroyed by the Nazis. He emigrated to London in 1938 with his Jewish wife, Erna Nonnenmacher, also a sculptress. He was lecturer in modelling and pottery at Morley College from 1948 to 1970.

Felix Nussbaum Painter
1904 Osnabrück — 1944 Auschwitz

After moving to Berlin in 1923, and attending the private Lewin-Funcke School of Art where he studied under Willy Jaeckel, Nussbaum was accepted by the Combined State School for Fine and Applied Art in 1924 and became a pupil of Paul Plontke and César Klein. He had the first one man exhibition in 1927, in gallery Casper in Berlin. He spent time studying in Belgium and France during 1928/29. He was master pupil of Hans Meid from 1928 to 1930. He was awarded the Villa Massimo grant to Rome in 1932/33. The National Socialists caused a fire in his Berlin atelier in 1933, destroying about 150 of his works. They withdrew his grant earlier than due, and Nussbaum left for Alassio in 1933 after anti-semitic incidents at the Villa Massimo. He spent 1934 in Rapallo. From 1935 onwards he lived in Ostende, where he was in contact with James Ensor, and after 1937 he lived in Brussels. In 1938, he participated in the exhibition of the *Freier Künstlerbund* (Free Federation of Artists) in Paris. When German troops invaded the Netherlands, Belgium, Luxembourg and France in 1940, Nussbaum was interned as an enemy alien in a camp in Saint-Cyprien in the South of France. During transportation to Bordeaux, still during 1940, he was able to make his escape to Brussels. He went underground, only to be arrested by the Nazis in 1944 as a result of deliberate denunciation. He was murdered in Auschwitz by the Nazis, having been sent there from Belgium on the last deportation train before the liberation of Europe by the Allies.

Achim Pahle Sculptor
1949 Darmstadt — lives in Berlin

Pahle studied at the College of Fine Arts in Berlin from 1969 to 1975, becoming the master pupil of Helmut Lortz in 1975. He has worked together with the sculptor George Rickey since

1972. In 1974, he received a grant to the Skowhegan School of Painting and Sculpture, Skowhegan (Maine/USA). During 1975/76, he lectured at the Berlin Art College, also working there as an art assistant from 1976 to 1979. He was awarded a fellowship by the Hand-Hollow-Foundation in East Chatham (New York) in 1984, in the context of a grant from the German Academic Exchange Service. In 1987, he was a fellow of the Djerassi Foundation in Woodside (California/USA). He was commissioned to design a square and fountain in Charlottenburg, Berlin in 1989.

Wolfgang Petrick Painter
1939 Berlin — lives in Berlin

Petrick began his study of painting at the College of Fine Arts in Berlin in 1958 and completed it in 1965 as the master pupil of Werner Volkert. During 1959/60 he also studied biology at the Free University in Berlin. In 1964, he was co-founder of the exhibiting association *Großgörschen 35* in Berlin, from which the Critical Realists — Petrick, Hans-Jürgen Diehl, Peter Sorge and others — seceded in 1967. He received the Prize for Painting from the city of Wolfsburg in 1969, a grant from the Cité Internationale des Arts in Paris in 1971 and a gold medal at the 3rd Biennale Internazionale della Grafica in Florence in 1972. He was involved in the establishment of the group of artists known as *Aspekt* in 1972, leaving the group in 1978. During 1973 and 1974, he created stage sets for August Stramm's *Rudimentär* and Hartmut Lange's *Trotzki in Coyoacan* at the *Forum-theater* in Berlin. He was taught at the Berlin Art College as a professor since 1975. In 1976, he received the Art Prize of Berlin from the Academy of Arts, Berlin, in which a grant is also included. In 1981, he was awarded the Prize of the Association of German Critics, Berlin. He was represented in the exhibition *Ambiente Berlin* at the Biennale in Venice in 1990.

Iwan Puni Painter
1894 Kouokkala (Finland) — 1956 Paris

From 1910 to 1912, Puni studied firstly at the Académie Julian, and then at other private academies in Paris. He returned to Petersburg in 1913 and made contact with Vladimir Burljuk, Kazimir Malevich, Vladimir Tatlin and others through the artists association *Union of Youth*, with whom he exhibited in 1911 and 1913. He took part in the first futurist exhibition in Petrograd in 1915, *Tramway V*, and in 1915/16 in the final *0,10*. During this exhibition, he and his wife, Xana Boguslavskaja, signed Malevich's *Suprematist Manifesto* along with Ivan Kljun and Michail Menkow. In 1916, together with Malevich, Michail Larionov and others, he took part in the exhibition of the association of artists *Jack of Diamonds* founded in 1910. In 1918, he designed posters for the first of May and for the first anniversary of the Russian Revolution, and was nominated as a lecturer at the Free State Workshops in Petrograd and in 1919, he was appointed to those in Vitebsk by Marc Chagall. He emigrated to Finland for political reasons in 1919, after imprisonment he emigrated to Berlin via Danzig in 1920. He exhibited in Herwarth Walden's gallery *Der Sturm (The Storm)* in 1921; at the gallery's opening, he organized an advertising parade through Berlin of ›sandwich-men‹ in cubist costumes he had designed himself. In the same year, he created his *Synthetic Musician*. In 1922, he took part in the *Erste Russische Kunstausstellung* (First Russian Art Exhibition) organized by David Sterenberg, Nathan Altmann and Naum Gabo in the van Diemen gallery in Berlin. He exhibited with the *Novembergruppe* in Berlin from 1922 to 1924 and in 1926. He became a friend of Hans Richter, Viking Eggeling, Raoul Hausmann, Theo van Doesburg and Rudolf Belling. In 1924 he moved to Paris permanently.

Raffael Rheinsberg Sculptor, concept, object and environment artist
1943 Kiel — lives in Berlin

Rheinsberg completed an apprenticeship as a metal moulder and caster in Kiel between 1958 and 1961. He made his first artistic attempts in the techniques of collage and frottage in 1959. In 1970, he moved into the condemned residential and office building *Sophienblatt* in Kiel, and converted it into the environment *Museum Sophienblatt* during the years up to 1979. He studied sculpture under Winfried Zimmermann at the Training College for Design in Kiel from 1973 to 1979. He has lived in Berlin since 1979. He had a grant to the *Künstlerhaus Bethanien* in Berlin from 1979 to 1982. In 1983, he was awarded the P.S. 1 grant to New York from the Senate for Cultural Affairs in Berlin. Rheinsberg received the Art Prize of Berlin (to promote ›young‹ art) from the Academy of Arts,

Berlin and the prize from the Association of German Critics, Berlin, in 1984. In 1988, he received the Cultural Award of the city of Kiel. He was represented in the exhibition *Ambiente Berlin* at the Biennale in Venice in 1990.

Martin Riches Architect, object and installation artist, composer
1942 Isle of Wight (GB) — lives in Berlin

Riches studied at the Architectural Association in London, moving from there to Berlin in 1969. In Berlin, he at first worked in films, in the theatre and as an architect. Since 1972, he has experimented with kites to which stereo cameras are attached, and with machines which carry out human functions, such as *Walking Machines* and *Drawing Machines*. His first music machine was created in 1979/80, the *Flute-Playing Machine,* for which other musicians or composers, such as Eberhard Blum, Charles Boone, Tom Johnson, Roland Pfrengle and Schaun Tozer have also written music. Since then he has worked only on music machines, sound objects and sound installations. In 1982 and in 1990, he was awarded working grants from the Senate for Cultural Affairs.

Angelik Riemer Painter
1948 Kiel — lives in Berlin

From 1966 to 1972, Angelik Riemer studied painting at the College of Fine Arts in Berlin, becoming the master pupil of Hann Trier in 1971. Since 1968, she has also worked with Super-8 films. In 1970, she received a grant from the Educational Foundation of the German People, Bonn. Her first one woman exhibition took place in 1971 at the Clytie Jessop Gallery, London. She has taken part in the exhibitions of the German Association of Artists, Berlin, since 1971. During 1972/73, she spent time at the Slade School of Fine Arts in London with a grant from the Educational Foundation of the German People, Bonn, and studied under Bartholomäus dos Santos. From 1975 to 1981, she continued to paint her egg tempera pictures with representational themes; plants in a spatial context. At the same time, she experimented with black and white photography between 1978 and 1980. During a one month stay in New York during 1979, she made the Super-8 film, *New York 1979.* Since 1982, she

has worked in a non-representational style, with Paris Blue dominating her pictures. Her work is concerned with the problem of colour and space — until 1984, it was constructivist, between 1985 and 1989 expressive in style, since 1990, the constructivist style has returned. In 1990, she took part in the exhibition *Blau. Farbe der Ferne* (Blue. Colour of the Distance) in Heidelberg.

Alexander Mikhailovich Rodchenko
Painter, graphic artist, photographer
1891 Petersburg — 1956 Moscow

From 1910 to 1914, Rodchenko attended the art school in Kazan and studied under Nikolai Feshin and Grigorii Medvedev. Alongside his studies, he painted decorations and taught drawing himself. He became a close friend of Varvara Stepanova, whom he married in 1913. In 1914, he moved to Moscow and studied for two years in the department of graphics at the Stroganov School of Applied Art before being called up as a medical orderly in 1916. In 1915/16, he got to know Vladimir Tatlin, Ljubov Popova and Kazimir Malevich in Moscow. During 1916, he participated in the exhibition *The Store* in Moscow, organized by Tatlin. In 1917, he was amongst the organizers of the Union of Artists, becoming the secretary of its Youth Federation. Together with Tatlin, Georgii Yakulov and others, he designed and created the Café Pittoresque in Moscow. In 1918, he worked as the director of the museums' office and as a member of the acquisition commission in the department of visual art at People's Commissariat for Education NARKOMPROS. He was a founding member of the Museum of Artistic Culture (MKhK). His first spatial constructions emerged in 1918. From 1918 to 1926, he taught the theory of painting in the atelier of the Moscow Organization for Proletarian Culture. In 1919, together with Olga Rosanova, he directed the subsection of art and production in the department of fine art at NARKOMPROS. His first collages were created in 1919, the first photo-montages in 1921. From 1920 to 1924, he was a member of the Institute for Artistic Culture (INKhUK), founding and organizing the Working Group of Constructivism within it in 1921, together with Alexander Gan and Stepanova. In 1921, he participated in the Moscow exhibitions *Obmochu* and $5 \times 5 = 25$ with monochrome pictures and mobiles. In 1921, he proclaimed the end of

painting. From 1920 to 1930, he was professor at the Higher Artistic Technical Workshops (VKhUTEMAS) and from 1926 onwards, at the Higher Artistic Technical Institute (VKhU-TEIN) in Moscow; he became the dean of the faculty of metalwork there in 1922. In 1922, he was represented at the ›First Russian Art Exhibition‹ in the gallery van Diemen in Berlin. In 1923, he began producing typographical work for various publishers. In 1923, he used photomontages to illustrate *Pro Eto* (About This) by Vladimir Majakovski, whom he had known since 1920. Under the latter's editorship, he was a member of the editorial committee and a regular contributor to the journal *LEF* from 1923 to 1925 — and to the follow up publication *Novyi LEF* during 1927/28. In 1924, Rodchenko began to take photographs himself. In 1925, he took on the decoration of the workers' club room in the Soviet pavillion at the *Exposition Internationale des Arts Décoratifs et Industriels Modernes* in Paris. Between 1926 and 1928, he worked as a costume and sets designer for several films. From 1928 to 1932, he was the author of photographic reports for various magazines. In 1929, he designed the costumes and sets for Igor Glebov (= Boris Assafjev)'s play *Inga* at the Revolutions-Theatre and for Majakovsky's play ›The Bedbug‹ at Vsevolod Meierhold's theatre. In 1930, he was one of the organizers of the artists' group OKT-JABR, from which he was expelled in 1932. During 1932, he taught photography at the Polygraphic Institute in Moscow. From 1933 to 1941, he contributed to the journal ›The USSR in Construction‹. Together with Stepanova, he published several photographic albums between 1934 and 1947. In 1935, he began to paint again, and in the years up until 1941, he created a series of pictures with circus motifs. In 1941, he was evacuated from Moscow to Perm and Otcher; during 1941/42, he worked in an artists' brigade there which made propaganda posters for the ›great patriotic war‹. In 1942, he returned to Moscow. In 1944, he became the artistic director of the House of Technology in Moscow. During 1955, he and Stepanova worked on sketches for Majakovski's poem *Choroscho!* (Good!).

Christian Schad Painter
1894 Miesbach (Upper Bavaria) — 1982 Keilberg near Aschaffenburg

Schad studied during 1913/14 under Heinrich von Zügel and Carl Johann Becker-Gundahl at the Academy of Art in Munich. His first woodcuts emerged in 1913. From 1915 onwards, he contributed to Franz Pfemfert's journal *Die Aktion*. He avoided conscription to war service in 1915 by pretending illness. He lived in Switzerland from 1915 to 1920, initially in Zurich, where he met Hans Arp, Hugo Ball, Leonhard Frank and Ludwig Rubiner, and became a close friend of the author Walter Serner, to whose journal, *Sirius,* he contributed in 1915/16. After 1916, he lived in Geneva, and together with Serner, he ran the Geneva centre of the Dada movement. In 1919, he created a series of photogrammes, or ›Schadographs‹, a technique of photography without a camera which was also rediscovered by Man Ray and Laszlo Moholy-Nagy. In 1919/20, he created wooden reliefs and relief assemblages. Between 1920 and 1925, he lived mainly in Rome, where he met Julius Evola, and in Naples, but also briefly in Munich, Paris and Berlin, and then in Vienna until 1927. He finally moved to Berlin in 1928, having spent most of his time there since 1927. The works he offered to the *Große Berliner Kunstausstellung* (Great Berlin Art Exhibition) in 1934 were rejected. He worked as a salesman in a Berlin brewery from 1935 to 1942. He joined the Association of Berlin Artists in 1936, taking part in their exhibitions regularly until 1942. During 1938/39, after concerning himself with Asiatic philosophy and letters, he studied Chinese at the Humboldt University. His atelier in Berlin was badly damaged during an air raid in 1943. He finally moved to Aschaffenburg in the same year, having lived there since 1942. After 1962, he lived in Keilberg.

Hans Scheib Sculptor
1949 Potsdam — lives in Berlin

After A-Levels, an apprenticeship as a typesetter and his military service in the ›Nationale Volksarmee‹ (People's Army) between 1966 and 1971, Scheib completed his study of sculpture at the College of Fine Arts in Dresden from 1971 to 1976. From 1976 onwards, he was a member of the Association of Artists of the GDR, which he left in 1984. He lived as a free-lance sculptor in Prenzlauer Berg in East Berlin from 1976 to 1985. In 1982, he worked together with Anatol Erdmann and Stefan

Reichmann on an anti-war sculpture in Trepto-wer Park (East Berlin). He moved to West Berlin in 1985.

Rudolf Schlichter Painter
1890 Calw — 1955 Munich

From 1904 to 1906, Schlichter was an apprentice enamel painter in Pforzheim, but broke off his studies before completion. From 1907 onwards, he attended the School of Applied Art in Stuttgart, from 1910 onwards, the Academy in Karlsruhe, where he studied under Walter Georgi, Caspar Ritter, Wilhelm Trübner and Walter Conz. He was called up to war service in 1916 as a munitions commander, but was discharged after a hunger strike. In 1919, he and Georg Scholz founded the group *Rih* in Karlsruhe, which considered itself the local branch of the Berlin *Novembergruppe*. After moving to Berlin in 1919, he became a member there. In the same year, he also became a member of the KPD (German Communist Party). He joined the Berlin Dada movement and took part in the *Erste Internationale Dada-Messe* (First International Dada Fair) in 1920. When works by Schlichter and Dix were removed from the *Große Berliner Kunstausstellung* (Great Berlin Art Exhibition) in 1920, not only Schlichter and Dix, but also Raoul Hausmann, Georg Grosz, Hannah Höch, Georg Scholz and others declared their withdrawal from the *Novembergruppe* in a public letter. Schlichter was co-founder, with Grosz and Heartfield, of the *Rote Gruppe* (Red Group) in Berlin in 1924. In 1925, he took part in the exhibition *Neue Sachlichkeit* (New Objectivity) in Mannheim. In 1928, he joined the ASSO. He was a contributor to satirical and left-wing journals such as *Der Gegner* (The Opponent), *Der Knüppel* (The Cudgel), *Die Rote Fahne* (The Red Flag), *Eulenspiegel,* and *Arbeiter-Illustrierte-Zeitung.* Among his friends during the twenties were Bertolt Brecht, Egon Erwin Kisch, Oskar Maria Graf, Alfred Döblin, and after the beginning of the thirties, Ernst Jünger and Arnolt Bronnen. In 1932, he moved to Rottenburg on the Nekkar, in 1935 to Stuttgart. The National Socialists banned Schlichter from exhibiting. In 1937, 17 of his works were removed from public collections and some were shown at the exhibition ›Entartete Kunst‹ (Degenerate Art) in Munich. He was interned for three months during 1938 after being accused of ›Anti-National-Socialist conduct‹. He moved to Munich in 1939. His flat and his atelier were destroyed in an air raid in 1942. He was conscripted to service in the arms industry as late as 1943.

Georg Scholz Painter, graphic artist
1890 Wolfenbüttel — 1945 Waldkirch

From 1908 to 1914, Scholz studied at the Academy of Fine Arts in Karlsruhe, from 1912 to 1914, under Hans Thoma and Wilhelm Trübner, becoming the latter's master pupil in 1912. During this period, between 1912 and 1914, he also studied one semester under Lovis Corinth in Berlin. Around 1914, he came into contact with Rudolf Schlichter, Karl Hubbuch and Willi Müller-Hufschmid. From 1915 to 1918, he was an infantryman in the First World War. In 1919, he moved to Grötzingen near Karlsruhe as a free lance artist. He became a member of the German Communist Party in the same year. In 1919, Scholz was one of the founders of *Gruppe Rih,* which existed until 1920 and was a local Karlsruhe branch of the Berlin *Novembergruppe* and included Oskar Fischer and Rudolf Schlichter. In 1920, John Heartfield and George Grosz persuaded him to exhibit his oil painting collage *Industriebauern* (Industrial Farmers) at the ›First International Dada Fair‹, which led to a question in the German Reichstag. He had contact with Otto Dix, George Grosz, John Heartfield, Alexander Kanoldt, Georg Schrimpf and Carl Hofer. In 1920, he was among those who signed the *Offener Brief an die Novembergruppe* (Public letter to the Novembergruppe) written by the *Opposition der Novembergruppe,* to which Raoul Hausmann, Hannah Höch, Dix and Schlichter belonged. The letter was published in the journal *Der Gegner* (The Opponent) in 1920/21. To earn a living, Scholz designed cigar packets and illustrated books, such as Daniel Defoe's *Robinson Crusoe,* Abel & Müller, Leipzig 1920, Miguel de Cervantes' *Don Quixote de la Mancha,* Abel & Müller, Leipzig 1921, and Johann Jakob Christoffel von Grimmelshausen's *Simplicissimus,* Abel & Müller, Leipzig 1922. In 1922, two of his works in the section of the *Novembergruppe* at the ›Great Berlin Art Exhibition‹ were officially confiscated. In 1923, Scholz became an assistant in the graphics department at the Academy of Fine Arts in Karlsruhe, in 1924, he was director of the preparatory class for the painting classes, and in 1925, he became a professor in the newly established class of nature drawing, taking over its directorship in 1926. In 1925, he participated in the exhibition *Neue Sachlichkeit* (New Objectivity) in Mannheim. In 1926, he became a regular contributor to the illustrated weekly journal *Der Simplicissimus* in Munich. He got to know the sculptor Christoph Voll in 1929. In 1932, he designed, together with Bruno Paul and oth-

ers, the stand for the IG-Farben AG at the agricultural exhibition in Berlin. In 1933, under the National Socialists, he was obliged to take compulsory leave from his teaching position at the Academy of Arts in Karlsruhe. In the same year, he moved to Haßmersheim. In order to earn a living, he took on commissions from a military museum in Karlsruhe (1933), for altar pictures in the St. Urban Church in Freiburg (1936/37), for frescos at the Dragoons' House in Müllheim (1937) and for an officers' casino in Böblingen (1939). In 1935, Scholz converted from the Evangelical to the Catholic faith. In the same year, he moved to Waldkirch near Freiburg. In the course of the National Socialists' campaign against ›degenerate art‹ in 1937, many of his works were confiscated from public collections. From 1940 onwards, Scholz lived chiefly from portrait commissions. In 1942, he began to write his novel, *Anton Bundschuh.* In 1945, the French military government appointed him mayor of Waldkirch.

Stefan Schröter Painter
1954 Wedel (Holstein) — lives in Berlin

At first, Schröter studied under Gisela Bührmann at the College of Design in Hamburg from 1973 to 1976, afterwards, from 1976 to 1981, he studied painting under Klaus Fußmann at the Berlin Art College, becoming his master pupil in 1980. Between 1982 and 1984, he received an atelier grant from the Karl Hofer-Society, and his first one man exhibition took place in their gallery in 1984. In 1987, Schröter was awarded the prize of the Darmstadt Secession, and has been a member there since. In 1987/88, he participated in the touring exhibition, *Hommage to Berlin* in Berlin, Luxembourg, Brussels, Amsterdam and elsewhere. In 1988, he again received an atelier prize from the Karl Hofer Society, Berlin, and in 1989, he was awarded a working grant by the Senate for Cultural Affairs, Berlin.

Arthur Segal Painter
1875 Jassy (Rumania) — 1944 London

In 1892, Segal studied at the Art Academy in Berlin under Eugen Bracht, becoming his master pupil in 1893. He travelled to Paris in 1895 and studied at the Académie Julian. He attended the private school of painting of Ludwig Schmid-Reutte and Friedrich Fehr and then studied under Carl von Marr at the Art Academy in Munich, where he lived as a free-lance artist from 1899 onwards. He moved to Berlin in 1904 and took part in the exhibitions of the *Berlin Secession* in 1909 and 1913, and in 1910 to 1912 he participated in those of the *New Berlin Secession,* newly-founded by Segal, Erich Heckel, Ernst Ludwig Kirchner, Max Pechstein, Moriz Melzer and others. His first woodcuts appeared in Herwarth Walden's journal *Der Sturm* (The Storm) in 1911, and during the next year, he exhibited in the gallery of the same name. He emigrated to Ascona in 1914, where he met Leonhard Frank, Hans Arp, Alexej von Javlensky, Hugo Ball and Lou Albert-Lasard. It was here that he developed the basic ideas for his aesthetic theory of ›equivalency‹. He exhibited in the *Cabaret Voltaire* of the Zurich Dadaists in 1916. He returned to Berlin in 1920 and established his own school of painting, where Nikolaus Braun and Lou Albert-Lasard also took classes. He became a member, for certain periods a committee member, of the *Novembergruppe,* and frequently took part in their exhibitions between 1921 and 1931. The jours fixes in Segal's atelier were a regular meeting place for Salomo Friedlaender (Mynona), Adolf Behne, Raoul Hausmann, Hannah Höch, Kurt Schwitters and George Grosz. His ›prismatic‹ pictures began to appear in 1922/23. In 1924, he took part in the SPD and unions' action ›For an 8 hour working day‹ along with Otto Dix, George Grosz, Käthe Kollwitz and others. In 1925, he and Braun published the paper, *Lichtprobleme der Bildenden Kunst* (Problems of Light in Fine Art). Between 1926 and 1928, he created ›optical‹ reliefs, after 1929/30, naturalistic pictures. He emigrated to Mallorca in 1933 and moved to London in 1936, opening an art school there in 1937. Segal died of heart failure during an air raid by the German Air Force in 1944.

Frank Seidel Sculptor
1959 Berlin (East) — lives in Berlin-Weißensee

From 1977 to 1979, Seidel completed an apprenticeship as a tool maker in Berlin, then had various jobs, as a dishwasher, cleaner and stoker, until 1984. In 1980, after autodidactic beginnings, he then took up evening studies under Rolf Winkler at the Art College in Berlin-Weißensee, completing these in 1982. In 1984, his first one man exhibition took place in *Schaufenster* (Show Case), the youth club of the state

museums in Berlin (East). Since 1984, he has lived as a free lance sculptor in Berlin. In 1984, he became a candidate for membership in the Association of Artists of the GDR and in 1987, a full member. Since 1986, he has developed several series of larger than life figures in a porous technique with plaster, since 1988, he has also created groups of figures made from a mixture of clay, turf, plaster, iron parings and a solidifying glue, which are connected to each other with the use of flat plates and rods. In 1989, he was represented at the exhibition *Zwischenspiele. Junge Künstler und Künstlerinnen aus der DDR* (Interludes. Young Artists from the GDR) in Berlin (West), in 1990, in the exhibition *GegenwartEwigkeit. Spuren des Transzendenten in der Kunst unserer Zeit* (PresentEternity. Traces of the Transcendental in the Art of Our Times) in the *Martin-Gropius-Bau* in Berlin (West) and in *Ambiente Berlin* at the Biennale in Venice.

Gerd Sonntag Painter, sculptor, object artist, photographer
1954 Weimar — lives in Berlin-Prenzlauer Berg

Between 1960 and 1973, with two years interruption from 1966 to 1968 as a competitive sportsman, Sonntag received training in painting, mime, dance, music, sculpture and ceramics at the People's Art School in Jena. Alongside this training, he also completed, from 1970 to 1972, an apprenticeship as a chemigrapher and reproduction photographer. In 1973, he began studies at the College of Graphic Art and Book Design in Leipzig, but broke off after only two months. His first one man exhibition took place at the Town Museum in Jena in 1974. In 1973/74 he was a caretaker in Jena, 1974/75 a stone mason's apprentice in Jena, from 1975 to 1977 he was a soldier in the national army, during 1977/78 a stoker at the nationally-owned plant Carl Zeiss in Jena, and from 1978 to 1980, he was a telegramme messenger for the post office in Berlin. During this period, he worked autodidactically as a sculptor and a painter. In 1980, he published poetry, written in 1976, and drawings in *Dimension. Contemporary German Arts and Letters,* Austin, Texas/USA. From 1980 to 1982, he was the master pupil of Theo Balden at the Academy of Arts Berlin (GDR). He has worked as a free lance artist since 1982 and has worked together with the photographer Samia Hussein since 1985. After he had been refused membership of the Association of Artists of the GDR for

fourteen years, he was finally made a full member in 1988. During 1988, he exhibited in New York in the Castillo Cultural Center and in London in the City Artists' Gallery. At the beginning of 1989, he travelled to Mexico for two months, which has influenced the series of pictures since 1989, *Köpfe* (Heads). He stayed in the USA from September 1989 to February 1990 — apart from November/December 1989, when he returned to Berlin. In 1989/90, he was the first artist from the earlier GDR to exhibit at the Brooklyn Museum in New York.

Peter Sorge Painter, graphic artist
1937 Berlin — lives in Berlin

Sorge studied art education at the College of Fine Arts in Berlin from 1958 to 1964, and was the master pupil of Fred Thieler and Mac Zimmermann during 1964/65. In 1964, he was co-founder, with Hans-Jürgen Diehl, K. H. Hödicke, Markus Lüpertz, Wolfgang Petrick and others, of the artists' self-help gallery *Großgörschen 35* in Berlin which survived until 1968. He himself seceded from the group in the movement of Critical Realism, along with Diehl, Petrick and others, in 1967. He received the 2nd Burda-Prize for graphic art in 1968 and the graphics prize of the city of Wolfsburg in 1969. Also in 1969, together with Diehl, Petrick and others, he founded the art dealing co-operative *zehn neun (ten nine),* which was disbanded in 1977. He was a member of the Berlin group of artists, *Aspekt,* founded together with Diehl, Petrick, Arwed Gorella, Klaus Vogelgesang, Jürgen Waller and others, from 1972 to 1978. In 1979, he took on a lectureship in the technique of etching at the department of further education for teachers at the Senate for School Education in Berlin. From 1980 to 1982, he was a guest professor at the College of Fine Arts in Braunschweig.

Gerdi Sternberg Painter
1959 Mainz — lives in Berlin

At first, from 1974 to 1977, Sternberg completed her apprenticeship as an optician with an examination as an assistant. From 1978 to 1983, she studied under Thomas Bayrle and above all Raimer Jochims at the College of Fine Art *Städelschule* in Frankfurt on Main, becoming the master pupil of Jochims in painting and art theory in 1983. In 1984, she moved to Berlin, and between 1985 and 1987, she completed further studies at the centre for cultural

pedagogics of the Berlin Art College. As a result of the book which she wrote during this period and published herself in 1987, *Geordneter Wahnsinn oder die Vermessung der Hölle* (Ordered Madness or a Survey of Hell), containing descriptions of the perception of art works, she has been teaching at the centre for cultural pedagogics with the theme ›Experiments in the Perception of Art‹ since 1987. In 1989, she had a one woman exhibition in the series ›Art in a Dominican Monastery‹ organized by the local evangelical association in Frankfurt on Main, showing the four part semi-circular pictures which she had developed from square pictures painted in 1986. In 1989, she received a working grant from the Senate for Cultural Affairs in Berlin. In the same year, she participated in the exhibition *40 Jahre Kunst in der Bundesrepublik Deutschland* (40 Years of Art in the FRG), Oberhausen, Berlin, Rostock — she was also involved in its organization.

Hartmut Stielow Sculptor
1957 Benthe near Hanover — lives in Berlin and Gehrden-Everloh near Hanover

Stielow studied sculpture under Bernhard Heiliger at the Berlin Art College from 1977 to 1983, completing his studies as Heiliger's master pupil. In 1982, together with Gisela von Bruchhausen, Klaus Duschat, Klaus H. Hartmann, Gustav Reinhardt and David Lee Thompson, he founded the group of sculptors known as *Odious,* whose common ground lies in the same source material for their sculptures; finds from scrap yards. They have exhibited together since 1983. Between 1983 and 1985, the first joint works of the group emerged in public places in Berlin, in Ostalbkreis/Aalen (Baden-Württemberg), in Neuenkirchen near Soltau and on the occasion of the Federal Garden Show in Berlin. In 1986, Stielow also moved into an atelier on the manor land Erichshof in Gehrden-Everloh near Hanover. He created *Kassiopeia II,* a work for a public place in Harsefeld near Hamburg, during 1987. His first one man exhibition was in the gallery *In Fonte* in Berlin in 1987.

Walter Stöhrer Painter
1937 Stuttgart — lives in Berlin and Scholderup (Angeln)

Stöhrer studied under HAP Grieshaber at the Academy of Fine Arts in Karlsruhe from 1956 to 1959. He has lived in Berlin since 1959. In 1962, he received the German Youth Art Prize, Stuttgart, and in 1964, the prize awarded by the Association of German Critics, Berlin. He was awarded the Will-Grohmann-Prize by the Academy of Arts, Berlin, in 1971. He was able to spend a period of study in Paris during 1973 on a grant given by the Cité Internationale des Arts. He received the Berlin Art Prize from the Academy of Arts, Berlin in 1976. As the winner of the 1977 Villa Romana prize, he spent 1978 in Florence. In 1980, Stöhrer was awarded the Art Prize of Böttcherstraße, Bremen. He was a guest professor at the Berlin Art College during 1981/82, and has been a member of the Academy of Arts in Berlin since 1984. He has been a professor at the Berlin Art College since 1986. Stöhrer was represented in the exhibition *Ambiente Berlin* at the Biennale in Venice in 1990.

Strawalde (Jürgen Böttcher) Painter, film-maker
1931 Frankenberg (Saxony) — lives in Berlin

Since 1976, Böttcher has called himself Strawalde as a painter — though not as a film-maker — a name taken from the place Strahwalde (Oberlausitz) where he spent his childhood and youth between 1937 and 1949. He studied at the College of Fine Arts in Dresden from 1949 to 1953, from 1951 onwards under Wilhelm Lachnit. Between 1953 and 1955, he lived as a free lance painter in Dresden and gave painting and drawing courses at the adult education centre there. During this period, his lasting circle of friends emerged — Peter Herrmann, Peter Makolies and Ralf Winkler (A. R. Penck), who were all taught by Böttcher; Winfried Dierske and Peter Graf later joined the group. In 1955, Böttcher took up studies in direction at the German Academy of Cinematic Art in Potsdam-Babelsberg. After concluding these in 1960, he worked as a director in the documentary film studios of the DEFA in Berlin (East). In 1961, he participated in the exhibition at the German Academy of Arts, *Junge Künstler der DDR* (Young Artists of the GDR), Berlin, against which defamatory propaganda was made public. In the 1960s, he was tacitly expelled from the Association of Artists in Germany, of which he had been a member since 1954. His first film, which emerged in 1961, *Drei von vielen* (Three among Many) which portrayed his artist friends from Dresden, was banned in the same year. At the international festival of documentary film in Leipzig in 1962, he received the ›silver dove‹ for his film *Ofenbauer.* Böttcher has been a close friend of the singer

and song-writer, Wolf Biermann, since 1964. His first and only feature film, with the working title *Jahrgang 45* (Born in '45), was forbidden after the first cutting in 1966. His first unofficial one man exhibition took place in the communal ateliers in Erfurt. In 1979, he received the national prize of the GDR, second class, for his film work — in a collective. His first official one man exhibition took place in 1981 in the gallery *Mitte* in Dresden. In 1981, he realized, stimulated by the montage of series of art postcards which he had himself painted over, the experimental film triptych, *Potters Stier/Venus nach Giorgione/Frau am Klavichord* (Potter's Bull/Venus after Giorgione/Woman at the Clavichord). These ›painted-over‹ films were shown, though not officially presented in the GDR, at the gallery *Oben* in Karl-Marx-Stadt/ Chemnitz. In 1984, he shot the documentary film *Kurzer Besuch bei Hermann Glöckner* (A Short Visit to Hermann Glöckner), the constructivist painter who died in 1987 at the age of ninety-eight. In 1986, the Centre Georges Pompidou in Paris gave a retrospective of his cinematic work in the context of its film festival, *cinéma du réel*. In 1988, he was represented at the exhibitions *Der eigene Blick. Berliner Kritiker zeigen Kunst ihrer Wahl* (Personal View. Berlin Critics Show Art of their Choice) and *Visuelle Poesie* (Visual Poetry), both in Berlin (East). He has been a member of the Academy of Arts in Berlin (West) since 1988. Since the beginning of 1989, he has been a guest professor in the department of visual communication at the College of Fine Arts in Hamburg. During 1989/90, he shot his documentary film, *Die Mauer* (The Wall) and painted his ›wall pictures‹ and ›rubble pictures‹ in 1990. He participated in the festival of art *L'autre Allemagne hors les Murs* in the Grande Halle de la Villette, Paris, in 1990; his largest pictures emerged here during a painting session. In 1990, a retrospective of his drawings and paintings took place in the *Altes Museum*, Berlin.

Rolf Szymanski Sculptor
1928 Leipzig — lives in Berlin

Szymanski began his studies between 1945 and 1950 under Alfred Thiele at the School of Applied Art in Leipzig and continued them from 1950 to 1955 at the College of Fine Arts in Berlin, where his teachers were Bernhard Heiliger, Richard Scheibe and Paul Dierkes. He received the Prize of the Association of German Critics, Berlin, and the Art Prize of the city of Wolfsburg in 1961, in 1963, he won the Berlin Art Prize (Young Generation) from the city of

Berlin. He was awarded grants to study at the Villa Massimo in Rome in 1962 and at the Villa Romana in Florence in 1964. He received a grant from the Cité Internationale des Arts, Paris, in 1968. He has been a member of the Academy of Arts in Berlin since 1970. From 1971 to 1974 he was deputy director of the department of fine art at the Academy, director from 1974 to 1983 and again from 1986 onwards, and from 1983 to 1986, he was vice-president of the Academy itself. He has taught as a professor at the Berlin Art College since 1986. In the context of the project *Skulpturenboulevard* (Boulevard of Sculpture) during Berlin's 750th anniversary celebrations in 1987, his two parts sculpture *GroßeFrauenFigurBerlin* (LargeFemaleFigureBerlin) was set up at the corner of Kurfürstendamm and Albrecht-Achilles-Straße. Szymanski was represented in the exhibition *Ambiente Berlin* at the Biennale in Venice in 1990.

Fred Thieler Painter
1916 Königsberg — lives in Berlin and Radegast

At first, in 1936, Thieler began to study medicine in Königsberg, until in 1941, the National Socialists forbade him to study for ›reasons of race‹. He took private painting classes with Hein König in Munich between 1941 and 1943, and lived from then until the end of the war in hiding. He studied painting under Carl Caspar at the College of Fine Arts in Munich from 1946 to 1950. In 1950, he became a member of the Munich group of artists *ZEN 49,* founded in 1949, and took part in their exhibitions during 1950, 1953, 1955 and 1956/57. During 1952, he worked in the *Atelier 17* of Stanley William Hayter in Paris. From 1953 onwards, he was a member of the *Neue Gruppe* (New Group) in Munich, and after 1954, of the German Federation of Artists, Berlin. In 1959, he moved from Munich to Berlin, where he taught as a professor of painting at the College of Fine Arts until his retirement in 1981. He took part in the documenta II in Kassel in 1959 and the documenta III in 1964. He was a guest professor at the College of Art and Design in Minneapolis (USA) during 1972/73. He has been a member of the Academy of Arts in Berlin and of the New Secession Darmstadt since 1978. In 1979, he became a member of the International Society of Fine Arts in Paris, of which he was vice-president from 1979 to 1984, and has been honorary president since 1984. He was also, between 1980 and 1983, vice-president of the Academy

of Arts, Berlin. Thieler was awarded the Lovis-Corinth-Prize in Regensburg in 1985.

Hann Trier Painter
1915 Düsseldorf-Kaiserswerth — lives in Mechernich-Vollem (Eifel) and Castiglione della Pescaia (Tuscany, Italy)

Trier studied under Werner Heuser, Heinrich Reifferscheid and Paul Bindel at the Art Academy in Düsseldorf from 1934 to 1938, and completed his qualifications as a teacher of art in Berlin in 1938. He served in the war from 1939 to 1941 and again during 1944/45, interrupting this to work as a technical draftsman for a firm of glass-fibre art printers in Berlin from 1941 to 1944. Between 1946 and 1952, he lived in Bornheim Castle near Bonn, where he became one of the co-founders of the *Donnerstagsgesellschaft* (Thursday Society) at Alfter Castle, together with Toni Feldenkirchen, Hermann Schnitzler, Hubert Berke, Joseph Faßbender and others. He participated in the exhibitions given by the group *ZEN 49* in 1951 and 1953. He emigrated to Medellin (Columbia) in 1952, and from there he travelled in South and Central America and the USA until 1955. During 1955/56, he was invited as a guest professor to the College of Fine Arts in Hamburg and was professor at the College of Fine Arts in Berlin from 1957 to 1980. In 1962, Trier was awarded the Major Art Prize of the State of North Rhine-Westfalia, in 1966 the Berlin Art Prize of the city of Berlin, and in 1967, the Art Prize of the city of Cologne. In 1972 and 1974, he executed two large ceiling paintings in Charlottenburg Palace in Berlin, further public commissions for large scale murals and ceiling paintings in Heidelberg, Cologne, Rome and Bonn followed in the years until 1986. He received the Major Award of the Distinguished Service Order of the Federal Republic in 1975, the Distinguished Service Order of the State of North Rhine-Westfalia in 1989 and in 1990, the Stephan-Lochner Medal from the city of Cologne. In 1990, he created the mural in the *Von-der-Heydt-Museum* in Wuppertal.

Hans Uhlmann Sculptor, graphic artist
1900 Berlin — 1975 Berlin (West)

Uhlmann studied at the Technical University in Berlin from 1919 to 1924, completing his studies as a certificated engineer. At the same time, he was a violinist at the Collegium musicum of the Friedrich Wilhelm University in Berlin. From 1924 to 1926, he worked at an electro-mechanical engineering firm in Kiel. His first sculptures emerged during this period. He was Max Kloß' assistant in the Department of Electro-mechanical Engineering at the Technical University Berlin from 1926 to 1933. His first one man exhibition was at gallery Gurlitt, Berlin, in 1930. He travelled to the Soviet Union and elsewhere in 1932. Uhlmann was dismissed from his position at the university in 1933 by the National Socialists because of his political attitudes. He was imprisoned for one and a half years from 1933 to 1935 on a charge of ›conspiring to commit treason‹ after taking part in a leaflet campaign against the National Socialists. He worked in a Berlin firm producing calculators between 1935 and 1945, initially as a draftsman, later as an engineer in the office of new inventions and developments. From 1935 onwards, he created sculptures from wire, sheet iron and sheet zinc, but these were not exhibited until 1945. He was appointed by the art authorities in Steglitz to organize the first art exhibitions in Kamillenstraße after the end of the war during 1945/46, and re-established contacts to artists who had been persecuted and scorned by the National Socialists. During 1947/48, he organized exhibitions, lectures and discussions at the Gerd Rosen gallery in Berlin. He was awarded the Art Prize from the city of Berlin in 1950, in the same year, he was appointed professor at the College of Fine Arts. He received the prize for drawing at the Biennale in Sao Paulo in 1951, and in 1952 he was awarded the prize of the Federal Association of German Industry in an international competition to design a memorial to an unknown political prisoner. In 1954, he won the prize given by the Association of German Critics in Berlin. He took part in exhibitions given by the group *ZEN 49* in 1951 and 1955. He was nominated a member of the Academy of Arts in Berlin in 1956. In 1957, he received the first prize in the sculpture competition organized by INTERBAU, Berlin, for his design for a sculpture to stand on Hansaplatz. He took part in the documenta in Kassel in 1955, 1959 and 1964. During 1960/61, he created a memorial to the resistance during the Third Reich in Leverkusen. Uhlmann was awarded the Cornelius-Prize of the city of Düsseldorf in 1961.

Jens Umlauf Painter
1958 Moelln (Holstein) — lives in Berlin

Umlauf has lived in Berlin since 1979 and studied painting under Marwan at the Berlin Art College, becoming his master pupil in 1985. He

spent three months of study in Morocco during 1985/86. Between 1986 and 1988, he had a grant from the Karl Hofer Society in Berlin. His first one man exhibition took place at the *Lietzow* gallery in Berlin during 1987. He received the grant for the promotion of up-and-coming artists offered by the Berlin Art College between 1988 and 1990.

Klaus Vogelgesang Painter
1945 Radebeul near Dresden — lives in Berlin

Vogelgesang studied from 1965 to his state examination in 1969 at the Academy of Graphic Art, Printing and Advertising in Berlin. In 1972, together with other representatives of Critical Realism, such as Hans-Jürgen Diehl, Arwed Gorella, Wolfgang Petrick and Peter Sorge, he established the group of artists known as *Aspekt*, exhibiting with them until 1978. In 1975, he received the prize of the Association of German Critics, Berlin, for the year 1974. During 1976, he spent three months of study at the Villa Massimo in Rome. In 1984, he won the first prize in a competition organized by the art magazine, *art*, Hamburg, during which an exhibition, *Deutsche Landschaft — heute* (German Landscape — Today), was held in Berlin. He was represented in the exhibition *Ambiente Berlin* at the Biennale in Venice in 1990.

Wolf Vostell Painter, Happening artist, experimental film-maker
1932 Leverkusen — lives in Berlin and Malpartida (Spain)

Vostell completed training as a photo-lithographer in Cologne between 1950 and 1953. In 1954/55, he studied painting and experimental typography at the School of Art and Crafts in Wuppertal, in 1955/56 painting at the Ecole Nationale Supérieure des Beaux-Arts in Paris, and in 1956/57 at the Academy of Art in Düsseldorf. In 1954, he began to develop his artistic principle of dé-coll/age — at first using tear-off poster pictures, later extending it to staged or improvised Happenings. In 1958, his first Happening took place in Paris, *Das Theater ist auf der Straße, eine dé-coll/age Demonstration* (Theatre is on the streets, a demonstration of dé-coll/age). Together with Jean Pierre Wilhelm, Nam June Paik, George Maciunas and others he founded the group Fluxus in 1962 and was among the organizers of the first Fluxusfestival in Wiesbaden. Between 1962 and 1969, he was the publisher of the magazine *dé-coll/age-bulletin aktueller ideen* (décollage

bulletin of new ideas). He has produced experimental films consisting of blurred and mingled television programmes and film action sequences since 1963. In 1968, with Mauricio Kagel, Alfred Feussner and Fritz Heubach, he established the *Labor zur Erforschung akustischer und visueller Ereignisse* (Laboratory for research into acustic and visual occurrences). In 1971, he moved from Cologne, where he had lived since 1959, to Berlin. In 1973 and 1974, he was co-founder and co-organizer of the festival *ADA — Aktionen der Avantgarde.* He set up the *Museo Vostell* in Malpartida (Spain) in 1976, a museum concerned with the concept of art in the second part of the 20th century. During 1977, he was a guest professor at the University of Essen. In 1981, he realised a mobile museum *Vostell* in the form of a *Fluxus Zug* (train) consisting of seven Environments in separate containers. In 1987, in the context of the project *Skulpturenboulevard* (Boulevard of Sculpture) during the 750th anniversary celebrations in Berlin, he applied his technique of cementing-in objects to two Cadillacs which were then erected on Rathenauplatz. He was represented in the exhibition *Ambiente Berlin* at the Biennale in Venice in 1990.

Elke Wagner Sculptress
1953 Coblenz — lives in Berlin

At first, Wagner studied romance languages and literature at the Free University Berlin from 1972 to 1974. From 1974 to 1983, she studied sculpture under Michael Schoenholtz at the Berlin Art College, becoming his master pupil in 1980/81. In 1981, she took part in the exhibition *Situation Berlin* in Nice. During 1983 and 1985/86, she taught basic courses in sculpture at the Berlin Art College. Her first one woman exhibition took place at the *Quergalerie* in Berlin in 1984. In 1985, she travelled to Rome, Pompeii and Sicily. In 1986, she received a grant from the Bonn Art Funds, in 1987 a working grant from the Senate for Cultural Affairs, Berlin, and in 1990, a working grant from Philip Morris Ltd., Munich, to work in the sculpture workshops *Pankehallen* in Berlin.

Jürgen Waller Painter
1939 Düsseldorf — lives in Bremen

In 1959, Waller began his studies under Ferdinand Macketanz at the Art Academy in Düsseldorf, breaking them off after two semesters in 1960. He lived in France from 1960 onwards, in Paris, Vallauris and Varreddes — then moving to Berlin in 1968. In 1972, he was co-found-

er of the group *Aspekt,* an association of Critical Realists, among whom were Hans-Jürgen Diehl, Arwed Gorella, Wolfgang Petrick, Peter Sorge, Klaus Vogelgesang and others. They exhibited together until 1978. He has been a member of the German Federation of Artists since 1974. In 1976, he became the first president of the *Freie Berliner Kunstausstellung* (Berlin Open Art Exhibition). In 1977, he was appointed to the then College of Design, today College of Arts in Bremen, of which he has been vice-chancellor since 1989. In 1980, he was the initiator and co-founder of the Society for New Art in Bremen.

Trak(ia) Wendisch Painter, sculptor
1958 Berlin (East) — lives in Berlin-Pankow and at Burg Goldbeck near Berlin

From 1977 to 1982, Wendisch studied painting and graphics under Wolfgang Peuker, Sighard Gille and above all, Dietrich Burger and Bernhard Heisig at the Academy of Graphic Art and Book Design in Leipzig. He has lived as a free lance artist in Berlin since 1982. In 1982, he became a candidate for membership of the Association of Artists of the GDR, in which he was active in the central working group of young artists from 1984 to 1989. From 1983, he earned a living by assisting in the realization of public work in an architectural context, above all in Berlin. His first one man exhibition took place in the *Galerie am Prater* in Berlin (East) in 1984. He has also worked as a sculptor since 1984. In 1985, he became a full member of the Association of Artists of the GDR, remaining so until 1990. Since 1985, he has also worked in an atelier, renovated by several artists, in Burg Goldbeck near Berlin. During 1985/86, he was the master pupil of Gerhard Kettner for a year at the College of Fine Arts in Dresden. In 1987, he travelled to Cagnes-sur-Mer, where he was represented at the exhibition of its international painting competition. In 1988, he exhibited, together with thirty-one other artists from the GDR, at the Biennale in Venice. Since 1988, he has created sculptures in large formats and several parts presented in a spatial context. Together with Ulrich Müller-Reimkasten, he created an installation with painted flags and a figure for a public place, which was shown in 1988 in Schwerin and in 1989 in Berlin. He took part in the exhibition *Zwischenspiele. Junge Künstler und Künstlerinnen aus der DDR* (Interludes. Young Artists from the GDR) in Berlin (West) in 1989. In 1990, he was represented at the exhibition *Ambiente Berlin* at the Biennale in Venice.

Pomona Zipser Sculptor, graphic artist, assemblage and installation artist
1958 Sibiu/Hermannstadt (Rumania) — lives in Berlin

Pomona Zipser, the daughter of the painter Katharina Zipser and the sculptor Paul Zipser, emigrated to Munich in the Federal Republic in 1970. In 1979, she received the ZIS travel grant, Salem/Lake Constance, donated by Jean Walter — and spent three months completing church frescoes in Tirgu Mures, Rumania. In the same year, she received a grant from the Educational Foundation of the German People in Bonn. From 1979 onwards, she studied painting under Mac Zimmermann at the Munich College of Fine Arts. However, following her move to Berlin in 1982, she studied sculpture under Lothar Fischer at the Berlin Art College, becoming his master pupil in 1985. During 1981 and 1983, she worked together with Katharina Zipser on large scale murals in Heideckhof and Asamhof in Munich. Since 1983, Zipser has been working with found objects, usually made of wood, which she sometimes paints and combines with thread and wire to make sculptures or entire room installations. In 1986, she made lithographies to illustrate the short story *Heilige Cäcilia* (Holy Cecilia) by Paul Schuster, published by the Mariannen Press, Berlin. In the same year, she received a working grant from the Educational Foundation of the German People, Bonn, for Venice, where her first one woman exhibition took place in the *Paradiso Perduto*. In 1987, she joined the communal ateliers in Kreuzberg which had been set up in 1983 by Christian Rothmann, Horst-Martin Herrmann and Toni Wirthmüller — in the same year, they exhibited together under the name *z-Art.* Since 1987, she has also cast small sculptures in bronze. In 1988, she took part in the symposium of sculptors held by the German Federation of Artists, Berlin, and the German-French Centre for Youth Work, Bonn, at the College of Fine Arts in Stuttgart. Also during this year, she received the grant to promote up-and-coming artists from the Art College in Berlin. In 1990, she was awarded a working grant by the Senate for Cultural Affairs in Berlin and the Marianne-von-Werefkin Prize from the Society of Women Artists, Berlin — of which she has been a member since then. In the same year, she designed the stage sets for the dance theatre piece *Schwestern* (Sisters) by Stefanie Erhard at the R.A.M.M. ZATA Theatre in Berlin. She was represented in the exhibition *Ambiente Berlin* at the Biennale in Venice in 1990.

Selected Biographies of the Photographers

Compiled by Janos Frecot and Armin Schulz

Erwin Blumenfeld Photographer
1897 Berlin — 1969 Rome

In 1913, Blumenfeld began an apprenticeship as a dress designer. He came into contact with the avantgardist artists early on, becoming a friend of George Grosz. After the end of the war, he went to Holland, but continued to keep in close contact with the Berlin Dadaists. Together with his friend Paul Citroen, he founded the Amsterdam headquarters of Dada. He painted, wrote, took photographs and created dadaist collages, whilst making a living — after a fashion — from the proceeds of his Amsterdam leather goods business. In 1936, he began his career as a fashion and advertising photographer in Paris, continuing it after his internment in France as a contributor to big American magazines in the USA. His photography continued bear the impressions of the Dadaists' and Surrealists' artistic success. His autobiography, which last appeared in 1988 with the title *Durch tausendjährige Zeit* (Through a Thousand Years of Time), is of considerable literary quality and a significant comment on his time.

Hans G. Casparius Photographer
1900 Berlin — 1986 in London

In 1915, after completing his Lower School Certificate in Berlin, Casparius spent four years as a trainee at the Arnold Müller department store, Berlin. During 1919, he worked a year for a spinning mill in Cottbus. In 1920, he became an employee in his father's textile business, taking the firm over together with his brother in 1924, but leaving it again in 1925. From that time onwards, he concerned himself with photography. His ambition, however, was to become an actor. After 1928, he worked on several films, by Ernö Metzner, G. W. Pabst and Paul Czinner among others, as both an actor and a stills and action photographer. In 1929, an exhibition of his stills and action photos from the film *Die weiße Hölle vom Piz Palü* (The White Hell of Piz Palu), by Arnold Frank and Pabst, took place on the occasion of the premiere. In 1930, Casparius and Arnold Höllriegel, the correspondent of the Berlin *Tage-blatt* and the *Neue Freie Presse*, Vienna, undertook a journey to Africa, during which several short films and around 2500 photos were made. In the same year, he made 1200 studies of G. W. Pabst's film, *Die 3-Groschen-Oper* (Threepenny Opera). His own film, *Ginsterrausch in Hiddensee* (The Rustle of Gorse in Hiddensee), from 1932, was never completed. In 1932, he moved to Vienna in order to assemble a pictorial archive for the new magazine *Jedermann* (Everyone). In 1933, he accompanied the Almasy-Penderell-Expedition to Libya, where he photographed the rock paintings in the caves of Uwenat. During this journey, he and Arnold Höllriegel made the film *Nomaden der Wüste* (Desert Nomads). In 1933, he became the photo-reporter of *France Soir* in Paris. In 1934, following a journey to Palestine, he published *Das Palästina-Bilder-Buch* (The Palestine Picture Book), with 96 photographs. He emigrated to London in 1935, but returned to Vienna in the same year in order to learn colour photography at the publishing house Steyermühlen. In 1938, he emigrated to London once again, where he opened the first colour photography studio to produce advertising and book illustrations. In 1939, he volunteered for war service, but was rejected for health reasons. During the war he was employed by the ABCA. In 1940, he worked as a photographer for the exiled governments of Luxembourg, Czechoslovakia and Belgium, and for the Habsburg family. During the war he also made short propaganda films. After the war, he was photographer for *Good Housekeeping* (from 1945 to 1949) and *Field*. From 1949 onwards, he made his own documentary films as a director and producer for various film companies.

Rolf Cavael Photographer
1898 Königsberg — 1979 Munich

As well as his activities in photography and film, Cavael also studied typography, painting and music. He taught commercial graphics at the State Technical College in Frankfurt (Main). In 1927, he began to make his own discoveries in absolute painting. His most significant stimulus

in this was a meeting with Kandinsky in 1931. During this period, in which he lived in Berlin, he created strict, geometric photograms. His first exhibition was closed down by the Nazis in 1933. He was forbidden to carry out his profession and taken to the concentration camp at Dachau in 1936. In 1949, he exhibited in Munich and was one of the founding members of the group ZEN 49. During the 1950s, he was finally able to work intensively as an artist and as a teacher, and public recognition followed.

Erich Comeriner Photographer
1907 Vienna — 1978 Tel Aviv

Comeriner, who grew up in Berlin, began to take photographs in 1924. From April 1927 to October 1928, he studied at Bauhaus in Dessau: the basic tenets under Josef Albers, typography under Joost Schmidt and printing under Herbert Bayer; he worked for Oskar Schlemmer in the stage workshops, and studied under Paul Klee, Vassily Kandinsky and Lyonel Feininger. In 1929, he participated with an individual presentation in the exhibition *Film und Foto* of the German *Werkbund* in Stuttgart. Between 1929 and 1933, he worked in Berlin, together with Laszlo Moholy-Nagy, as an advertising graphic artist and on stage sets for the Kroll Opera and Piscator's Theatre; he also worked as a free lance commercial artist and press photographer. Using the name *comofot*, he himself organized the distribution of his photographs to various magazines, such as *Weltrundschau, Kölnische Illustrierte Zeitung* and the *Berliner Illustrierte Zeitung*. In 1934, he emigrated to Palestine, where he lived and worked on a kibbuz. From 1940 onwards, he was a free lance photographer and advertising graphic artist in Tel Aviv. He did commissioned work for the Jewish Foundation Fund, WIZO.

Caroline Dlugos Photographer
1959 Berlin — lives in Berlin

Between 1977 and 1982, Dlugos studied for a diploma in sculpture and photography under Harry Kramer and Floris Neusüss at the polytechnic in Kassel. Still during her studies in 1980, she was co-founder, with Hanno Otten and Hannes Brunner, of the group of artists *Graue Welle* (Grey Wave). In 1982/83, she received a grant to study at the Ecole Nationale Supérieure des Arts Decoratifs in Paris from the German-French Centre for Youth Work in Bonn, and the artists' prize for Paris from the same institution. She spent various periods working in Cologne between 1982 and 1984. Her first one woman exhibition took place at the Goethe Institute in Paris in 1984. She spent time in Paris during 1986/87. She has lived in Berlin since 1988.

Hugo Erfurth Photographer
1874 Halle/Saale — 1948 Gaienhofen/ Lake Constance

From 1892 to 1896, Erfurth completed an apprenticeship to the court photographer, W. Höffert, in Dresden — at the same time, he studied painting there at the Academy of Arts. As early as 1894, he received the first of his numerous prizes and awards, the silver medal at the International Exhibition of Amateur Photography in Erfurt. After his examination as a master in 1896, he took over the photo studio of the court photographer, Schröder, in Dresden. He maintained contacts with the groups *Kunstfotografie* in Germany and Austria, the *Linked Ring* in Great Britain and the *Photo-Secession* in the USA. In 1903, his first one man exhibition took place in the German Photography Society in Dresden. In 1904, he organized a section on photography at the Great Dresden Art Exhibition. From 1906 to 1934, he had his atelier at the Lüttichau-Palais in Dresden, where he produced photograms, rubber prints, oleographs and, after 1925, industrial photographs. In 1908, he became a member of the German *Werkbund*. In 1914, he taught photography under Walter Tiemann at the Academy of Book Design in Leipzig. In 1919, he was co-founder of the Society of German Photographers, and was a member of their jury from 1924 to 1948. From 1920, he was the portrait photographer of many German artists and intellectuals, such as Käthe Kollwitz, Oskar Kokoschka and Gerhart Hauptmann. Otto Dix became his friend in 1925. During 1929, he taught commercial photography at the Academy of Graphic Art and Book Design in Leipzig. He moved to Cologne in 1934, where he again set up an atelier, but this was bombed out in 1943, together with his archive and equipment. In 1946, he set up a new photo studio in Gaienhofen/Lake Constance.

Thomas Florschuetz Photographer
1957 Zwickau (Saxony) — lives in Berlin

Between 1964 and 1966, Florschuetz completed an apprenticeship as a skilled building worker in Karl-Marx-Stadt/Chemnitz. After

this, he worked as an assistant to a master photographer. In 1981, he moved to Berlin (East). His first one man exhibition took place at the *Haus der Jugend* (House of Youth) in East Berlin during 1983. In 1984, he became a candidate for membership of the Association of Artists of the GDR. Since then, he has worked as a free lance artist. During 1984, 1985 and 1988, he exhibited together with Wolfram Adalbert Scheffler in East Berlin and Paris. He applied for expatriation from GDR in 1986. In 1987, he received the prize for ›Young European Photography‹, awarded for the first time by German Leasing Inc., Frankfurt on Main. This was linked with a period of time as Artist in Residence at Lightwork in Syracuse, New York, and in Houston, Texas, during 1988. He did not return to the GDR and took up residence in Berlin (West). In 1988, he received a working grant from the Senate for Cultural Affairs in Berlin. In 1989, he participated in the exhibition *New Photography* in the Museum of Modern Art, New York. In 1990/91, he was represented at the exhibition *Ausgebürgert. Künstler aus der DDR und aus dem Sowjetischen Sektor Berlins 1949—1989* (Expatriated. Artists from the GDR and the Soviet Sector of Berlin 1949—1989), in Dresden and Hamburg.

to 1942, he worked on a free lance basis in Jerusalem. Between 1942 and 1945, he was chief reporter for *Parade Magazine,* a British Army illustrated magazine; during 1942/43, this took him to North Africa and the Mediterranean, during 1943/44 to China, Burma, India and the Middle East. From 1945 until his emigration to New York in 1947, he worked on a free lance basis in Jerusalem once again. From 1955 to 1958, he taught visual communications at the New School for Social Research, New York. From 1959 to 1964, he was an editorial adviser at *Life Magazine,* New York. In 1965, he became a member of the Royal Photographic Society in London. In 1970, he emigrated to Jerusalem. He has taught visual communications at the Hebrew University in Jerusalem since 1971. In 1972, he became a corresponding member of the German Photographic Society in Cologne. In 1972, he published the book *Deutschland. Beginn des modernen Photojournalismus* (Germany. The Beginnings of Modern Photo Journalism). In 1980, he received the Kalvin-Prize of the Israel Museum, Jerusalem, and in 1983, together with Lotte Jacobi, the Dr.-Erich-Salomon-Preis of the German Photographic Society, Cologne.

Nachum Tim (Ignaz) Gidal (ewitsch)
Photographer
1909 Munich — lives in Jerusalem

Gidal studied history, art history, law and national economics during 1928/29 at the University of Munich, from 1929 to 1931 at the University of Berlin, and from 1933 to 1935 at the University in Basle, where he received the title Doctor of Philosophy for his thesis ›Picture Reporting and the Press — a Contribution to the History and the Organization of the Illustrated Press‹. In 1929, at the instigation of his brother, an amateur photographer, he began to take photographs. From that time onwards, he worked on a free lance basis, producing more than 190 photo reports. From 1929 to 1933, he worked for the *Münchner Illustrierte Zeitung,* and after his emigration to Palestine in 1936, he worked for British and American magazines until 1938. His first one man exhibition took place in the Steimatzky Gallery, Jersulalem, in 1937. In 1938, his first colour photo report appeared in the magazine *Marie Claire* in Paris. The editor in chief of the *Picture Post* in London, Stefan Lorant, contracted him as chief photo reporter from 1938 to 1940. From 1940

Raimund Kummer Room-installation
artist, photographer
1954 Mengeringhausen — lives in Berlin

From 1972 to 1978, Kummer studied at the College of Fine Arts in Berlin, completing his studies as the master pupil of Fred Thieler. In 1980, together with Fritz Rahmann and Hermann Pitz, he founded the artists' organization *Büro Berlin* (Office Berlin), which followed a concept of artistic production relating to a specific situation. This organization disbanded in 1987. In 1980/81, he spent time in New York with a grant from the German Academic Exchange Service, Bonn. In 1982, he received working grants from the German-French Centre for Youth Work, Bonn, and from the Senate for Cultural Affairs, Berlin. The latter also awarded Kummer the P. S. 1 grant to New York in 1984. He received a working award from the Bonn Art Funds in 1985. Kummer, together with Pitz and Rahmann, was awarded the 1986 prize from the Association of German Critics for their *Büro Berlin* projects during the year 1985. In 1986, he received the prize to promote artists given by the Federal Association of German Industry, Cologne.

Will McBride Photographer
1931 Saint Louis (Missouri/USA) — lives in Italy and Frankfurt (Main)

During 1950, McBride studied illustration at the Academy of Design in New York. From 1951 to 1953, he studied art history and painting at various academies and universities in the USA. From 1953 to 1955, he completed military service in the American Army as a photographer stationed in Würzburg. He studied philology in Berlin from 1955 to 1956. From 1956 onwards, he worked as a free lance photographer in Berlin for the magazines *Life, Look, Paris-Match, Stern* and chiefly for *Twen;* from 1961 to 1972, he worked on a free lance basis in Munich. Since 1973/74, he has worked on free ›pictorial essays‹ and has founded a Summer Academy of Photography in his country house in Tuscany.

Lucia Moholy Photographer, publicist
1894 Karlin (Bohemia) — 1989 Zurich

The editor and publicist, Lucia Schulz, became a photographer following her meeting with Laszlo Moholy-Nagy, whom she married in 1921. A period of joint experimentation with photographs and photograms followed; she learnt the necessary technical basics at Bauhaus in Weimar. In the years which followed, until her separation from Moholy-Nagy, she was his most important colleague. In 1929, she became a teacher of photography at the private art school of Johannes Itten in Berlin. During this period, she created impressive portraits of artists. In 1933, she emigrated via Prague and Paris to London, where she worked as a portrait photographer and gave lectures on Bauhaus. After 1945, she was the Unesco representative for the filming of cultural assets. From 1959 until her death, she lived as a free lance publicist in Zurich and worked to assemble a photographic archive to document the life and work at Bauhaus.

Laszlo Moholy-Nagy Painter, photographer, art theorist
1895 Bacsborsod (Hungary) — 1946 Chicago (USA)

In Hungary and Vienna, Moholy-Nagy was already in contact with the artists of the avant-garde surrounding Lajos Kassak and the journal *MA*. In 1920, he moved to Berlin and made the acquaintance of the circle of *Sturm* (Storm) artists and the dadaists. In 1922, together with Lucia Moholy, he produced the first photograms. In 1923, he was appointed director of the metal workshop and of the basic course at Bauhaus in Weimar. Together with Walter Gropius, he published the *Bauhaus* books. His book *Malerei, Photographie, Film* (Painting, Photography, Film) appeared as volume 8 of this series in 1925. In 1925 he moved to Dessau together with Bauhaus, returning to Berlin, where he began to work more in the fields of theatre, stage and film, in 1928. In 1934, he left Germany, emigrating to the USA in 1937 via Amsterdam and London. In the USA, he continued the ideas of Bauhaus in Chicago, firstly as the director of the New Bauhaus and then at the School of Design, later Institute of Design, which he founded in 1938.

Hermann Pitz Painter, installation artist, photographer
1956 Oldenburg — lives in Düsseldorf

From 1975 to 1980, Pitz studied painting under Raimund Girke at the Berlin Art College. Since 1978, he has created sculptures, Happenings and room installations, and in 1982 he has produced his first photographic work with the theme of perception. In 1980, together with Fritz Rahmann and Raimund Kummer, he founded the artists' organization *Büro Berlin* (Office Berlin). His first one man exhibition took place in the ›Cabinet of Contemporary Art‹, Bremerhaven. In 1982, he received a working grant from the German-French Centre for Youth Work, Bonn, and in 1985, that from the Senate for Cultural Affairs, Berlin. In 1985, Pitz, together with Kummer and Rahmann, was awarded the prize given by the Association of German Critics, Berlin, for the *Büro Berlin* projects. In 1986, he received a prize to promote young artists from the Federal Association of German Industry, Cologne, in 1987, the P. S. 1 grant for New York from the Senate for Cultural Affairs in Berlin, and in 1988, a working grant from the Bonn Art Funds. He was represented at the documenta 8 in Kassel in 1987; in 1988, he participated in the Biennale in Venice in *Aperto 88*, and in 1989/90, he took part in the exhibition *Ressource Kunst. Die Elemente neu gesehen* (Resource Art. A New Way of Looking at the Elements) in Berlin, Saarbrücken, Munich and Budapest.

Henry Ries Photographer
1917 Berlin — lives in New York

In 1938, Ries emigrated to the USA. In 1945, he returned to Berlin as an American soldier and worked as a photo reporter for the *OM-GUS-Observer,* later as the German correspondent of the *New York Times* and the *Sunday Magazine.* In 1950, his book *German Faces* appeared, a pictorial and written report from Germany. Since 1955, he has had his own photographic studio in New York. With his ›helioptix‹, he has developed a graphically attractive, abstract pictorial language. Events in and around Berlin have continued to be his great historical theme, repeatedly taken up in exhibitions (*Berlin Now,* 1977) and publications (*Berliner Galerie,* 1981). In 1988, the *Berlinische Galerie* devoted a comprehensive exhibition to his early photographic work.

Erich Salomon Photographer
1886 Berlin — 1944 Auschwitz

Salomon was the son of a well-to-do family from the liberal Jewish bourgeoisie, however, they lost their property during the bankruptcy of the state after 1918. Salomon, a doctor of law, supported his family during the difficult years of the 1920s with casual work, until he — almost by chance — discovered an opportunity of earning money with a camera. Through his first pictures of a murder trial, he became a much demanded photo reporter as it were overnight. He worked mainly for Ullstein's *Berliner Illustrierte Zeitung* and he not only reported on political, social and cultural events in Berlin, but was soon taking photographs at the League of Nations sessions in Geneva and international conferences in Lugano, Paris, The Hague and London. At the invitation of the American illustrated magazine *Fortune,* he travelled to America. He brought back sensational reports, for example from the legendary castle of the press giant, Hearst, but also less spectacular — yet from today's perspective extraordinarily modern — pictures of American every day life. After 1933, Salomon remained in the Netherlands. He met a diminished economic basis and a more limited field of action on the world stage with an increase in work from the Netherlands, France and Great Britain. After the occupation of the Netherlands by the Germans, he succeeded in going underground for some time. In 1943, he was traced by the Gestapo and was murdered in Auschwitz in 1944.

Friedrich Seidenstücker Photographer
1882 Unna (Westfalia) — 1966 Berlin (West)

Seidenstücker really wanted to become a sculptor — he completed his studies at the Berlin Academy as the master pupil of August Gaul in 1921. But photography, which he initially used to investigate form, fascinated the sculptor more and more: from 1930 onwards, he became one of the busiest illustrative and press photographers, in particular of big city life in Berlin. At the same time, he was an intelligent observer of every day life at the zoo. After the Second World War, he documented the ruined city and the reconstruction of the 1950s.

Herbert Tobias Photographer
1924 Dessau — 1982 Hamburg

Until the start of his war service in 1942, Tobias completed an apprenticeship as a surveyor at the land registry in Höxter/Weser. In 1943, he took his first photographs in Russia. He deserted before the end of the war and was made prisoner of war. In 1947, he attended the stage school in Siegburg (Rhine). He was engaged by the *Niedersachsen-Bühne,* a touring theatre company, until 1948. After his own theatre group — in the Heidelberg area — had disbanded in 1951, he went to Paris, where he earned a living working for the photographer, Wilhelm Maywald, and began to take photos himself. Michel de Brunhoff, the editor in chief of *Vogue,* became aware of Tobias' work and contracted him as a fashion photographer. As the result of an homosexual ›offence‹ and resisting a public officer ›in the performing of his duty‹, he was expelled from France and returned to Germany. In 1953, he won the title page competition of the *Frankfurter Illustrierte.* During 1953/54, he came to Berlin and worked as a fashion photographer and documentalist of the post war period and the reconstruction of Germany. His first one man exhibition took place in 1954. In 1969, he moved to Hamburg, where financial pressure compelled him to work for homosexual magazines, such as *Him-Applaus,* which was published between 1970 and 1981.

**Hannah Höch, Edmund Kesting
and El Lissitzky:
see Selected Biographies of the Artists**

Short Biographies of the Authors

Eberhard Blum
Born in 1940 in Stettin (Szczecin), he studied at the Academy of Music in Berlin, and has performed new musical compositions and experimental music.

Gunhild Brandler
Art historian, for fifteen years she has worked regularly on exhibitions and publications concerning contemporary art in the GDR, and has lived in West Berlin since 1988.

Janos Frecot
Born in 1937, he has been the Head of the Archives, the Library and the Photographic Collection of the *Berlinische Galerie* since 1978.

Hubertus Gaßner
Born in 1950, an art historian, his doctoral thesis was on Russian Constructivism. The director of the documenta archive in Kassel, he has published several works on Constructivism and Photography.

Eckhart Gillen
Born in 1947, an art historian, he has worked on exhibitions and published texts concerning 20th century art, he is employed by the *Museumspädagogischer Dienst* Berlin.

Jörn Merkert
Born in 1946 in Bremerhaven, after studying art history, archaeology and history in Bonn and Berlin, he firstly became the assistant of Werner Haftmann at the *Nationalgalerie* in West Berlin, later the secretary of the department of fine art at the *Akademie der Künste* in West Berlin. He was then deputy director of the *Kunstsammlung Nordrhein-Westfalen* in Düsseldorf before becoming the director of the *Berlinische Galerie* in July 1987.

Heinz Ohff
Born in 1922, an art critic and feuilleton editor-in-chief at the Berlin *Tagesspiegel* of many years standing, he writes biographies and travel reports, lives in Berlin and St. Ives (Cornwall).

Ursula Prinz
After receiving her doctorate in art history, archaeology and philosophy, she became an assistant at the *Nationalgalerie* in West Berlin, and has been deputy director of the *Berlinische Galerie* since 1977.

Eberhard Roters
Born in 1929, after studying art history in Halle and Berlin, he received his doctorate for a thesis on the woodcuts of the *Brücke* movement. He then became an assistant at the *Nationalgalerie* in West Berlin, the general secretary of the *Gesellschaft für Bildende Kunst* in West Berlin, the director of the *Kunsthalle* in Nuremberg, the presidential secretary of the *Akademie der Künste*, West Berlin, and was the founding director of the *Berlinische Galerie* from 1976 to 1987. Numerous exhibitions and publications.

Wieland Schmied
Born in 1929, he is author, poet, producer of exhibitions, art historian and art critic, producing numerous publications concerning fine art. Since 1989, he has been president of the *Akademie der Bildenden Künste* in Munich.

Catalogue of the Works

Armando
Kopf, 31. 12. 88, 1988
Head
Oil on canvas
251 × 198,5 cm
Illustration page 171

Gefechtsfeldbesichtigung
1980—1982
Viewing the Battlefield
Oil on canvas
2 parts, each 226 × 175 cm
Illustration page 172/173

Das Rad 1/3, 1989
The Wheel 1/3
Bronze
170 × 160 × 20 cm
Plinth, 8 × 160 × 60 cm
Illustration page 220

Frank Badur
Weiß neben Weiß, 1985
White and White
Oil on canvas
150 × 250 cm
Illustration page 208

Georg Baselitz
Ein Moderner Maler 1966
A Modern Painter
Oil on canvas
162 × 130 cm
On loan from Aberbach
Fine Art, New York
Illustration page 151

Susanne Bayer
Fahren, 1989
Driving
Steel and concrete
30 × 210 × 400 cm
Illustration page 182

Klazina Boer
Vom Bild im Bild, 1989
About the Picture in the Picture
Oil on canvas
180,5 × 150,5 cm

Nikolaus Braun
Berliner Straßenszene, 1921
Berlin Street Scene
Oil on hardboard
74 × 102 cm
Illustration page 114

Gisela von Bruchhausen
Corrida, 1988
Bull-Fight
Steel, coloured setting
183 × 246 × 113 cm
Illustration page 183

Erich Buchholz
Großer Blitz (Fuge), 1920
Great Flash (Fugue)
Oil on canvas
165 × 134 cm
Donation from private collection
Illustration page 91

Claudia Busching
Ohne Titel, 1988
Untitled
Acrylic, dispersion paint,
collage on paper
190 × 174 cm
Illustration page 210

Alexander Camaro
Vorstadtkino, after 1945
Suburban Cinema
Oil on hardboard
62 × 87 cm
Not in the exhibition
Illustration page 134

Caza Muerta, 1980
(Der Käfig, Der weiße Fuchs,
Die Falle, Objekt Strandgut II)
Dead Hunt
*(The Cage, The White Fox,
The Trap, Object Driftwood II)*
Combined techniques on canvas
Triptych, each 250 × 200 cm
Wooden object, 36,5 × 70 × 100 cm
Illustration page 136/137

Gobi — Großes Mühlrad
1981/82
Gobi — Great Mill-Wheel
Combined techniques, tulle
collage on canvas
241 × 287 cm
Illustration page 135

Hans-Jürgen Diehl
Freiheit, 1976
Freedom
Oil on canvas
151 × 230,5 cm
Donation from private collection
Illustration page 158

Otto Dix
Bildnis des Dichters Iwar von
Lücken, 1926
*Portrait of the Poet Iwar von
Lücken*
Oil and tempera on canvas
226 × 120,5 cm
Illustration page 103

Eldorado, 1927
Water-colour on paper
56 × 34 cm
Not in the exhibition
Illustration page 95

Klaus Duschat
Eisentirade, 1982
Iron Tirade
Steel
165 × 140 × 230 cm
Illustration page 181

Lajos d'Ebneth
Composition (Blue Square on
Black Background), 1925
Oil on canvas
60 × 42 cm
Donation of the artist, 1980
Illustration page 86 (left)

Composition, 1927
Oil on canvas 48 × 38 cm
Donation of the artist, 1980

Composition, 1927
Oil on canvas
56,5 × 41,5 cm
Donation of the artist, 1980
Illustration page 86 (right)

Karl-Heinz Eckert
Tu Peux Situ View, 1986 — 1990
Wire found objects on synthetic
boards
0,5 × 25 m
Illustration page 234

Ulrich Eller
Das Quadrat, 1987
The Square
35 square panes of glass in varying
sizes, 35 loudspeakers of varying
design, 4 walkmen, 4 amplifiers,
4 sound cassettes, 200 m unipolar
black litz and other cabling
250 × 250 cm
Illustration page 232

Lilli Engel
In contemplation of the topic II
From the series ›Zerstörte Bilder‹
(Destroyed Pictures), 1989
Combined techniques on canvas
280 × 280 cm
Illustration page 214

Wolfram Erber
24 Kombinationen nach dem
I Ging, 1987
24 Combinations after the I Ging
Composition for ›24 Piece
Percussion Installation‹
by Martin Riches
8 Scores
Pencil and coloured crayon on
photostat
each 50 × 80 cm

Conrad Felixmüller
Der Schaubudenboxer, 1921
The Show Booth Boxer
Oil on canvas
95,5 × 105,5 cm
Illustration page 108

Rainer Fetting
Drummer und Gitarrist, 1979
Drummer and Guitarist
Distemper on canvas
200 × 290 cm
Illustration page 185

Peter Foerster
Orangenstilleben, c. 1924
Still Life with Oranges
Oil on wood
54 × 65,5 cm
Illustration page 98

Hannes Forster
Autobahn A 4, 1989
Motorway A 4
Pieces of asphalt
with existing white line
11,60 × 1,20 m
Illustration page 225

Ernst Fritsch
Berlinbild, 1920
Berlin Picture
Oil on canvas
79,5 × 99 cm

Der Wächter, 1921
The Watchman
Oil on canvas
100 × 88,5 cm

Naum Gabo
Constructed Head No. 3
(Head in a Corner Niche)
1917/1964
Silica-bronze
62,2 × 70 × 35 cm
Illustration page 69

Maquette for the ›Constructed
Torso‹, Winter 1917/18
Reassembled in 1985
Cardboard
117 × 93 × 50 cm
Illustration page 71

Kinetic Construction (Standing
Wave), Winter 1919/20
Reconstructed in 1990
Metal rod with electric motor,
plinth
Height 61,5 cm
Illustration page 73

Model for a ›Monument for an
Airport‹, 1924/25
Reassembled in 1987
Celluloid
Height c. 10 cm
Donation of Nina and Graham
Williams, 1988

Monument for an Airport,
1924 — 1926
Reassembled in 1985
Glass (replaced), enamelled brass
(newly painted)
and wood on wooden base
49 × 73,3 × 30 cm
Illustration page 77

Model for a ›Construction in
Space with Balance on Two
Points‹, c. 1924/25
Reassembled in 1978/79
Celluloid on plastic base
13,5 × 18,2 cm
Donation of Nina and Graham
Williams, 1988
Illustration page 76

Column, 1922/23/c. 1947
Perspex on aluminium base
Height 28,2 cm
Donation of Nina and Graham
Williams, 1988
Illustration page 74

Construction in Space: Vertical
1923 — 1925
Reassembled in 1986
Glass, painted brass and plastic on
black painted wooden base
Height 110 cm
Illustration page 75

Model for a ›Spheric Theme‹
1936/37
Perspex
Diameter 10,2 cm
Donation of Nina and Graham
Williams, 1988
Illustration page 78

Construction in Space: Suspended
c. 1957 — 1965
Perspex, nylon monofilament,
gilded phosphor-bronze cradle on
aluminium base
51,3 × 61,6 × 52,7 cm
Illustration page 79

Studies for ›Head No. 2‹, 1915
Pencil on paper
43,5 × 34,5 cm

Study for a Nude, c. 1915/16
Ink on paper
12,6 × 14,2 cm
Donation of Nina and Graham
Williams, 1988
Illustration page 80

Study for ›Head in a Corner
Niche‹, c. 1916/17
Ink on paper
14 × 12,5 cm
Donation of Nina and Graham
Williams, 1988
Illustration page 68

Study for a Relief, c. 1917—1919
Pencil on paper
48 × 35 cm
Illustration page 83

Study for ›Torso‹, 1916
Pencil on paper
42,2 × 33 cm
Illustration page 70

Study for a Kneeling Figure
c. 1915
Pencil and charcoal on paper
51 × 36 cm (irregular)
Illustration page 81

Study for a Tower, c. 1917
Pencil on paper
40,3 × 28,5 cm
Not in the exhibition
Donation of Nina and Graham
Williams, 1988
Illustration page 82

The Realist Manifesto, Moscow
1920
Leaflet
64 × 76,2 cm
Donation of Nina and Graham
Williams, 1988
Illustration page 72

G. L. Gabriel
Fabrikhaus, 1987
Factory Building
Oil on canvas
189,5 × 219,5 cm
Illustration page 176

Bernhard Garbert
Bongo, 1987
Charcoal on cardboard
195 × 195 × 62 cm
Illustration page 221

Johannes Geccelli
Schwarzspalt — Weißspalt, 1987
Black Crack — White Crack
Acrylic on canvas
Diptych, each 200 × 180 cm
Illustration page 206/207

Raimund Girke
Ohne Titel, 1983
Untitled
Egg tempera on canvas
201 × 220 cm
Illustration page 209

Kuno Gonschior
Erinnerung III, 1989
Memory III
Oil and wax on canvas
250 × 200 cm
Illustration page 211

Arwed Gorella
Die Galerie der Philosophen, 1974
The Gallery of the Philosophers
Oil and acrylic on canvas
160 × 203 cm
Illustration page 154

George Grosz
Selbstporträt, 1928
Self Portrait
Oil on canvas
109,5 × 80 cm
Illustration page 102

Gott mit uns, 1920
God with Us
Portfolio with title page and
9 lithographies
(Malik Publishers, Berlin)
each 48 × 39 cm
Illustration page 36

Johannes Grützke
Bach, von seinen Kindern gestört
1975
Bach, Disturbed by his Children
Oil on canvas
205 × 180 cm
Illustration page 155

Dieter Hacker
Landwehrkanal, 1986
Oil on canvas
192 × 286 cm
Illustration page 177

Raoul Hausmann
Abstrakte Bildidee, 1919
Abstract Idea for a Picture
Block Print
32 × 23 cm

Cover design for
›Volk, Kunst und Bildung‹/
eine Flugschrift von Adolf Behne
c. 1919
*People, Art and Education/
a Pamphlet by Adolf Behne*
Water-colour on paper
22 × 15 cm
Illustration page 32

Ohne Titel (Die Menschen sind
Engel und leben im Himmel)
c. 1920
*Untitled (Men are Angels and
Live in Heaven)*
Photo-montage and collage on
paper and cardboard
31 × 20,5 cm
Illustration page 33

Petite Fleur en Herbe
1932
Little Flower in Grass
Photo-montage
29,5 × 23 cm

Raoul Hausmann and John Heartfield
Dadaco
Dadaistischer Handatlas, 1919/20
Dadaist Hand Atlas
Book project of the Kurt Wolff
publishing house (did not appear)
13 proof pages
Illustrations page 38, 39

Poster for ›Eine kleine Dada
Soirée‹
(*A little Dada Soiree*)
with Theo van Doesburg, Vilmos
Huszár and Kurt Schwitters, 1923
30,1 × 30,1 cm

Raoul Hausmann and Hannah Höch
dada cordial, c. 1919
Collage and photo-montage on
cardboard, 45 × 58 cm
Illustration page 35

Werner Heldt
Häuserstilleben (Fächerbild), 1954
Still Life with Houses (Fan Picture)
Oil on canvas
60 × 105 cm
Not in the exhibition
Illustration page 122

Ter Hell
Ich bin's, 1980
It's Me
Combined techniques on canvas
2 parts, each 260 × 154 cm
Illustration page 187

Peter Herrmann
Chicken and Chips, 1986
Oil on canvas
200 × 160 cm
Illustration page 179

Hannah Höch
Journalisten, 1925
Journalists
Oil on canvas
86 × 101 cm
Not in the exhibition
Illustration page 52

Roma, 1925
Rome
Oil on canvas
90 × 106 cm
Illustration page 53

Dada-Rundschau, 1919
Dada-Panorama-Illustrated
Photo-montage and water-colour on cardboard
45 × 35 cm
Donation of the Press Foundation
›Tagesspiegel‹
Illustration page 34

Denkmal I
Aus einem ethnographischen Museum VIII, 1924
Memorial I
From an Ethnographic Museum VIII
Photo-montage and water-colour on paper
19,8 × 8,9 cm
Illustration page 45

Mit Mütze
Aus einem ethnographischen Museum IX, 1924
With Cap
From an Ethnographic Museum IX
Photo-montage and water-colour on paper and cardboard
27,5 × 15,5 cm
Illustration page 44

Ohne Titel
Aus einem ethnographischen Museum X, 1924
Untitled
From an Ethnographic Museum X
Photo-montage on cardboard
19,5 × 12,5 cm
Illustration page 46

J. B. und sein Engel, 1925
J. B. and his Angel
Collage on cardboard
24 × 19,8 cm
Illustration page 48

Der heilige Berg
Aus einem ethnographischen Museum XII, 1927
The Holy Mountain
From an Ethnographic Museum XII
Photo-montage on cardboard
33,7 × 22,5 cm
Illustration page 47

Deutsches Mädchen, 1930
German Girl
Photo-montage on cardboard
21,5 × 11,5 cm
Illustration page 49

16 stage designs and figure sketches for the anti-revue:
›Schlechter und Besser‹
(*Worse and Better*), 1924/25
by Hannah Höch, Kurt Schwitters, Hans Heinz Stuckenschmidt
Combined techniques on paper
Illustrations page 50, 51

K(arl) H(orst) Hödicke
Großer Schlachter, 1963
Great Slaughterer
Synthetic resin on canvas
Triptych, 180 × 80/175 × 130/ 180 × 80 cm
Illustration page 148/149

Kriegsministerium, 1977
War Ministry
Synthetic resin on canvas
184,5 × 270 cm
Illustration page 166

Martin-Gropius-Bau
(ehem. Kunstgewerbemuseum)
1977
Martin Gropius Building
(Former Arts and Crafts Museum)
Synthetic resin on raw cotton
187 × 270 cm
Illustration page 167

Wegweiser (arms), 1986
Sign (arms)
Bronze
201 × 114 × 44 cm

Rolf Julius
Drei Steine, 1982—1987
Three Stones
3 stones, 1 audio-cassette with recording, 3 loudspeakers with cables, 1 autoreverse walkman, 1 adapter
Illustration page 226

Alexander Kanoldt
Stilleben III mit Amaryllis, 1926
Still Life III with Amaryllis
Oil on canvas
106 × 80 cm
Illustration page 100

Joachim Karsch
Fragende, 1929
Questioner
Bronze
109 × 48 × 50 cm
Illustration page 106

Herbert Kaufmann
Porte bleue, 1961
Blue Door
Collage on canvas
200 × 130 cm
Illustration page 130

Metropolis, 1962
Collage on canvas
200 × 130 cm
Illustration page 131

Ralf Kerbach
Der Zwilling, 1984
The Twin
Oil on canvas
266 × 195 cm

Edmund Kesting
Collage, 1920
Combined techniques
on cardboard
30 × 24 cm
Illustration page 85

Edward Kienholz and Nancy Reddin
Kienholz
The Drawing for the Dumb Dumm
Duel, 1986
Photo, toy cars, metal bears,
wooden console, metal rails, paint
185 × 143 × 12 cm
Donation of Klaus Groenke,
Berlin, 1988
Illustration page 223

Klaus Killisch
Das Atelier des Malers, 1990
The Atelier of the Painter
Oil on canvas
248 × 268 cm
On loan from the artist
Illustration page 197

Erika Klagge
Ohne Titel, 1988
Untitled
Building beam, 7 parts
Height 220 cm
Illustration page 224

Bernd Koberling
Selbst mit roter Angeljacke, 1963
Self Portrait in Red Angler's Jacket
Synthetic resin on raw cotton
70 × 155 cm
On permanent loan from
Olga Gartner, Berlin
Illustration page 153

Loch im Fluß, 1988
Hole in the River
Oil on canvas
225 × 210 cm
Illustration page 175

Issai Kulvianski
Meine Eltern I, 1925
My Parents I
Oil on canvas
150 × 125 cm
Illustration page 109

Henning Kürschner
Große Karyatide Blau, 1987
Large Caryatid Blue
Acrylic, collage, paper on canvas
301 × 156 cm

Hans Laabs
Der Raucher, 1946
The Smoker
Oil on canvas
46,5 × 36 cm
Donation of the artist
Not in the exhibition
Illustration page 121

Franz Lenk
Berliner Hinterhäuser, 1929
Berlin Tenements
Oil on canvas on plywood
113,5 × 94 cm

Walter Libuda
Der Kopfstand, 1985
The Headstand
Oil on canvas
210 × 100 cm
Transferred from the former
Zentrum für Kunstausstellungen
der DDR
Illustration page 192

Das Rondell, 1988
Oil on canvas
130 × 130 cm
On loan from the artist
Illustration page 193

Werner Liebmann
Die große Freiheit, 1990
The Great Freedom
Oil on hardboard
170 × 175 cm
On loan from the artist
Illustration page 195

El Lissitzky
Pen Rack, 1923
Billiard ball, brass casing,
metal rod
5,2 × 9,2 × 5,2 cm
Donation of Hannah Höch
Illustration page 88

Catalogue of the
First Russian Art Exhibition
Berlin 1922
22,5 × 15 cm
Cover design by El Lissitzky
Not in the exhibition
Illustration page 58

Markus Lüpertz
Kongo-Mann mit Speer, 1981
Congo Man with Spear
Oil on canvas
162 × 130 cm
Illustration page 174

Kazimir Malevich
Suprematist Drawing
c. 1925—1927
Pencil on paper
15,5 × 10,5 cm
Illustration page 86

Suprematist Drawing
c. 1925—1927
Pencil on paper
18 × 11 cm
Illustration page 87

Suprematist Drawing
c. 1925—1927
Pencil on paper
21 × 12,5 cm

Jeanne Mammen
Portrait, end of the 1920s
Pencil on paper
50 × 38 cm
Not in the exhibition
Illustration page 104

Marwan (Kassab-Bachi)
Figuration, 1963/64
Oil on canvas
89 × 130 cm
Donation from private collection
Illustration page 150

Kopf, 1986
Head
Oil on canvas
260 × 195 cm
Illustration page 170

Martin and Brigitte Matschinsky-Denninghoff
Die Versammlung, 1984
The Assembly
Brass and tin
Height 3 m
Donation of the Sparkasse der
Stadt Berlin West
Illustration page 219

Jakob Mattner
Percussion II, 3rd version: Wirbel
(Whirl), 1986—1988
Glas, mirrors, tripods, light
3 × 11 m
Not in the exhibition
Illustration page 205

Katharina Meldner
Der Planet VI, 1989
The Planet VI
Pastel crayon on black paper
Installation with 9 drawings
150 × 195 cm

Harald Metzkes
Meerkatze, 1986
Guenon
Oil on canvas
179,5 × 200 cm
Transferred from the Museum der
bildenden Künste Leipzig, 1990
Illustration page 157

Modell mit Maler, 1988
Model with Painter
Oil on canvas
180 × 200 cm
On loan from the artist
Illustration page 156

Helmut Middendorf
Großstadteingeborene, 1979
Natives of the City
Combined techniques on canvas
189,5 × 280,5 cm
Illustration page 184

Otto Möller
Straßenlärm, 1920
Street Noise
Oil on canvas
62 × 75,5 cm
Illustration page 113

Hermann Nonnenmacher
Abschied, 1928
Parting
Mahogany wood
105 × 38 × 19 cm
Illustration page 107

Felix Nussbaum
Der Leierkastenmann, 1931
The Hurdy-Gurdy Man
Oil on canvas
88 × 73,5 cm
Illustration page 111

Der tolle Platz, 1931
The Mad Square
Oil on canvas
97,5 × 195,5 cm
Illustration page 110

Achim Pahle
Stele XII, 1978
High grade steel
255 × 21 × 21 cm
Donation from private collection
Illustration page 218

Wolfgang Petrick
Haubenleute, 1965
Crested People
Combined techniques on raw
cotton
161 × 93 cm
Illustration page 144

Krankenschwestern, 1966
Nurses
Pencil, coloured crayon,
wax crayon on cardboard
89,5 × 62,5 cm

Tarnkappe, 1983
Magic Hood
Gouache on photostat
41,5 × 29,5 cm
Not in the exhibition
Illustration page 143

Ute Pleuger
Häuser am Hang II, 1987
Houses on the Slope II
Oil on canvas
2 parts, each 170 × 200 cm

Iwan Puni
Komposition
Konstruktivistisches Stilleben
1920
*Composition, Constructivist
Still Life*
Oil, ceramic collage on canvas
54 × 63 cm
Donation from private collection
Illustration page 64

Synthetischer Musiker, 1921
Synthetic Musician
Oil on canvas
145 × 98 cm
Joint ownership with the Sparkasse
der Stadt Berlin West
Illustration page 65

Stilleben mit weißer Flasche, 1922
Still Life with White Bottle
Oil on canvas
68 × 42 cm
Donation from private collection
Illustration page 66

Stilleben mit Säge und Palette
1923
Still Life with Saw and Palette
Oil on canvas
77,5 × 51 cm
Donation from private collection
Illustration page 67

Raffael Rheinsberg
Zwischen den Schienen, Berlin
Nordbahnhof, 1984
*Between the Rails, Berlin North
Station*
11 drawings and 69 found objects
Illustration page 222

Martin Riches
24 Piece Percussion Installation
1987
for the composition
›24 Combinations after the I Ging‹
by Wolfram Erber
24 stands, sound boards and
switchboxes, 100 m cable and
1 perspex box with electric control
system
Illustration page 233

Hans Richter
Portrait of Theodor Däubler, 1914
Pencil on paper
26 × 23 cm
Donation of the collection Hans
Richter, Zurich

Study for Emmy Hennings'
›Gefängnis‹ (*Prison*), 1917
Pencil on paper
28 × 21 cm
Donation of the collection Hans
Richter, Zurich

George Rickey
Four lines in a T (Berlin), 1985
Stainless Steel
400 (max. 772) cm
× 550 (max. 1118) cm
Not in the exhibition
Illustration page 204

Angelik Riemer
Drei Große, 1983
Three Large Ones
Egg tempera on canvas
Triptych, 280 × 600 cm
Illustration page 212/213

Alexander Rodchenko
Untitled, c. 1923
Gouache on wood
14 × 17,7 cm
Illustration page 89

Ursula Sax
Fahne/Windskulptur, 1990
Flag/Wind Sculpture
Spinnaker Material
488 × 297 cm
Not in the exhibition
Illustration page 165

Christian Schad
Ludwig Bäumer, 1927
Oil on Wood
61 × 50 cm
Illustration page 101

Hans Scheib
Du mußt doch bewaffnet sein!
1984
But You Must Be Armed!
Painted wood
185 × 40 × 120 cm
Illustration page 178

Rudolf Schlichter
Sitzende Jenny, undated
(c. 1922/23)
Jenny Sitting
Oil on canvas
86,5 × 65 cm
Illustration page 99

Blinde Macht, 1937
Blind Force
Oil on canvas
180 × 100 cm
Illustration page 115

Männerporträt, c. 1925
Portrait of a Man
Charcoal on paper
58,9 × 45,9 cm
Not in the exhibition
Illustration page 105

Georg Scholz
Wucherbauernfamilie, 1920
Family of Profiteering Farmers
Lithography
27 × 36 cm
Illustration page 37

Eugen Schönebeck
Ohne Titel, 1963
Untitled
Ink and water-colour on paper
61 × 43 cm
Not in the exhibition
Illustration page 152

Georg Schrimpf
Zwei Mädchen am Fenster, 1928
Two Girls at the Window
Oil on canvas
85 × 72 cm
Illustration page 97

Stefan Schröter
Ohne Titel, 1988
Untitled
Oil on canvas
190 × 280,5 cm
Illustration page 215

Arthur Segal
Künstlers Erdenwallen
(Der Maler), 1921
*Artist's Pilgrimage on Earth
(The Painter)*
Oil on canvas
62 × 82,5 cm
(with painted frame
77,5 × 98 × 3,5 cm)
Illustration page 112

Frank Seidel
Three Sculptures
No. 190, No. 191, No. 192
Plaster, iron parings and iron
185 × 144 × 55/183 × 143 × 55/
175 × 150 × 52 cm
On loan from the artist
Illustration page 194

Gerd Sonntag
Oedipus-Köpfchen, 1990
Oedipus I
Little Oedipus Head
Oil on paper on canvas
100 × 73 cm
On loan from the artist
Illustration page 198

Marzahner Kopf, 1990
Oedipus II
Head from Marzahn
Oil on paper on canvas
100 × 73 cm
On loan from the artist
Illustration page 199

Peter Sorge
Versuche über die Großstadt, 1977
Experimental Sketches of the City
Coloured crayon on cardboard
4 parts, 179 × 90/98 × 90/
98 × 90/179 × 90 cm
On permanent loan from the
Federal Republic of Germany
Illustration page 160

Gerdi Sternberg
Halbrundbild I, 1986—1988
Semi-Circular Picture I
Combined techniques on canvas
183,5 × 368 cm
Illustration page 216

Jürgen Waller

Die lädierte Identität des vom
Berufsverbot betroffenen
Kunsterziehers H. J. Schreiber
1976
*The Ruined Identity of the Art
Teacher H. J. Schreiber, Hit by
›Berufsverbot‹*
Oil on canvas
150×120 cm
Donation from private collection
Illustration page 159

Trak(ia) Wendisch

El Coloso, 1986/87
The Colossus
Oil on canvas
240×204 cm
Transferred from the former
Zentrum für Kunstausstellungen
der DDR
Illustration page 196

Theodor Werner

Pierrot lunaire, 1944
Oil, pencil on canvas
114,5×145,5 cm
Not in the exhibition
Illustration page 123

Gustav Wunderwald

Travemünder Straße, 1927
Oil on canvas
60×85 cm

Pomona Zipser

Der elfte Gesang, 1987
The Eleventh Hymn
Wood, string, dispersion colour,
coal-tar paint
400×450×550 cm
Illustration page 235

All works not mentioned as loans
or donations were acquired by
means of the VEBA Foundation,
of the Stiftung Deutsche
Klassenlotterie Berlin or of the
Senate Department for Cultural
Affairs, Berlin.

Photography

Erwin Blumenfeld

Untitled, c. 1935—1938
Silver gelatine paper
30×24,2 cm
Illustration page 254

Untitled (Hair), 1930s
Silver gelatine paper
30×24,2 cm

Untitled (Portrait of
Karin Leyden), 1930s
Negative process
30,3×24 cm

Fritz Brill

800 000, 1932
Photogravure
29×23 cm
Donation of the artist

Hans Casparius

Portrait of Valeska Gert, c. 1931
Silver gelatine paper
21,6×16 cm
Donation of kunstspedition apv,
Berlin
Illustration page 251

Rolf Cavael

31/F7, 1931
Photogram
Silver gelatine paper
24×18 cm
Donation of Heinz Trökes, 1981
Illustration page 249

Paul Citroen

Kiko, 1933
Silver gelatine paper
23,4×17,3 cm

Erich Comeriner

Der Lausbub, c. 1930
The Rascal
Silver gelatine paper
24,3×18 cm
Illustration page 252

Rast im Wald, c. 1930
Rest in the Wood
Silver gelatine paper
18×12,8 cm
Illustration page 259

Caroline Dlugos

Opfer und Täter, 1988
Victim and Perpetrator
Silver gelatine paper on canvas
Unique print
2 parts, 150×127/
195×127 cm
Illustration page 228

Hugo Erfurth

Portrait of Max Liebermann, 1920
Silver gelatine paper
28,2×23,8 cm
Donation of the Press Foundation
›Tagesspiegel‹, 1988

Portrait of Otto Dix, 1929
Silver gelatine paper
22×16,2 cm

Portrait of Heinrich George
Undated
Oleograph
41,8×34,8 cm
Donation of the Press Foundation
›Tagesspiegel‹, 1988
Illustration page 250

Fritz Eschen

Blind Street Musician at the
Vibraphone, Kurfürstendamm,
the Corner of Uhlandstraße, 1949
Silver gelatine paper
New print, 1988
20×29,8 cm

Arno Fischer

Berlin 1956, Unter den Linden
1956
Silver gelatine paper
New print, 1990
30×44 cm

Thomas Florschuetz

Untitled, Triptych No. 12, 1988
3 parts, unique print, C-prints
Entire size 150,5×301,5 cm
Illustration page 229

Elfi Fröhlich

Inszenierung der Authentizität
1987
Production of the Authenticity
20 parts installation, C-prints
each 40×60 cm
Illustration page 263

Tim Gidal
Kurt Gerron During the
6-Day-Race
at the Berlin Sportpalast, 1930
Silver gelatine paper
33,5 × 23,7 cm
Illustration page 253

Hannah Höch
Self Portrait, c. 1927
New enlargement, 1985
Silver gelatine paper
31,2 × 24,3 cm
Illustration page 243

Ewald Hoinkis
Untitled, 1929
Silver gelatine paper
17,3 × 22 cm
Donation of the Grundkreditbank,
Berlin, 1989

Lotte Jacobi
From the Wallmann School, Berlin
Directed by Margarete Wallmann
c. 1928
Silver gelatine paper
17,3 × 23,1 cm

Anna Seghers, Authoress
Before 1930
Silver gelatine paper
17 × 22,3 cm

Ludwig Jubelsky and Toni van Eyk
in ›Scampolo‹ by Darion
Niccodemo in the Deutsches
Volkstheater. Directed by Joachim
v. Oslau, c. 1930
Silver gelatine paper
15,5 × 16,6 cm

Edmund Kesting
Photogram, 1923
Silver gelatine paper
23,5 × 15 cm
Illustration page 84

Portrait of Heinrich Ehmsen, 1948
Silver gelatine paper
39,8 × 29,7 cm
Donation of Galerie Berinson,
Berlin

Raimund Kummer
Untitled, 1985 — 1987
Cibachrome and aluminium
Unique print
125 × 223 × 16 cm
Illustration page 230

El Lissitzky
Poster Design for Pelikan, 1924
Vintage print
Silver gelatine paper
49,7 × 34,8 cm
Illustration page 247

Brüder, 1928 or 1929
Brothers
Silver gelatine paper
12 × 16,7 cm
Illustration page 242

Will McBride
Children Near the Station
Friedrichstraße, 1954
Silver gelatine paper
25,5 × 37,8 cm
Illustration page 260

Laszlo Moholy-Nagy
Blumenfotogramm, 1925
Flower Photogram
Silver gelatine paper
23,9 × 17,7 cm

Oskar Schlemmer in Ascona
1926/27
Silver gelatin paper
23,5 × 17,5 cm
Illustration page 245

The Sailor, 1926/27
Silver gelatine paper
24 × 18 cm
Illustration page 244

Poster Design for the Department
Store Schocken, probably 1927
Vintage print
Silver gelatine paper
22 × 16,3 cm
Illustration page 246

Photogram, 1935
Silver gelatine paper
18,2 × 23,9 cm
Illustration page 248

Lucia Moholy-Nagy
Portrait of Lily Hildebrandt, 1926
Silver gelatine paper
17,8 × 23,9 cm
Not in the exhibition
Illustration page 255

Portrait of Clara Zetkin, 1929
Silver gelatine paper
11,3 × 8,1 cm

The Hands of Clara Zetkin, 1929
Silver gelatine paper, 1929
8,1 × 10,7 cm

Gabriele and Helmut Nothhelfer
Dame beim Pfingstkonzert, Berlin
1974
Lady at a Whitsun Concert
Silver gelatine paper
21,4 × 29,7 cm

Hermann Pitz
Byl 4, 1988
Colour transparency, perspex,
light box and drop-shaped floor
objects
Unique print
125 × 262 × 60 cm
Illustration page 231

Henry Ries
Berlin 1947
Silver gelatine paper
27,8 × 34,4 cm

Erich Salomon
The Reuter correspondent,
Wandel, and an unknown
journalist during a rather long
speech by the Lithuanian delegate,
Woldemaras, at the League of
Nations.
Geneva, 1928
Silver gelatine paper
33 × 43,6 cm

The first photograph to be taken
of High Court, the Supreme Court
of Justice, during a trial.
London, 1929
Silver gelatine paper
38,4 × 48,4 cm

Erich Salomon shows the British Foreign Minister, Sir Austen Chamberlain, his photographs of the League of Nations.
London, Foreign Office, April 1929
Silver gelatine paper
31,6×42,3 cm

A night sitting of the German and French ministers at the Conference on War Debts in The Hague, 1930
Silver gelatine paper
29,5×41,4 cm
Not in the exhibition
Illustration page 256

A servant waits patiently under the hats of the ministers for the end of the night sitting. The Hague, 1930
Silver gelatine paper
43×29,8 cm
Not in the exhibition
Illustration page 257

The American newspaper publisher, William Randolph Hearst, used to retire after dining in order to study the reports of correspondents from the staff of his various newspapers. All communication was sent through his own post office. San Simeon, California, 1930
Silver gelatine paper
34,2×45 cm

French and German politicians in the saloon carriage of the French government's special train on the journey from Paris to Calais and to the economic conference in London.
July, 1931
Silver gelatine paper
30,8×47,1 cm

The British Prime Minister, Ramsay MacDonald, in conversation with Albert Einstein. On the left: Max Planck.
Berlin, 1931
Silver gelatine paper
31,6×48,4 cm

The British Prime Minister, Ramsay MacDonald, in conversation with Albert Einstein. On the left: Max Planck.
Berlin, 1931
Silver gelatine paper
30×38,8 cm

Henny Porten and her husband Dr. Wilhelm von Kaufmann, 1931
Silver gelatine paper
Vintage print
18,2×24 cm

The American Senators, Couzens, Robinson and Schall (from left to right), members of the Senate Committee on Justice during a session.
Washington, February 1932
Silver gelatine paper
34,4×45,5 cm

Michael Schmidt
Waffenruhe, 1984—1987
Cease-Fire
Silver gelatine paper
1 of 45 parts, 60×50 cm
Not in the exhibition
Illustration page 239

Friedrich Seidenstücker
Montags. Oberbaumbrücke, 1930
Mondays
Silver gelatine paper
12,5×18 cm
Donation of Heinz Trökes and Renate Heyne, 1982
Illustration page 258

Untitled, c. 1930—1935
Silver gelatine paper
18,2×13 cm

Tochter und Pappa Knautschke
Undated
Daughter and Daddy Knautschke
Silver gelatine paper
16,8×22,9 cm

Herbst im Zoo, afr. Nashorn
Undated
Autumn at the Zoo, African Rhinoceros
Silver gelatine paper
29×23,4 cm

Karl String
Versuch, etwas ohne Erfahrungswert zu sehen oder ein bestehendes Prinzip in Frage zu stellen, 1977
Attempt to See Something Without Empirical Value or to Question an Established Principle
Silver gelatine paper
4 parts sequence
each 18,5×28 cm
Illustration page 262

Herbert Tobias
Jerusalem Church Destroyed, Berlin. 1954
New enlargement, 1981
Silver gelatine paper
34,5×34,5 cm
Illustration page 261

Yva (Else Simon)
Untitled, c. 1930
Silver gelatine paper
20,9×16,2 cm
Donation of the Stiftung Preußische Seehandlung, 1988

The original titles are printed in German, whereas only the English translations of later descriptions are given.

References

Berlin or the Round Head by Jörn Merkert is a revised and extended version of the one first published in *Berliner KUNSTstücke — Die Sammlung der Berlinischen Galerie zu Gast in Leipzig und Berlin (Ost)*, catalogue of the exhibition, Berlin 1990. *Iwan Puni. A Russian in Berlin* by Eberhard Blum was also originally published in this catalogue.

Dada in Berlin by Eberhard Roters, *Constructivism and the Constructed* by Hubertus Gaßner, *Comeback of the External World* by Eckhart Gillen and *It's Me* by Heinz Ohff are (in some cases) abbreviated versions of ones first published in *Sammlung Berlinische Galerie. Kunst in Berlin von 1870 bis heute*, Berlin 1986.

New Beginnings and *New Constructivist and Conceptual Art* by Ursula Prinz and *The Photographic Collection* by Janos Frecot are revised and extended versions of those first published in *Berlinische Galerie — Museum für moderne Kunst, Photographie und Architektur, Berlin* in the series *museum*, Georg-Westermann-Verlag, Braunschweig 1989

Pictures of Life in a Sea of Stone by Eberhard Roters first appeared in MERIAN Berlin, No. 7, Verlag Hoffmann und Campe, Hamburg 1989.

New Objectivity by Wieland Schmied is the abbreviated version of the one first published in *Kritische Grafik in der Weimarer Zeit*, Klett-Cotta, Stuttgart 1985.

These texts were all translated into English for the first time for this catalogue: *Dada in Berlin, Comeback of the External Wold, It's me, Pictures of Life in a Sea of Stone, New Objectivity* by Richard Carpenter, and *Berlin! or the Round Head, Iwan Puni, Constructivism and the Constructed, New Beginnings, New Constructivist and Conceptual Art, The Photographic Collection* by Lucinda Rennison, who also translated the forewords, the introduction, the biographies and the legends.

Naum Gabo—International Figure of Constructivism by Jörn Merkert is the revised version of the English one first published in *Naum Gabo 1890—1977. Centenary Exhibition*, catalogue of the exhibition, Annely Juda Fine Art, London 1990.

Photograph Credits

© for the works illustrated, if not with the artists or their legal successors, lies with VG Bild-Kunst, Bonn.

© for the photographs of Naum Gabo's works lies with Nina and Graham Williams, Biddenden, Ashford/Kent.

© page 27, inside front and back cover: Karl Ludwig Lange

© page 40: Bildarchiv, PK, Berlin

© page 41: Archives Nakov, Paris

© page 43: Hannah-Höch-Archiv, Berlinische Galerie

© page 191: Gudrun Petersen

Photograph Reproductions

Berndt Borchardt
Ulrich Görlich
Markus Hawlik
Udo Hesse
Hermann Kiessling
Bernd Kuhnert
Jochen Littkemann
Götz Rakow
Angelika Weidling

gegenwart museum

**Series Published by the
Berlinische Galerie and the
Museumspädagogischer
Dienst Berlin**

Diether Schmidt,
Die Krönung des Vagabundendichters
Iwar von Lücken.
Ein Gemälde von Otto Dix. 1988

Zwiesprache.
Photographen sehen Künstler.
Mit Texten von Janos Frecot, Bernd Weise
und Elisabeth Moortgat. 1988

Jörn Merkert,
»Was soll denn das beinhalten«.
Zu den Arbeiten von K. H. Hödicke in der
Berlinischen Galerie.
1988

Skulptur in Berlin 1968—1988.
Zehn Jahre Künstlerförderung des Senats —
Ankäufe im Besitz der Berlinischen Galerie.
Mit Beiträgen von Friedrich Teja Bach, Ursel
Berger, Jörn Merkert u. a.
Herausgegeben zusammen mit dem
Georg-Kolbe-Museum. 1988

Naum Gabo. Ein russischer Konstruktivist in
Berlin 1922—1932.
Skulpturen, Zeichnungen und
Architekturentwürfe. Dokumente und Archive aus
der Sammlung der Berlinischen Galerie. Mit
Beiträgen von Helen Adkins, Jörn Merkert,
Georg Rickey u. a.
(Hrg. Jörn Merkert). 1988

Eberhard Roters zu Ehren.
Schenkungen von Arbeiten auf Papier an die
Berlinische Galerie zu seinem 60. Geburtstag.
1989

Max Missmann.
Photograph für Architektur, Industrie, Illustration,
Landschaft und Technik. Mit Beiträgen von
Wolfgang Gottschalk, Janos Frecot, Ludwig
Hoerner und Michael Rutschky. 1989

Hannah Höch 1889—1978.
Ihr Werk — ihr Leben — ihre Freunde.
Katalog zur Ausstellung der Berlinischen Galerie
anläßlich des 100. Geburtstages der Künstlerin.
1989

Wände aus farbigem Glas.
Das Archiv der Vereinigten Werkstätten für
Mosaik und Glasmalerei Puhl & Wagner,
Gottfried Heinersdorff.
Katalog zur Ausstellung. 1989

Beatrice Vierneisel,
Die Engländerin — Eine Bronzeplastik von
Ernesto de Fiori im Georg-Kolbe-Museum

Zone 5.
Kunst in der Viersektorenstadt 1945—1951.
Hrg. Eckhart Gillen und Diether Schmidt. 1989

Kunstszene Berlin (West) 86—89.
Erwerbungen des Senats von Berlin.
Katalog zur Ausstellung. 1990

Berliner KUNSTstücke.
Die Sammlung der Berlinischen Galerie zu Gast in
Leipzig und Berlin (Ost).
Mit Beiträgen zu 140 Kunstwerken von
90 Autoren aus Berlin und aus der DDR.
Katalog zur Ausstellung. 1990

Johannes Niemeyer.
Architekt und Maler
Katalog zur Ausstellung. 1991

BERLIN!
The Berlinische Galerie Art
Collection Visits Dublin 1991.
Katalog zur Ausstellung. 1991

Eberhard Roters,
Iwan Puni. 1991

In Preparation

Jörn Merkert
Wolf Vostell in der Sammlung der
Berlinischen Galerie

Helen Adkins
Erste Internationale Dada-Messe